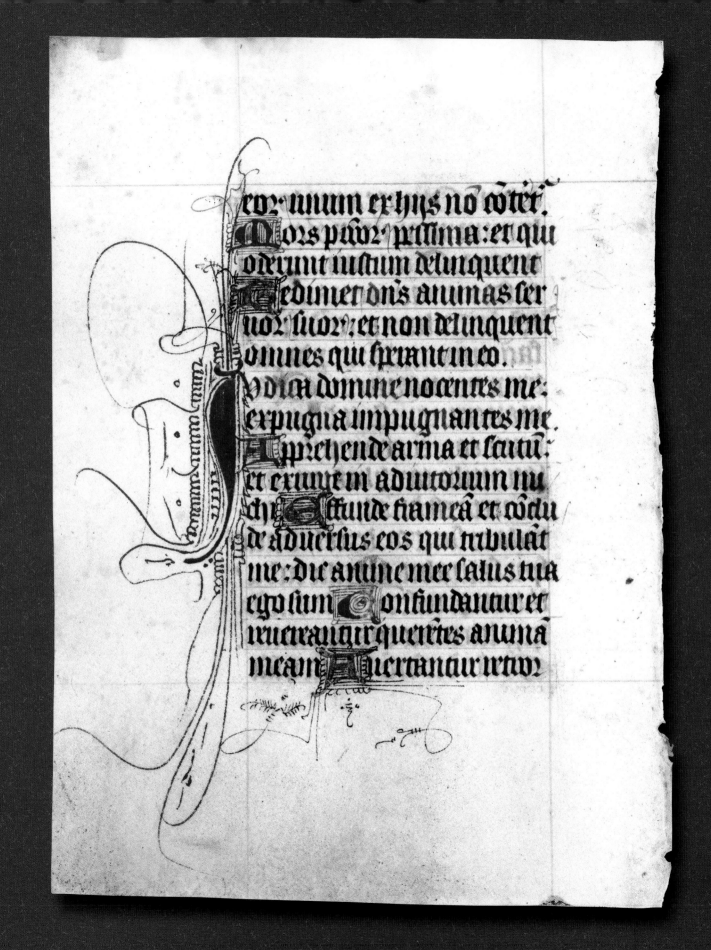

eo2 uuuin er hijs no cotet̄

Mo2s ptoz petiima: et qui
oderunt iustum delinquent

Redimet dn̄s animas ser
uo2 suo2: et non delinquent
omnes qui sperant in eo.

Ydica domine nocentes me:
expugna impugnantes me.

Apprehende arma et scutu:
et exurge in adiutorium mi
chi. Effunde frameam et conclu
de aduersus eos qui tribulat
me: dic anime mee salus tua
ego sum. Confundantur et
reuereantur querentes animam
meam. Auertantur rtro2

The WORLD ENCYCLOPEDIA

of

Calligraphy

The Ultimate Compendium on the Art of Fine Writing

HISTORY ❧ CRAFT ❧ TECHNIQUE

Compiled and edited by

CHRISTOPHER CALDERHEAD

and HOLLY COHEN

STERLING

New York

STERLING
New York

An Imprint of Sterling Publishing
387 Park Avenue South
New York, NY 10016

Project Editor: Ellin Yassky, Medici Editorial Services, LLC
Designer: Veronica Naranjo, Ziga Design, LLC

ISBN 978-1-4027-3368-0

Library of Congress Cataloging-in-Publication Data
Calderhead, Christopher.
 World encyclopedia of calligraphy : the ultimate compendium on the art of fine writing-history,
craft, technique / Christopher Calderhead, Holly Cohen.
 p. cm.
 Includes bibliographical references and index.
 ISBN 978-1-4027-3368-0 (alk. paper)
 1. Calligraphy--Dictionaries. I. Cohen, Holly. II. Title.
 NK3600.C24 2011
 745.6'1--dc23
 2011022316

Distributed in Canada by Sterling Publishing
c/o Canadian Manda Group, 165 Dufferin Street
Toronto, Ontario, Canada M6K 3H6
Distributed in the United Kingdom by GMC Distribution Services
Castle Place, 166 High Street, Lewes, East Sussex, England BN7 1XU
Distributed in Australia by Capricorn Link (Australia) Pty. Ltd.
P.O. Box 704, Windsor, NSW 2756, Australia

Please see picture credits on page 308 for image copyright information.

Frontispiece: Leaf from a Book of Hours. Northern Europe, (France or Flanders),
c. fifteenth century. Private collection.

For information about custom editions, special sales, and premium and corporate purchases,
please contact Sterling Special Sales at 800-805-5489 or specialsales@sterlingpublishing.com.

Manufactured in China

10 9 8 7 6 5 4 3 2 1

www.sterlingpublishing.com

ACKNOWLEDGMENTS

This book is the product of many hands. We are very grateful for the many calligraphers and scholars who have provided samples of their work and text for this book. We are deeply in their debt. Their contributions are acknowledged within the text of the book.

Ellin Yassky, our Managing Editor, is one of the kindest people we have ever worked with. Charles Ziga and his team of Veronica Naranjo, the designer of this book, and Photoshop expert Jim Kahnweiller, who retouched and prepared all the 900-plus images that have appeared here, all worked under high-pressure deadlines to lay out the book. The credit for the final result belongs entirely to them.

Barbara Berger, Senior Editor at Sterling Publishing, went over the whole book with a razor eye for detail and was invaluable in bringing it to its final form.

In the course of our research, many people helped us find contacts and information. Sometimes this project felt like a great international game of telephone, and it would be impossible for us to list every person who helped us along the way. But certain people stand out for their generosity and willingness to help.

Kristina Dy-Liacco at the Trace Foundation's Latse Contemporary Tibetan Cultural Library has lent consistent support to the book. We are grateful that she allowed us to examine items on exhibition at the library, and to photograph them. She also put us in direct contact with several calligraphers.

Tsering Choedron, the daughter of Rigzin Samdup Langthong, helped us stay in contact with her father, and served as a helpful go-between and translator.

William J. Dane, retired Supervising Librarian, Keeper of Prints and Posters, Special Collections Division at the Newark Public Library, allowed us to photograph an album of manuscript leaves at the Library. After his retirement, Chad Leinaweaver, Special Collections Division, Newark Public Library, gave us permission to use the photographs we had taken.

The monks at the New York Buddhist Vihara in Queens, New York, opened their library to us, where we were able to meet with Dr. S. Leelaratne. They also invited us to join in their meals and participate in their ceremonies. We are very grateful for their warmth and generosity.

Dr. Getatchew Haile, Regents Professor of Medieval Studies and Cataloguer of Oriental Manuscripts at the Hill Museum and Manuscript Library, gave us important pointers about Ethiopian sources.

Jerry Kelly generously allowed us to photograph objects from his extensive collection. Rory Kotin did so as well.

Eva Kokoris, as President of the Society of Scribes in New York, helped us facilitate a study day during which Western-trained scribes explored the writing of some of the smaller world traditions. Calligraphers who participated in Study Day included Anna Pinto, Eleanor Winters, Maureen Squires, Chi Nguyen, Rosemary Kracke, Elinor Holland, Cynthia Dantzic, Emily Brown Shields, Alice Koeth, Nathan Simmons, Rebecca Farber, and Lisa Perkins.

Elaine W. Ng, Editor and Publisher of ArtAsiaPacific and Don J. Cohn, Senior Editor of ArtAsiaPacific, helped us with the Chinese translation.

Chad Pollock, Reference Librarian at the JKM Library, and Stuart Creason, PhD, Lecturer in Aramaic at the Near Eastern Languages and Civilization department at the University of Chicago's Division of Humanities, guided us to George Kiraz.

Jinyoung Kim, Senior Program Officer at the Korea Society, and Heewon Kim, Program Officer at the Korea Society introduced us to Yoo Sung Lee.

Maka Gabelia, Executive Director of the Georgian Association introduced us to Eka Maraneli.

Joyce Teta, calligrapher and book artist at the Calligraphy Centre in Winston-Salem, North Carolina, and creator, along with her husband Jim, of Cheerio Calligraphy and

Bookarts Retreats in North Carolina, helped us contact John Stevens.

Pat, and the owners of the Nirvana Gallery in Bangkok, Thailand, generously allowed us to photograph and print pages from their manuscripts in their collection.

Ruth Phaneuf and Lauren van Haaften-Schick at the Nicole Klagsbrun Gallery provided images and information about Jacob El Hanani.

Tim Ternes, Director of Programming and Exhibitions for the Saint John's Bible and the Hill Museum and Manuscript Library, provided an image of an Ethiopian manuscript from the HMML collection.

We would also like to thank Sovan Tun, President of the Cambodian Buddhist Society, Inc.; Mr. Seng Ouk, artist; Jeffrey Cunard, Secretary, Friends of Khmer Culture, Inc.; Gilda Buchakjian Kupelian, Coordinator, Armenian Studies, Department of Youth and Education, Diocese of the Armenian Church of America (Eastern), NYC; Elizabeth McKee and Marianne Fisher for help in sourcing contacts; Malik Anas, who corresponded with us from his home in Iraq; Sambuu Dawadash, Second Secretary/Political/ Embassy of Mongolia; Carol Wahler, Executive Director, Type Directors Club; and Catherine Raymond, Associate Professor, Southeast Asian Art History, Director, Center for Burma Studies, Northern Illinois University.

Christopher Calderhead would like to thank Anna Pinto, who listened to many gripes and made valuable suggestions as the book was in process. Brad Winters also lent a wise, sympathetic ear at many stages in the book's development.

Holly Cohen would like to thank her brother Andy Cohen for being, as Hemingway put it, her "built-in, shock-proof, sh-t detector," and her brother Jimmy Cohen and mother Joan Nelkin for their love and support; Joan Petty for her guidance, Marsha Sesskin for her wisdom, and Jim Dore for his enthusiasm.

Dedicated to the legendary Mongolian
horsemen who, we are told, did calligraphy
while riding their steeds across the
steppes of Central Asia.

CONTENTS

IN YOUR
OWN BOSOM YOU
BEAR YOUR
HEAVEN & EARTH
AND ALL

WILLIAM

BLAKE
YOU BEHOLD;
tho' IT APPEARS
WITHOUT,
IS WITHIN.

JERUSALEM · III · 71

PREFACE

It's been an extraordinary adventure writing this book. We wish we could say it has taken us across the globe. But in fact, all the work had been done from our base here in New York City. That's been a good place to begin. Because where else in the world is so much of the world concentrated in one spot? New York is a meeting place of people and cultures, and we have mined the city for everyone we could find who might have some idea about the many calligraphic traditions from around the globe.

In Manhattan, we have used the vast resources of the New York Public Library. And we have tapped immigrant communities around New York, as well as the research institutes, cultural centers, and universities and schools, ransacking the city for as much information as we could find.

Of course, the Internet is now an invaluable resource as well—we have used the World Wide Web to find calligraphers in far away places, such as Israel, the United Arab Emirates, Turkey, Russia, and England, to name but a few.

In the course of our research, we have traveled to Buddhist monasteries, over cups of coffee and tea met with people from far-away countries, and cajoled and begged for material from people from many different backgrounds.

In the process, we have learned much about ourselves, and much about the cultures we sought to study. Sometimes the insights have been uncomfortable. Our point of view has been one of multicultural exchange and respect. But when we've met people from distant countries, sometimes we have encountered the rivalries and distrust that separate people and nations. Each calligraphic tradition we have studied has its own history. Some of these are tragic since many of the smaller-world cultures bear the wounds of protracted civil strife and cultural destruction. As we have met calligraphers and teachers from other cultures, we have often been humbled by the tenuousness of cultural traditions in societies that have been wrenched by war and dictatorship.

But we don't want to paint a fragile picture of what we have been able to do in this book. Many, many people have helped us bring this project to fruition. And the most important feeling we have experienced is one of extreme gratitude. We are hugely indebted to the many people who have helped us by providing contacts, information, sharing stories, and making available their exquisite talent in the art of calligraphy. We have been humbled many times by the unquestioning generosity of the many people who provided samples of their artwork and craft for this book. Calligraphers are, on the whole, generous people.

It is our hope that this book will become a valuable resource to anyone who has an interest in the art of fine writing from around the world. It has taken us almost five years to pull this much together. We could have taken longer; heaven knows, there is more to cover than what we've managed to gather here. Every time we have thought we had mastered some aspect of the scribal craft, we were amazed to find the circle of knowledge grew wider: you begin, you gather samples and stories, and then you discover you have just scratched the surface of traditions that stretch back into time. But this book is more than just a beginning. It is a window into a wide world of calligraphy. And we hope it will give to you, our readers, a pathway into a topic that is as fascinating as it is broad.

Christopher Calderhead
Holly Cohen

Opposite: Holiday Card by Jerry Kelly, 1986. Original calligraphy with metal type, printed in letterpress.

The WORLD ENCYCLOPEDIA

of

Calligraphy

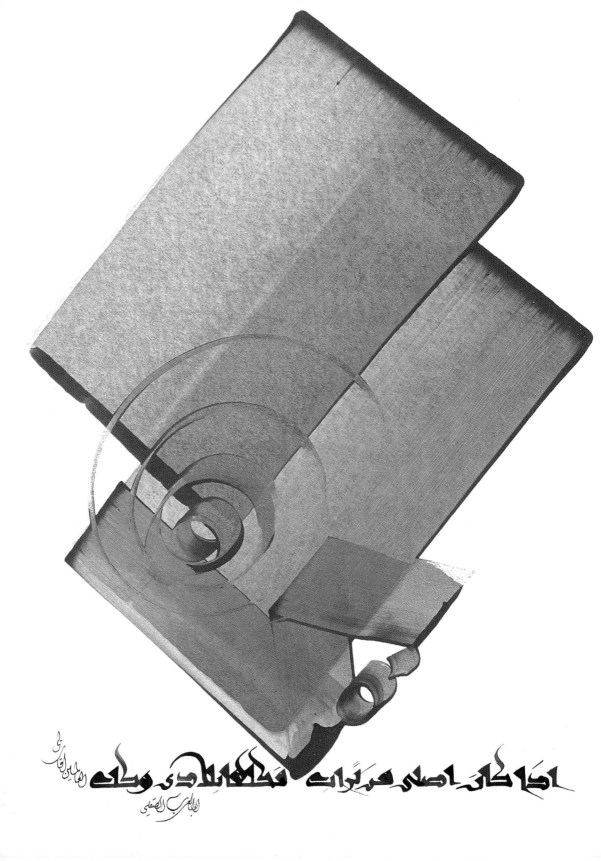

اذا كان اصلى هريزات مخاخلتلادى ولك

الهادى راقاس

ابالعري العصاى

INTRODUCTION

By Christopher Calderhead

This is a book about living calligraphic traditions. That should be a simple enough thing to accomplish: go out and find calligraphers writing scripts from all over the world. Ask them to write out an alphabet and a short piece of text, and you're done. Were it so easy! As soon as you begin to explore the calligraphic traditions of the world, questions arise. What, exactly, is calligraphy? Does one definition fit all the different writing traditions? What happens when writing turns out to involve more than the twenty-six letters of our Roman alphabet? How do you teach complex calligraphy traditions like Chinese, with its thousands of distinct characters? What do you do with handwriting or carved inscriptions? Do those things count as calligraphy? What's the difference between a living tradition and an antiquarian exercise? What is calligraphy for?

Within each calligraphic tradition, there are answers to these questions formed by centuries of history, cultural development, and debate. But when you leave the comfortable confines of your own tradition, the boundaries become less clear. A Jewish ritual scribe, a *sofer*, will tell you that his is a sacred art, its boundaries defined by the debates and rulings of learned rabbis; the most important consideration is that they are *ritually valid*. Beauty is important, but it is considered an addition to the critical task of making something in accordance with the ritual requirements. A commercial artist making greeting cards in Ohio will describe their work as an applied art, designed to express personal sentiments; the cards help people communicate their feelings to those they love and care about. A newspaper calligrapher in Pakistan will say writing out text is easier and more cost-effective than setting Urdu script in type. A Tibetan will tell you that calligraphy is a matter of cultural survival, preserving traditions that in the last century have risked annihilation. An English scribe writing out a royal charter with a quill on vellum will say that the Crown has required handwritten documents for more than a thousand years, so of course this is how it is to be done.

What ties all these different people together is that they all make written texts where *the form of the writing matters*. They are deeply invested not only in the meaning of the words they write, but in the shapes of the letters or characters themselves. They have spent years practicing the craft of writing, honing their skills, internalizing the movements of the hand, and deeply considering how their tools and materials can best be used. For the calligrapher, form matters.

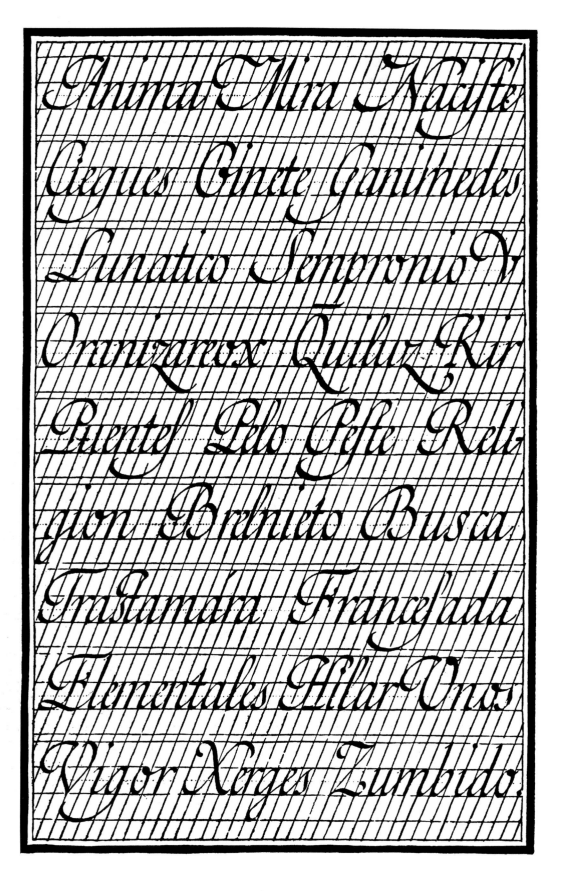

What is Calligraphy?

Let's take our definition a step further. The word *calligraphy* comes from the Greek words καλλι and γραφειν. It is a compound of two words: *beautiful* and *to write*. For most traditions, this would seem to be a workable way of separating calligraphy from, say, day-to-day handwriting on the one hand and typography on the other. To be calligraphy, a text should be lovely to look at—*form matters*—and it should be directly written, rather than drawn in outline and filled in.

That definition works well for writing in the Roman alphabet, practiced by people whose work grows out of the Western European tradition. But examined more closely, the boundaries are not always clear. A formal script written with an edged pen would conform neatly to the definition. The writing that comes off a typewriter clearly is outside the bounds. But the distinctions begin to blur at the edge of handwriting. Some of the Western scripts, such as Spencerian or Italic, in their simplest manifestations, look very much like neat handwriting.

At the other end of the spectrum, where does lettering that is retouched, filled in, or carved in stone, fit in? Does it count? For the Chinese, the idea of touching up a single stroke on a piece of calligraphy is anathema. But the Chinese have no qualms at all about transferring that same piece of calligraphy to a stone tablet and painstakingly carving a representation of the brush-made strokes.

There is no easy answer to this question. The fact is, calligraphy does begin to blur into other practices like stonecutting and handwriting. It won't do to be fundamentalist about it. And when you cross cultures, you find your pat definitions begin to give way to a broader vision.

If the edges are sometimes unclear, the broad center is, however, quite clear. Calligraphy is a letter-based art where the quality of the gesture is part of the content of the work. The expressive line, usually

modulated, passes gracefully from thick to thin and back again. It is the coarse stroke of a brush on rough paper. A calligraphic line is rarely flat and straight. It is a living gesture. It is balance, dynamic symmetry, and rhythm.

There will never be a perfect definition of calligraphy that will serve all the traditions of the world equally well. But across the barriers of language and culture, our work does speak. And that, in the end, is all that matters.

The Origins of Writing

Since the Paleolithic Era, more than 30,000 years ago, human beings have made representations of the things around them. Cave paintings discovered in Southern France and Northern Spain include representations of animals. Ancient silhouettes of human hands, made by blowing pigment across an outstretched hand put flat against an underground wall, still communicate their presence. While these are not *writing* in a formal sense, they are marks that convey meaning. We cannot read them—any interpretations offered are speculative. But for the people who made them, they had a clear purpose and significance. Cave paintings certainly do not represent language—you can't decipher them into sentences or complete thoughts. But they do communicate, "a ceremony took place here." The shaman initiated the boys into the hunting fraternity. The animal spirits have been asked to offer their bodies for our nourishment. Humans are mark-making animals. We use graphic representations and abstract marks to communicate.

Actual writing—the graphic representation of language—first emerged in a number of cultures around 3000 BCE. In each place where writing first emerged, in Egypt, Mesopotamia, China, and among the Maya in Central America, writing began with drawing pictures of things. Why these particular early cultures created writing systems while other cultures did not remains somewhat mysterious. Why, for instance, did

the Maya develop writing, when the Inca, with their vast empire to the south, did not? But specific elements certainly had to be in place for a society to begin to want to write language down. The earliest writing cultures share characteristics: a settled, agricultural social system, a system of organized governance covering substantial territories, and an emerging awareness of mathematics. Such a complex society needs to keep records.

The earliest writing might record tallies of harvests and tributes paid to central authorities. Or it might be used as it was in China, to mark ideas on oracle bones, which were placed in a fire; heat produced cracks in the bones, with the intersecting marks indicating a course of action.

The simplest writing involves simple pictures of oxen or wheat sheaves or a mother nursing her young. An ancient Sumerian might count out the numbers of his cattle with a notation: twenty-three calves; fifty-two fish. In time, such systems began to grow into complex sets of symbols representing nouns, verbs, and adjectives. Often, as in Egyptian hieroglyphics or Chinese ideograms, the symbols could be used to represent not only distinct ideas, but also sounds.

As written language developed, its form also changed. People wrote with what was at hand. The Egyptians might use discarded potshards, carved stone, or, eventually, papyrus sheets. The Sumerians, in their wide river valley, used tablets made of clay,

Above: A brush stroke by Karen Charatan illustrates the graphic potential of a tool used expressively.

Opposite: A Spanish writing sample of c. 1802. What are the boundaries of calligraphy? When does it become handwriting? This exemplar was produced by Torquato Torio, and is reproduced in Frank Chouteau Brown's 1902 book *Letters & Lettering*.

a plentiful substance. The Chinese used bones, strips of bamboo, and, eventually, paper and silk, with the writing materials they used changing the nature of their writing. In Mesopotamia, a cut reed was used to write on the clay tablet. Very quickly, the tool began to shape the script. It is easier and more efficient to press the end of a reed into a wet clay tablet than to scratch or incise lines into it. Primitive pictures became stylized into a series of wedge-shaped marks, giving rise to an abstracted set of signs that no longer looked exactly like the objects being represented. The cut reed pressed into clay created the script we call Cuneiform—from the Latin, *cuneus*, or wedge. Similar processes of abstraction took place in all the early writing centers. The Egyptian scribes, writing with reeds on papyrus, created the simplified scripts known as Hieratic and Demotic, which bore little resemblance to the formal hieroglyphics that continued to be carved on their formal monuments. The Chinese, adopting a brush, squared off their earlier writing to create the Clerical script still in use today (see the chapter on Chinese writing for a sample of this elegant historical script).

These earliest writing systems were unwieldy. In order to write full sentences, scribes had to master hundreds, if not thousands, of distinct symbols. New written words could be devised using combinations of older symbols. One Chinese character, for instance, represents the idea "good" by combining the characters for a woman and a child. Or symbols could be used for their phonetic value alone. Mastering such a system took extensive education and created professional scribes who dominated the practice of writing in these societies. It is important to note that, while it seems awkward to require students to memorize thousands of individual symbols, English spelling, with its peculiar rules and endemic exceptions, requires students to do much

the same task. The Chinese and Japanese, who continue to use the complex characters devised and refined over the last two thousand years, are able to use the system successfully, and, indeed, have achieved high levels of literacy. Of these early writing systems, only the Chinese-derived script survives in our time; the systems of Ancient Egypt and Mesopotamia were replaced by later, simpler scripts; the writing of the Maya and Aztec was obliterated by the Spanish Conquistadors.

One of the most important developments in the history of writing took place along the Eastern Mediterranean coast, with the Phoenicians in the first millennium BCE. A mercantile culture of independent city-states, the Phoenicians were the first to devise a set of purely abstract symbols that represented nothing more than the sounds of speech. This changed the game entirely. For one thing, the Phoenician alphabet was composed of only twenty-two letters, simplifying enormously the task of mastering the basic components of writing. And by representing sounds alone, the alphabet proved itself enormously adaptable; rather than learning a complex set of rules for combining characters, the letters could be used or adapted to write almost any spoken language.

The origins of the Phoenician alphabet remain debatable, although the current consensus is that it arose from a simplified set of Egyptian hieroglyphic symbols. Its impact was enormous. The alphabetic concept spread west, giving rise to the alphabets of the Greeks, Etruscans, and Romans. It spread south into the Arabian Peninsula, where it gave rise to Arabic scripts. Moving eastward, Phoenician is credited by some scholars as the progenitor of the Indian Brahmi script, and thus of all the scripts that grew out of that tradition. Along the Silk Road, its descendants include Mongolian and Manchu. In the modern era, due to colonization and other political influences, alphabetic writing replaced earlier writing systems in countries such as Vietnam, and provided a basis for creating writing systems for previously oral traditions, as in the alphabet of the Cherokee and Inuit in North America.

What then, you may ask, does this brief overview of writing history have to do with the practice of calligraphy? In books about a single tradition—introductions to Chinese or Arabic or Hebrew calligraphy, for example—there is an assumed language tradition that needs little or no explanation. In a book of this scope, however, which tries to explain

Opposite: This 2008 example of ordinary, Arabic handwriting provides advice about healthy living, including getting some exercise and drinking a warm cup of water with lemon in the morning.

Below: Written in Bengali, this 2008 text provides a statement of faith in God.

calligraphic scripts from across the world, we immediately find ourselves needing to understand how the different writing systems came to be. And in cultures as diverse as the ones we look at in later chapters, questions of language and history become a lens through which to comprehend the scripts we illustrate.

Not every writing system produced a calligraphic tradition—the Cherokee alphabet, for example, was devised in the nineteenth century in a society where printing was the dominant mode of making formal lettering. But for those societies that received writing systems before the advent of printing, a rich system of formal writing usually developed.

Writing and Language

It is already established that the Phoenician alphabet gave rise to other alphabetic systems used for writing non-Phoenician languages. Many world scripts are used to write more than one language. Arabic, for instance, is used for both Farsi and Urdu,

both of which require the addition of several extra letters. The Hebrew aleph-bet is used for Hebrew (both in its classic and modern Israeli forms), Aramaic, and Yiddish. In the case of Yiddish, certain letters have different sound values than they do when writing in Hebrew. The northern Indian script Devanagari may be used for contemporary Hindi and Singhi, as well as the historical languages Pali and Sanskrit. Ethiopic may be used for the liturgical language Ge'ez and modern Amharic. Cyrillic, with its regional variants, is used for Slavic languages such as Russian, Ukrainian, Serbian, and Bulgarian.

To make things more complex, some closely related languages use different scripts, usually reflecting historical and cultural differences. Croatian, for instance, which is close enough to Serbian that the speakers of the two languages can carry on extended conversation without difficulty, is written in Roman letters, while its Eastern cousin is written in Cyrillic.

The Roman alphabet is probably the most promiscuous of scripts. In the Middle Ages, when Western Europe was fragmented politically but united in the use of Latin for church, scholarship, and government, the Roman alphabet naturally began to incorporate all the varied languages of the region. With the emergence of vernacular writing, all the languages of Western Europe expressed themselves quite naturally with the alphabet of Rome. Since the nineteenth century, colonization and commerce have continued to spread the Roman alphabet, with the phenomenon of "Romanization" present all over the world.

For the calligrapher, this produces both opportunities and challenges. Having mastered the basics of one script, one is often able to write texts in a number of languages. One has to be careful, however, to observe the distinctions between the different variations of the script used in each language tradition. When writing a language with

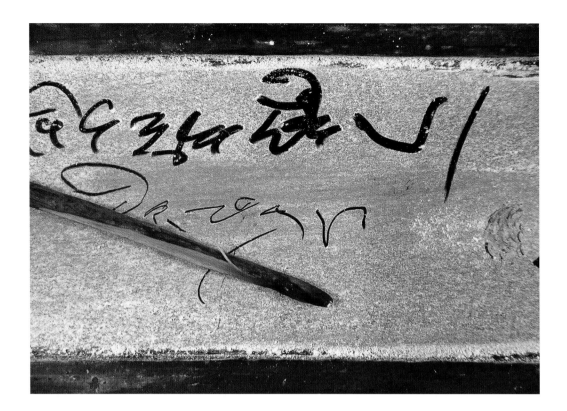

Above and opposite, top and bottom:
A *Sam ta*, or writing tablet, from Tibet. These tablets (here shown with writing detail, closed cover, and fully opened) could be used to send messages. The inner panels have a lip on both sides, protecting the dished inner surface. The surface of the insets were dusted with fine white powder, either flour or chalk or ground roast barley. This allowed the writer to scratch his message on the panels with a fine stick. The recipient could erase the message after reading it. This is an example of ordinary handwriting raised to a high art.

which one is unfamiliar, it is crucial to have one's work proofread by someone proficient in the language in question, not just for simple errors of spelling, but to make sure that the shapes of variant letters have been properly understood.

Ordinary Handwriting and Calligraphy

Calligraphy is related to handwriting in a number of ways. Handwriting is quick, ephemeral, and includes everything from quickly jotted notes to doctor's prescriptions to carefully written love notes. The most important consideration for handwriting is legibility and speed. In our own era, handwriting is not exactly dying out, but it has become far less important since, for most people, the writing done on keyboards of various kinds (computers or cell phones) has come to dominate contemporary life.

People often lament the loss of fine handwriting, and feel that taking a calligraphy class will improve the situation.

In many ways, this is a misunderstanding. The pace of the two practices is markedly different: calligraphy, although it often looks quickly written, is far more deliberate than handwriting. In almost every tradition, if you watch a calligrapher writing, you will see the pen or brush moving in an almost musical fashion, executing straight strokes quickly, pausing at the beginning or end, and speeding up as the tool leaves the page. Fluent handwriting, on the other hand, marches along at a speedy pace without much interruption of the flow. The tools for handwriting and calligraphy also tend to differ. A rough rule of thumb: if the preferred tool is a ballpoint pen, the writing is probably not calligraphy.

But calligraphy and handwriting are also in constant conversation. The formal scripts have always drawn from the demotic hands. It takes very little for an informal hand to turn into something far more intentional. We can see this with the brush lettering that is being done today by calligraphers in the Western tradition; yesterday's handwriting is today's calligrapher's "spontaneous" brushwork.

Processes of Change: Decay and Formalization

Over the history of every calligraphic tradition, there have been twin forces at work. A formal script decays; it is written more quickly, becomes more cursive and, often, simpler in form. It becomes an informal script. But the converse is also true. An informal script rises in prestige; its shapes and stroke orders are regularized and defined. It becomes a formal script. Consider two examples, one from the ancient world, and one from recent Western history.

Millennia ago, Egyptian hieroglyphics began as carefully rendered drawings of physical objects. On papyrus scrolls, these could be created as simplified line drawings.

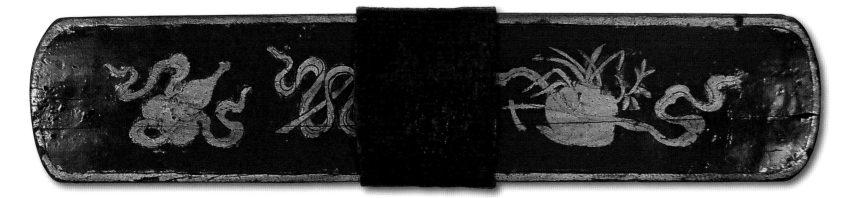

In time, however, the scribes began to simplify the forms and write them with an edged reed. Time, efficiency, and familiarity meant that a quickly jotted pair of strokes could be enough to suggest a more complex drawn hieroglyph. Eventually, the writing reached a state of abstraction, so that the figures no longer resembled their original representational prototypes. The script known as *Demotic*, meaning *common*, was born. The more formal hieroglyphics were retained for formal purposes, but the bulk of texts were written in the newer, faster script. You will not find Demotic carved inscriptions in Ancient Egyptian temples—it did not have that kind of gravitas.

By contrast, we can see in the last century or so that old-fashioned business scripts have come to be regarded as examples of elegant, stylish writing. In the mid-eighteenth century, George Bickham published his treatise on handwriting, *The Universal Penman*. The writing samples in it are exquisite. But notice what his aims are:

> *The Use of the Pen is of so great Importance to Mankind in general, and so indispensably necessary for the Man of Business that I think it needless to make any Apology for the Publication of this work*
>
> *Writing is the first Step, and Essential in furnishing out the Man of Business. And this qualification is* more excellent, as 'tis more useful in Business, and beautiful to the Eye, & may not improperly be consider'd in two Respects, as it proceeds from the Eye and the Hand; From the one, we have Size and Proportion; From the other, Boldness and Freedom. For as the Exactness of the Eye fixes the Heights and Distances; so the Motion of the Joints, and Position of the Hand, determine the black and fine Strokes, and give the same Inclination and Likeness to the Standing & Turn of the Letters.*

> *But in Order to write well, there must be just Rules given, and much Practice to put 'em in Execution. Plain, Strong, and Neat Writing, as it best answers the Design for Use and Beauty; so it has most obtain'd among Men of Business. A full, free, open Letter, struck at once, as it discovers more of Nature, so it gives a Masterly Beauty to the writing; to which may be added such ornamental Turns of the Pen, as seem rather design'd to fill up Vacancies on the Paper, than studiously compos'd to adorn the Piece.*

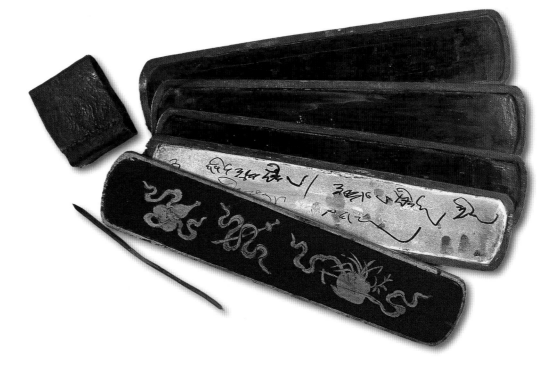

There is no question that Bickham cared about the quality of his writing, or that his writing was beautiful. But his appeal to his reader that lettering is a basic attainment of business doesn't entirely match the image his elegant script conjures for today's audience. We are more likely to think of elegant dinner receptions and social occasions when presented with a lovely example of pointed-pen writing—not overdrafts, bills, and bookkeeping. How the world changes.

The Practice of Writing

We close this introduction with words about things to look for in this book.

Learning

Charles Paillasson, a Writing Master (calligraphers in 18th to 19th-century Europe who worked in the pointed-pen tradition), comments on learning to write:

> *On general temperament*
> *(From Diderot's* Enyclopédie, 1751*)*
> *There are some people in which the talent for writing seems to be innate; with good will and a little effort, we see them making obvious progress in this art. There are others, however, who have no such disposition. These, having to fight their stubborn nature, will not arrive at reducing it except by exercise and practice. They need more time to arrive at the same goal as the first. But are they not well rewarded by the greater good they thus derive?*

It takes time to learn calligraphy. On the whole, really mastering a calligraphic script takes several years. Every tradition has its own way of instructing its pupils. In old Tibet, writing boards allowed novices to practice without wasting precious paper. In China, students will trace characters printed in special copybooks. In the United States, students will fill reams of inexpensive paper practicing their Italic. There is no shortcut. But the ways that each culture has chosen to pass calligraphy on may provoke us to rethink our own practices, and find new ways to build the discipline it takes to become good writers.

Posture

The posture of the body affects not only the writer's well-being, but also the quality of the work. A comfortable body position is crucial to the practice of calligraphy. This is one of the hardest things when working across cultures, because we have such different relationships to our bodies and to the environment around us. While some cultures relish sitting on the floor, for others the same physical position is an act of slow torture, cutting off circulation. Finding a comfortable position allows you to concentrate on your work, and, more importantly, to maintain your concentration for extended periods of time.

Below: A man seated at a writing desk, as reproduced from Charles Paillasson's *The Art of Writing condensed to true and simple demonstrations with clear explanations for the Dictionary of Arts*. In every tradition, posture differs slightly, depending on the cultural customs and local methods of furnishing a house. The eighteenth-century French writer shown here sits at an exquisite table, his legs at a slight angle to his torso.

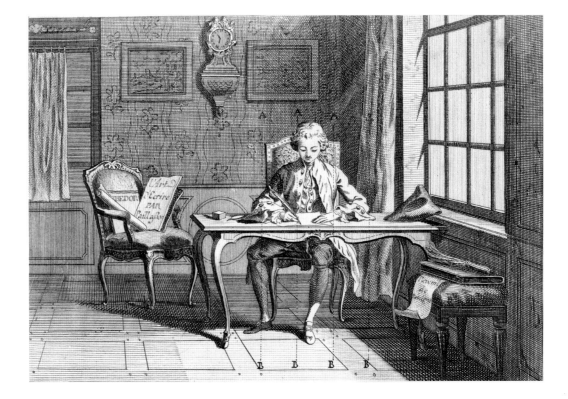

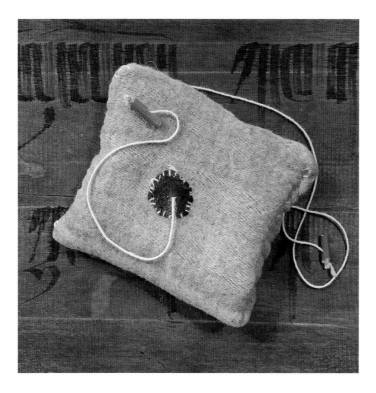

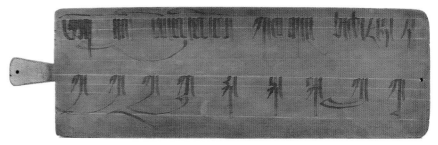

Left and above: A Tibetan *johng shing* (a student's writing board). The student would position a chalk line from his homemade chalk bag and snap it to rule lines. The inked letters on the board were created by the teacher, allowing the student to copy them. The board could be washed off for repeated use.

Below: The word *pod*, where the *p* and the *d* are closely related.

pod

We can't help but quote Paillasson again:

Three things are necessary for writing: a beautiful day, a solid table, and a comfortable seat. The light which one receives from the left side is always favorable, when from the place where you write you can see the sky. The table and the seat must be in such a proportion that the seated person may easily put his elbows on the table without stooping. Since this position is the most natural, one should prefer it above all others. A table too high for the seat impedes the arm from moving, and makes the writing heavy. A table which is too low makes one lean too closely, tires the body, and forces the effects of the pen. It is therefore necessary to furnish oneself, as much as possible, with all these conveniences, so that one's writing may be bold and flowing.

Stroke Order

A stroke can be defined as a single mark made on a surface with a tool. In ordinary handwriting, the pen is infrequently lifted from the page. By contrast, in calligraphy, many letters or characters are made of several separate strokes. The pen or brush is lifted from the page between each stroke. Stroke order refers to directions that tell the writer in what sequence to make each mark in order to write a letter or character. Many traditions are quite firm about the order in which a letter should be written, while others may treat the matter more loosely.

Related Forms

Every script has its own visual logic. There are certain shapes that are made, and these will be repeated again and again. Looking for these related forms helps unpack the mysteries of an alphabet or other writing system. In the word *pod*, which is written in Italic (left), the shape of the *d* and *p* are closely related. So closely, in fact, that if the page were turned 180°, the word will

look exactly the same, despite the fact that the letters are made with different orders of strokes.

Of course, related forms should never be *assumed* to mean identical forms. Very often, subtle changes take place in similar shapes from letter to letter. But once you begin to understand the logic of an alphabet, the subsequent letters become easier to learn.

Proportion

All scripts share an interest in proportion, although this may be differently expressed from culture to culture. Where one script is defined by a carefully proportioned ratio between the width of the nib and the height of the letter, another might be more designed with the interrelationship of the various elements of the letter in mind.

Whenever approaching a new script, watch for clues about how proportion plays a role in the tradition to which it is native.

Guidelines

Almost all calligraphic script in the world is written using a set of guidelines (Japanese Hiragana is a unique exception to this rule). In some cases, these lines are actually marked in pencil on the writing page to ensure the lines of text are straight and evenly written. In other cases, the guidelines are *notional*; the position of letters in relation to one another and the proportions of the individual letters themselves have been sufficiently internalized that the scribe is able to write without any guidelines being marked on the page. In the chapters that follow, the different systems for each script will be explained more fully.

Layout

Scripts and layout are intimately related. Every script establishes its own way of engaging the space around it. The free-flowing forms of a cursive Arabic could never be crammed into the tight space of a little book of hours. When learning new scripts, especially from traditions we find foreign, we should always look to see how those letters fit to a page.

How to Use This Book

This is a story largely told in pictures. There is no substitute for carefully looking at the visual examples and trying to copy them precisely. Our text can offer commentary and point out things to observe. But in the end, learning to do calligraphy in any tradition requires patience, steady practice, and careful observation.

The short chapters on the Edged Pen and the East Asian Brush should be read before embarking on any of the scripts that use those tools. These two chapters give a basic introduction to the use of the tools.

Below: These library cards might have been ordinary in their time, but are striking now that most library entries are computerized.

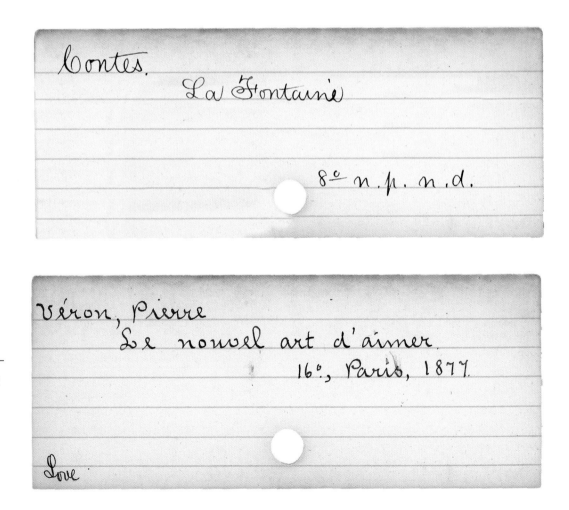

Pack my box with six five dozen liquor jugs.

Sphinx of black quartz, judge my vow.

A novice calligrapher wanting to learn the edged-pen scripts should begin with the Uncial Script in the chapter on the Roman alphabet. This early medieval script is simple, and it is explained in great detail. Having begun with Uncials, a beginner will have much more success than if he or she leaps into one of the other scripts.

A novice calligrapher who wants to learn the brush scripts would do well beginning with either the Chinese or Korean chapter, as both lay a firm foundation for brush work.

Some of the other scripts use unique tools. The Roman chapter contains Inscriptional Roman capitals made with an edged brush, Copperplate made with a pointed pen, and brush scripts made with a pointed brush. The chapter on scripts derived from India contains a Sinhala exemplar made with a pointed bamboo pen and a Thai script made with a Speedball nib. In any of these cases, a beginner may simply start there; in those instances notes are given about the appropriate tool to use.

More experienced calligraphers will probably have enough background to explore any of the scripts in the book.

The Choice of Scripts

The subject of this book is so broad, that of necessity some process of selection has had to guide our presentation of the world's calligraphic scripts. In addition, captions throughout include all information available to us.

The different scripts are shown in three ways—as exemplars, studies, and samples.

An *exemplar* is a carefully made sample of letters or characters accompanied with detailed directions for how writing is made. It is a comprehensive guide to writing the script illustrated. We have used the exemplar format for one or more of the most important scripts in each tradition. Pages on which exemplars appear are marked with a small symbol in the upper corner of the page indicating the basic writing tool used.

A *study*, by contrast, examines the form and construction of a script, but

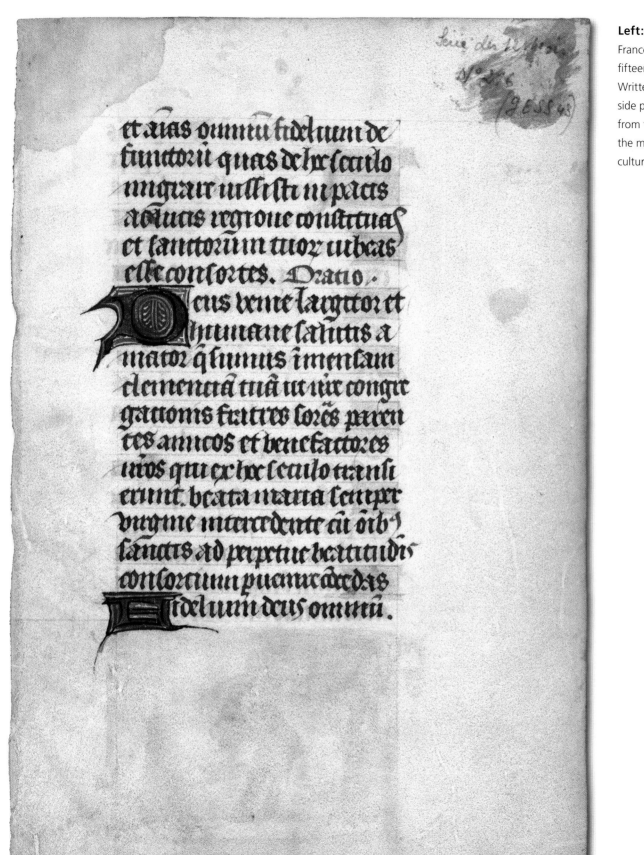

Left: Leaf from a book of hours, from France or Flanders, probably from the fifteenth century.
Written in Gothic script, this is a right-side page that has been removed from the book. The proportions of the margins are specific to the book's culture and time.

may only include a representative group of letters. The studies in the book are used to discuss other scripts important within a particular tradition.

A *sample*, as the name suggests, is an image showing a script, which does not examine technique in detail.

In our selection of scripts, we have made sure that each tradition is represented by a full exemplar, and we have used our studies and samples to round out our presentation, giving the reader, we hope, a sense of the breadth and depth of each tradition.

Writing Systems

Each script introduced in this book is accompanied by a small box that summarizes the characteristics of the writing system used. The chapters then enlarge on this to explain how the calligraphic script is used to represent language. In the introductory boxes, writing systems are described in four ways: what kind of writing system is used; the direction and sequence of lines of continuous text; whether there is a distinction between majuscule and minuscule in the script; and the principal tool used in the calligraphic rendition of the script.

Scholars of written language divide writing systems into several categories:

Abjad: A consonant alphabet, where the letters represent consonants and perhaps some, but not all of the vowels. Vowels not represented by letters can be indicated with diacritics, but the diacritics are often not used. Hebrew is a classic example of such a writing system.

Alphabet: Letters of consonants and vowels are ordered and represent the corresponding sounds of speech. Our Roman alphabet follows this pattern.

Semanto-phonetic writing system: Individual characters can convey either semantic meaning or phonetic meaning. This involves memorizing thousands of individual symbols in order to attain basic literacy. Chinese is the most important contemporary example (Egyptian hieroglyphics followed this pattern as well).

Syllabic Alphabet: Each consonant character is inherently followed by the same vowel sound, unless modified by diacritical marks to indicate other vowels. Vowel characters are used when vowels appear before or separate from a consonant character. The scripts of India follow this pattern.

Syllabary: Symbols phonetically represent syllables. The Japanese Kana script is a good example of this system.

Direction of Writing

All the languages that use the Roman alphabet are written in lines running from left to right, top to bottom. By contrast, Hebrew and Arabic are written from right to left, top to bottom. Chinese is traditionally written in vertical lines, top to bottom, the lines reading from right to left. Diagrams in each chapter show these patterns for each script.

Note that, in contemporary usage, Chinese or Japanese are often typeset in a different direction: left to right, in the Roman fashion. Calligraphers, however, retain the older method. As a result, our diagrams represent the *calligraphic* norm.

Majuscules and Minuscules

In every major calligraphic tradition, a variety of scripts may be used, depending on the purpose of the writing. Older, more formal lettering may be suited to page headings or important documents, while more cursive forms might be used to write long blocks of text or for more intimate subjects like love poetry. In some writing traditions, however, two distinct forms of the alphabet must be used in conjunction. We are referring here to the use of majuscules and minuscules—known also by the printers' terms *uppercase* and *lowercase*, or, more simply, as *capitals* and *small letters*.

The majuscule/minuscule distinction does not exist in scripts like Chinese, Hebrew, or Arabic. Within any given text, only one form of the script would be used. In the languages that use the Roman alphabet, however, we have distinct forms for our capitals and small letters, which *must be used together*. One could not write text in English without using both majuscules and minuscules in conjunction. When learning calligraphy with the Roman alphabet, scribes need to master two forms of each script in order to write any text. This applies to many of the scripts in this book, and so we indicate which scripts use this distinctive system.

Principal Tool

Here, again, we are referring to the most important tool used by calligraphers to write the scripts in this book. In practice, of course, ordinary handwriting might be done with a ballpoint pen. Furthermore, the open-ended nature of today's society means that many calligraphers will experiment with alternative tools, either newly invented or borrowed from other traditions. But each of the calligraphic scripts of the world are usually born of the specific tool used, and we list that here for each script.

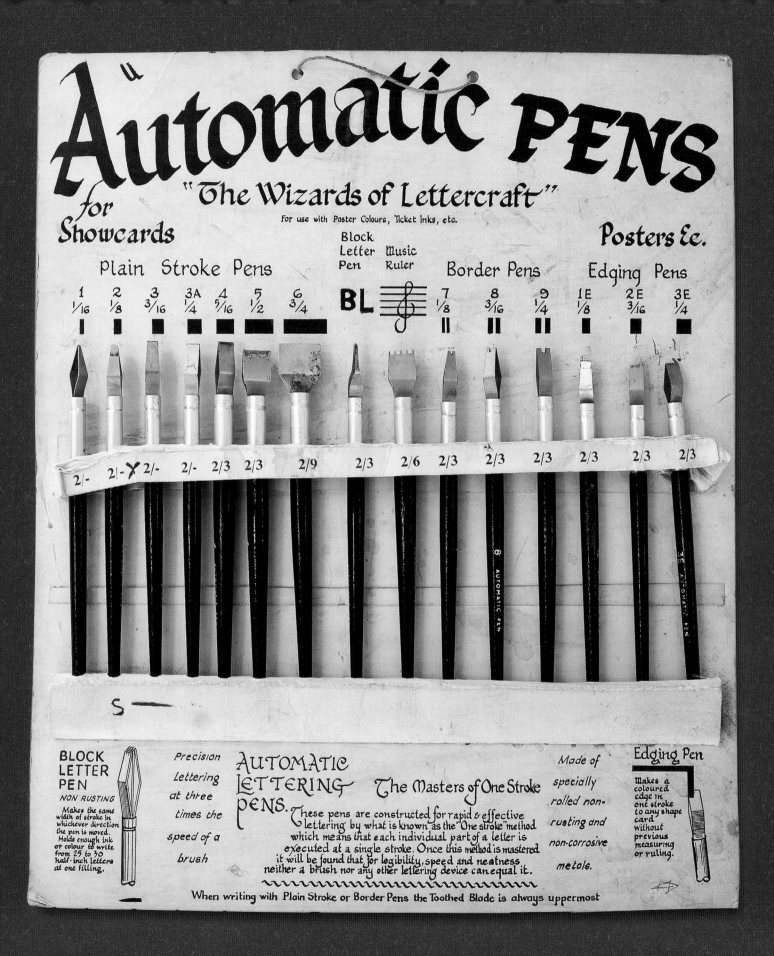

THE EDGED PEN
Reeds, Quills, and Metal Nibs

By Christopher Calderhead

The two basic tools of calligraphy are the edged pen and the East Asian brush. There are other tools, such as the pointed pen, but these two have been the primary shapers of the great calligraphic traditions.

The edged pen, in the form of a cut reed, a quill, or a metal nib, has one defining characteristic: its square-cut tip creates thin or thick marks depending on the direction of the stroke. Drawn sideways along its edge, it produces a crisp, thin line. Pulled or pushed using the full width of the edge, it creates a thick line. Strokes made in a diagonal direction to the edge of the pen are of medium thickness; the weight of the stroke is in a geometrical relation to the position of the pen's writing edge to the direction of the stroke. Curved strokes result in a modulated line, waxing and waning as the pen describes an arc. The edged pen was the dominant tool of Western calligraphy until the time of the Renaissance, and it is used for many scribal traditions around the world, including Arabic, Hebrew, and the scripts derived from India.

The oldest form of edged pen was the reed, which continues to be the dominant tool for calligraphers in the Arabic tradition and others (see the chapter on Arabic calligraphy for a detailed discussion of reed pens and the techniques for cutting them).

The quill is the classic tool of Western calligraphy. It was the principal tool in use until the metal pens became popular in the nineteenth century.

Whatever variant of the edged pen one chooses, the basic principles of writing with the tool remain the same. Metal pens have the virtue of being ready-made; the writer wastes no time cutting or sharpening the nib. Nibs also come in the widest variety of shapes and sizes, from fine, almost pointed shapes to large steel pens used for making posters and notices. Most Western calligraphers choose to use metal nibs for the sake of convenience. By contrast, the organic reeds and quills are limited in size and require mastery of the art of cutting. They remain, however, some of the most precise and flexible tools with which to do edged-pen calligraphy.

It should be noted that fountain pens and felt-tip markers, while they offer convenience because they come with an internal ink supply, are generally not used for anything but ephemeral work. The ink in a fountain pen is generally rather thin, and the selection of nibs is very limited. A felt-tip does not have the sharpness requisite for fine work. The work of the professional is almost always executed with a pen that may be dipped in ink.

Above: The standard pen holder has a hollow middle lined with a metal sleeve. The metal "teeth" inside are designed to hold the pen against the metal sleeve.

Left: Reed pens come in all variety of sizes, from very fine, thin reeds to large bamboo pens.

Opposite, top: The most common feathers used to make quills are from turkeys, geese, and swans.

Opposite, top right: This straight-cut nib has a detachable reservoir. The reservoir on this pen slides onto the underside of the nib.

Opposite, center left: Most metal nibs come in series, giving calligraphers a range of sizes to choose from.

Below: When considering pen holders, a holder with a round shaft is best, as this gives the fingers flexibility of movement. Faceted pens impede that free motion.

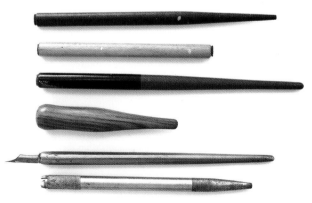

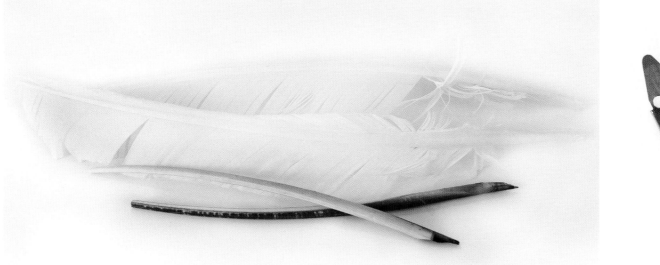

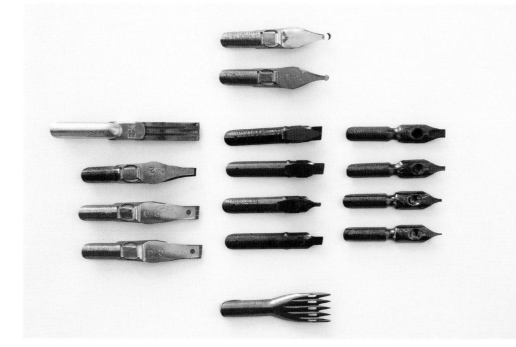

Above: Most metal pens come with a reservoir to hold a puddle of ink near the tip. These nibs are cut on a slant, rather than straight across. Whether or not to use a pen with an oblique writing edge is a matter of personal preference.

Right: A close analog to the edged pen is this graphite carpenter's pencil. Although its use has faded in recent years, it was once a fairly common tool, recommended for beginners to try out the forms of edged-pen writing. It has to be sharpened with a knife; sometimes the writing edge is further sharpened against fine sandpaper.

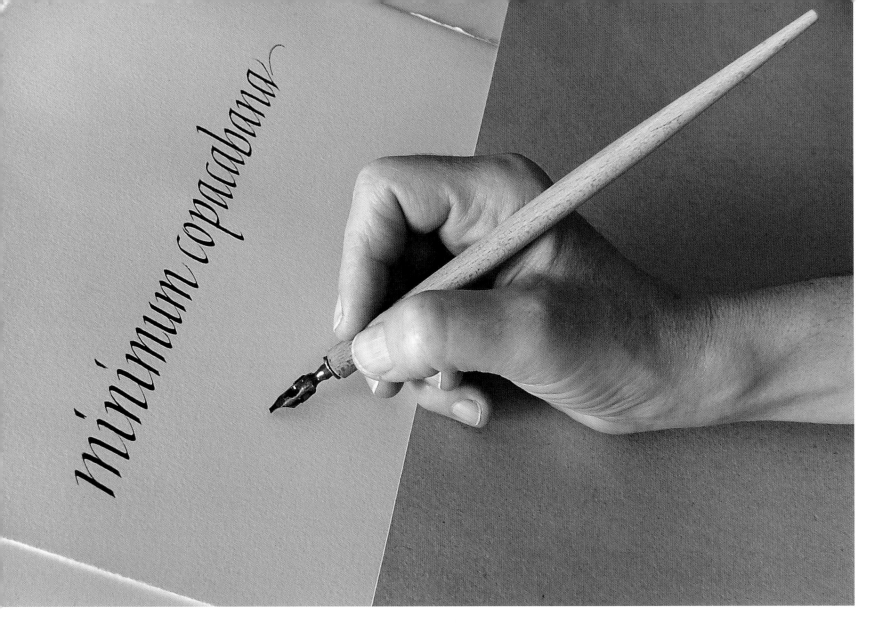

Mastering the Pen Angle

The simplest exercise for the beginner is to make a series of zigzag marks on the page (see example on the facing page). Most beginners find this exercise intuitive and straightforward. The position of the pen shown here is natural to anyone who is right-handed. The "thicks" and "thins" are achieved with minimal effort.

In order to begin making letters, however, we need to consider the concept of pen angle. Pen angle is defined as the angle of the writing edge of the nib relative to the baseline.

A right-handed person holding an edged pen will tend to hold the tool in such a way that the edge of the nib is at about a 30º or 40º angle to the horizontal baseline. This is referred to by many Western scribes as a "natural" pen angle. Most of the Roman alphabet scripts are written at an angle between 20º and 45º.

Left-handed writers will find these angles somewhat harder to achieve. Those who are left-handed will find it easier to buy a special edged pen that is cut at an angle, rather than straight across. This is referred to as a "left oblique" nib. In addition, left-handers usually prefer to tilt their writing paper so that their writing hand is more comfortable.

Above: The pen rests against the first segment of the third finger. The thumb and index finger hold it on either side, while the remaining fingers are tucked under the hand.

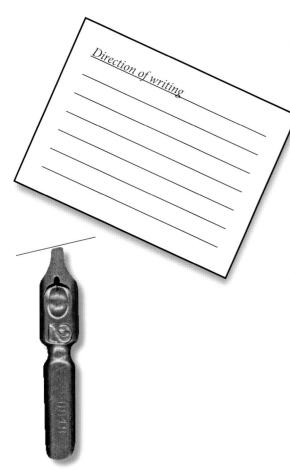

Direction of writing

Left: Left-handed calligraphers writing Western scripts with an edged pen generally tilt the paper to one side, as shown here. Right handed calligraphers prefer to keep the paper straight, with its bottom edge parallel to the edge of the desk.

Many left-handed calligraphers prefer to use a special nib cut at an angle. This is referred to as a "left oblique nib," such as the one shown here.

Right: When dipping a metal pen in ink, it is usually necessary to "bleed" the point against the rim of the edge of the inkwell. Simply touching the tip of the pen to the edge breaks the surface tension of the ink and releases any excess back into the well. Ink control is one of the basic skills to master.

Below: One of the best exercises for a novice scribe is to make a regular zigzag pattern.

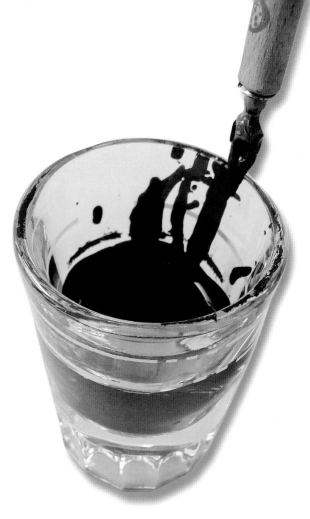

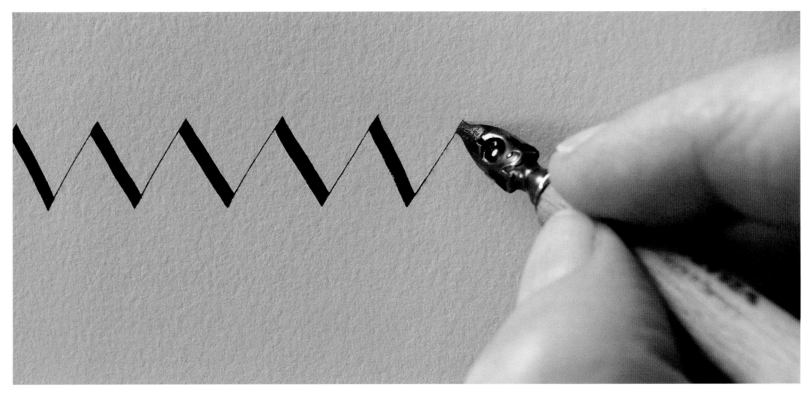

Pen Stroke Diagram

Holding the pen with the edge parallel to your baseline, your strokes will vary in width depending on their direction. Pull the pen straight down, and it makes a broad, thick stroke. Slide it sideways, and the pen makes a fine, thin stroke. A diagonal stroke is less thick than a downstroke because there is a narrower surface of contact between the pen and the surface. And a curved stroke begins thin, grows fat, and ends on the thin. Note that for all these strokes, the relationship of the chisel edge to the baseline does not change as the pen moves across the page: the pen angle remains constant. This transition of thicks and thins is what gives the edged pen its expressive force. Unless you are writing very large—letters taller than two inches—your arm will move only slightly. The entire movement is limited to the fingers and, to some extent, the wrist.

The demonstration (see top example) was made with a pen held parallel to the baseline. Now let us see what happens when the pen is turned, making a steeper pen angle. The three different positions common to calligraphy are shown here (see middle example). A 30º angle is relatively shallow; a 45º angle is steeper; and a 60º angle is steeper yet.

How does pen angle affect the writing (see bottom example)? We see a sequence of strokes made at two different pen angles. On the left, a pen held at a flat pen angle (0º) makes a plus-shaped mark, then two diagonal strokes, and, finally, describes the two halves of a circular mark. Note that the pen is lifted between strokes, and note also that, in the Western fashion, the pen is not pushed: it is always pulled, or moves sideways. Arabic calligraphers do the opposite: they push almost all their strokes. They do, of course, use appropriately smooth paper that allows for that kind of movement. When making

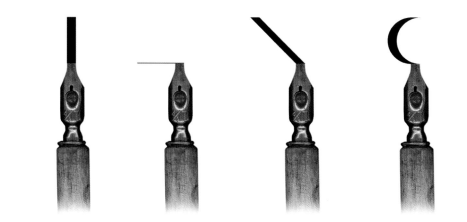

Above: The position at which the pen is held determines what kinds of thick and thin stokes it will make. This pen is held at a flat pen angle (0°), which produces a thick upright stroke and a thin horizontal. A diagonal stroke is somewhat less thick than the upright. Curves shade from thin to thick and back to thin again.

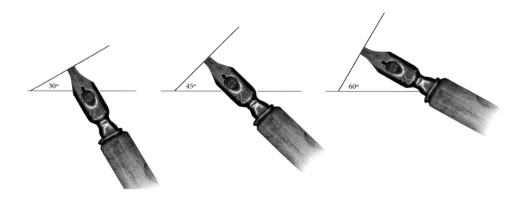

Above: Pens are held at different angles, depending on what script is being written. These diagrams show the pen held at three commonly used angles. The horizontal line indicates the baseline on which the writing will sit.

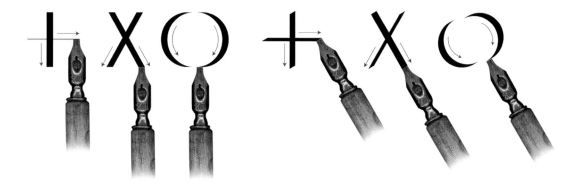

Above: Two sets of strokes show what happens when the pen angle is changed. The three figures on the right are written at 0°. The same three strokes are written at a 30° pen angle. Note how the different positions of the pen change the weight of each stroke. The curved strokes written at 30° have slightly different starting and ending points than those written at 0°; in general, curved strokes join at the thin point of the stroke.

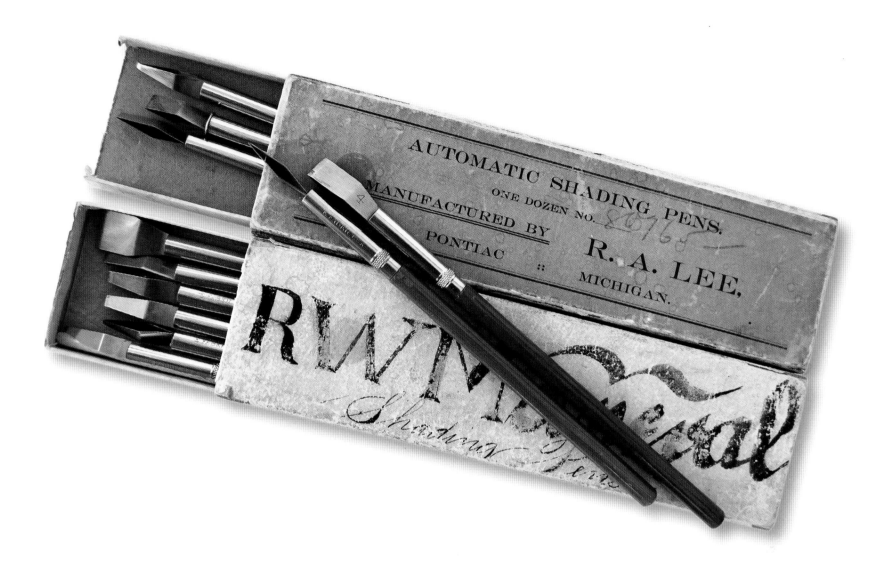

a circle with an edged pen, the circular shape is almost always described with two arcs joining on the thin.

What happens, then, when the pen angle is steepened? The second sequence shows the same set of strokes, this time made with a pen held at 30º. Not only do the strokes acquire slanted ends, but the component strokes have different weights. Now the downstroke, written with the chisel edge on a bias, is less thick than the downstroke made with the flat pen angle. The flat horizontal stroke has some weight, but remains less heavy than the downstroke. The diagonals, similarly, have a difference in weight. All the straight strokes are made

here in exactly the same sequence and direction as their flat-pen companions. The circular strokes, however, are tilted. Why? Because it is best to join curved strokes on the thins.

Each pen angle carries with it its own balance of heavy and light strokes.

The dominant pen angle in any particular script will create its own sequence of thick and thin. This is one of the key variables that give each script its character. In most cases, only slight variations of pen angle are needed to write a whole alphabet. Some scripts, however, require significant *pen manipulation*—a change in pen angle while making a stroke.

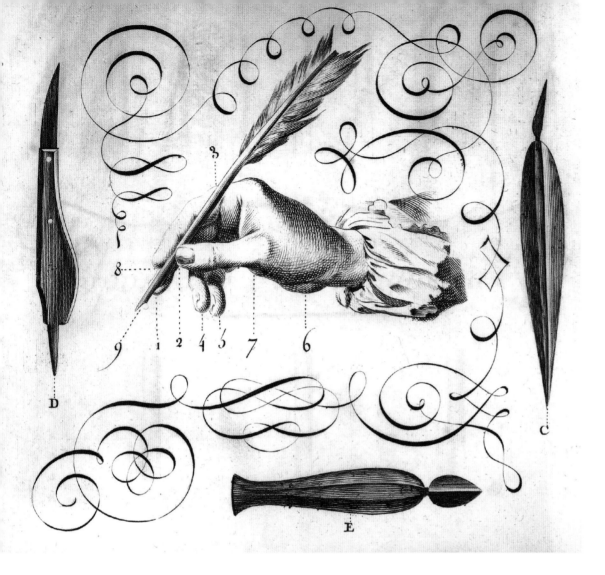

Working with Quills

As we mentioned earlier, many, if not most, calligraphers in the Western tradition use commercially manufactured nibs. Arabic calligraphers, by contrast, continue to use reeds they cut by hand. Jewish ritual scribes are required by their religious laws to use quills, and in cases, reeds—one must never write a Torah with a tool made of metal, the material used to make weapons. Some Western calligraphers use quills as well; the flexibility of the quill allows for changes in pressure, resulting in very subtle changes in weight and shading. The quill also has exquisite ink flow—flourishes that are laborious with a metal pen are much easier to achieve with a quill.

The cutting of the quill has not changed appreciably since the Middle Ages. Until the early 1900s, quills were readily available at ordinary stationers. But by the early part of the twentieth century, having fallen entirely out of use by ordinary writers, they became harder to find, and calligraphers had to seek them out on their own. Calligraphers who use quills prefer those naturally shed from wild birds. Quills are generally taken from fairly large birds: turkey, goose, and swan. These birds have large quills with thick shafts. Other birds' feathers may be used, but their small size makes cutting a broad edge impracticable. A crow quill, with its very narrow shaft, could be used to cut a very fine pointed quill; indeed, the name

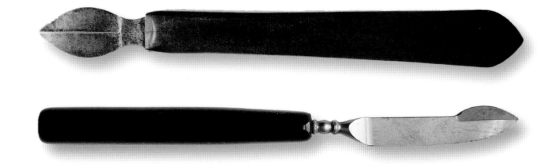

"crow quill" is still applied to a very fine metal mapping pen. Calligraphers use quills from the first three flight feathers of the tip of the wing.

Preparing and Curing the Quill

A quill in its natural state is rather soft. The material of the shaft is similar to a human fingernail, but is much thinner. Now that quills are no longer available from stationers, a certain amount of preparation is required before the cutting may begin. First, the barbs are removed, then the tip is cut off, revealing the hollow barrel of the feather. The feathery inner membrane should be removed from the center of the barrel. The outside has a greasy outer layer that should be scraped off with a pen knife (in the past, the skin of a dogfish was sometimes used).

The most important process prior to cutting, however, is the curing of the quill; an uncured quill is too soft to hold its form once cut. The curing hardens the shaft of the feather. This is a delicate operation requiring the application of heat. One classic method of doing this is to soak the quill overnight in water, then plunge it into hot sand. An electric skillet is employed to heat the sand. A spoon is used to ladle sand into the interior space of the shaft before the whole tip is immersed in the sand-filled skillet. The tip is held in the sand for only one or two seconds. Careful timing is required. Leaving the quill too long in the hot sand will result in a brittle shaft that will shatter when cut. Too little time, and the walls of the barrel will not harden sufficiently to keep a clean cut and provide the necessary firmness for the nib end. Once mastered, the technique produces a quill with just the right balance of firmness and flexibility.

Cutting the Quill

The essential technique for cutting has remained remarkably stable over the centuries. In the late eighteenth century, Denis Diderot included in his *Encyclopédie* a section on quill cutting written by Charles Paillasson, a French writing master who died in 1789. The *Encyclopédie* is one of the monuments of the Enlightenment, an attempt to gather all useful knowledge of arts and sciences in one set of volumes. Paillasson's two-hundred-year old instructions are as valid today as they were in his time.

Below: The distinctive shape of this modern quill knife is ideally suited to the cutting of quills.

Cutting Quills

These engravings are from *The Art of Writing condensed to true and simple demonstrations with clear explanations for the Dictionary of Arts* by Charles Paillasson, from the *Encyclopédie*. His instructions have been adapted and modernized here.

The Manner of Holding the Pen and the Penknife

At the top of the page, Paillasson shows how to hold the quill and the pen knife for cutting. The shaft of the quill is held directly in front of your body, pointing toward your chest. The knife is gripped in the other hand with the blade facing your body. All the cuts are pulled toward you.

The Different Cuts of the Pen

In the middle of the page, Paillasson describes each cut in sequence. He begins with a figure that shows the names of each part of the finished, cut pen. His terminology, which reflects the usage of his time, is still useful for describing the parts of the cut pen.

Figure A, which shows a pen from the side, shows these cuts:

1 Belly side
2 Back side
3 Beginning of the large/great opening
4 *Carne du pouce* [projecting angle on the thumb side]
5 *Carne du pouce* [projecting angle on the finger side]
6 Slit and the extremity of the tip
7 Thumb-angle [near side]
8 Fingers-angle [far side]

Paillasson then takes us step by step through the process:

Figures B and C: Begin by cutting obliquely a little of the tip of the pen from the belly

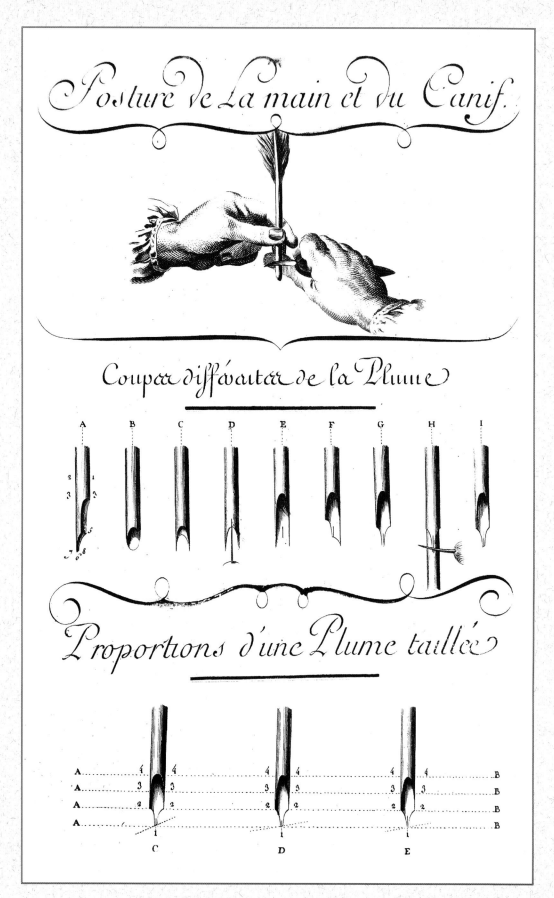

side, pulling the knife toward yourself; repeat this, but from the back side. Then prepare the pen to receive the slit. This slit, which is cut on the backside, is the channel through which the ink flows.

Figure D: Place the pen knife, blade up, inside the shaft. Raise it from inside the tube, cutting a fine slit down the center of the shaft. You should hold your thumb against the top of the shaft to stop the action of the knife, and prevent it from making too long a slit.

Figure E: Turn the pen over and make the large opening on the belly.

Figures F and G: Next, place the pen on its right side to make a scoop on the left, making the *carne du pouce* above the slit, rounding the cut as it approaches the slit. Then turn the pen on its other side, and repeat the process.

Figure H: Take another quill and place it inside the barrel of the first in order to cut the tip. First shave off a little of the thickness of the top, then place the cutting edge of the pen knife on the place where you wish to cut. This last cut, which is called "nibbing," must be done quickly, while rocking the blade from right to left.

Figure I: The finished, cut pen. Paillasson has cut his nib at a slight angle. The last cut can also be made straight across the tip.

On the Proportions of a Cut Pen

In his final illustration (opposite, bottom) he shows several cut pens. He writes: "A pen that has been cut carefully according to the above rules may well not have the correct proportions. The long opening could be too large or too small, the tip too long or too short, the slit too small or too long. In order to avoid these inconveniences, take a close look at the pen shown in the illustration."

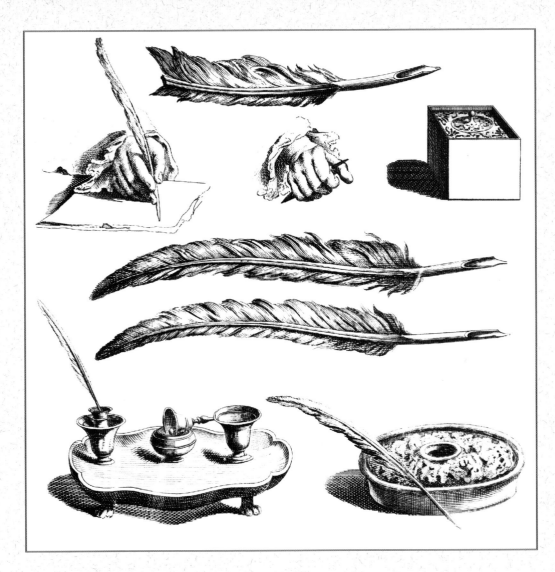

Paillasson's method still works today. When you cut your own quill, you have perfect control over the size and shape of the writing edge. You can make a wider nib or a narrower one. You can even cut the quill to a sharp point, if you wish to write a pointed-pen script such as Copperplate.

Above: Paillasson's illustration of inkwells and quills.

Left: The final result of quill preparation.

By F. W. Martin, Boston, Mass.

Continuing a Six Month's Course. For Instructions See Page 256

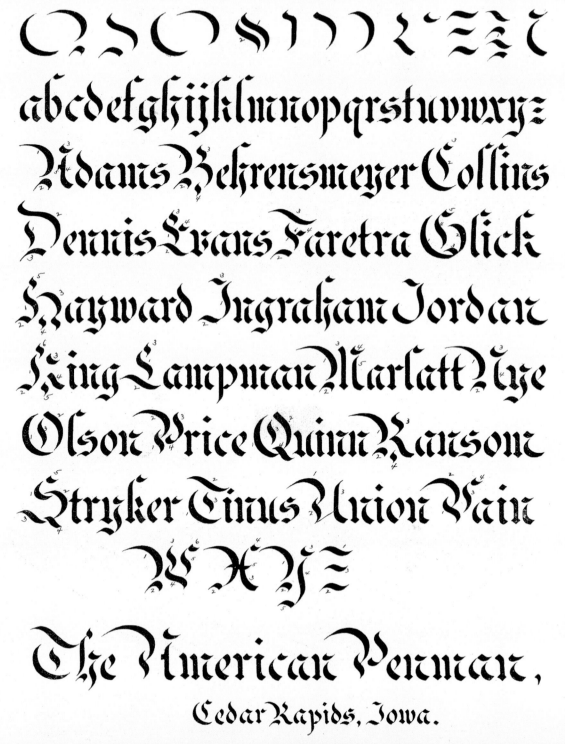

abcdefghijklmnopqrstuvwxyz

Adams Behrensmeyer Collins

Dennis Evans Faretra Glick

Hayward Ingraham Jordan

King Lampman Marlatt Nye

Olson Price Quinn Ranson

Stryker Titus Union Vain

The American Penman,

Cedar Rapids, Iowa.

THE ROMAN ALPHABET

Scripts in the Western Tradition

By Christopher Calderhead

Alphabet: *26 ordered letters of consonants and vowels represent the corresponding sounds of speech.*

→ Direction of writing: *left to right*

→ Majuscule/minuscule distinction

→ Principal tools: *broad-edged pen and pointed pen. Brushes are also used.*

Languages: *Latin and Western European languages. In the modern era, many world writing systems have adopted Romanization.*

Opposite: This sample, made with an edged pen, was published in the November 1910 edition of *The American Penman.* It is an early twentieth-century interpretation of a Gothic script.

The styles of calligraphy using the Roman alphabet are incredibly diverse. Unlike the Arabic and Chinese traditions, which have a long, continuous history of calligraphy and strongly developed aesthetic principles, calligraphy in the West has been a much more diversified practice. At its origins, Western calligraphy was an exercise in craft. The great medieval manuscripts were made by expert scribes in the scriptoria of Western Europe. The edged pen was the main tool used during this formative period of Western calligraphy, however the advent of printing in Europe in the fifteenth century interrupted this tradition and broke the continuity with the past. Calligraphy continued to be practiced, but its emphasis shifted from the making of manuscript books to the art of the master penmen, who taught handwriting as well as formal calligraphy. The elegant and flowing scripts of the eighteenth century and later shifted to the use of a pointed pen, which can be used to produce thick strokes with the application of pressure. In the early part of the twentieth century, a major revival of calligraphy began, and a renewed interest in medieval practices led to new styles of edged-pen writing. By the middle of the twentieth century, Western calligraphers could be found working in many different modes, either consciously imitating the historical edged-pen or pointed-pen scripts, or experimenting with entirely new tools such as the pointed brush.

Western calligraphy today is an extremely broad practice. It has links both to craft and to the graphic arts. In some ways, this is a strength; there is no limit to experimentation, nor is there the heavy hand of a long, coherent tradition to stifle new developments. On the other hand, Western calligraphy lacks a coherent identity, and the calligrapher has no fixed place within society. Some traditionalists uphold the great historical styles, while more commercially minded calligraphers push the limits of legibility and play with the letterforms with great abandon. Often the two do not see eye-to-eye. Edged-pen and pointed-pen advocates can have, from time to time, an adversarial relationship. Those who see the art of calligraphy as a craft practice often lock nibs with those who want to move it in the direction of the fine arts. Some calligraphers are happy working across these lines, of course, as these are tendencies rather than firmly divided factions.

As a result, it is hard to generalize about Western calligraphy. The scripts in this chapter reflect the diversity of Western practice. Broadly speaking, we can divide calligraphy with the Roman alphabet scripts into three basic categories, defined by their tool: edged pen, pointed pen, and brush. Each tool defines certain attitudes to the practice of calligraphy. Just as musicians might be able play the piano, the saxophone, and the violin, few people can play all three equally well, and most serious players will focus on one instrument and the musical styles to which it is appropriate. It is the same with Western calligraphy. Most people will prefer one of the particular calligraphy tools, and will explore it in greater depth than the others.

A Place to Work

The basic physical arrangements for a cal-ligrapher working in the Western tradition

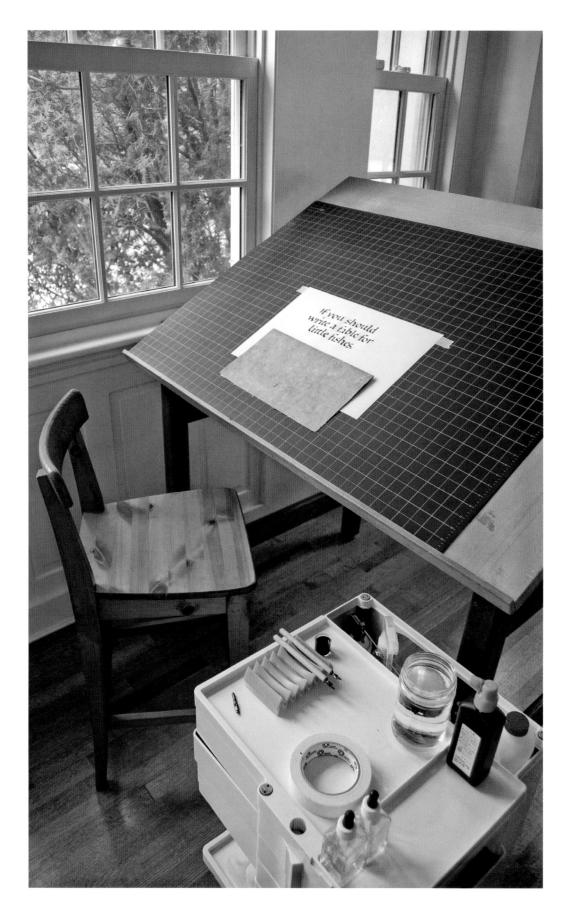

with a pen, either pointed or edged, have not changed in their essence since the Middle Ages. The furniture may be a little more sophisticated and the tools may be more numerous and made out of different materials, but the writing table and other furnishings have remained remarkably similar to those used a thousand years ago in the monasteries of Europe.

A table with a slanted top is the basic writing surface for most scripts. In the Middle Ages and later, this was often a table with a fixed top. A modern calligrapher usually has an adjustable table, allowing the writing surface to be angled differently according to the task at hand. Ruling up might be done with the adjustable table surface laid flat, while writing might require a steeply slanted setting. Furthermore, while a steeply angled table is ideal for edged-pen writing, a flatter surface might be used for pointed pen writing. Brush lettering is quite often done on a flat surface. Being able to adjust the table is important if you try many different styles of writing.

Tabletop easels are also frequently used. These sit atop ordinary flat tables or desks. They have the benefit of being removable and portable, allowing a table to be used for other purposes. Commercially available easels are the most common. In his 1906 book *Writing & Illuminating & Lettering*, Edward Johnston described a home-made tabletop easel that could be made of two hinged drawing boards. A round can placed upright between the two boards allows the writer to adjust the tilt.

Once you begin writing, the purpose of the slanted table becomes clear. A slanted surface presents the work most efficiently to the eye and hand. This is why computer keyboards, for instance, often have a slight upward tilt, or why information panels at national parks are mounted at a slant. If you consider a flat table, you will see that the surface of the

table is very close to your hand and body at the front, but if you move your hand forward even a few inches, significant movement of the arm is required. A piece of work spread out in front of you on a flat table is foreshortened, causing problems when you try to judge proportions as you write. On a slanted surface, a large area is easily reachable with minimal extraneous movement. Johnston warned that writing on a flat surface encourages the writer to hunch over the work—an uncomfortable (and ultimately unsustainable) position. And, as he points out, a flat table changes the position of the pen, steepening it in relation to the table, and causing the ink to flow too quickly.

Very often, a small lip is added to the bottom of the slanted top. This proves to be extremely practical, preventing things from falling off the table. When large work is being done, it is sometimes necessary to allow the lower end of the paper to fall below the bottom edge of the table. In that case, some calligraphers will use a cardboard tube to cover the lip, providing a rounded edge to the table so the calligrapher will not accidentally press against the table, creasing the sheet of paper.

The surface of the table needs to be padded in some way. A hard wood panel, or its modern equivalent, Formica, has no give. When writing on such a surface, the pen does not make clean contact with the page. For this reason, the writing table has traditionally been padded with leather, suede, or a blotter. Alternatively, a pad of five or six sheets of paper may be fixed to the desk with drafting tape. In the studio shown on the opposite page, a self-healing cutting mat has been placed on the table surface.

The page on which the scribe intends to write is attached to this padded area. In the past, this was often accomplished with small pins. Now, most calligraphers use drafting tape.

Above: A medieval desk, after an illumination from a Burgundian manuscript of c. 1450. The fixed board on which the scribe is ready to write has a series of holes drilled along the right-hand side. One of these holds an inkhorn—literally, an animal horn filled with ink. The smaller holes present a place where nibs may be stored, handy for use. The manuscript page is held in place with a little weight hung on a string draped over the desktop; a counter weight would hang down behind.

Opposite: Western calligraphers generally work at a tilt-top table. A flat surface nearby holds tools, inks, and paints.

A guard sheet is always kept between the hand of the writer and the surface being written on. This protects the writing surface from dirt and the natural oils that accumulate on the hand. The guard sheet can be fixed in place with thumbtacks or with masking tape, or it can simply be held in place by the weight of the hand. A fixed guard sheet, if it is quite taut, can hold the work itself in place. Some calligraphers will use the guard sheet for the purpose of testing or cleaning the pen, though this is less than ideal; wet ink on the guard sheet can only too easily be smeared onto the work in progress.

Many calligraphers keep a scratch sheet immediately adjacent to the writing area. This allows the scribe to test the pen, to rid the tip of excess ink, and occasionally to wipe the pen when it becomes clogged with ink residue. This might provide a safer solution than using the guard sheet for these purposes.

Because the writing surface is slanted, it provides nowhere to lay one's tools. A flat surface within easy reach should therefore be positioned immediately next to the writing area. A graphic artist's tabouret is used, providing not only a surface for pens, ink, water jar, and a rag, but also shelves and drawers where other tools and materials can be handily stored.

The direction of the light is extremely important, and should come from the side opposite the writing hand, preventing the hand from casting a shadow over the work. Some calligraphers strongly advocate the use of natural light, although, in practice, any professional scribe uses artificial light at some point. Like natural light, lamps should be set opposite the writing hand.

The writing table should be as clean and efficient as an airplane cockpit: everything is close at hand, so the writing can be done with the most efficient movements possible. The inkwell needs to be positioned so that

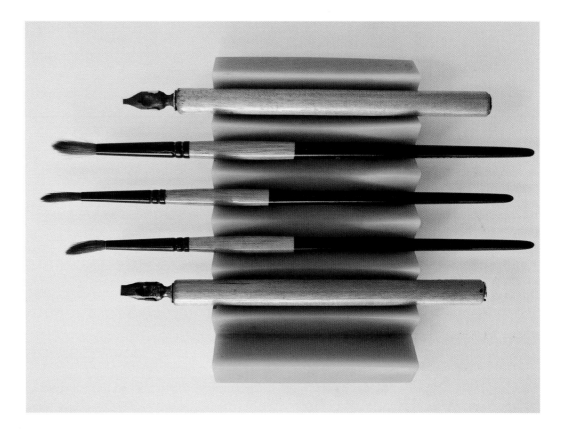

the pen can be dipped without moving the upper body at all. Once an extended piece of writing is begun, the calligrapher should be able to sit, relaxed and centered. The body should be positioned directly in front of the table, without being twisted or turned. The head and shoulders should be relaxed, not stooped or tense.

Tools

The tools of the Western calligrapher are as diverse as the many practices within the tradition. Some of them are deeply traditional, but most of them are the kinds of tools used by graphic designers, at least until recently. The computer has completely changed the workplace of the modern graphic designer, who no longer works with ink, paper, and pencil, but instead produces his work with pixels on a screen. But until the 1990s, the contemporary Western calligrapher would have been quite at home in a contemporary advertising agency. In

Above: Edged pens and brushes are held on a rubberized pad with a zigzagged surface. The brushes may be used to load the pens with ink.

Below: The T-square is the most efficient tool for ruling guidelines.

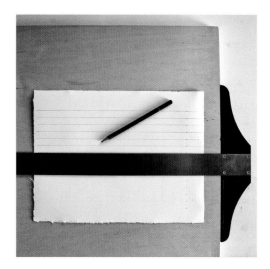

Above: Triangles are used for ruling upright lines, at 90° to the horizontal lines ruled with the T-square.

Below: Bottled ink is the easiest medium to work with.

Above: Pencils are generally used for ruling, as the lines can be erased once the writing has been done and the ink has dried. A kneaded rubber eraser, soft as putty, is an ideal tool for erasing lines.

Above: Oak gall ink is a dark brown ink. It can be purchased in powdered or in liquid form. When bought in powdered form, add water to the crystals to liquefy the ink. It is not perfectly opaque; when it is used for writing, it tends to have a variable tone, darkening as the ink pools at the end of a stroke. Many calligraphers enjoy the artistic effect of this ink.

our own time, the tools of the calligrapher are becoming specialist items.

The essential writing tools are fairly simple. The edged pen was described at length in the previous chapter. Pointed pens and brushes are described in the sections on Copperplate and brush scripts later in this chapter. Most calligraphers write with commercially available tools. For pens, either edged or pointed, most opt for machine-made metal nibs. Quills are only used by a few who wish to go to the time and trouble of finding appropriate flight feathers, curing them, and cutting them. The brushes used by calligraphers are the common artists' brushes available in art supply stores.

On the practical side, many calligraphers like to have a pen-rest to hold their pens or brushes. This is especially useful when putting down the wet writing tool in the middle of work, as it protects the table or tabouret from ink splatters.

Tools for Ruling Up

To make lines, rulers, T-squares, and triangles may be used. To mark the lines, a hard pencil such as a 2H pencil is helpful; soft pencils leave dark lines that smudge easily. A kneaded rubber eraser or other soft eraser may be used to remove lines after the writing is completely dry. Marking out the sequence of lines to be ruled may be done with a pencil, or the lines may be pricked with a pointed set of dividers.

Inks and Colors

Many commercially available inks may be used for Western calligraphy. Generally, a non-waterproof ink is recommended, as waterproof inks will quickly clog the pen. Bottled India ink or bottled Sumi ink from Japan are the most common choices. Although bottled Sumi inks may need to be thinned with water, they provide a dense, rich black. Still, some calligraphers will

Right: More ambitious calligraphers sometimes use powdered pigments. Here, a sample of pure ultramarine powder is shown in a ceramic mixing dish. In order to use a powdered pigment, the calligrapher places a small amount of the powder in a ceramic dish, adds water and a binding agent, and grinds the mixture together with a muller (which is the small glass object leaning on the edge of the ceramic palette). The binding agent in this case is gum arabic (the yellow substance in the small jar).

Far right: Gum sandarac can be lightly dusted on a writing surface and rubbed in gently. Any excess is brushed off the page before writing commences. Gum sandarac repels water and helps ensure that ink will not bleed into a paper that is somewhat absorbent.

choose to use East Asian stick ink (see the chapter on the East Asian brush).

Colored inks and fountain pen inks are not generally used, as these are thin and often do not produce an even, opaque stroke. Using thin ink will result in uneven color, as the ink pools at the end of each stroke. On the other hand, this variation in tone can be used to artistic effect, making these thinner inks perfectly appropriate. Oak gall ink, a thin brown ink, is a traditional medium, and has been used for many of the examples of writing we reproduce in this book.

For writing in color, gouache is commonly used. An opaque watercolor medium, it produces a flat, solid stroke. Gouache is available from any art supply store. The calligrapher can use gouache to mix almost any color desired. When using gouache, the paint is delivered to the nib with a brush. The paint is too thick to allow the pen to be dipped directly into the paint-pot.

More ambitious scribes may use powdered pigments that are ground in a small dish. Gum arabic and water are added to these pigments, with the gum functioning as a binding agent; without it, the powdered pigment would not adhere to the page.

Papers

A smooth, properly sized paper is needed for Western calligraphy. The sizing is important—the paper should not be highly absorbent. Thus, the papers commonly used in Japan, Korea, and China, which are highly absorbent, are not usually suitable for pen-made calligraphy. An absorbent paper will not produce the crisp, sharp edges that are so important for pen-work.

Ordinary bond paper is good for practice and for work that is designed as a prototype for printed work. For work of a more permanent nature, a good art paper may be used. Hot-pressed watercolor paper, with its smooth texture, is good for finished work. The many grades of Ingres paper, with their fine laid lines, are also good. Ingres paper comes in a wide variety of colors, which is helpful. Many calligraphers will use paper designed for printmaking. The finest papers, of course, are handmade. Each calligrapher will have their own particular favorite, arrived at by trial and error. The most important considerations are that the paper be appropriately smooth, not have fibers that get caught in the pen, and not be so absorbent as to make the ink bleed or feather.

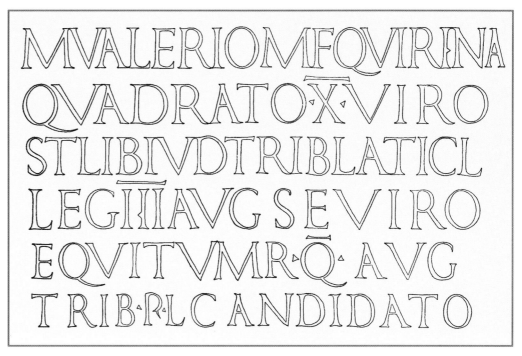

Inscriptional Roman Capitals

We begin this survey of the Roman alphabet not with edged-pen letters, but with inscriptional Roman capitals, which were written in ancient times with an edged brush. Why do we do this? The inscriptional capitals remain a touchstone for Western calligraphy. They are the earliest form of the Roman alphabet that still remains in use, and calligraphers and typographers have returned to them again and again through the history of Western lettering. Although they were written with brushes during the Roman Empire, we know them principally through carved examples that were brush-written, and then carved in stone.

The inscriptional capital has its origins near the beginning of the Common Era in the stone monuments of Imperial Rome. They survived in the form of carved inscriptions, rather than in the form of directly written examples (although one famous painted example did survive, brushed on a wall in the city of Pompeii). As carvings, they would not normally have formed part of the *calligraphic*, i.e., the handwritten, tradition. But their influence on calligraphy through the ages has been inestimable.

In ancient Rome, these elegant and subtle letterforms were used for the most important monuments. They can be found carved onto triumphal arches, the façades of temples, and on funerary monuments. A version of the Inscriptional Roman capital can be seen, cast in bronze and set into stone, on the pediment of the Pantheon in the city of Rome (although it should be noted the bronze now in place is a modern replacement, based on the channels left in the stone). For calligraphers and typographers, the most famous of these inscriptions can be found on a panel at the base of Rome's Trajan Column found in Trajan's Forum. It dates to the second decade of the second century.

At various times in the history of calligraphy, the inscriptional capitals were revived and adapted to the use of the pen. During the Carolingian Renaissance of the ninth century, they inspired pen-drawn letters used to decorate the most

Above: A drawing of two Roman inscriptions by Frank Chouteau Brown, from his 1902 book, *Letters & Lettering: A Treatise with 200 Examples.* Brown made these pen-and-ink renderings after rubbings taken directly from the inscriptions. He has also supplied his own versions of letters missing from the inscription (see image on left, fourth row from the top). (Note that he has not included **J**, **U**, or **W**, as these letters entered the alphabet after the Roman period).

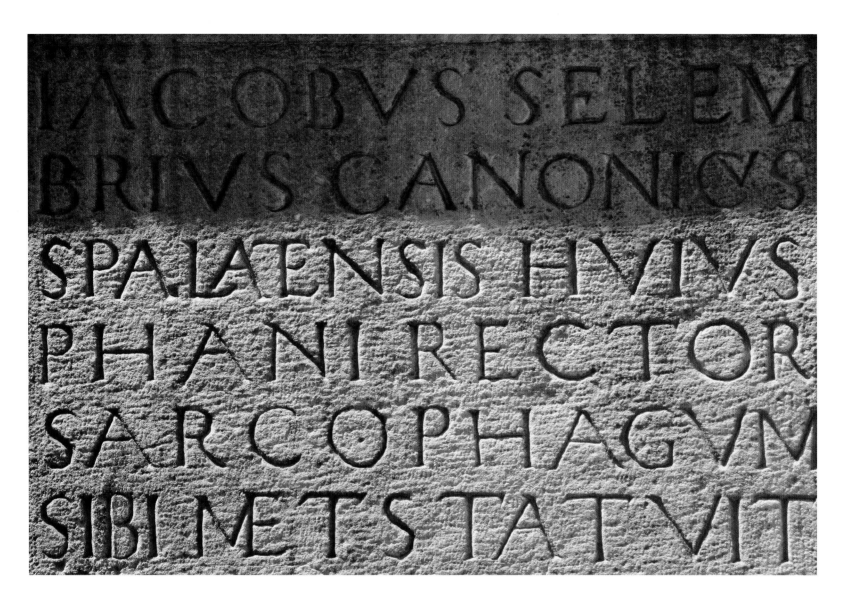

IACOBVS SELEM
BRIVS CANONICVS
SPALAENSIS HVIVS
PHANI RECTOR
SARCOPHAGVM
SIBI METSTATVIT

Above: Renaissance-era inscription. Split, Croatia. During the Renaissance, Roman inscriptional forms were revived, first in Italy, and then throughout Europe.

important manuscripts. In the Italian Renaissance, the Humanist scribes again recreated the forms with a pen for manuscript use. Interestingly, these two revivals were imitating stone inscriptions alone; there were, as far as we know, no handwritten examples available to scribes of the time. Making these letters with a pen at a small scale naturally changed them; new tools always do. So the Carolingian and Italian Renaissance letterforms are distinctive to their period: they are not facsimiles of the ancient letterforms.

In the twentieth century, largely because of the work of the American scholar

and calligrapher Edward Catitch, the origins of the inscriptional capital as a brush-made script were revealed. Catitch, who trained as a sign writer in his youth, was a Roman Catholic priest whose studies led him to Rome. There, he realized that the classic forms of the Inscriptional capital matched perfectly with the use of an edged brush. Before Catitch, all sorts of theories had circulated about the ways in which these letters had been made, including the suggestion that stencils may have been used, or that the shapes of the letters derived from the use of metal chisel on stone. Catitch demonstrated that the unique swellings and

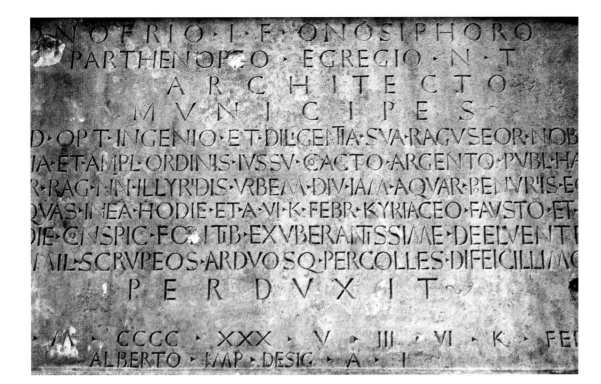

diminutions of the various strokes could only be logically produced with a brush, and he reproduced these convincingly. He argued that the inscriptions were written on stone with a brush; carving did not influence their shape, it only made the letters permanent. And so, ironically, the Roman inscriptional capital, which had been seen as a stone-cut letterform, and had influenced centuries of scribal imitation, turned out in fact to be based on directly written forms. An interesting side note is that in China, where carved copies of brush lettering are a crucial source for the study of calligraphy, the knowledge that their carved inscriptions were based on brush-made letters was never lost. (See the chapter on Chinese calligraphy for a discussion of ink rubbings.)

This twentieth-century discovery has led to a major rekindling of interest in the classical letterform. Unlike earlier revivals of the inscriptional capital, the revival underway now reaches back to the techniques probably used by the Romans. Calligraphers today have continued to develop the brush techniques Catitch popularized, and have adapted the edged pen to make convincing modern letters based on the ancient prototypes.

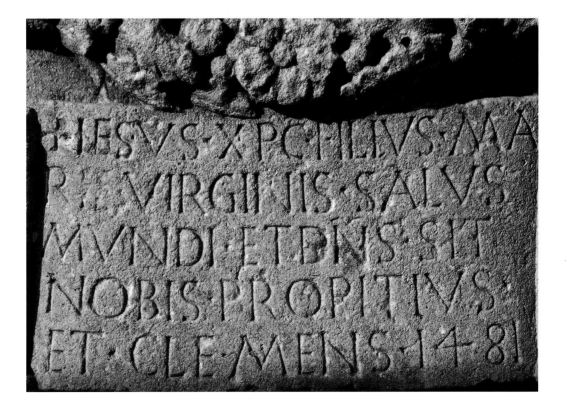

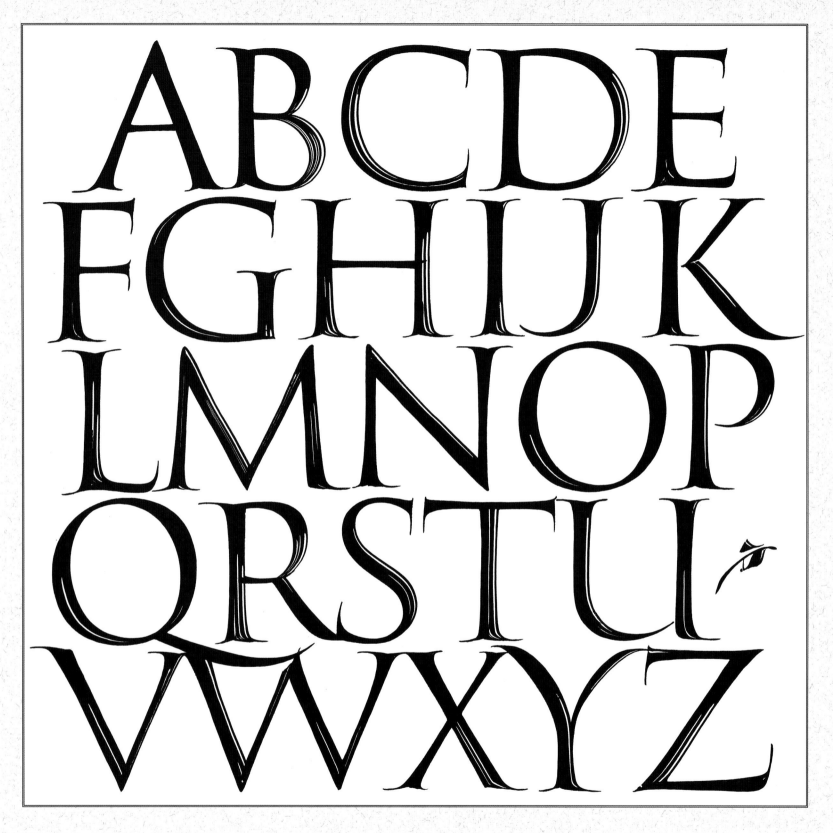

Above: Painted Roman capitals by John Stevens.

On Roman Capitals

By John Stevens

John Stevens is a calligrapher, designer of logotypes, and illustrator of expressive letterforms with thirty years of professional experience. He has worked for well-known clients in book and magazine publishing, packaging, type design, graphic design, television, and film.

Origins

About two thousand years ago, the Romans evolved these lovely forms, which they borrowed from the Greeks and, perhaps, the Etruscans. The beauty of these forms is that they remain the classic standard. Roman capitals also offer lessons to calligraphers and typographers on the subtleties of calligraphy, letter structure, and letter contour. With their undulating swells and curves, their design and proportion remain the pinnacle of letter design. They are worthy of careful study.

Tools

I use both pen and/or brush, but I think the broad-edged brush is the native tool, so to speak. This is my opinion based on twenty-eight years experience and study; this belief is, however, somewhat controversial. When writing with a pen, one has to do special techniques like pressure and release, twisting, building-up, and nib-cornering in order to match the elastic/plastic qualities of the brush. The flexibility of the chisel-edged brush, which informs the shapes of the classic Roman capitals, cannot easily be re-created with the firmer edged pen. As a result, listed here is a series of techniques to make the pen imitate the functioning of the brush. Adding pressure to the nib widens the stroke; releasing pressure thins it. Using this technique, one can achieve the subtle gradations in weight required for the major strokes, which are distinctly thinner in the middle and flare at either end. Twisting, as the word implies, is the use of pen manipulation, changing the angle of the writing edge to adjust the thickness of the stroke. Pen-cornering refers to the use of the corner of the pen to draw in small details or fill in small gaps between the pen-made strokes.

Surfaces

One of the many advantages of a brush is that it can write on virtually any surface *and* it can be applied on a vertical (like a wall) or horizontal surface. I like paper, and that is what is most commonly used as a surface. I also regularly write on stone as a way to lay out the lettering design for letter carving.

Guidelines

Ruling up is a good idea and usually I do it in pencil. Sometimes I might use chalk on larger work. Sometimes I do it without any guidelines. It depends on what I am trying to do.

Posture

For large writing, I stand. Otherwise, I sit at a table.

Roman Capitals are Bedrock

Roman capitals form a basis for a unified view of the Roman scripts. They are structure, power, and nuance. The other important scripts for Western calligraphy are Roman minuscules and cursive (or italic). Minuscules and italic devolved from the capitals over a period of 1500 years.

It is possible to do very fine work with only these three scripts (and their variants) One could argue that almost any Western letterform can be related to these three

Above: John Stevens painting Roman capitals with a chisel-edged brush. Note that he has ruled guidelines that ensure the letters remain consistent in size. Roman capitals are written on a two-line system.

core structures. When I was teaching my intensive six-month class, I focused on students learning an integrated upper and lower case and cursive version of the Roman alphabet, usually based on pen forms. Because many calligraphers had only taken short workshops as their lettering education, most students did not have a unified set of Roman capitals, minuscules, and cursives that work in harmony when they are combined. Most students had learned each hand separately; each one was to them a new "style" or hand, and therefore students had difficulty unifying their pages. I taught the three scripts as a unified whole (three parts of the same alphabet) because it equips students with a basic groundwork, and helps with structural unity when designing pages. It offers a constant upon which one can create variations (i.e., a light Roman capital with a bolder Italic or vice versa).

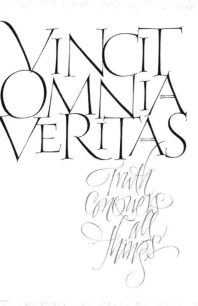

Uses for Roman Capitals

Roman capitals are everywhere. For instance, the typeface Trajan is ubiquitous and specifically follows the forms from the Trajan inscription in Rome from 113 CE. Any serious student of letterforms has studied these Trajan forms. There are many aspects to them: from basic structure, to subtleties and refinement in detail. For calligraphers, they represent some technical challenges—the sort one might confront learning to play the violin. They represent grace and elegance. They require excellence, and generally a calligrapher's technical abilities will be improved by their study and practice. They are also a point of departure on the expressive side.

The most common uses for Roman capitals are titling in book and publication design, inscriptions such as headstones, and architectural uses (buildings and monuments). In calligraphic terms, they are used for special treatments, which could be titling, headings (in contrast to body text), or they can be used to write a passage of text. Edward Johnston said in his famous book *Writing & Illuminating & Lettering*, "When in doubt, use Roman capitals." His tastes were decidedly classic (his was the time of the Arts and Crafts Movement, whose adherents were opposed to superfluous decoration, filigree, design, and Art Nouveau. He was also an advocate of architect Louis Sullivan's axiom that "form follows function.") I have studied the Roman capital extensively, but I don't necessarily belong to any "school" of calligraphy. Things today are in flux.

Top left: From *Hebrews 3:16*, 1985. Calligraphy by John Stevens. Stick ink and gouache on JB Green handmade paper.

Top right: Lech Walesa, *"Let Deeds Follow Words Now,"* 1990. Calligraphy by John Stevens. Gouache on Twinrocker handmade paper.

Bottom left: *Vincit Omnia Veritas*, 1995. Calligraphy by John Stevens. Stick ink and gouache on paper.

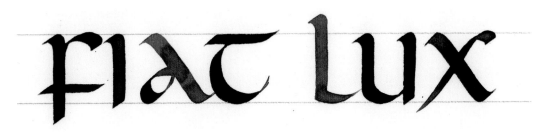

This sample is written at a 30° pen angle.

The Uncial script came to prominence in the early Middle Ages, and was popular between the fourth and the eighth centuries. It is an entirely majuscule script—all the letters are capitals. This may seem a strange claim, because many of the forms are clearly more like small letters than our capital letters. Uncials are a transitional form, mixing letters that would later develop into our minuscules with forms directly derived from Roman capitals. In the historical manuscripts, when emphasis was needed—at the beginning of a verse, for instance—the scribe would simply use a larger letter of the standard Uncial form.

This is the first of the edged-pen scripts that we show in this book. As a result, the letters are shown out of the standard order. When a student is learning a script in the Western tradition, he or she never learns their letters in alphabetical order. Instead, letters are usually taught in groups that *share related forms*, and that is what we do here. This not only aids learning, as students master each of the component strokes in turn, but it also demonstrates that related form is part of what gives a script its unity. The letterforms are not a random series of marks, but share certain components, which are arranged and rearranged to make a coherent whole. Note that *related form* is not synonymous with *identical form*. Although letters share components, small adjustments are made for many of the letters, as will become clear as we work through the example.

Uncials are characterized by their rounded appearance; a passage written in Uncial presents a rhythm of curves and straight upright strokes in a stately progression across the page.

This Uncial is a modern alphabet inspired by the slanted-pen Uncial of the Stonyhurst Gospel (late seventh century). It is not in any sense a facsimile of the Stonyhurst script, but it takes its basic proportion and letter-shape from that earlier model. It also rationalizes the earlier script, making it more internally consistent, and adds letters missing in the original Latin of Stonyhurst. *Calligraphy by Christopher Calderhead.*

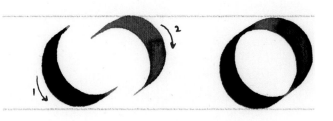

Above: The letters are five nib-widths tall. Ascenders and descenders project slightly above and below the writing lines.

The best way to start working with Uncial is to begin with the straight **I** and the round **O**. The **I** begins with a small entrance stroke, the little curved stroke at the top. To get the ink flowing, the pen slides very briefly along the thin edge, quickly turning through the curve, and then resolving into a perfectly straight upright stroke. At the bottom, a slight pressure is applied before the pen is lifted cleanly off the page, leaving a crisp, well-formed end.

The **O** is made in two strokes, both of which look like tilted crescent moons. They join (and may slightly overlap) on their thin ends. The finished **O** should appear perfectly round. But note that the *whole letter* is not a perfect circle; *each side of the nib* describes a perfect circle, so the effect is that of two perfect circles that overlap.

The **I** and the **O** provide the building blocks for many of the next letters.

41

Circular Letters

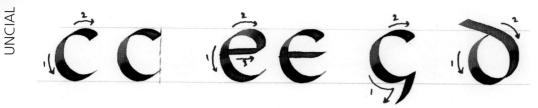

C begins with the same stroke as the beginning of **O**. The stroke is, however, very slightly extended at the bottom. The top stroke follows the same curvature as the top of the **O**. Note that the strokes should align at the right-hand side of the letter, as shown in the diagram.

The **E** has a structure much like **C**. Note that the letter can have two different forms, closed or open. The crossbar should be made just above the actual middle of the letter.

G is made like the **C**, but with the addition of a small tail that breaks the baseline.

D starts with the same first stroke as the **O**. The second stroke begins flat and diagonal, above the top line, and then curves at the bottom, picking up the same curve as the **O**. Note, however, that the flatness of the first part of this second stroke creates a different interior shape, or counter, for the letter. Rather than having an oval white space in the middle, like the **O**, it has a teardrop-shape white space. Many beginners find this letter tricky.

Letters Combining Curves with Straight Strokes

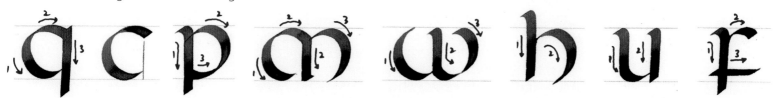

Q is also related to the **C** as well, but with one important difference: where the two strokes of **C** aligned on the right hand side, in the **Q**, the top stroke has an "overbite." The diagram shows how this top stroke overshot the mark; the left nib-corner lines up with the bottom of the first stroke. The third stroke overlaps the second stroke, and comes cleanly down, breaking the baseline.

P begins with a straight stroke, breaking the baseline. The second stroke is just like the second stroke of the **O**. A third stroke completes the bowl, or round part, of the letter. This stroke is a slightly flattened curve, if you compare it to the curvature of the **O**.

The first stroke of **M** is like the first stroke of **O**. The second stroke follows the same curve as the top of an **O**, but then becomes a straight stroke. There should be a clear corner where the curve shifts into straight; this gives a clear point of join for the third stroke, which is like the second stroke of **O**. Note that this last stroke has to be pulled down more deeply than the **O**-stroke; it should touch the baseline.

The **W**, which does not appear in Medieval Latin manuscripts, has been adapted from a similar form in Greek Uncials. It is essentially an upside-down **M**—its structure is identical. Note that the second stroke is new; a straight followed by a curve. But its shape is just like the similar stroke of the **M.**

H begins with a stroke just like an **I**, but the stroke is taller, beginning above the top line. The second stroke is like the back of an **O**, but is slightly elongated to touch the baseline.

With a straight beginning and a curved bottom, the first stroke of **U** is joined to a second stroke that is identical to the **I**.

The **F** has a long first stroke that breaks the baseline. The top stroke is just like the second stroke of **C**. A long horizontal stroke finishes the letter. This last stroke sits just above the baseline.

Straight Letters

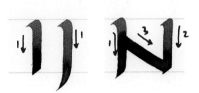

The **I** and the **J** are closely related. The ending of the **J**, however, breaks the baseline (not as deeply as the other descenders), and it is pulled off in a small curve to the left.

N is made of three straight strokes. The second stroke begins at about the middle of the letter, a feature unique to the Uncial script.

The L Stroke

L is made with a single stroke. It begins above the top line. When the pen has almost arrived at the baseline, it changes direction, making a sharp turn. The bottom of **L** points slightly downwards; it is not a flat horizontal stroke.

B begins with the **L** stroke. The two bowls may be made in one stroke, without lifting the pen. Note that the top bowl of the **B** is smaller than the bottom bowl.

R and K

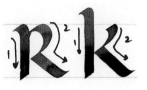

R has a distinctly large top bowl and a generous tail. In the version shown here, the first stroke just breaks the baseline. The second stroke should just kiss the upright stroke with its corner, not overlap.

The **K** begins with a long **I**-shaped stroke above the top line. Like the **R**, the second stroke of **K** should only touch the downstroke, not overlap.

Straight T and Round T

A **T** may be made in two ways: it may be made of two straight strokes, or it may have a wide bowl and a straight top.

Diagonal Letters

For the first stroke of **V**, the pen angle is slightly steeper than normal. Look at the top ends of the two strokes: the pen angle is steeper on the left than on the right. Both strokes begin with a slight curve, and then they are made quite straight. The two strokes overlap where they touch.

Two forms of **Y** are given here. In both, the first stroke is slightly steeper in pen angle than the other parts of the letter.

Once again, steepen the angle of the first stroke of **X**. This stroke is made at an even steeper angle than the first strokes of **V** and **Y**. The two straight strokes should cross just above the middle of the letter.

The **Z** is made of two horizontal strokes and a diagonal. For this diagonal stroke, flatten the pen angle to 5° or 10°.

A and S

The **A** and the **S** are unlike most of the other letters:

The long first stroke of **A** begins and ends with a distinct curve. The bowl should be quite small; the second stroke should begin below the middle of the letter.

The **S** should describe a sinuous, continually curved shape. Note that the bottom of the **S** is slightly larger than the top.

The diagram above shows how **S** is related in the shape and proportion of the **O**.

IN PRINCIPIO ERAT VERBUM.

Left: *"In the beginning was the word."* An apt New Testament quotation for the beginning calligrapher. This sample is written in letters directly based on the exemplar letters above.

Right: A cover for *Letters From New York: 3* using Uncials in a photographic treatment. Calligraphy and photography by Christopher Calderhead.

Below: A freer interpretation of the Uncial letters, written without ruled lines, shows that the Uncial script does not have to be rigid or stiff. The letters here are heavier, having been written at only three nib-widths high.

keep your love
of nature, for
that is the
true way to
understand
art, more
and more.
VINCENT VAN GOGH.

Writing Carolingian

Carolingian is a script that became formalized in the ninth century. Carolingian was the first Western script to introduce the use of mixed majuscule and minuscule forms. For the first time, a capital would be used to indicate meaning—to mark the beginning of a sentence, or mark a proper name. This was a major development in the history of Western writing. From the Carolingian period on, Western scribes and their descendants, the modern typographers, have used a mixed system, with two variants of the Roman alphabet used together. The type you are reading now is set in upper and lower case; we could not write grammatical English using only small letters, and we only rarely write things entirely in capitals. We owe this to the innovations of the Carolingian-era scribes.

The script has a number of unique characteristics. The small letters are written at a very small x-height; in this version, they are only three nib-widths high. The ascenders and descenders are very extended. The script also has a distinct forward lean. *Calligraphy by Christopher Calderhead.*

This sample is written at a 30° pen angle.

This Carolingian has an x-height of three nib-widths. Ascenders and descenders are four nib-widths.

The **o** is a wide oval shape. The arched letters, like **n**, may be made in a single stroke.

The ascenders are made with a pushed stroke that doubles back on itself.

Above: Note the generous line spacing; lines should be far enough apart so ascenders and descenders from each line never collide.

Alice Beth Chad Edward Frank

George Helen Inga John Kurt

Liam Mary Nestor Oliver

Peter Quentin Rufus Samuel

Xerxes Yasmin Zack

Above: For capitals, leaning Uncials may be used.

Right: A quotation in Carolingian.

The creation
of a thousand forests
is in one acorn.

emerson

The Foundational Hand

The Foundational Hand is a modern creation based on a tenth-century English prototype. Edward Johnston, the founder of the modern English calligraphy revival of the early twentieth century, based this script on the Ramsey Psalter, also known by its shelf number in the British Library as Harley 2904. The Ramsey Psalter was written in a late version of the Carolingian minuscule. It is extremely legible. Johnston used it as the basis for this logical and consistent script.

Foundational is an upright Roman hand with a round **o** and with wide, arched letters like **n** an **m**. It is written at a 30° pen angle. It is written here simply on ruled baselines, unlike the two previous scripts, which were written using a more comprehensive set of ruled lines. Note that the letters float just above the baselines, giving the writing a freedom that the extra ruled lines might inhibit. Many professional calligraphers write on nothing more than baselines.

The exemplar shown here is an abecedarian sentence; it contains all the letters of the minuscule alphabet. Like the classic Carolingian, it may be paired with Uncials to provide capital letters. The stroke order closely follows the stroke orders given for classic Carolingian.

Johnston was in the habit of giving samples of his writing to students. He had sheets of paper printed with two short explanatory paragraphs at the bottom of the page, describing the basic principles of edged-pen writing. The bulk of the page was blank. On these printed sheets, he would actually hand-write a sample for the student. Many times, he would write an actual text, not an exemplar alphabet. That is the practice followed here. The benefit of this method is that it demonstrates a script in the way *real writing works*. Sample alphabets are an expedient short cut: they explain a script with great clarity, as we have done with Uncials and Carolingian. But they are denatured; real writing does not function as discrete letters set apart from one another. By writing a sample sentence, the teacher gives the student a fully realized work. Not only are the individual letters present, but letter spacing, line spacing, and the natural variation that comes of actual writing are immediately apparent.

One of Johnston's aphorisms was, "Practicing teaches you to practice." In other words, simply repeating exercises by writing individual letters can become an end in itself. He encouraged his students, as soon as they could, to actually *make something*. Only when faced with the problem of writing out a real text for a real purpose does the student begin to synthesize letters of a script into a piece of living writing.

This holistic attitude to the learning of calligraphy was inherent in all of Johnston's teaching. And so, this simple sample sentence stands here as an example of an approach that differs from the more formal exemplars in this chapter. Looking at the sample sentence, copying it, and analyzing the letterforms on one's own, a student will learn more than just a set of letters. He or she will learn how a script is a living whole.

Below: An abecedarian sentence exemplifies Edward Johnston's Foundational Hand.

And from every quarter flowing joyful crowds assembled round and spake with exalted zeal.

Above: (front and back) This small vellum fragment was retrieved from an old binding, where it had been used to stiffen a book spine. Its script shows transitional early Gothic. While still retaining some of the roundness of the earlier Carolingian forms, this script is more condensed—squeezed laterally—and has some of the angular quality that characterizes the mature Gothic scripts. Date and provenance unknown.

Above: Leaf from a Book of Hours. Northern Europe, (France or Flanders?), c. fifteenth century.
This lushly ornamented Gothic manuscript shows the strong angularity and tight spacing associated with the script. The lines have been ruled using washy red ink, creating a decorative framework that holds the writing. Note that the scribe writes above, rather than on, the ruled baselines. The painted capitals in the margins are known as Lombardic capitals, and were a common accompaniment to the Gothic text hand. This Gothic is written at any angle that varies between 30° and 40°.

Right: Leaf from a Book of Hours. Northern Europe (France or Flanders?), c. fifteenth century. Written with a quill, as were most Western Medieval manuscripts, this script has the fine hairlines its tool allows. Not the most legible of scripts, the Gothic nonetheless creates a dense, rich texture on the page. The first lines read: *Homo natus / de muliere / brevi vivens tempo / re: repletur multis / miseriis.* ("Man born of woman, living a short time, is full of miseries.") Note that the word *tempore* is broken at the end of line 3; the medieval scribes felt free to break words as needed (we do not have that luxury in English). Note also the alternative form of **r** in *brevi*. This Gothic form of **r** is only used when following a curved letter like the **b**.

Gothic

As the Middle Ages progressed, scripts in Northern Europe became progressively narrower and taller. As the letterforms became more compressed, they also became more angular, and the Gothic letterform was born. Gothic scripts were popular from the late thirteenth century to the sixteenth; they continued to be used in German-speaking countries as a major script right into the twentieth century.

With its densely packed, upright vertical strokes, Gothic creates a rich, dark appearance. Its structure is clearly derived from the use of an edged pen; the strong diamond-shaped terminals on the upright strokes could only be made with an edged tool. It is not the most legible of scripts, and it carries with it strong historical connotations, so it needs to be used with caution. Depending on the context, it can convey two diametrically opposed moods—ecclesiastical primness or heavy-metal biker wildness.

Writing Gothic

The basic rhythm of Gothic script is a pattern of equidistant, upright parallel lines, like a picket fence. This is especially apparent in a word like *minimum*, in which all the letters are composed of upright strokes. When other letters, such as **s** or **c**, appear in a word, the spacing is adjusted visually to give an even texture. Many calligraphers who are first learning the script will practice making rows of parallel lines first, to achieve this evenness of rhythm, and then to begin learning the individual letters. This Gothic sample is written at an angle that varies from 40° to 30°. It has fairly open spacing, which is to say, the distance between the upright strokes is generous. Comparing this to the historical samples it can be seen that much closer spacing of the uprights is possible, making for a darker texture. *Calligraphy by Alice Koeth.*

This sample is written at an angle that varies between a 30° and 40° pen angle.

Gothic Minuscules

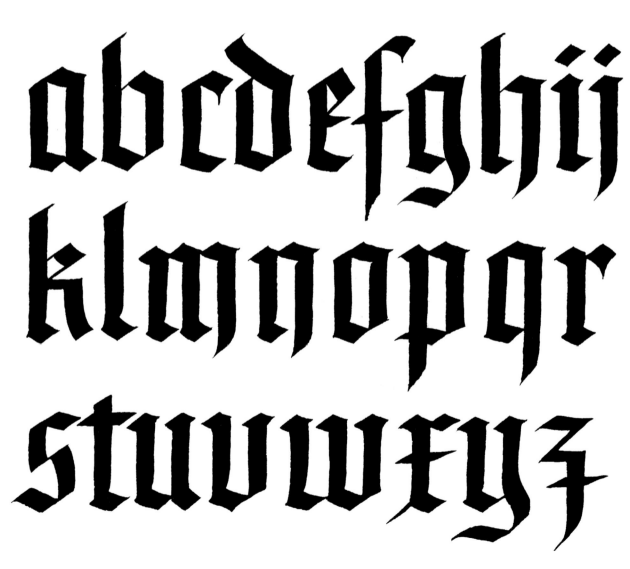

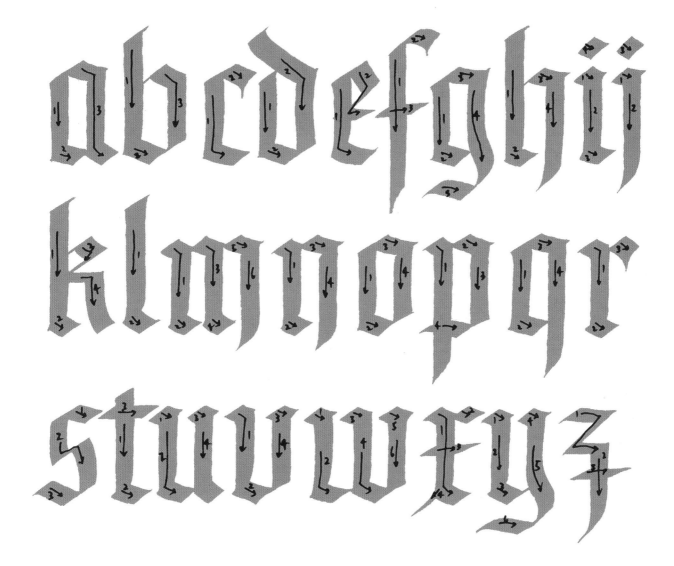

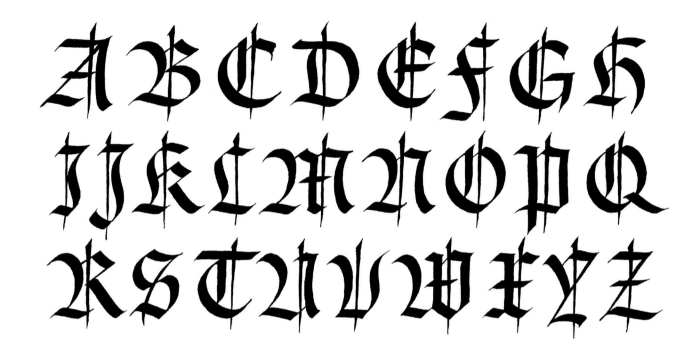

Gothic Majuscules Stroke Directions

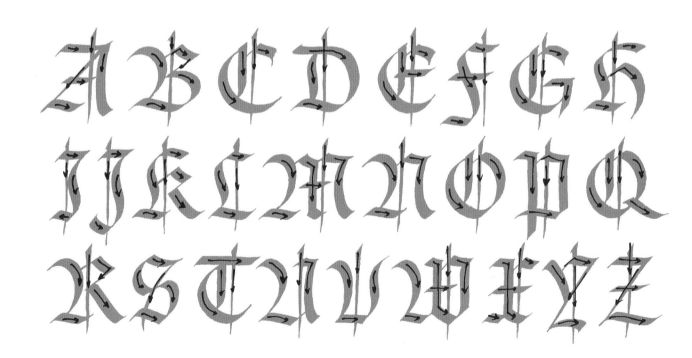

Above: Gothic capitals.

Right: A finished composition shows the Gothic script in use. A translation of the German text is provided between the lines in freely made Roman capitals.

Gestatten Sie, dass ich

LET ME INTRODUCE

vorstelle: meine Frau,

MY WIFE, MY DAUGHTER

meine Tochter, mein

MY SON, MY HUSBAND

Sohn, mein Mann,

MY UNCLE, MY NEPHEW

mein Onkel, mein Neffe,

MY AUNT, MY NIECE.

meine Tante, meine Nichte.

Writing Gothicized Italic

This is another script that, like the Foundational Hand, is a twentieth-century confection. Broadly based on two historical scripts—the late Gothic cursive known as Batarde, and on a classic Italic—it combines the richness and sharp angularity of the Gothic with the lyrical, flowing quality of Italic.

The dominant pen angle is 40° or steeper. The pen angle shifts as high as 55° and as shallow as 20° for some letters. *Calligraphy by Barry Morentz.*

These samples are written at a 40° angle.

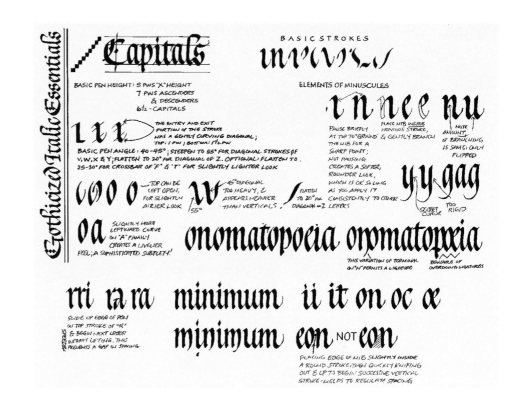

Below: Cursive Gothic minuscules. The playful possibilities of Gothicized Italic are many. Certain letters lend themselves to variant forms, as shown here. There is no reason why letters need to have the same form throughout a single text.

Above: Barry Morentz's instructions, handed out in workshop classes, describe some of the fundamental characteristics of this lively script.

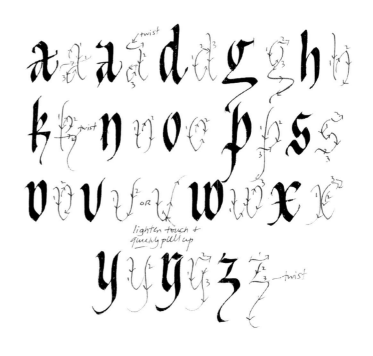

/ AAAHA BBBB CCC
DDDDD EEEE FF GGG
HH II JKK LL MMMM
NNOGOO PPQRR SSS
TTUUVWWW XX YY ZZ

honorificabilitudinitatibus

honorificabilitudinitatibus

Its biting is immortal
and those that do die from it
do seldom or never recover.

Above: A sheet of capitals shows the many variations possible. In keeping with late medieval Gothic cursives, the capitals here have many variant forms, and are an invitation for experiment.

Left: Gothicized Italic can be written at different widths. Packing the upright strokes tighter together produces a richer effect. Note that in a single piece of writing, one would always want to retain a consistent width.

Writing Italic

Italic emerged, as the name implies, in Italy during the Renaissance. It was a hand much favored by the Italian Humanists, and was used both as a formal bookhand and as the basis for daily handwriting.

Italic is an extremely malleable script. It is one of the basic hands in a contemporary calligrapher's arsenal, and is extremely popular. *Calligraphy by Anna Pinto.*

Below: Conventionally, Italic is said to be written at a 45° pen angle. In practice, this is rarely the case. In fact, a classic Italic is written at a 45° angle to the angle at which the letters lean, not to the baseline (thus a classic Italic would be at something like a 40° pen angle, if one measures the angle from the baseline). The straight strokes here are written at a fairly shallow 20–25° pen angle, although the curved strokes are written at closer to a 40° angle.

The sample is written at an angle that varies between a 20° and 40° pen angle.

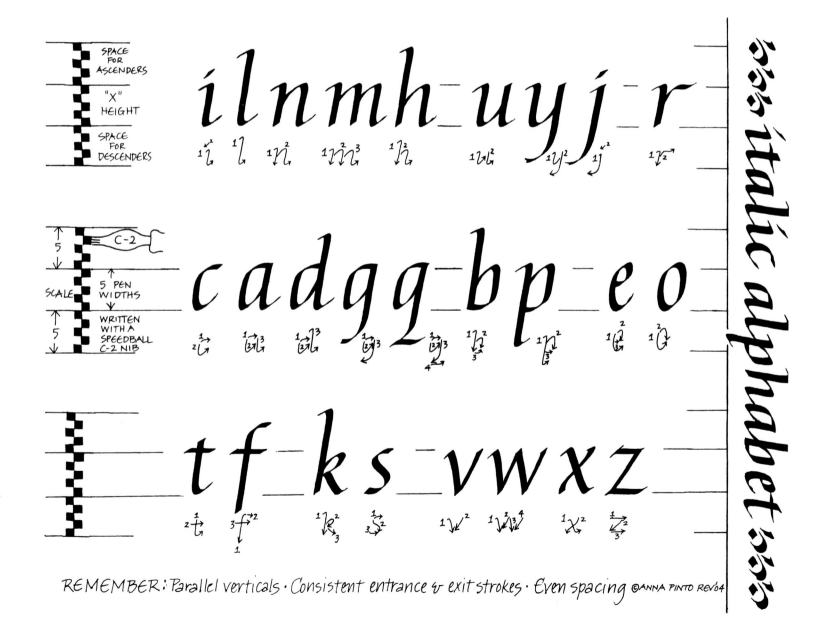

REMEMBER: Parallel verticals · Consistent entrance & exit strokes · Even spacing ©ANNA PINTO REV'04

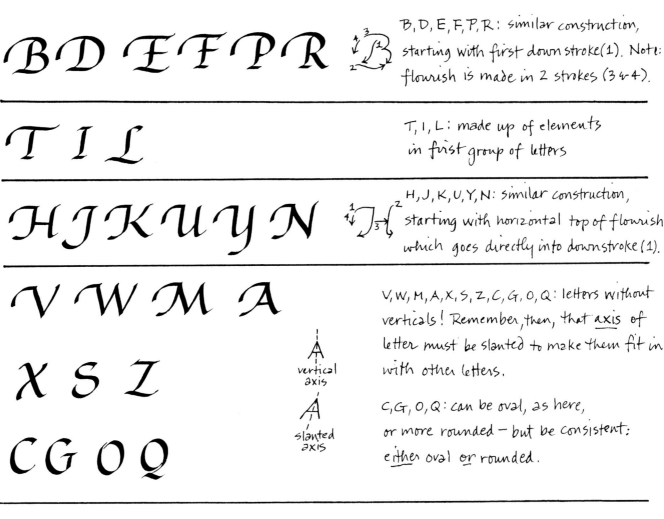

Italic ½ Capitals

approximately 7 pen widths in height · Rexel 2½ nib

B, D, E, F, P, R: similar construction, starting with first down stroke (1). Note: flourish is made in 2 strokes (3 & 4).

B D E F P R

T, I, L: made up of elements in first group of letters

T I L

H, J, K, U, Y, N: similar construction, starting with horizontal top of flourish which goes directly into downstroke (1).

H J K U Y N

V W M A

X S Z

C G O Q

V, W, M, A, X, S, Z, C, G, O, Q: letters without verticals! Remember, then, that <u>axis</u> of letter must be slanted to make them fit in with other letters.

A — vertical axis

A — slanted axis

C, G, O, Q: can be oval, as here, or more rounded — but be consistent: either oval <u>or</u> rounded.

CAUTION! DO NOT OVER-CURL FLOURISHES! Keep them open & smoothly curved (imagine a beach ball fitting into the curve) not hooked & cramped.

Above: Flourished capitals make a natural accompaniment to the Italic minuscule. Flourishes, also referred to as swashes, are decorative strokes added to the letters. For example, the horizontal stroke at the top of the **A** that extends from the top and loops down to the left is not an integral part of the letter—the **A** would still read as an **A** without it. On other letters, like the **E**, the flourish is an extension of the top and bottom strokes.

Commentary and Self-Critique

In the Western tradition, calligraphy is often used for work in reproduction, as in books or other media. But just as often, calligraphers are asked to make orginal works that stand alone. When calligraphy will be used in print, the calligrapher has the opportunity to retouch the artwork with ink and paint or by using a computer program such as Photoshop. When the task calls for original writing on paper, as with a diploma or envelope addressing, there is no chance to touch up the letters. This is a real test of a calligrapher's skill.

This exemplar, also by Anna Pinto, shows the Italic hand in use, without touching up. Anna describes this exemplar: "This sample of Italic was written with a 3.5 Rexel nib, using diluted bottled Sumi ink, on Fabriano Ingres paper. Except for a few pen touch-ups that I just couldn't resist, it has not been corrected in order to show some of the inconsistencies that can happen in directly written calligraphy."

Left: Twisting the pen created some of the effects in this sample:

The dots on the **i**'s and the serifs on the **f**'s, for example, get their triangular shape by twisting the left corner of the nib down as you lift the right corner.

The ends of the descenders get their tapered look by lifting the left corner of the nib up as you continue around the curve with the right edge. (Sometimes the result is a little too wispy, and that might be a place I would touch up with the pen so that the letter is properly balanced.)

The left corner of the nib is lifted as you continue on the right corner to make the ligature stroke from the **t** to the **s** or **c**. The tapering of the end of the flourishes on the caps is done this way, too.

Certain joins are made to adjust and equalize spacing between letters:

In "refinements," the **f** is joined to the **i**, and the serif is moved slightly away from the **f** so that it serves also to dot the **i**.

The **r** in "clarity" is dipped before joining the **i**, so that it will still read as an **r** and not as a lumpy **n**.

The serif on the **i** after the **t** in "imagination" has been removed so that it doesn't interfere with the **t** and the dot on the **i** curves toward the crossbar as though it were the end flourish on that stroke.

The **r** and **t** in "Barthel" are joined by their common crossbar.

Since this was done to show an unretouched-for-reproduction piece of writing, there are certain letters that I would probably fix under other circumstances:

Some of the **s**'s are not as smooth as I'd like.

The **y**'s in "clarity" and "subtlety" have diagonals that are too heavy, which create dark spots in the texture of the writing. If you make the angle of the pen a little steeper when you make the diagonal from top left to bottom right, it will make the stroke thinner and in sync with the strokes in other letters.

The bottom stroke of the minuscule **z** projects a little too far to the left.

The capital **Q** looks too small compared to the **O**. This is an example of another optical subtlety—if the body of the **Q** is the same size as the **O**, once the tail is added, the whole letter looks too big.

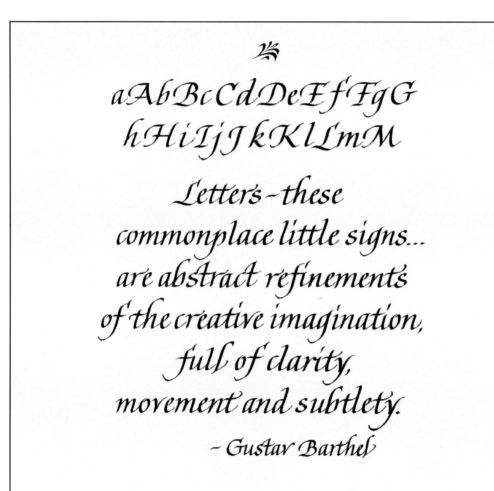

Writing Modern Roman

This version of the Roman alphabet shows a distinctly contemporary approach to the script. Rather than keeping to a strict pen angle, the pen is manipulated a great deal to make fine, thin strokes. Instead of being rooted in the historical prototypes that influenced most of the previous scripts, this elegant alphabet has a distinctly modern feel, reflecting the influence of typography on the practice of calligraphy. The letters do not join; they sit distinct from one another, just as typographic letters do. Compare this to the Carolingian or Foundational, for instance, both of which lend themselves to spontaneous ligatures tying letters together. *Calligraphy by Marcy Robinson.*

The dominant pen angle is 30°. Note that the thin upright strokes are made at about 80°, while the thin horizontal strokes are made at a very shallow 10° or 15°.

Modern Roman Majuscules with Stroke Directions

ABCDEFGHIJ
KLMNOPQR
STUVWXYZ

Modern Roman Minuscules with Stroke Directions

abcdefghijklm
nopqrstuvwxyz

The Pointed Pen

A major shift took place in Western calligraphy at the end of the Renaissance. With the advent of printing, the important work of making books by hand gradually began to die out. The edged-pen scripts became significantly less important, and the pointed pen became the most important tool used by calligraphers. The kinds of work calligraphers produced also changed. The distinction between ordinary day-to-day handwriting and formal calligraphy became much less obvious. Where the medieval scribes had reserved their best writing for major documents such as Bibles, missals, and royal charters, the eighteenth-century writing masters concentrated on the practical needs of business—letters, receipts, and financial documents. By the nineteenth century, calligraphy was flourishing in American business schools. Pointed-pen calligraphy remains crucially important for social calligraphy, and is often used today for wedding invitations and addressing envelopes for formal occasions. It is also used as an art form in its own right, to write out beautiful set-pieces and valued quotations.

The pointed pen functions in a very different way than the edged pen. As we have seen in the previous sections of this chapter, the edged pen produces a modulated line that varies in thickness. The variations are produced by the direction in which the strokes are made. The pointed pen, by contrast, naturally produces a thin, fine line of equal thickness. This is referred to as a monoline. But if you apply pressure to the stroke, pushing down on the nib as you write, the ends of the pointed nib gently split, producing a thicker stroke. Writing with a pointed pen involves continual variations in pressure. Placing the pen on the page, light pressure will produce a thin stroke; by gradually pressing down while continuing the stroke, the writer makes the line grow thicker. As the stroke nears

Above: A page of alphabets from George Bickham's book *The Universal Penman*, published in London in 1741.

Right: *The Universal Penman* remains one of the most lavish and influential compilations of pointed pen writing. Published by George Bickham, a writing master who also engraved the plates, it collects samples of writing from some of the most prominent penman of his time.

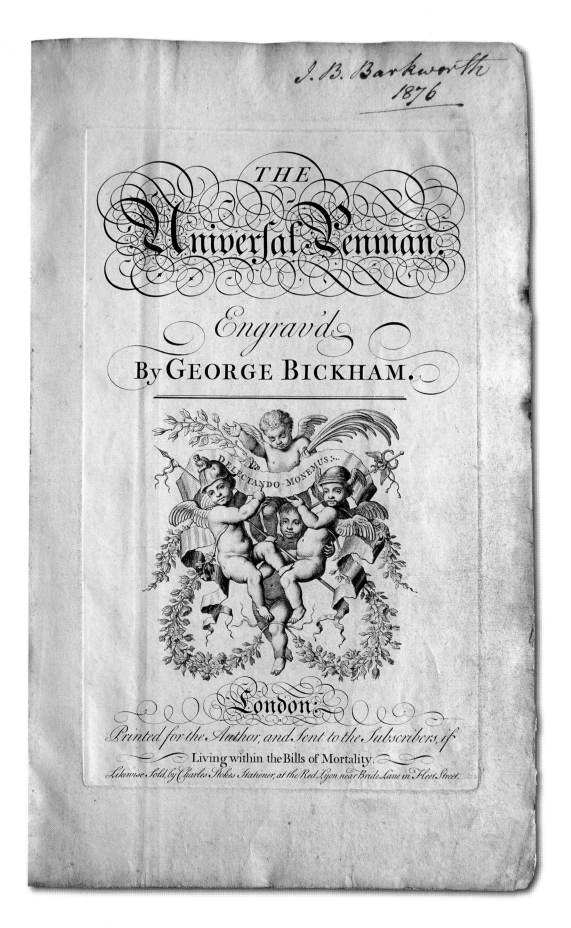

completion, pressure is relieved, and the line returns to its thinner weight.

Nan DeLuca is a professional calligrapher working in New York City. She has a thriving business doing enevelopes and wedding invitations. I asked her to talk about the practice of pointed-pen calligraphy.

The Pen and Other Tools

Many pointed-pen calligraphers use a special penholder. Nan said, "I use wooden, handmade oblique penholders, but you can use straight penholders just as well, although the oblique holder is made to easily maintain the proper letter slant. A penholder that has an adjustable flange is ideal to accommodate different size nibs."

Nan also commented that controlling the ink-flow with a pointed pen can be challenging. She sometimes uses a small container with a dampened sponge; touching the nib to the sponge helps the ink flow more easily on the first stroke made after loading the pen. In addition, she recommends a shallow ink bottle or "dinky dip" vial to keep the flange out of the ink. About other tools, she says, "Ammonia or alcohol is great to clean nibs either before using when new or after writing; an old soft toothbrush can be used to gently clean the nib. Needle-nosed pliers can be used to pull the nib out of the flange when it is no longer needed. Padding under the paper you are writing on is important to provide a cushion for the pen."

Very often, Nan uses a lightbox, which has a translucent top, lit from behind with a powerful lamp. This allows her to place guidelines under the page on which she writes, rather than ruling lines directly on the page. "I write on a light box that has been padded with a thin sheet of foam (the kind used to pack up dishes).Padding your paper helps keep your hand 'soft' and makes hairlines more attainable, while using the foam allows light to shine through."

On On no no now
a-aaaa c ccccc e eeeee
r rrrrr s sssss -ac ersc
swim seam came can
earn vine issue wives a
common mirror same
music cause success

Above: This pen exercise by E.L. Brown appeared in the October 1901 issue of *The Western Penman,* published in Cedar Rapids, Iowa.

Below: Pointed pen nib in oblique holder.

Guidelines

Nan uses ruled guidelines. These are not usually pencilled directly onto the envelopes or invitations on which she is writing. Instead, the guidelines are made on a separate sheet that "can be inserted into the envelope or behind the place card."

When dealing with opaque or dark papers, Nan uses a Phantom Liner, which projects lines onto the page, leaving no marks. When it is absolutely necessary, she draws lines and erases them when she is done. This is obviously less than ideal, because speed is of the essence when doing envelopes. She added, "On most dark papers, a soapstone can be used to draw lines that can be just wiped away with tissue."

Posture and Lighting

Nan keeps her slanting desk at a fairly flat tilt. She uses a sheet of Lucite on an easel with cool fluorescent lighting underneath. About lights, she said, "I have one larger light in the upper right corner of my desk and, to my left, a small spot light. The larger light can be adjusted for direction, bouncing light, or giving indirect light as needed. A 'daylight' light bulb is wonderful, as it allows me to see colors properly. I place my desk near a window so I can also use daylight to see colors."

Maintaining good posture is crucial to the sustained, repetitive work of social calligraphy. "A good chair is very important. My chair has a firm back support and I keep a storage box under my feet for further support/balance; the table and chair height are that I can comfortably rest my forearms on the writing surface without straining or bending. And it's important not to have any impediments near my writing arm that would impede my movement when creating flourishments."

The Writing Surface

The papers Nan uses are the same as those used for edged-pen calligraphy. She added, "Some soft, loose fibered papers may 'catch' on the sharp point of the nib and be unsuitable for writing. The same preparation that other calligraphers use, such as gum sandarac on a glossy surface, is also used when writing with a pointed pen." The pointed pen also lends itself to non-traditional materials: "I have written on gold foil, 'elephant' paper (very bumpy and looks like it sounds), glass/mirrors, and sand dollars/sea shells."

Writing Copperplate

Nan DeLuca explains: "Students typically learn the basic shapes that comprise the letters and, after attaining some skill by consistently rendering them, are introduced to letter families. The students must learn to master the 'pressure-release' strokes needed to generate the thick-thin lines that give Copperplate its grace. Gently adding pressure on a downstroke and then, gently releasing it, gives the 'swell' shape to the thicker strokes (known as 'shades'). Likewise, having a soft touch where only the ink seems to touch the paper on an upstroke will give the elegant hairlines. Studying letters that are similar in shape helps to train both the eye and the hand; looking at the negative shapes carved out by the pen and ink assures consistent forms. Copperplate is taught by looking at classic exemplars, practicing minuscules, and then expanding into majuscules." *Calligraphy by Nan DeLuca.*

Copperplate Minuscules

Copperplate Minuscules Stroke Directions

Left: The basic strokes used to write Copperplate. These are shown below, without guidelines, and above, written on a pre-ruled, printed guide sheet, available from stores specializing in calligraphy supplies. The pre-printed sheets not only have horizontal lines to guide the writing, but also have slant lines to help the novice writer lean all the letters with a consistent slope.

Copperplate Majuscules

A B C D E F G H
I J K L M N O P Q
R S T U V W X Y Z

Bottom left: A quotation demonstrates the simple elegance of Copperplate in use.

Bottom right: The letters should be spaced to produce an even, rhythmic flow. The word *minimum* demonstrates how the thicker strokes should produce an even pattern of parallel lines.

Copperplate Majuscules Stroke Directions

The best memory is not as good as pale ink.

dotted

minimum

lettering

Practicing Pointed-Pen Scripts

(Calligraphic penmanship exercises showing repeated letters and practice words:)

//////////////// //////////// \\\\\\\\ \\\\ ttt

ddddd ppppp qqqqq twins turn

smitten tutor question quitter ttttt

pique poise depend private totem

petition ditto quiver timid tare

aim to improve strive to win q

Above: Exercises involving repeated letters and selected words have long been a staple for the student of pointed-pen scripts. This example was printed in the November 1910 issue of *The American Penman*. Labeled "Engraver's Script," it is attributed to E. L. Brown of Rockford, Maine.

Right: Another exercise by E. L. Brown appeared in the September 1901 issue of *The Western Penman*.

(Second set of calligraphic exercises:)

/////////////////////~ U U U U U

mmmmm uuuuuuuu

v~nimmu~ö oooooooo

iiiii uuuu wwww iw

vvvv nnn mmm xxx

noun win vim mix vi

winnow vow union ~

Calligraphy and Ornament

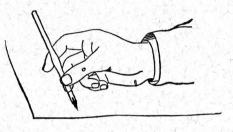

Left: Decorative drawings from George Bickham's *The Universal Penman*.

Above: This method of holding the pen gives the writer greater fluidity of movement, ideal for decorative drawings using the pointed pen. It comes from *Penmanship* by Henry Ellsworth.

Below Henry Ellsworth published a decorative rendering of a bird using pointed-pen flourishes in his 1897 book *Penmanship*.

The practice of Copperplate and other pointed-pen scripts lends itself naturally to making drawings with the pen. The large looped strokes of these scripts may be transformed into figures, birds, fish, and scrolls. Great dexterity and a fluid hand are required. In making such figures, the whole arm must move freely, not just the wrist.

The best of these drawings show not only control of the strokes, but also an awareness of the negative spaces in between. Dimension is suggested by the waxing and waning of repeated loops, as well as the swelling and diminution of the strokes themselves. These ornamental drawings today continue to be created by people working in the pointed pen tradition.

Brush Lettering

All of the calligraphic styles shown in this chapter so far have been scripts with rich historical antecedents. The edged-pen and pointed-pen scripts we have been examining have either survived into the present day, or were revived in the last century. This would suggest that Western calligraphy is largely a matter of ancient traditions adapted to modern needs. That is not entirely the case. The twentieth century has its own calligraphic styles—new explorations of the Roman alphabet with new tools and techniques. Brush lettering is one of these.

Brush lettering in the twentieth century was largely connected to the needs of advertising. It was used for ephemeral signs promoting goods and services in local stores. In the middle of the century, almost every store on an American Main Street would have handmade signs advertising the goods on offer. Every city and town in the country had local artisans who produced these signs. Known as "show card writiers," these skilled professionals had to work fast and have tremendous manual dexterity. Because show card writing came out of the need to generate sales, it emphasized spontaneity and experimental letterforms. With the advent of inexpensive printing and computer-generated signs, show cards have gradually disappeared from the American scene.

Brush lettering continues to be used in print and broadcast advertising. The grace and flair of hand-lettering enlivens the printed page, and makes a nice contrast to the more rigid forms of typography. Brush lettering can be found in supermarket packaging and in ads in magazines and newspapers.

Because it is a lively contemporary tradition, and because it thrives on novelty, brush lettering is far less codified than the historical styles we have seen earlier in this chapter. The "rules," such as they are, should be considered the starting point for exploration, rather than rigid parameters.

The principle tool used is a pointed brush, although some metal tools are also used to produce similar results. The brush is held like a pen, although the grip is somewhat looser. The writing is made with the tip and the side of the brush, pressed down onto the page. Adding pressure brings more of the brush's side into contact with the page, producing a relatively thick line. Less pressure produces a thinner stroke.

Right: Brush letters thrive on a sense of freedom and spontaneity. These examples show how the letterforms can be extremely variable and playful. In some of the lines of writing shown here, a centerline has been ruled, allowing the letters to dance above and below the line. Calligraphy by Karen Charatan.

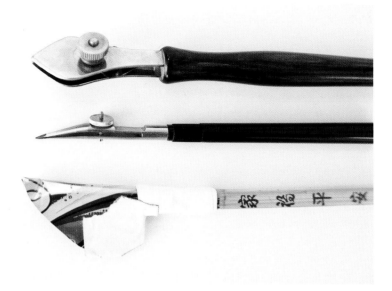

Left: Brush lettering was popularly used for "showcard writing"—handmade signs such as this one were a common sight in mid-twentieth-century America, advertising all manner of products and services in local stores. Calligraphy by Karen Charatan.

Above: Metal tools can also be used to achieve the brush-lettered effect. Dragged along their sides, they produce a thick line; the curved edges of the tool allow the writer to produce wider or narrower lines depending on how much of the edge is in contact with the page. The line produced is often characterized by rough edges and small ink splatters, lending a sense of spontaneity to the writing. The pen at the bottom is a so-called "cola pen." It is made of a chopstick to which a folded flange of metal cut from the side of a soda can has been attached with tape. The writing is made with the side where the two cut edges join.

Bottom left: In contemporary graphic design, brush lettering is frequently used to enliven package design and advertising. Calligraphy by Karen Charatan.

Writing Brush Lettering

The basic alphabet shown here is a starting point for experimenting with brush lettering. Once these simple letterforms have been mastered, a great deal of variation is possible. The letters may be written on a firm baseline, or they may dance above and below the baseline. Variations in weight can be achieved by using more or less pressure. The sample shown here has a fairly narrow stroke, indicating that it was written with very light pressure. *Calligraphy by Karen Charatan.*

Right: A heavier weight minuscule can be made simply by writing with more pressure. The thick strokes are made with a lot of pressure, the thinner strokes with less.

Below: Brush letter minuscules with stroke order.

Below right: Brush letter majuscules.

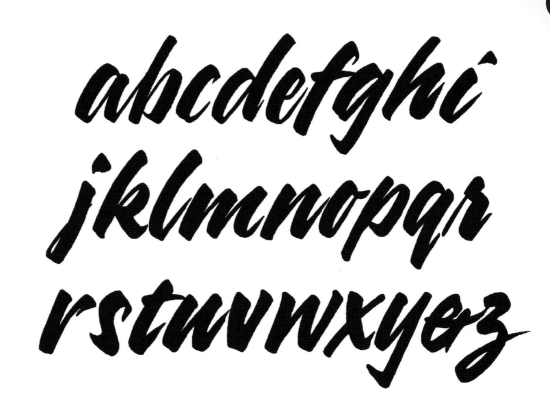

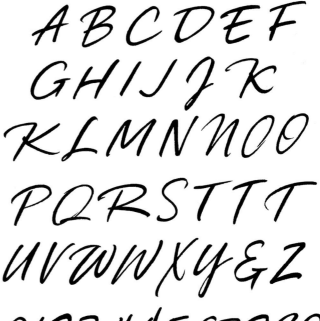

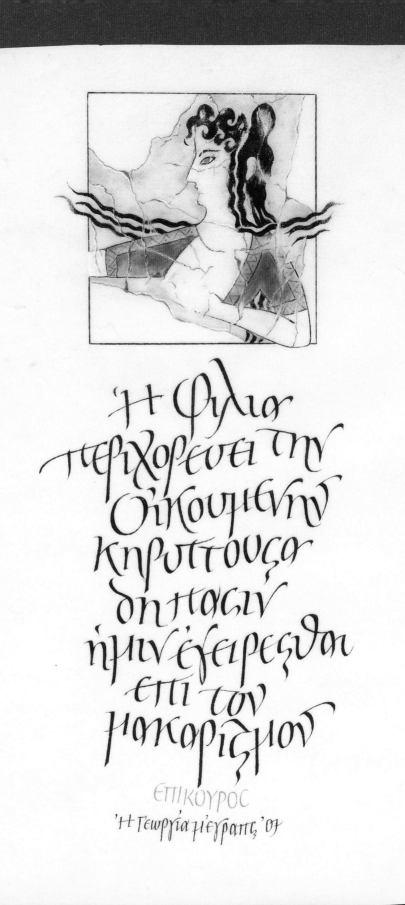

Ἡ Φιλία
περιχορεύει τὴν
Οἰκουμένην
κηρύττουσα
δὴ πᾶσιν
ἡμῖν ἐγείρεσθαι
ἐπὶ τὸν
μακαρισμόν

ΕΠΙΚΟΥΡΟΣ

Ἡ Γεωργία ἔγραψε ᾽01

GREEK AND CYRILLIC
Scripts of Eastern Europe

By Georgia Angelopoulos and Christopher Calderhead

Left: Quotation from Epikouros: "Friendship dances around the world proclaiming to us all to awake to its many blessings." Calligraphy by Georgia Angelopoulos. Gouache and pigments on vellum.

Greek and Cyrillic are closely related scripts with similar letterforms, and so they are grouped together in this chapter. Greek is one of the oldest scripts in continuous use in the world. After the conquests of Alexander the Great, Greek language and its alphabet became the lingua franca of the educated elite across the Eastern Mediterranean world. After the establishment of the imperial city of Constantinople, and the division of the Roman Empire, Greek remained ascendant in the Eastern Empire. Even after the fall of Constantinople to the Ottomans in 1453, Greek remained in use within the Hellenic communities spread throughout Anatolia (today comprising the majority of Turkey), the Levant (known as the Holy Land during the Crusades), and Alexandria. Only in the twentieth century, with the rise of new nationalisms and the expulsion of ethnic minorities from many countries around the Eastern Mediterranean, would Greek be confined within the small boundaries of the modern Greek state.

Greek is the root script of a number of important writing systems. It predates Latin, and inspired it by way of the Etruscans, who based their alphabet on the Greek. In turn, Latin was based on this Greek-derived alphabet.

In the Byzantine period, as a result of missionary efforts to convert the Slavs to Christianity, Greek would give rise to another important script. The Cyrillic alphabet was derived directly from the Greek Uncial hand, and adapted to accommodate sounds specific to Slavic languages. With the spread of Orthodox Christianity, Cyrillic spread northwards, through Eastern Europe and into Russia. Cyrillic became the vernacular script in the Orthodox Slavic communities. It should be noted that Roman Catholic societies in the Slavic lands have often used the Roman alphabet, not Cyrillic.

Greek

by Georgia Angelopoulos

Alphabet: *24 ordered letters of consonants and vowels represent the corresponding sounds of speech.*

Direction of writing: *left to right*

Majuscule/minuscule distinction

Principal tool: *broad-edged pen*

Language: *Greek*

The Greek alphabet grew out of the Phoenician alphabet and it was the first alphabet to include vowels; the order and name of the letters was derived directly from its Phoenician prototype. Remarkably, it has been in continuous use since 750 BCE. Early inscriptions were written boustrophedon, that is, in alternating lines that reversed direction, like an ox ploughing a field. Around 500 BCE, Greek began to be written consistently from left to right, as it is today.

Greek calligraphy flourished through antiquity and the Middle Ages. It also flourished among the scholars of the West through the Renaissance and Enlightenment.

Now, unfortunately, there seems to be little interest in the calligraphic tradition within the Greek community. What contemporary Greek calligraphy there is tends to be the product of expatriate communities versed in the calligraphy of the West and among Westerners interested in Greek culture, language, and history.

Devising a Greek Exemplar

Before I tackled this script, I looked at as many examples that I could find of Greek literary hands (with the exception of Uncials) and Secretarial or Documentary hands dating from the eighth to the

Opposite: Quotation from Sappho. Calligraphy by Georgia Angelopoulos. Ink on paper.

Below: Stoic saying: *Monos ho sophos eleutheros, kai pas aphroon doulos*, meaning, "Only the wise man is free, and all fools are slaves." Calligraphy by Yves Leterme.

Ἔρος δ' ἐτίναξέ μοι

LOVE SHOOK ME
WILDLY

φρένας

LIKE A MOUNTAIN WIND
THAT FALLS UPON
THE OAKS

ὡς ἄνεμος κὰτ

ὄρος δρύσιν ἐμπέτων

Sappho

sixteenth centuries. I also looked at samples of "everyday" handwriting, cursive writing on icons, and early Greek printed matter. Although cursive scripts existed long before the ninth century CE, it was only between the eighth and ninth centuries that a formal literary, minuscule hand was standardized. The Literary hands, which continued to be used up until the eighteenth century, vary considerably in weight, forms used, and texture, but identifying them stylistically is difficult as the styles do not have names— they are more like variations on a theme.

Greek minuscules of the Middle Ages are divided into four classes: *codices vetustissimi* dating from the ninth to the mid-tenth centuries; *codices vetusti* from the mid-tenth to the mid-thirteenth; *codices recentiores* from the mid-thirteenth to the mid-fifteenth; and *codices novelli*, of a later date.

Though many were beautiful and tempting to emulate, they were fraught with complex joins, ligatures, and abbreviations, so I aimed to create a script that included some unique qualities of Greek minuscule scripts but remained basic and easy to learn,

and which did not require a background in paleography. The Hellenic Institute at the Royal Holloway, University of London, conducted the Porphyrogenitus Project, begun in 1992 and now complete; its aims were to identify and classify the enormous range of ligatures and abbreviations in Greek script.

There were some challenges and things to consider. Since my calligraphy is mostly grounded in the English or Johnstonian tradition, I had to avoid the temptation to make the Greek conform to scripts familiar to me. Although many Greek letters look like Latin letters, there are important differences—not only in their sound value but in their character and *ductus* (stroke order). For example, the Greek minuscule ρ—*rho*—looks like a Latin **p** but has a sound value of **r**. While at a glance it may look the same, the Greek ρ differs from the Latin in that it is not formed with a stem and a bowl—it is made in one stroke and the descender often inclines emphatically to the right. The Greek ρ or *rho*, like most letters, has a wide range of possible historical forms.

Sometimes ρ was made with a stem, but from the eighth century onwards it tended to be made in one stroke. Whereas many Latin letters can conform to an underlying, consistent form—be it oval or round or rectangular—Greek letters are not so patient of such regularity.

Several Greek letters are round, but some are often square, rectangular, or oval, and some defy description. Some historical scripts achieve more uniformity, but others are complex and contain certain enlarged letters that create an exciting polyrhythmic effect on the page. The bowls of some letters are not contained in a calculated **x** height; likewise, the ascenders and descenders are not standard in length. While some letters exhibit a development from majuscule to minuscule, other letterforms are smaller, identical versions of their majuscule parents and some could best be described as Uncials. Trying to impose a basic form, shape, or script style that was familiar would almost be Latinizing the Greek letters, and they would lose their uniqueness.

Another consideration regarded which tool to use. Writing this script with a broad-edged pen was something of a challenge; it is possible that a small, slightly more rounded nib was used to create an almost monoline script. This was more conducive to the formation of joins that resulted from a more elastic and economical ductus. While I have tried to replicate some of the joins, they are perhaps mannered or formal in that they require additional pen lifts. Another feature of many Greek minuscule literary hands is that they were written with a ruling line at the waistline rather than the baseline; the letters appear to hang from the top and the writing has a strong, horizontal emphasis, as many joins are not diagonal but horizontal. Also, some ligatures/joins are achieved by linking ascenders and descenders to the following letter.

Writing Greek

Since there are no contemporary exemplars of Greek calligraphy, I was mindful of not mimicking current Greek type, some of which is very uniform and some of which suggests the influence of "Englishman's Greek," the form of Greek letters used within educated English society in the Renaissance and later periods. Although not without beauty, Englishman's Greek is not part of the native tradition.

In the end, I decided to start with a basic, round form not unlike Edward Johnston's Foundational hand. However, not all the letterforms fit. The ϑ—*theta*—is long and narrow as it appears in many historical scripts, and the bodies of some letterforms dip below the baseline or above the waistline, for example *zeta* and *xi*. Another difference is the point of intersection of χ—*chi:* it is at the baseline, not slightly above or at the middle of the **x** height.

The majuscules on the facing page have a quasi-informal look and some of them have an Uncial flavor, as it was common for Uncials to be used as capitals in historical cursive scripts. *Calligraphy by Georgia Angelopoulos.*

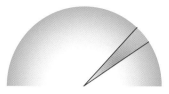

The dominant pen angle varies between 30° and 45°.

Below: ✳ There are two forms of *sigma* used in the Greek alphabet and are starred and highlighted with a red box. The *sigma* with a closed or partially closed bowl is used at the beginning of, or within a word; the open bowl *sigma* is used at the end of one.

Minuscule Letters

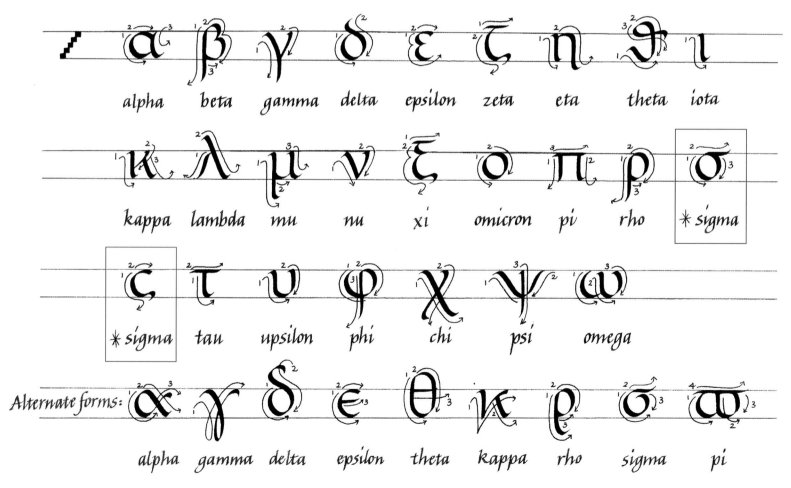

alpha beta gamma delta epsilon zeta eta theta iota

kappa lambda mu nu xi omicron pi rho ✳ sigma

✳ sigma tau upsilon phi chi psi omega

Alternate forms: alpha gamma delta epsilon theta kappa rho sigma pi

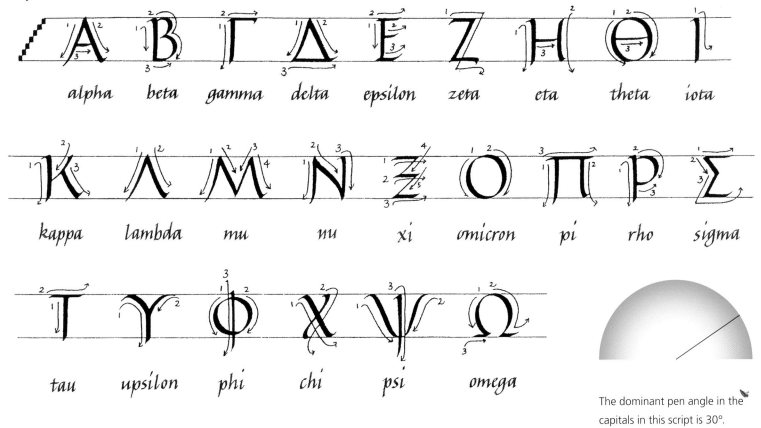

alpha beta gamma delta epsilon zeta eta theta iota

kappa lambda mu nu xi omicron pi rho sigma

tau upsilon phi chi psi omega

The dominant pen angle in the capitals in this script is 30°.

Below: From the poem "The Lantern of the Cemetery of Athens" by Demetrios Paparrhegopoulos. Calligraphy by Georgia Angelopoulos.

Ἐν μέσῳ πένθους, οἱονεὶ γλυκείας,
εὐτυχίας,, φάροι τὸν νοῦν εὐθύνοντες,
πρὸς, τὴν ἀθανασίαν, διάδημα ἐπι-
κοσμοῦν τὸ φάσμα τῆς, σκοτίας,, τὰ...

Cyrillic

By Christopher Calderhead

Alphabet: *Ordered letters of consonants and vowels represent the corresponding sounds of speech. The number of letters varies depending on the language being written.*

Direction of writing: *left to right*

Majuscule/minuscule distinction

Principal tool: *broad-edged pen*

Language: *Russian and Slavic languages.*

Many world-writing systems have adopted Cyrillization.

Cyrillic takes its name from St. Cyril, who was a missionary to the Slavs from the Byzantine Empire. It was invented to write Old Church Slavonic, the liturgical language of the Orthodox Churches in the Slavic lands. The forms of Cyrillic *azbuka* (alphabet) are derived from Greek, and, in the case of letters like Ш, from the Hebrew (the Hebrew letter *shin* is the prototype for this letter). Like the Roman alphabet, it is a mixed majuscule/minuscule form of writing.

Cyrillic is used to write many of the Slavic languages. In general, it has been used where the Slavic peoples embraced Orthodox Christianity; Slavs practicing Roman Catholicism have tended to gravitate to the Roman alphabet. In some places, like the republics of the former Yugoslavia, one's choice of the Roman alphabet or the Cyrillic azbuka can be seen as a highly charged political act.

The principal languages historically written in Cyrillic include Russian, Ukrainian, Bulgarian, Serbian, and Macedonian. It has also been used to write non-Slavic languages within the Russian sphere of influence, sometimes replacing existing scripts.

Czar Peter the Great (1672–1725) is credited with the modernization of the Cyrillic alphabet. While delving into Western European culture, he commissioned new typefaces from Dutch typographers to be used in place of the old Cyrillic in public notices and publications. As a result, the azbuka was simplified, some letters disappeared, and typographic (and therefore calligraphic) norms became aligned with the highly developed typography and writing of the West. The resulting Civil writing became the norm for non-ecclesiastical writing in the Russian Empire. The lower case forms were generally derived directly from the capital letters. In the Roman alphabet, the minuscule grew incrementally over a period of many centuries. Roman minuscule letters are distinctly different from the capitals, with strongly developed ascenders and descenders. By contrast, the minuscule Cyrillic is largely an alphabet of small capitals, and only a few letters have significantly different shapes in the minuscule. The cursive introduces a few more alternative forms. Through the eighteenth and nineteenth centuries, the forms of the Cyrillic letters continued to develop. There is a tradition of Copperplate writing in Russia, which adopts the pointed pen and pressure-made thick strokes of the Western style.

Below: Medieval Russian Gospel book. Photograph by Sergeĭ Mikhaĭlovich Prokudin-Gorskiĭ, c. 1909.

Cyrillic Uncial

One of the most striking scripts within the Cyrillic tradition is the Cyrillic Uncial, or Ustav. Based closely on Byzantine-era Greek Uncials, it reached a stable form by the beginning of the second millennium. Manuscripts were written in this script well into the nineteenth century, and it remains a recognizable script for Cyrillic readers today, although it contains certain archaic characters that are unique to the Old Church Slavonic of the Orthodox liturgy.

The study of Cyrillic Uncial shown here is based on several Russian ecclesiastical manuscripts from the fourteenth and fifteenth centuries. Over its history, Cyrillic Uncial retained a remarkably stable form. In the Middle Ages, when the manuscripts examined here were written, the forms of the letters were quite heavy in weight. After 1500 CE, the letters tended to become somewhat lighter in weight, and also tended to be written with a distinct leftward-leaning slope, while retaining the basic shapes shown here.

The principal pen angle of the script is perfectly flat, but many letters are written with a much steeper, 60° pen angle. The triangular serifs that are such a striking feature of the script involve a careful twisting of the pen (also referred to as pen manipulation).

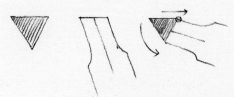

Above: One of the most distinctive aspects of this script are the triangular serifs added to many of the letters. The pen is placed on the page at a flat (0°) angle. The left corner of the nib is then rotated downward in a counterclockwise motion. At the same time, the right corner of the nib is drawn slightly to the right. This produces an almost perfect triangular stroke. The pen drawn here has been cut with an oblique nib; this would make the flat pen angle of many of the strokes easier to achieve.

As these letters were used to write Church Slavonic, they do not correspond exactly to the modern Cyrillic alphabet. For each of these letters, the modern Cyrillic equivalent is given, plus an approximation of its pronunciation in English.

These letters are written at four nib-widths high. The stroke directions are tentative, inferred from the mansucripts that were examined. Alternate stroke orders are certainly possible. The red lines indicate the pen angles used to write the strokes. The basic pen angle is a flat 0°, unless noted in the comments below. Small red circles indicate manipulated strokes.

А / **a** as in y**a**cht. Similar in shape to the small Roman **a**, the A has a more distinctly triangular shape. The bowl of the letter on the left side is written at a 60° angle.

Б / **b** as in **b**oy.

В / **v** as in **v**alue. Although appearing very much like the letter **K**, the **B** has thin connecting strokes top and bottom that close the two bowls of the letter. The distinct form of **K**, shown below, with its triangular serif, makes it quite distinct from the **B**.

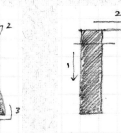

Г / **g** as in **g**as.

Д / **d** as in **d**asha. The very small triangular aperture of the Д is characteristic of this script. The long serifs at the bottom are more extended than the other triangular serifs used for the other letters. Very often, in the manuscript tradition, these long serifs point inward, as though they are pigeon-toed.

Е / **e** as in b**e**t. Three forms of the letter are shown here. The first, labeled (A), is relatively rare, but appears in some manuscipts. With its wide, round shape, it is similar to Greek Uncials. The middle form (B) is the most characteristic form of the letter: the strokes top and bottom overlap the long first stroke, making a letterform with no thins at all. Many modern calligraphers will adapt this letter as shown in (C), creating a more recognizable form for modern readers.

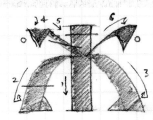

Ж / **zh** as in vi**si**on. This highly complex letter has club-footed serifs at the base of the two bottom diagonal strokes, made by doubling the stroke back on itself.

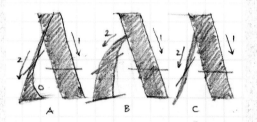

Two forms of the letter are shown here. The **Z** form, similar to Greek prototypes, is more common in the medieval manuscripts. The 3 appears later in the history of the script, and is often used in modern adaptations, since it more closely resembles the contemporary form of the letter.

И / **ee** as in wh**ee**l.

К / **k** as in **k**ey.

No exact modern equivalent / **z** as in **z**oo.

Л / **l** as in **l**amp.
Three forms are shown here. (A) and (B) are modern interpretations of the letter. (A) involves a complex twisting of the pen at the end of the left-hand stroke. The form shown in (C) is quite common in the medieval manuscripts, with its rather indistinct thin stroke made at a steep pen angle.

M / **m** as in **m**oon.
Two forms are shown here. In the manuscript tradition, the **M** was usually made like the letter on the left. The pen must be turned to produce the middle V-shape. In practice, this letter could become quite wide, with a long looped V-shape. The second letter is a modern adaptation.

H / **n** as in **n**ight.
With its diagonal stroke, this letter retained in the Middle Ages some of the quality of the Greek **N**. In modern Cyrillic, the crossbar is straight.

O / **o** as in **o**rgan.
The **O** is written at a steep 60°-pen angle, and has a distinctive curled point at the top.

П / **p** as in **P**eter.

P / trilled **r** as in the Spanish **r**ojo
The **P** is written at a very steep pen angle; the tail of the letter extends well below the baseline.

C / **s** as in **s**alad.
Two forms of **C** are shown. The one on the left, like the **E**, has overlapping strokes that produce a narrow letterform with no thins. The one on the right is a modern adaptation.

T / **t** as in **t**avern.

У / with a preceding **o**, **oo** as in z**oo**.
The У in Church Slavonic is usually written as a part of a dipthong with a preceding **o**. The first stroke is written at a shallow 20° angle, while the long descender is written at 60° or steeper. The serif on the right is twisted.

Ф / **f** as in **f**ancy.

X / **ch** as in the Hebrew **Ch**anukah. The X follows a pattern set by Medieval Greek, and is a descender.

No exact modern equivalent / **o** as in **o**rgan. This letter follows the pattern of a Greek Uncial omega.

Ц / **ts** as in ge**ts**.

Ч / **ch** as in **ch**apter.

Щ / **shch** as in English **ch**eddar. The middle stroke of this letter ends with a twist of pen, producing an angled stroke at the bottom.

Ъ / changes the pronunciation of a consonant it follows. In this script, the upright stroke of Ъ becomes a diagonal, creating a nice symmetry between the serif above and the bowl of the letter at the bottom.

Ш / **sh** as in **sh**all.

Ы / **ee** as in wh**ee**l (The pronunciation is slightly different from И) and Ь / changes the pronunciation of a consonant it follows. One diagram is provided for both these letters, as the construction is identical.

No exact modern Russian equivalent, although it does appear occasionally in Serbian words / **y** as in **y**ellow. This is the only letter in the script that is consistently rendered as an ascender.

Ю / **yoo** as in **you**.

No exact modern equivalent / **y** as in **ya**cht.

No exact modern equivalent / **y** as in **ya**cht.

No exact modern equivalent / **y** as in **ya**cht.

No exact modern equivalent / **x** as in bo**x**. The accent mark at the top of this letter is rendered at a gentle 20° angle, while the rest of the letter is made with a flat pen angle.

No exact modern equivalent / **ps** as in ho**ps**. Many changes of angle are required to make this equivalent of the Greek *psi*.

No exact modern equivalent / **f** as in **f**ancy. Used for loan words from the Greek, this is a Cyrillic version of the Greek *theta*.

No exact modern equivalent / as a vowel, **ee** as in wh**ee**l; can be used in a dipthong with the value of **v** as in **v**alue.

Writing Cyrillic

This exemplar was made with double pencils and filled in with a wash of ink. Double pencils are just what the name implies: two sharp pencils tied together with tape. In practice, the two-pencil tips function just like an edged pen: each pencil traces the trajectory of one side of a flat-edged pen nib. The benefit of the double pencil is that it shows clearly how the individual strokes are made. The ink fill allows you to see what a pen-made letter would look like. This method could be applied to all the edged-pen scripts in the chapter on the Roman alphabet.

Each letter is shown in three forms: capital, small letter, and small cursive letter. For cursive capitals, slanted versions of the upright capitals may be used.

The dominant pen angle is 30°.

The sound equivalent of each letter is provided in Roman letters.

Cyrillic Majuscules, Minuscules, and Cursive with Stroke Direction

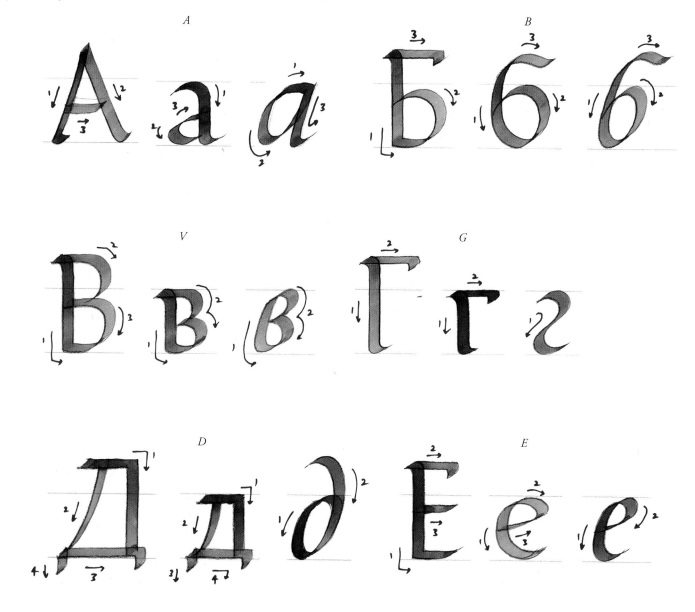

Zh

Z

I (no diacritic mark)
and I kratkoye (short I), with the diacritic.

K

L

M

N

O

P

R

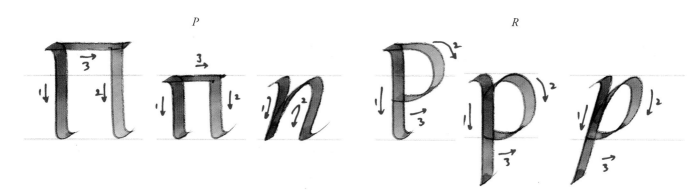

S

T

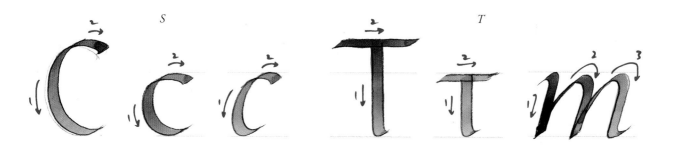

U

F

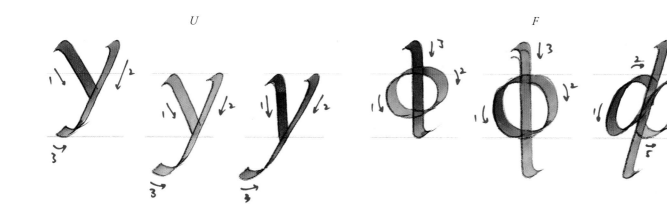

Kh

Ts

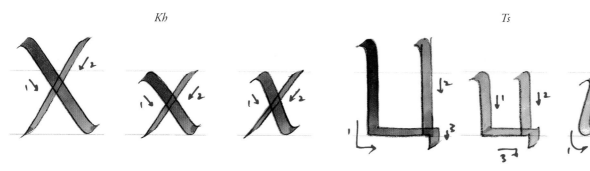

Ch

Sh.

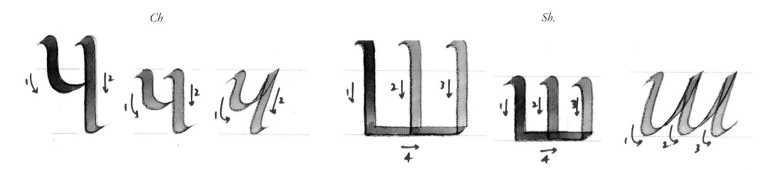

Shch

Tvyordy znak (Hard sign) (affects the pronunciation).

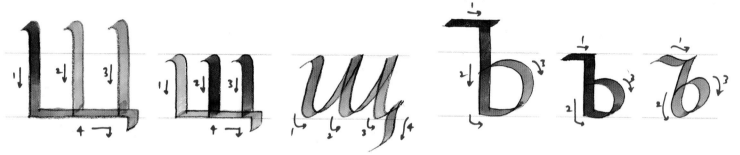

Y

Soft sign.

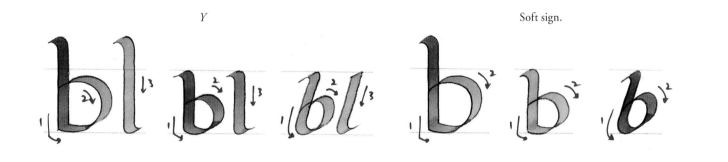

E oborotnoye (backwards E).

Ju (pronounced with a y-sound).

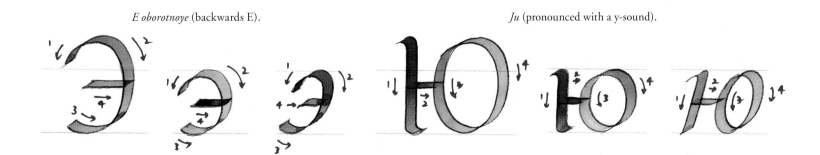

Ja (pronounced with a y-sound)

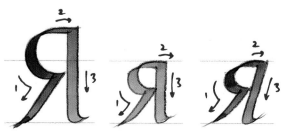

Non-Russian letters

Ge

Used in Ukrainian for a strong G sound.

I

Used in Ukrainian with or without the diacritic mark.

J

Used in Serbian and Macedonian
(pronounced with a y-sound).

Dje

Used in Serbian and Macedonian.

Lje

Used in Serbian.

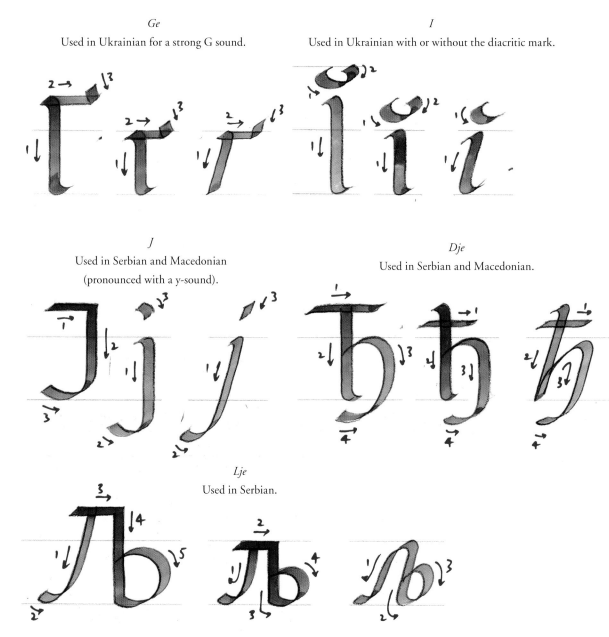

Nje

Used in Serbian and Macedonian.

Tshe

Used in Serbian; softer than Ch.

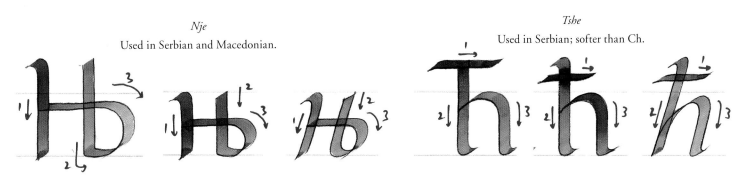

Dzhe

Used in Serbian and Macedonian.

Yat

Largely defunct; used occasionally in Serbian and Macedonian.

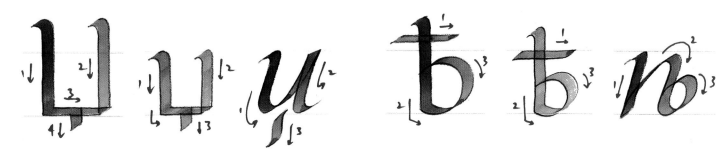

Below: Four Serbian proverbs.
Calligraphy by Christopher Calderhead.

The tongue has no bones, but it can break bones.

Језик кости нема,
али кости ломи.

Far from the eyes, far from the heart.

Далеко од очију,
далеко од срца.

A sparrow in the hand is better than an eagle in a tree branch.

Боље врабац у руци
него соко на грани.

You are not poor if you have little, you are poor if you want much.

Није сиромах ко мало има,
већ ко много жели.

HEBREW
The Aleph-Bet

By Holly Cohen

Abjad: *Consonant alphabet where 27 letters represent consonants and perhaps some, but not all, of the vowels. Vowels not represented by letters may be indicated with diacritics, but the diacritics are often not used.*

Direction of writing: *right to left*

Majuscule/minuscule distinction: *none*

Principal tool: *broad-edged pen*

Languages: *Hebrew, Arabic, Turkish, Yiddish, Ladino*

Left: Frontispiece for *The Illuminated Pirkei Avos,* 1991. Calligraphy by Rabbi Yonah Weinrib. Fine-point Rapidograph pen.
Rabbi Yonah Weinrib wrote out the complete text of the Pirkei Avos, comprising over four thousand words of microscopic letters in order to create this micrograph as a frontispiece for his book.

The Jewish people have been called "The People of the Book" for their love of Torah. The Five Books of Moses that make up the Torah, the Jewish Bible, is the living heart of Judaism. After the destruction of the First Temple in Jerusalem in 586 BCE, it was the written word, the Torah, which unified Jews throughout their exile. Today, Jewish religious life revolves around the study of Torah just as it has for thousands of years. The Torah is written in Hebrew, the scriptural language of the Jews.

Jewish synagogues are typically simple and unadorned with the exception of the *Aron ha-Kodesh*, the Holy Ark, where the scrolls of Torah are stored. The ark is always situated on the Eastern wall of a temple, facing Jerusalem, a few steps up from the ground with a perpetually lit lamp hanging before it. In reverence to the Torah, the congregation rises each time the Ark is opened. The Torah is brought to a raised platform called an *almemar* or *bimah* (in Ashkenazi synagogues). A silver pointer, a *yad,* is placed on the scroll to keep the reader's place. *Yad* means "hand" and the pointer is usually in the shape of a hand with a pointed finger.

A Torah must be handwritten by a *sofer,* a religious scribe who adheres to stringent laws in order to ensure the Torah is valid. These laws prescribe the use of tools, materials, and proper letter formation.

The Hebrew alphabet is known as the *aleph-bet*, after its first two letters, *aleph* and *bet*. Letters have been accorded living attributes, numerical values, and mystical properties.

A story in the *Midrash* (interpretations of biblical stories) illustrates the honor bestowed on the aleph-bet. The

RABBI RICHARD B. SIMON

Above: Ex Libris for Rabbi Richard B. Simon. Calligraphy by Lili Cassell Wronker.

Left: *Man Must Renew Himself Constantly.* Calligraphy by Izzy Pludwinski; marbling by Yehuda Miklaf. Gouache on paper.
13¾ x 5½ in. (35 x 14 cm).
In addition to using traditional Hebrew letterforms, Izzy Pludwinski continues to experiment with novel treatments of the aleph-bet. This brush lettering reinterprets the Lightning Hebrew script.

Below: *Man Must Renew Himself Constantly 2.* Calligraphy by Izzy Pludwinski. 11¾ x 59¼ in. (30 x 150 cm).
This printed accordion book incorporates brush-made letters and the artist's Shir typeface.

story relates how the Torah presented God with the twenty-two letters of the aleph-bet when God asked for helpers during the act of Creation. The *aleph* was the only letter that did not brag about its virtues. God honored the humble *aleph* by making it the first letter to appear in the Ten Commandments. According to another tale, when Moses smashed the tablets containing the Ten Commandments to the ground, the stones splintered but the letters flew up to the sky, wholly intact.

Each Hebrew letter has a numerical value. The calculation and comparison of these numbers as deciphered in letters, words, and phrases is called *gematria*. An example is the number eighteen, considered a good luck number. The word *chai*, "life," is spelled with a *het* and a *yod*. *Het* has a numerical value of eight and *yod* has a value of ten. Added together they equal eighteen, connecting this number and the word for "life." All multiples of eighteen are considered good luck. The celebratory toast, *L'chaim!* means "To life!" Gematria is but one aspect of *Kabbalah*, "receiving" the study of Jewish mysticism.

Hebrew letters are used to write two other Jewish languages, Yiddish and Ladino. Both languages had numerous speakers until the Holocaust. Today, both languages are in danger of dying out. Some ultra-Orthodox Jews, however, still consider Hebrew too holy a language for colloquial use and reserve it for religious practice only, using Yiddish as their first language.

Yiddish was the Ashkenazi Jewish lingua franca of Eastern Europe, also called the *mame-loshn*, or mother tongue. Primarily based on medieval German with Hebrew, Yiddish absorbed other language influences as well. The word *Yiddishkeit* can be translated as the "Jewish way of life." The term evokes an array of historic images from the shtetls of Eastern Europe to the Lower East

Side of Manhattan where Jewish immigrants had shops and theaters and pushcarts, all with Yiddish-language signs written in Hebrew letters.

Ladino (also known as Judeo-Spanish or Judezmo) is a Sephardi language based on medieval Castilian Spanish with some influence from Hebrew and other languages. It wasn't until the Jewish expulsion from Spain that Ladino became known as a Jewish language; prior to the expulsion it was the language of the region.

In the eighteenth and nineteenth centuries, a movement began in Prussia called the *Haskalah*, or Hebrew Enlightenment. Jewish intellectuals encouraged the Jewish masses to seek education outside of religious orthodoxy and to use the Hebrew language as the vernacular. This movement toward assimilation lost its strength after Russian Czar Alexander II was assassinated and anti-Jewish pogroms resumed in full force. Soon, a belief in nationalism became popular and along with it, the idea of Hebrew as a secular language, spoken not in Russia or Eastern Europe, but in a Jewish homeland.

Engaging Hebrew as a secular, colloquial language was a major tenet of Zionism. With the creation of the state of Israel in 1948, Hebrew as a spoken language was revived. With the revival of the language came the addition of contemporary words, new dictionaries, and a canon of secular Hebrew literature.

Modern Hebrew script, as we know it today, is descended from an Aramaic script that was prevalent among Jews and non-Jews during the Babylonian Exile. The script consisted of twenty-two letters and was written from right to left, like Hebrew.

Modern Hebrew has twenty-two basic letters, plus an additional five final letterforms, or "*sofit*," which are used for the letters *khaf, mem, nun, peh,* and *tzadi* when they appear at the end of a word.

Vowel marks (*nikudot*) consisting of dots and lines are placed beneath, beside, or inside letters, but often these diacritics are not used at all. The aleph-bet is an *abjad*, or consonant alphabet, but the letters *aleph, vav,* and *yod* can be used for long vowel sounds.

Hebrew calligraphy is commonly used for *kettubot* (marriage contracts), Bar and Bat Mitzvah cards, *mizrachim* signs (meaning "East") that are hung on the eastern walls of homes to direct prayers toward Jerusalem; book jackets, labels, and more. Religious scribes use a Hebrew script called *K'tav Ashurit* for writing religious texts (see the Scribal Arts Section in this chapter).

Above: Kettubah (Kreiger-Rosenzweig), 2007. Calligraphy, paper cuts, and illumination by Jeannette Kuvin Oren. Sumi black ink on paper, paper cutting with hand-dyed silk background, gouache illumination. 22 x 22 in. (55.9 x 55.9 cm).

כל כנסיה שהיא לשם שמים סופה להתקיים

When we gather together for a sacred purpose, we endure.

PIRKE AVOT 4

Above: *"When we gather together for a sacred purpose, we endure," from Pirke Avot 4,* 2007. Calligraphy by Ted Kadin. 10 x 3 in. (25.4 x 7.6 cm). Central Synagogue, New York, New York. Fabriano Ingres paper, Moon Palace Sumi-e ink, parallel pen, and Mitchell nibs.

Right: *"For in much wisdom is much vexation; and he that increaseth in knowledge increaseth sorrow."* Ecclesiastes 1:18. Calligraphy by Lili Cassell Wronker. Hand-tinted etching. 4 x 5 in. (10.2 x 12.6 cm).

Tools and Techniques

The Pen

Broad-edged quills and reeds are the traditional writing tools for Hebrew calligraphy but today, broad-edged metal nibs are commonly used for non-religious texts. The religious scribe (*sofer*) must follow strict guidelines regarding which tools, writing surfaces, and inks may be used but the layman is free from these restrictions and can use any tool, paper, parchment, or ink of their choosing.

Posture

The calligrapher may use a flat or slanted surface when writing. The paper should be centered in front of the scribe who sits with a straight back and has both feet on the floor. Some scribes recommend having both elbows touch the table.

Guidelines

Guidelines can be drawn with the same methods as those used for western calligraphy. Letter height is determined by number of nib-widths. With the pen nib held at a 90° angle, marks can be made one above the other in a staggered or checkerboard pattern. When the ink dries, parallel lines can be drawn across the top and bottom marks, between which is the x-height. This grid can be used as a ruling measurement to mark dots on a page according to the x-height, and guidelines can subsequently be drawn. Scribes may also use rulers, architectural lining devices, T-squares, and compasses.

In the Middle Ages, Sephardi Jews used Arabic *mastara* boards. Threads were incrementally attached to these boards in horizontal lines. The board would then be pressed into the paper, leaving indentations for use as guidelines, which would disappear with time. Scribes have also scored holes down the right and left edges of a page, and then drawn guidelines between them.

Unlike Western scripts where letters sit on the baseline, Hebrew letters dangle from the x-height line. Some scribes do not even use a baseline. Only one letter, the *lamed*, has an ascender.

Hebrew is written from right to left, but individual letter strokes are sometimes written from left to right, as in Western scripts. This can help the scribe achieve proper letter proportion and spacing. To achieve flush columns or for decorative purposes, certain letters can be extended horizontally without misshaping their anatomy such as *hey*, *lamed*, *tav*, *dalet*, *kuf*, and *resh*.

Both the Ashkenazi and Sephardi book hands grew out of the so-called "Eastern" Hebrew script that flourished between the ninth and eleventh centuries. As this Eastern script spread, it evolved according to the customs and influences of the countries and cultures in which the Jews found themselves.

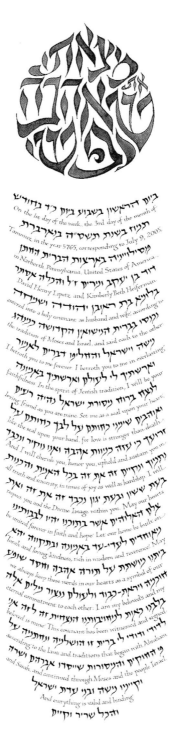

Above: Prayer for the New Month, 2004. Calligraphy by Lili Cassell Wronker. 8 x 10 in. (20.3 x 25.4 cm).

Right: *Soul's Delight*. Kettubah calligraphy by Melissa Dinwiddie. Calligraphic print, Yerushalmi script. 30 x 9 in. (76 x 22.8 cm). A kettubah is a Jewish marriage contract that has been an essential part of the Jewish wedding ritual since the Talmudic period. Traditionally, the husband's responsibilities to his wife, particularly the financial, are written into the contract. Today, different texts are used for Orthodox, Conservative, and Reform kettubot (plural of kettubah).

Since Jewish law does not require that a kettubah be written by a sofer, it is common for a betrothed couple to purchase a print of a hand-lettered kettubah from a calligrapher and have either the calligrapher or a rabbi write their names onto the contract.

Writing Ashkenazi

The Ashkenazi hand was influenced by the European use of quills, while the Sephardi letters were informed by the Arabic use of reeds. With the sharp and flexible quill, the Ashkenazi script developed ornate serifs. Most letters in this hand slope towards the right, and the horizontal strokes are heavier than the verticals.

The Ashkenazi aleph-bet is demonstrated here, showing step-by-step how each stroke adds to the next. The calligrapher created guidelines for this exemplar using a formula of roughly 3¾ nib-widths. Note that Hebrew reads right to left, and that is how the letters are shown here. *Calligraphy by Izzy Pludwinski.*

This sample is written at an 80º pen angle.

Opposite: Ashkenazi script aleph-bet.

Below: Ashkenazi script aleph-bet.

אבגדההוזחטיכלמנסע

פצקרשת רסוזחץ

ייי שׁ שׂ יוג

Right: Alternate "heads" can be used for heads of *gimmel, tet, lamed, nun, ayin, tzadi,* and *shin.*

ויהי בימי אחשורוש הוא אחשורוש המלך
מהדו ועד כוש שבע ועשרים ומאה מדינה
בימים ההם כשבת המלך אחשורוש על כסא

Left: A passage of text shows how the Ashkenazi aleph-bet works in practice.

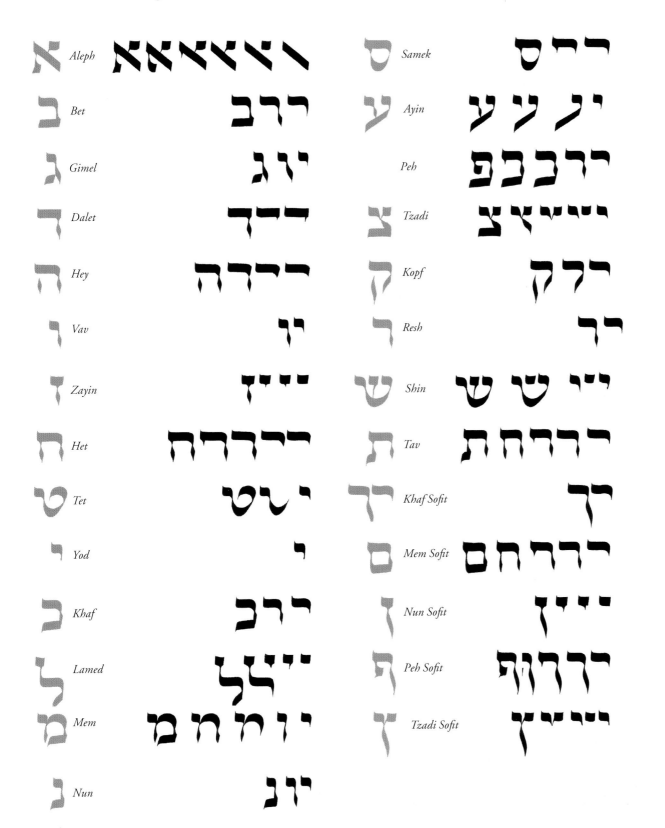

Notes:

Gimel. Note how the horizontal strokes are thicker than the vertical.

Hey. Compare the left vertical stroke with the left vertical stroke in the *het*. Note how much shorter the stroke is here.

Vav. Compare the *vav* to the *nun sofit*. The only difference is that here the vertical line does not descend below the baseline.

Het. Note how the left vertical stroke barely meets the horizontal line; it grazes it but does not cross it.

Yod. Note how the letter *yod* is a component of many other letters of the aleph-bet.

Lamed. This is the only letter in the aleph-bet with an ascender.

Resh. Similar to *vav*, but with a long horizontal stroke.

Khaf Sofit. Similar to *resh*, but with a vertical that descends below the baseline.

Nun Sofit. Compare the *nun sofit* to the *vav*. The only difference is that here the vertical line descends below the baseline.

Aleph

Bet

Gimel

Dalet

Hey

Vav

Zayin

Het

Tet

Yod

Khaf

Lamed

Mem

Nun

Samek

Ayin

Peh

Tzadi

Kopf

Resh

Shin

Tav

Khaf Sofit

Mem Sofit

Nun Sofit

Peh Sofit

Tzadi Sofit

SEPHARDI

Sephardi script was written with a reed, a duller tool than the quill. In contrast to the Ashkenazi hand, there is less of a weight distinction between horizontal and vertical strokes, and most Sephardi-style letters slope to the left. The curved strokes of the letters *ayin* and *shin* are angular in the

Sephardi hand, while Ashkenazi retains the curved forms of the Eastern Hebrew script. The calligrapher used a formula of roughly 3½ nib-widths to create the guidelines for this exemplar using a formula of roughly 3½ nib-widths. *Calligraphy by Izzy Pludwinski.*

This sample is written at a 60° pen angle.

Opposite: Sephardi script aleph-bet showing how each stroke adds to the next.

Below: Sephardi script aleph-bet.

אבגדהוזחטיכלמנסע

פצקרשת רסוףץ

THE WORLD ENCYCLOPEDIA OF CALLIGRAPHY

Left: A passage of text shows how the Sephardi aleph-bet works in practice.

ויהי בימי אחשורוש הוא אחשורוש המלך

מהדו ועד כוש שבע ועשרים ומאה מדינה

בימים ההם כשבת המלך אחשורוש על כסא

א	Aleph	אᴠᴠᴠᴠᴠᴠ
ב	Bet	בר
ג	Gimel	גוי
ד	Dalet	דדᴰ
ה	Hey	הדᴰ
ו	Vav	וי
ז	Zayin	זי
ח	Het	חדᴰ
ט	Tet	טװי
י	Yod	י
כ	Khaf	כר
ל	Lamed	ללװי
מ	Mem	מחװי
נ	Nun	נװ

ס	Samek	סזר
ע	Ayin	עעעי
פ	Peh	פכר
צ	Tzadi	צעוי
ק	Kopf	קלר
ר	Resh	ר
ש	Shin	ששששששוי
ת	Tav	תהר
ך	Khaf Sofit	ר
ם	Mem Sofit	םהר
ן	Nun Sofit	ןי
ף	Peh Sofit	ףר
ץ	Tzadi Sofit	ץזי

Writing Yerushalmi (Dead Sea Scroll Script)

The Yerushalmi script was designed in the twentieth century after the discovery of the Dead Sea Scrolls (first discovered in a cave at Qumran in 1947 and generally dated from 150 BCE to 70 CE). A triangular shape is often evident in the beginning of each letter; most letters do not have a left or right-leaning slant. The calligrapher created guidelines for this exemplar using a formula of roughly 3¾ nib-widths. *Calligraphy by Izzy Pludwinski.*

This sample is written at a 60° pen angle.

Below: Yerushalmi script aleph-bet.

אבגדההוזזחטיכלמנסע

פצקרשת דסוףץ

Different Ways to Make the Triangular Stroke

Method 1:
For when a triangle
is followed by a
vertical stroke:

1. Place the pen above the guideline.
2. Slide down the edge until the top of your nib hits the top guideline.
3. Without lifting your pen, slide across until the right edge of your nib aligns with the right side of where your pen was placed.
4. Place your nib exactly over where you began your first mark.
5. Make the down stroke.

Method 2:
For when
a triangle is
followed by a horizontal stroke:

1. Place the pen with the top edge just touching the top guideline.
2. Push the stroke straight up until the bottom of your nib touches the top guideline.
3. Slide on the edge of your pen until the top of your nib hits the top guideline.

4. Continue the horizontal stroke. All four steps are done without lifting the pen.
Note: If you make a sloped stroke instead of a perfectly vertical one, then you must overshoot the right edge in step 3 (right).

ויהי בימי אחשורוש הוא אחשורוש המלך

מהדו ועד כוש שבע ועשרים ומאה מדינה

בימים ההם כשבת המלך אחשורוש על כסא

Right: A passage of text shows how the Yerushalmi aleph-bet works in practice.

Aleph	א	א צ ז י ו
Bet	ב	ב ר '
Gimel	ג	ג ו '
Dalet	ד	ד ־ ' '
Hey	ה	ה ד ־ ' '
Vav	ו	'
Zayin	ז	ז ־
Het	ח	ח ד ־
Tet	ט	ט ו '
Yod	י	' '
Khaf	כ	כ ר '
Lamed	ל	ל ל ו '
Mem	מ	מ " ו ' ' '
Nun	נ	נ ו '

Samek	ס	ס ח ר '
Ayin	ע	ע ל ל "
Peh	פ	פ כ ר '
Tzadi	צ	צ ג ל '
Kopf	ק	ק ר
Resh	ר	ר '
Shin	ש	ש ש ש ו ו ו '
Tav	ת	ת ח ר
Khaf Sofit	ך	ך ־ ' '
Mem Sofit	ם	ם ח ר
Nun Sofit	ן	ן '
Peh Sofit	ף	ף ח ר
Tzadi Sofit	ץ	ץ ז ו '

Sofrut/Scribal Arts

By Marc Michaels (Mordechai Pinchas) Sofer STaM

A religious scribe is called a *sofer STaM*, from the initials S for *sefer torah*, T for *tefillin*, and M for *mezuzah*, as these are the scribe's three main activities.

The Hebrew script used for *sofrut* (scribal arts) is called K'tav Ashurit. There are basically three types of scripts:

Beyt Yosef, the script generally used by Ashkenazi Jews.

Beyt Ari, the script used by Chassidic descent or influence.

Sefardi (Veilish), used mostly by Sephardi Jews.

Beyt Yosef and *Ari* are similar, differing only in a few letters, while *Veilish* is much rounder and quicker to write. Most importantly, there are many rules governing the formation of the letters so that each one *temunah* (symbol) is defined precisely and so that there is no confusion between the letters written. They should be clean and crisp.

Taggin are small, ornate crownlets that grace the tops of letters. These decorative crownlets make much of the difference between what is merely Hebrew block lettering and what one sees in the holy texts (*K'tav Ashurit*). No one really knows exactly what these embellishments mean (though they are often said to represent little daggers to protect from demons) and the *Rambam* (Maimonides) argues that their absence does not invalidate the writing as the core of the letterform is there. However, the *halacha* (religious law) dictates that certain letters should have these decorative flourishes, which the sofer creates by drawing ink upwards from the roof of the letter with the very thin tip of the quill (or down from little blobs towards the roof of the letter).

Right: Column from a Megillat Esther. Ashkenazi Script, Beyt Ari Style. 2002. Calligraphy by Mordechai Pinchas. 28 lines per column; parchment. Height: c. 15¼ in. (39 cm). The South West Essex and Settlement Reform Synagogue, United Kingdom.

Taggin perhaps represent the scribe's best chance of individual expression and show that despite the vast amount of rules and regulations, the individualism of the scribe can shine through.

The study associated with all the intricate laws governing the letterforms, the rituals, the parchment, and the ink is an important part of the scribe's work. This study is not that simple, since all the laws are not gathered in one place. Being a sofer is just as much about understanding and adhering to the strict rules as to what is *kasher* (valid) or what is *pasul* (invalid) as much as the actual writing.

Writing is slow work and the scribe's concentration must be as sharp as the quill. Nonetheless, the pitfalls for the scribe are many, such as dittographic errors, made by writing the same word or letter twice; haplographic errors made by omitting one or two identical letters or words that rightfully follow each other; and homioletic errors made by omitting a few words or lines because they appear further on in the passages. The scribe's eye picks up on the repeated words and, as a result, fails to include the words in between.

A serious part of a sofer's work is repairing a Torah. Here, the sofer's work fundamentally breaks into two parts: checking the content and fixing any mistakes.

One textbook case error is described in detail in the *Keset Hasofer* (*The Inkwell of the Scribe*) reference manual. It involves the letter *mem sofit* and what happens when a drop of ink falls into the center, thus obscuring the form of the letter. Scraping out the blot is no good, as this would involve *chok tochot* (forming the letter by carving out). Letters can only be made by the deliberate addition of ink on the page, not forming a letter by scraping ink away from the page. If a mistake is made, the entire letter must be scraped out and rewritten. (This is a very quick summary of pages and pages of *halachic* detail, opinions from early and late authorities, commentaries, and super commentaries.) Many of the *halacha l'masseh* (laws of how to do it) are full of these hypothetical examples.

The Quill: *Kulmus*

Scribes, by and large, use quills, though some Sephardi scribes will use a reed.

Like artists of centuries ago, sofers and scribes create their own writing tools, which is time-consuming and detail-oriented but results in the creation of a quill that is literally "made" for the scribe. Materials to fashion a quill commonly include the leading-edge feathers of kosher birds such as the turkey, goose, and swan, though the latter is hard to source. Additionally, one needs sharp cutting tools, such as a steel "Stanley" knife or box cutter, a scalpel, and a loose knife blade for the final cut.

Guidelines

A scribe writing religious texts is bound by other conventions. He must be in a state of mind where he is completely, mentally dedicated to the task at hand. He is not allowed to use any base metals (i.e., materials that could also be used in weaponry) when writing sacred script. This state of cleanliness and dedication applies even to the way one rules the guidelines on parchment. Lines are ruled with a thorn, not a metal nib. The ruling implement, a piece of dowel with a thorn superglued on it, is known as a *sargel*.

Ink: *D'yo*

Scribes can purchase *d'yo* kosher ink or make their own. The most important ingredient is the humble *afatsa* (gallnut) made from the sting of the gall-wasp on an oak tree. There are several recipes for making ink, though all seem to revolve around the same basic set of ingredients.

An Ink Recipe, by Chasdey David:
Ingredients:
3 grams of *gumy-rabik* (gum arabic)
3 grams of *afatsim* (gallnuts)
1 gram of *kankantum* (vitriol: i.e., iron or copper sulphate)
¼ of a liter of water

1. Crush the gallnuts into a fine powder (basically this is tannic acid).
2. Mix all the ingredients together.
3. Cook on an open flame until the residue is left.
4. Strain out the larger lumps of gallnut.
5. Leave for six months to allow the ink to turn black.

Parchment: *K'laf*

Parchment can be made of the specially prepared skin of a kosher animal; goat, bull, cow, or deer. The hide consists of three layers, but only the flesh side of the inner layer (*g'vil*) and the outer side of the hairy layer (*k'laf*) can be used for holy writings.

Animal Sinew: *Giddin*

Sewing the *y'riot* (sheets of parchment) together is done with *giddin*. These course threads are made from the dried veins of a kosher animal.

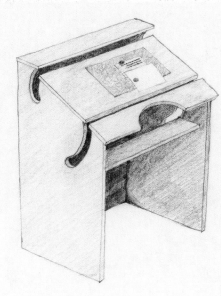

Above: Desk for a Sofer STaM. Drawing by Christopher Calderhead.
This desk, observed in a Jewish scriptorium in Brooklyn, New York, is perfectly suited to the specialized, repetitive work of the traditional Jewish ritual scribe.

The table is quite tall, allowing it to be used either while standing or seated on a tall stool. A semicircular scoop out of the front edge allows the writer to fit his body snugly to the desk. The desk has a permanently fixed tilted writing surface. A flat shelf provides space for ink, extra pens, knives, and other tools.

The most distinctive feature of this desk is the slits cut in the top and sides allowing the ends of a large Torah sheet to be slipped under the table. The edges of the slit are rounded, so there is no danger of creasing the vellum sheet. On either side, the curved slits allow the vellum sheet to be moved sideways without incident.

Atop the writing surface the scribes have a sheet of galvanized metal. Since the sofer is writing on a naturally supple surface—vellum—and using the most flexible of tools—a quill—this hard surface actually is perfectly acceptable to him and the metal sheet allows the use of magnets to hold the work gently in place—a clever use of modern technology in aid of a very ancient craft.

The Art of Micrography

Micrography is an art form where decorative pictures and patterns are made up entirely of tiny letters. From a distance, the image appears to be drawn and shaded, but a closer look reveals every mark to be a letter. Micrography can be found in both ancient and contemporary manuscripts, kettubot, and other Judaic art. An image that is outlined by tiny letters like a contour drawing with negative space inside is called a *microgram*. When the letters embody an image mass itself, it is a calligram.

The art of Hebrew micrography can be dated back to 896 CE in the *Masorah* of the Ben Asher Codex of the Prophets. *Masorah*, which translates as "tradition," has roots in the verb "to pass on." It is a compilation of notes written in the Torah to make sure the tradition of Torah study is passed on accurately. Vowel marks and accents help to ensure proper pronunciation of words for future generations. Micrography as a Jewish art form was initiated by the Masoretic scribes. They created elaborate carpet pages with patterns similar to those in Oriental rugs, all illustrated with micrography and heavily influenced by Muslim art from the communities in which they lived.

Top: Aleph-bet, 1999–2000. Calligraphy by Jacob El Hanani. Ink on paper. 22½ x 28½ in. (57.2 x 72.4 cm).
This work of modern micrography is created by a repetition of microscopic letters in a sweeping, textural expanse.

Bottom: Aleph-bet (detail).

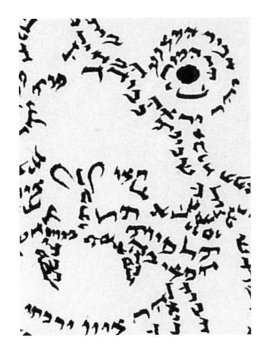

Below: Lion micrograph for a Passover Haggadah. Calligraphy by Izzy Pludwinski; illustration by Yael Hershberg. Ink, gouache; 4 mm and 0.5 mm Brause nibs. 11¼ x 8¾ in. (29 x 22 cm).

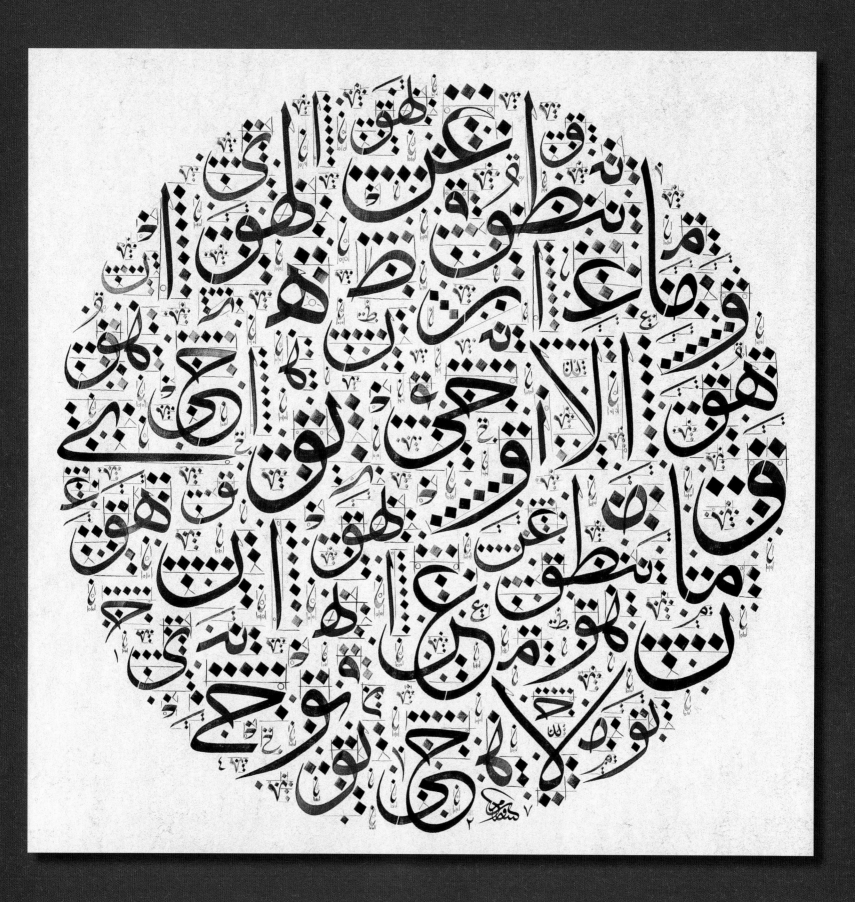

ARABIC
The Writing of the Islamic World

By Christopher Calderhead

Abjad: *A consonant alphabet, where 28 letters represent consonants and perhaps some, but not all, of the vowels. Vowels not represented by letters may be indicated with diacritics, but the diacritics are often not used.*

← Direction of writing: *right to left*

← Majuscule/minuscule distinction: *none*

← Principal tool: *broad-edged pen*

Language: *Arabic and other languages in Islamic lands*

Left: *Mashq.* Calligraphy by Wissam Shawkat. Ink and acrylic on treated paper. 19¾ x 19¾ in. (50 x 50 cm). The artwork, based on a Qu'ranic verse, is in the Jali Thuluth style. The thin lines and rhombic dots show the proportions of the letters.

In one classic tradition of instruction, the first task for the beginning student of Arabic calligraphy is to copy out a prayer known as the *Rbbi*. The prayer preceding asks that the task of writing will be made easy. Copying this prayer is an apt task for someone embarking on what will be the labor of many years to master the intricacies of Arabic script. It is also a test. Despite the request expressed in the prayer, the task is not easy. It is extraordinarily hard. Only a student with real passion and discipline can master this complex prayer, a prelude for a systematic study of the alphabet, letter by letter.

This manner of teaching differs dramatically from the usual approach of the Western calligrapher, which, as we discussed in the chapter on Roman scripts, usually begins with an exemplar showing all the letters. Where a Western scribe begins with the components (the letters) and later combines them into lines and whole compositions, the student of Arabic, in writing the Rbbi, is confronted with the full magnitude of finishing a complex piece at the very outset of his or her practice. Implicit in this approach is the insight that Arabic calligraphy is fundamentally about interrelationships, not individual letters. The letters themselves change depending on their position in the word, and in creating a fully realized composition, the negative spaces are as important as the strokes themselves. The dynamic flow of the script creates a dense web of carefully balanced elements. The student has to take all factors into account—control of the ink and pen, the sequence and direction of strokes, and the placement of the letters in the composition—as he or she copies the master's model. Only on completing this task successfully is the student given the next

ربِّ يسِّرْ ولا تعسِّرْ ربِّ تمِّمْ بالخير وبه

set of tasks: working through the alphabet letter by letter, and mastering every possible combination of letters.

Two other aspects of Arabic calligraphy are implicit in this approach. First, this is a sacred tradition, tied intimately to the writing of the Qu'ran. Arabic calligraphy arose in response to Islam and its sacred text. And second, the teacher-pupil relationship is intimate and sustained over a long period of time. After years of study, the student may be granted a diploma by the master, attesting to the student's mastery of the principles of Arabic calligraphy.

Origins

The rise of Arabic calligraphy parallels the growth of the Islamic empires, beginning with the vast expansion of Islam that followed soon after the death of the Prophet Mohammed. By 710 CE, Islam had spread out of the Arabian Peninsula by conquest, and its territories stretched from the Iberian Peninsula to the Indus Valley. Later, the realms of Islam would expand north to included Asia Minor and the Balkans, and progress east across northern India and down through the Indonesian archipelago. Over this vast territory, a dizzying array of scripts developed.

One of the central factors in the growth and flourishing of Islamic calligraphy is the central importance of the holy book, the Qu'ran. Unlike the Bible, which in Christian traditions has been widely translated, the

Above: This is the first exercise of an aspiring scribe. Calligraphy by Elinor Holland.

Right: Hadith. Calligraphy by Wissam Shawkat. Jaly Thuluth style, 2006. Ink on treated handmade paper. 31½ x 17¾ in. (80 x 45 cm). Private Collection, Kuwait.

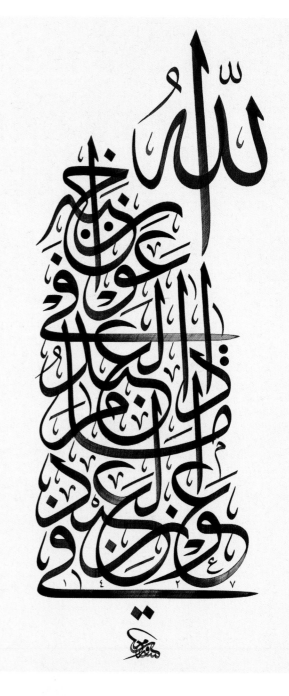

Right: *"If I am made of earth, the latter is my home in its entirety, and all humanity are my brothers."* Calligraphy by Hassan Massoudy. Eleventh century. Ink on paper. Text by Al Siquilli.

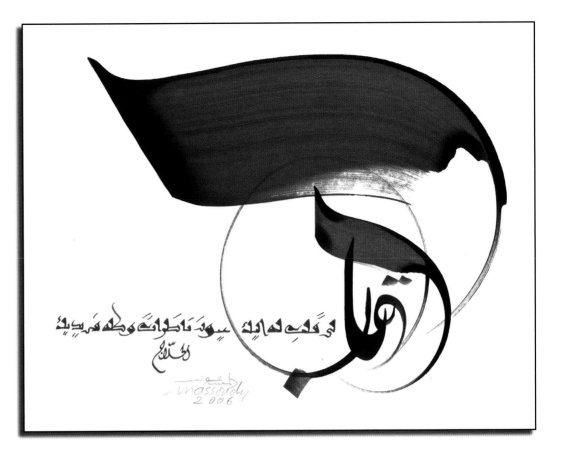

Below: *Love, Scent of Life.* Calligraphy by Wissam Shawkat. Soot ink and acrylic colors on handmade papers. 26 x 38 in (66 x 95.5 cm).

Qu'ran exists only in Arabic. Translations, though they exist, are tools for study—a translation is, by definition, not the Qu'ran itself. Even when the members of the *Ummah*, the community of Islam, do not speak classical Arabic, they nonetheless revere the original text, often memorizing verses and chapters by ear. The central importance of the original Arabic text encouraged the spread of Arabic script across the entire territory of Islamic nations. By contrast, Christians in medieval Europe lost touch with the Hebrew and Greek original texts of their Bible, preferring their own Latin Vulgate translation—and, from a calligraphic point of view, breaking the continuity of the script traditions. Islam and Arabic writing are inseparable.

A further aspect of Islamic culture that encouraged the practice of Arabic calligraphy was the fact that Islam is by nature aniconic; it discourages the artistic representation of animals and human beings, lest one fall into

Right: *Love and Freedom*, 2010. Calligraphy by
Wissam Shawkat. Soot Ink and acrylic colors on
handmade papers. 37⅜ x 25 in. (95 x 63 cm).
The piece is based on a text by Khalil Gibran:
"Love is the only freedom in the world."

Below: Word of Wisdom. Calligraphy by Wissam
Shawkat. Jaly Thuluth style, 2004. Ink on treated
paper. 25½ x 17¾ in. (65 x 45 cm).
Private Collection, Dubai, UAE.

idolatry. Hence the decorative and artistic impulses of the Islamic world were largely channeled toward abstraction, pattern making, and, importantly for our subject, into the elaboration of ornamental, beautiful writing.

Calligraphy, therefore, has enjoyed a uniquely privileged position in the arts of Islam. Beautifully written Qu'rans have continued to be created to the present day; the time and care taken with the sacred text is extraordinary. Calligraphy is also used to ornament buildings, textiles, metalwork, carved screens, and almost every kind of object. It is ubiquitous.

The script that began its spread across the world in the seventh century was quite simple compared to its later forms. The first formalized Arabic script to arise takes its name from the town of Kufa on the Euphrates in what is now central Iraq. Rather rigid forms and letters with flat tails are characteristics of Kufic (see the samples later in this chapter). Cursive scripts continued to develop over time, with enormous variability.

One of the key figures in the codification of Arabic script was Abu Ali Muhammed Ibn Muqla (866–940 CE). Ibn Muqla was a vizier to three successive Abbasid Caliphs in Baghdad. His life was tragic—court intrigues led to the cutting off of his right hand and tongue, and he was eventually executed. But he is credited with giving Arabic cursive a

Left: Interior of the Church of Hagia Sophia. When the Ottoman Turks conquered Constantinople in 1453 CE, they transformed the sixth-century church of Hagia Sophia into a mosque. In its new incarnation, the building was ornamented with huge calligraphic roundels filled with writing in Arabic. The role of calligraphy as an assertion of Muslim cultural identity could not be exemplified more clearly than this.

Bottom: Quranic verse. Jaly Thuluth style, 2006. Calligraphy by Wissam Shawkut. Illumination by Amal Turkman. Ink on treated handmade paper, acrylic, gold. 27½ x 35½ in. (70 x 90 cm). Private Collection, Dubai, UAE.

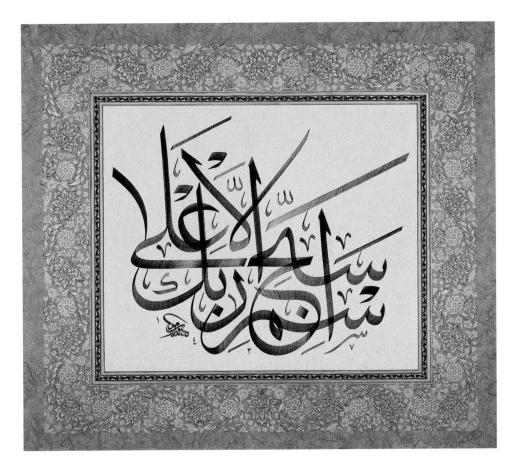

system of proportion that remains in use to this day. His theory of "proportioned script," known in Arabic as *al-Khatt al-Mansub*, organized the shapes of the letters according to a system of rhombic dots and related circles.

Ibn Muqla's method begins with a pen-made square turned on its side, diamond-wise. This provides a basic measure against which the different parts of each letter may be proportioned. Thus, the *alif*, the upright first letter of the alphabet, may be defined as eight dots high. The alif can also be used to define a circle: the eight-dot height of the letter is the radius of this circle. Using these two means of measurement, all the letters can be defined with specific proportions. Ibn Muqla's method was developed further by Abul Hasan Ali Ibn Hilal ibn el-Bawwab (d. 1298), who is said to have given Ibn Muqla's forms an even greater grace and elegance. The exemplars of Thuluth script that follow will make reference to these systems of proportioning the letters.

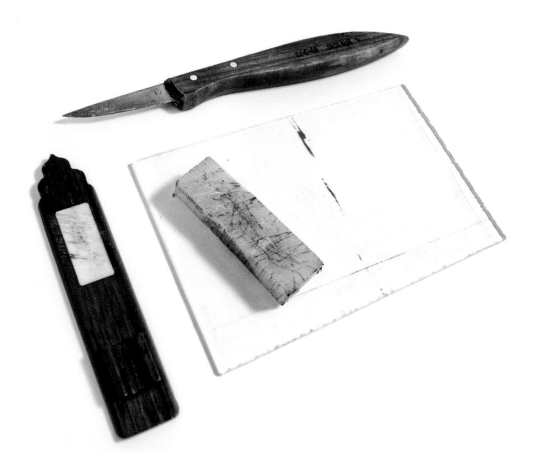

Above: Here we see a penknife and various surfaces for cutting the writing end of the pen. The traditional *makta* is shown at left. This example is made of hardwood with a bone inset to provide a firm cutting surface. The Plexiglass sheet and small rectangle of hard plastic serve the same function.

Right: The *makta* is ideally suited to the cutting of the nib.

Tools and Technique
The Pen

The *qalam*, or reed pen, is the standard writing tool. A calligrapher needs to master the art of cutting the reed, because it is a delicate instrument that becomes dull after sustained use. Even if one is provided with a pre-cut reed, it will become necessary over time to recut and sharpen the tip. After several sharpenings, the reed should be recut entirely. Novice scribes are therefore compelled to master the art of reed cutting

from the outset. Like all techniques, this one requires practice—only by cutting many reeds does one gain full mastery.

Two tools are need for the cutting: a penknife, or *sikkin*, and a small tablet known as a *makta*. The penknife needs to have a thin, short blade made of strong steel. Needless to say, it should be kept perfectly sharp. The makta is a cutting surface that supports the tip of the pen when the final cut is made. It may be made of any hard material that will not damage the blade of the penknife. The usual materials are hardwood, bone, or (historically) ivory. A piece of hard plastic or a small sheet of plexiglass are modern alternatives. Stone or metal are not used, as these would damage the knife's edge.

The traditional *makta* has a small, curved support at one end. This holds the shaft of the reed when the last cut is made, helping to keep it firmly in position, and slanting the writing end downwards, toward the surface of the makta at the other end.

Various kinds of reeds are commonly used for pens. Bamboo is effective for large-scale writing. Finer reeds grown in warm climates in riverine environments are also good. A length is cut from between the nodes of a long reed. Sometimes a node is left at the end opposite the writing end, a purely decorative option.

The initial cutting of the reed is done in several steps: holding the pen in one's left hand, the right hand holds the penknife, which is drawn toward one's body. The calligrapher takes a large scoop out of the bottom, or belly, of the reed. This cut is

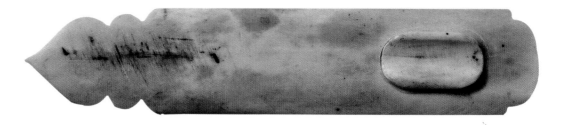

usually done in several stages, scooping the penknife into the shaft of the reed a little at a time to arrive at a gently curved, long cut. The slit is then cut down the center of the shaft opposite the long cut. Then, turning the reed on each side, scoops are taken out on either side. These must be perfectly symmetrical. The top, or back, of the reed is then thinned. In the final stage—what western calligraphers would refer to as the "nibbing"—the pen is laid, belly down, on the makta and given a clean, sharp end.

The basic shape of the pen, as well as the sequence of cuts, is almost identical to the system for quill cutting described by Diderot in his *Encyclopédie* (see Edged Pen chapter). The three cut reeds in diameter varying from ¼ inch to ¹/₁₆ inch, show how the cuts should look when completed. The writing end of the tool is cut at a slight angle for most scripts.

According to Lucien Polastron and Abdallah Akar in their publication *Découverte des calligraphies de l'arabe* (Dessain et Tolra, 2003), among Arabic calligraphers, there is some debate whether a slit is necessary in the preparation of the reed. The cutting of a slit weakens the tip of the pen somewhat, and if cut poorly,

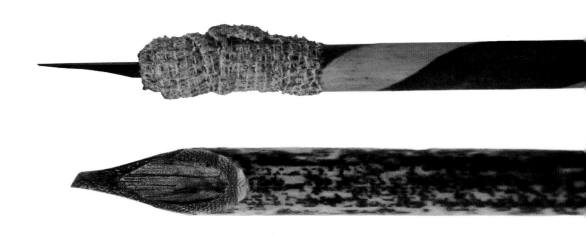

Above: A very small, fine reed (top). The cut reed has been inserted into a larger holder. The medical gauze is a practical modern addition that gives a firmer and somewhat larger grip (side view). A medium reed (bottom).

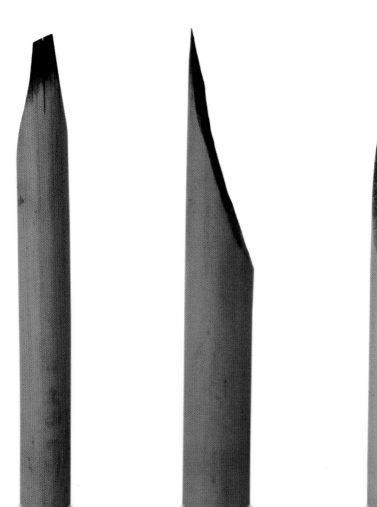

Left: A large cut reed pen, shown in three views: the top or back view; side view; bottom or belly view.

may cause the tip to spread open during the act of writing, especially when the pen is pressed too firmly into the paper. If a slit is not cut, then the pen needs to be replenished often, usually after each stroke. The benefit of cutting a slit is that it allows the pen to hold more ink. With a slit, multiple strokes may be made before dipping the pen again.

When the writing end becomes dull or soft, it needs to be recut. In the sequence of photographs shown at right, scribe Elinor Holland sharpens the end of her reed pen. Note that when recutting, the original sequence of cuts is not followed; the calligrapher is honing the edges as needed.

Inkwell

Ink is kept in a small jar in which a ball of raw silk yarn has been placed. Other organic material may be used, such as cotton thread or wool yarn. The ink soaks into the yarn. This has two advantages: the ink does not spill as easily, since it is absorbed by the fibers of the silk; and the amount of ink on the pen can be better controlled. The calligrapher, dipping his or her pen into the jar, is able to deliver an ideal amount of ink to the tip. As the pen is drawn out of the well, the silk fibers remove any excess ink, while distributing a thin coat of liquid evenly across the surface and in the slit of the pen. A porcupine quill may be used occasionally to stir the contents of the inkwell, ensuring that the top fibers do not dry out, and that they are evenly saturated with ink.

Ruling Up

In order to create guidelines for writing, one of the classic techniques is to make a *mastar,* a cardboard ruling guide. A stout sheet of cardboard is pierced with a set of holes down each side. Then a thick thread is laced through the holes, creating a set of parallel cords along the front. The thread

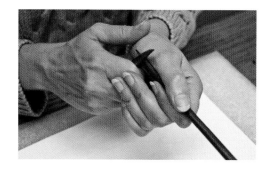

1. **Above:** Making a scoop along one side of the pen.

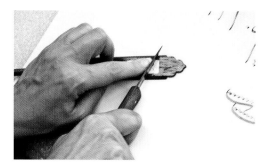

2. **Above:** The pen is placed on the *makta* and held firmly in place with the left index finger. Note the angle of the knife when the writing end is recut at an angle.

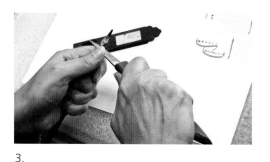

3.

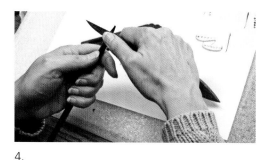

4.

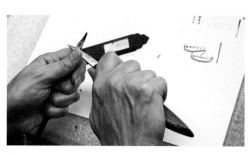

5.

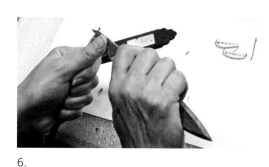

6.

Above: Recutting the long scoop in the belly of the pen. Note how the hands move in close when the cuts approach the delicate writing end. The action is repeated; this is delicate work, and only tiny slivers are being cut from the scoop each time.

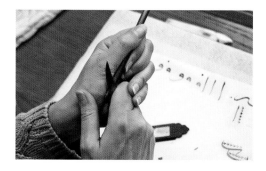

7. **Above:** Refining the sides of the nib.

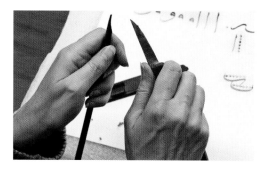

8. **Above:** The calligrapher examines the result.

should be pulled taut, but not so tightly as to bend the cardboard support. The thread is then tied off at the back.

The mastar allows the calligrapher to easily rule whole sets of identical pages. A sheet of paper is placed atop the cardboard sheet, and the calligrapher uses his or her hand to gently rub the surface, pressing the threads against the back of the page. The result is a series of gently raised lines that serve as a benchmark for writing.

After the writing has been completed and the ink is bone dry, the lines may be removed by rubbing the page again, either with a tool such as a bone folder, or with one's fingernail.

While in Western calligraphy, letters are written between tight guidelines, the use of guides in Arabic is far more fluid. The relationship of Arabic to the ruled baseline is dynamic. As Elinor Holland describes it, "Arabic is like a fretless violin. When people study violin, they tape on lines. But later, when they become expert players, they just have to know by feel where to place their fingers. This flexibility allows microtones and subtlety because there are no fixed lines to stay between. In Arabic calligraphy, there's not a strict horizon line. Over years of practice, you come to sense how the letters relate to the ruled baseline. This allows for a great deal of freedom, and you can create compositions where certain elements are overlapping. It's about proportion and relation rather than sitting rigidly on a baseline."

Paper

Many kinds of papers are used for Arabic calligraphy. Slick coated papers—the kinds used commercially for calendars and glossy magazines—are popular for practice, allowing the pen to glide with little friction over the smooth surface of the page. Since many of the strokes are pushed, rather than pulled, this lack of resistance is extremely important. Papers with too much "tooth" or texture interfere with the smooth movements of the pen.

For finished work, better papers should be used. Frequently, paper chosen for the writing is polished with a smooth oval stone or with the back of a smooth, curved seashell.

Writing

A gently sloping writing surface is used. This can either be a tilting drafting table, or a small portable writing desk. Ink and other tools are

Top left: Inkwells containing red and black ink. The interior is filled with fibers soaked in ink. Dipping the reed pen into the fibers delivers a perfect amount of ink to the tip.

Top right: A porcupine quill is used for stirring the ink-soaked silk.

Left: The cardboard ruling template, or *mastar*.

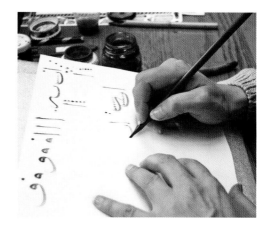

Above: The scribe Elinor Holland at work demonstrating in a workshop. She writes on a slightly inclined writing desk placed on a table.

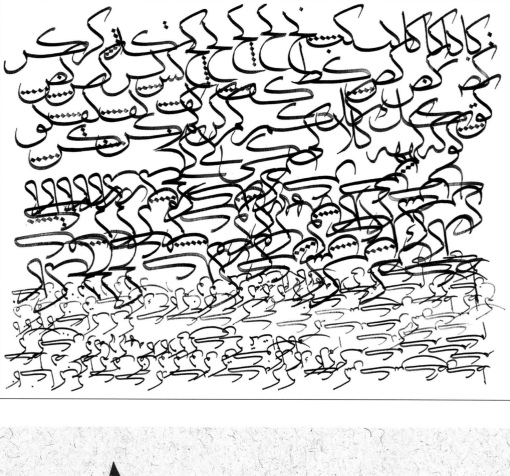

placed on the flat surface of the table, the ink near the writer's hand, immediately to the right of the writing surface.

A standard way to master the letters involves using every bit of a sheet of paper in a practice called "darkening the page." The novice calligrapher continues to write until the page is completely covered with text.

After completing the Rbbi, the next task of the student is to begin working through the letters of the alphabet in the Thuluth script. Each Arabic letter has four basic forms: independent, initial, medial, and final. In other words, when the letter stands on its own, outside the context of a word, it is independent. When it is written in combination with other letters, it changes shape depending on its position in the word—at the beginning (initial), in the middle (medial), and at the end (final). That is a simplistic explanation, however. In practice, the student needs to learn each independent form first, and then work through every possible combination of the letters. After completing the independent letters, a set of exercises is assigned in which each letter is written in combination with all the subsequent letters of the alphabet.

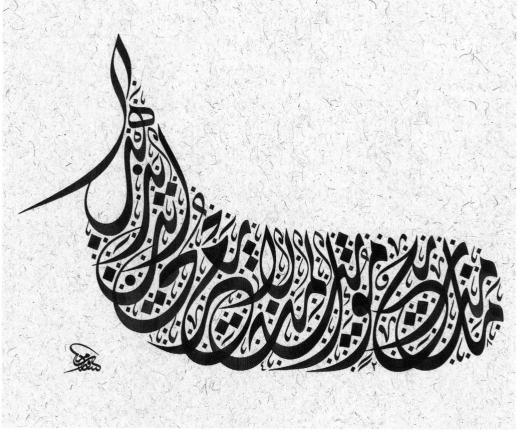

Opposite, top right: "Darkening the page." A student's worksheet filled with text. Notice how the small rhombus shapes have been used to check the proportions of some letters.

Opposite, bottom: *Destination.* Calligraphy by Wissam Shawkat. Ink and acrylic on treated handmade paper. 19¼ x 24³/8 in. (49 x 62 cm). The text, by Seneca, is in Jali Diwvani style.

Right: *"There is enough room on earth for everyone."* Calligraphy by Hassan Massoudy. Text by Friedrich Schiller. Nineteenth century. Ink on paper.
Hassan Massoudy's rich, experimental forms explore the expressive potential of contemporary Arabic calligraphy. Well-versed in traditional calligraphic technique, Massoudy pushes boundaries of legibility and letterform.

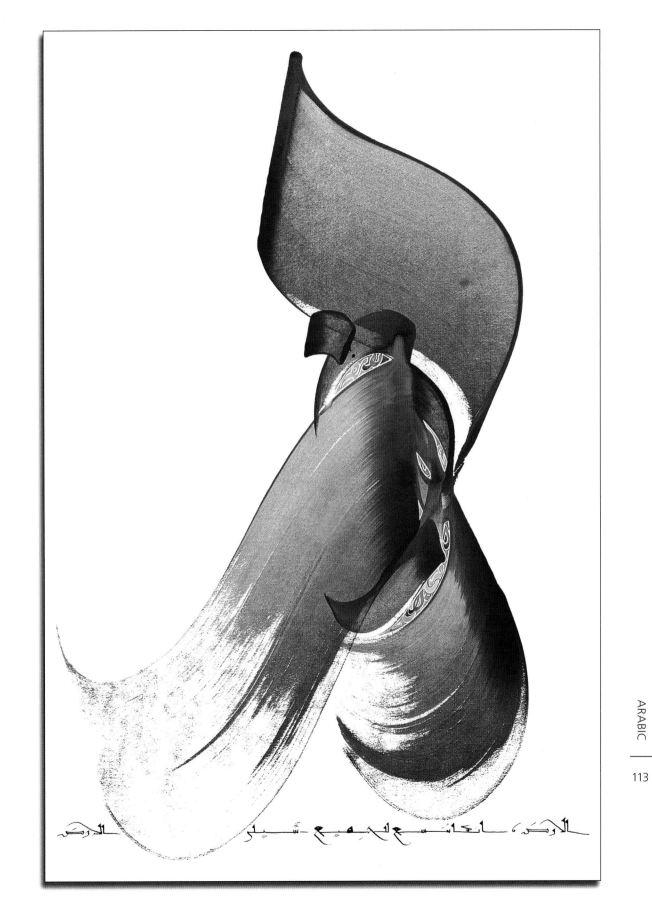

Writing Thuluth

Thuluth is a standard script for beginning students. It is large, graceful, and bold. This exemplar shows a full set of letters in their independent form. The angle of the pen will vary, depending on the letter being written; the pen angle is, in practice, quite variable. The proportions are determined through the use of rhombic dots, as described earlier. Horizon lines are indicated in the illustrations as a basic guide. As we have seen, the relationship of the letters to these horizon lines is not fixed, but fluid in actual finished compositions. The stroke count given for each letter refers to the number of strokes needed to complete the body of the letter. The dots that change the sound value of the form are not included in the stroke count.

A very smooth paper, such as bond paper, should be used. Many students like to work on coated, "calendared" papers, which are shiny and have no texture to interfere with the writing. Papers that have texture or "tooth" are not appropriate for Arabic. In many of the letters, the strokes are pushed forward, making a smooth paper a necessity. *Calligraphy by Elinor Holland.*

Alif

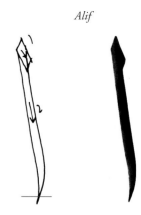

The *Alif* is eight dots tall. Note the slight inclination to the left. The end of the first stroke is pulled slightly to the left as the pen leaves the page, creating a slight curve at the bottom. The head is made last. This letter is created in two strokes.

Thuluth Script with Direction

Ba

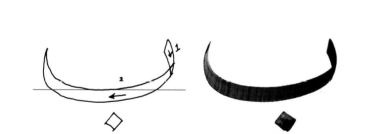

The space inside the *ba* should be six dots wide. The dot below the letter is an integral part of the *ba*. Two strokes and one dot.

Ta

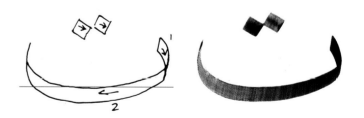

Ta is identical to *ba*, with two dots above. Two strokes and two dots.

Tha

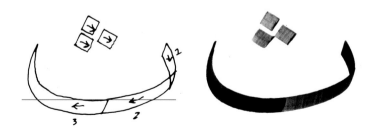

Jeem

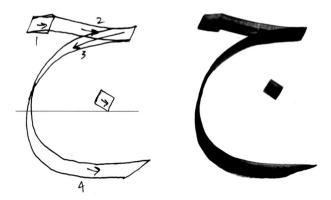

Tha also resembles the *ba*, but with three dots stacked in a distinctive pattern: two strokes and three dots. In this letter, the pen was lifted in the middle of the long stroke; this is a common practice in Arabic. When strokes are very long, sometimes it is best to lift the pen, reposition the hand, and then, placing the pen in exactly the same position from which it was lifted, continue the stroke seamlessly.

The internal curve of the *jeem* is eight dots tall. The curve straddles the horizon line. The dot in the middle of this space is integral to the letter. The bottom end is made by twisting the pen onto its right corner as it leaves the page. Three strokes and one dot.

Ha

Kha

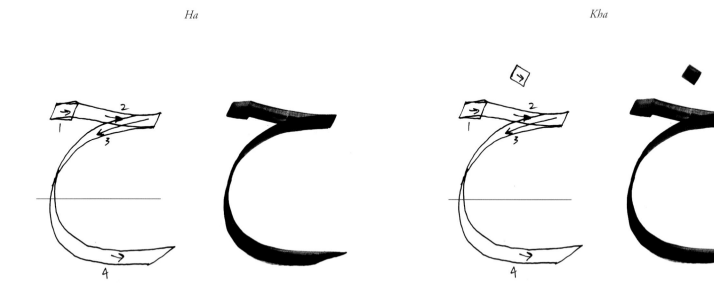

A *ha* is a *jeem* without a dot. Three strokes.

A *kha* is a *jeem* with a dot above. Three strokes and one dot.

Thuluth Stroke Direction (continued)

Dal

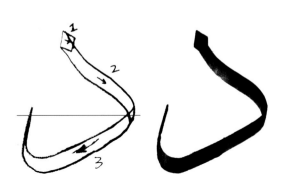

Note that the pen angle is extremely steep. Note as well the slightly sinuous curve of the second stroke. Three strokes.

Dhal

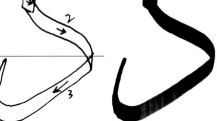

A *dhal* is a *dal* with a dot above. Three strokes and one dot.

Ra

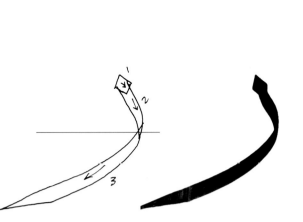

Note the subtle difference between *ra* and the *dal*. The *ra* is more squared off, and the last stroke is straight, rather than curving up at the end. Twist the pen at the end of the last stroke onto its right corner. The length of the top diagonal is three dots; the bottom is six dots long. Three strokes.

Zay

A *zay* is a *ra* with a dot. Three strokes and one dot.

Variant forms of Ra and Zay

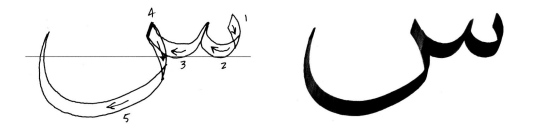

ز ر

The variant form of *ra* is made in a single stroke. The angle of the pen changes as the pen is moved along the stroke.

Seen

س

Seen is a complex letter made in five strokes. Note that from right to left, the arcs grow in width; each arc has its own unique shape.

Sheen

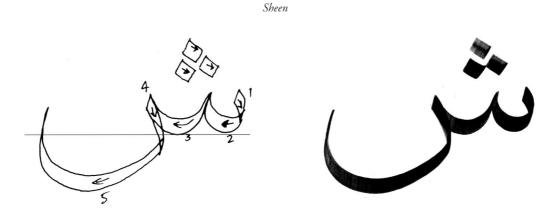

A *sheen* is a *seen* with three dots. Five strokes and three dots.

Sad

The first stroke is twisted from about a 45° angle, becoming quite steep at the end. The last two strokes are identical to the tail of the *seen*. Four strokes.

Dad

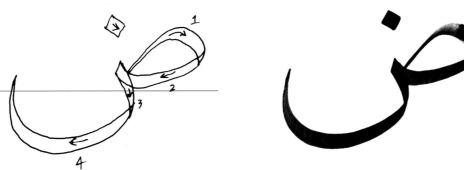

A *dad* is a *sad* with a dot. Four strokes and one dot.

Thuluth Stroke Direction (continued)

Ta

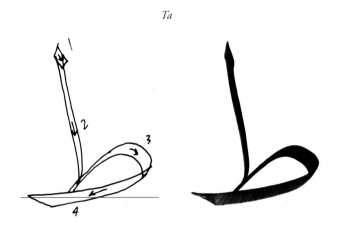

Za

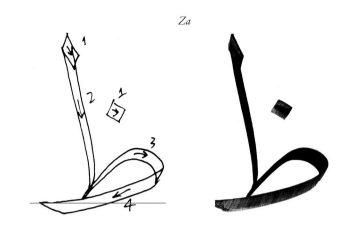

The *ta* begins with two strokes and is similar to an *alif*, but stops a little above the horizon line—it is a bit shorter than the *alif*. The arc described by the third stroke is a little rounder and fuller than the similar stroke of the *sad*. The width of this arc is three dots. The final stroke ends with the pen twisted onto its right corner, as we did with the *ra*. Four strokes.

A *za* is a *ta* with a dot over the second stroke. Four strokes and one dot.

Ayn

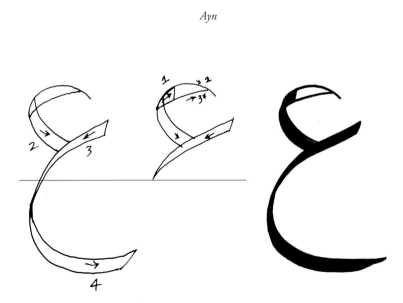

Ghayn

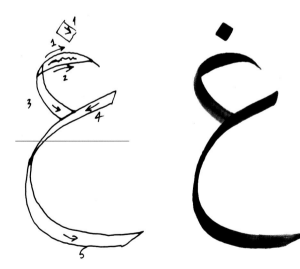

The first stroke of *ayn* is drawn with the corner of the pen and filled in. The large arc is eight dots tall, and the arc straddles the horizon line. Four strokes. The first stroke begins like a regular stroke, with the pen in full contact with the page. Then the pen is lifted on its corner, and the rest of the shape is drawn and filled in. Draw the top edge first, then the bottom edge, and fill the space in between with ink.

A *ghayn* is an *ayn* with a dot above. Four strokes and one dot.

Fa

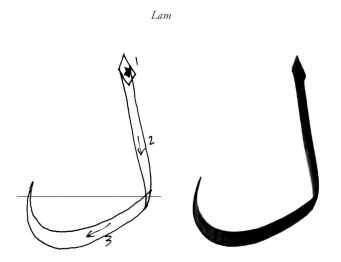

Six dots should fit within the long arc. Note that the arc is quite flat and loosely parallels the horizon line. The dot is integral to the letter. Three strokes and one dot.

Qaf

The *qaf* looks remarkably similar to the *fa*. Looking closely, however, notice that the curve of the arc is much deeper, more diagonal, and has a more strongly pronounced curve. Three strokes and two dots.

Kaf

The *kaf* begins with a perfectly formed *alif*, which is connected to the tail of the *ba*. The little mark in the internal space of the letter is made with a single sweep of the pen; the pen is twisted off at the end. Three strokes and a final added mark.

Lam

Much like the *kaf*, the *lam* has a shorter tail, proportional to the last stroke of the *seen*. Three strokes.

Thuluth Stroke Direction (continued)

Mim

Nun

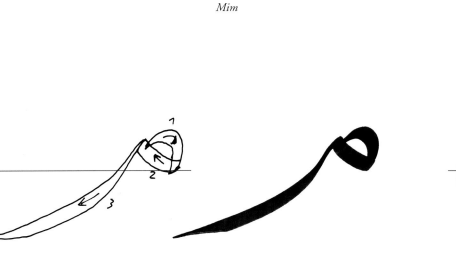

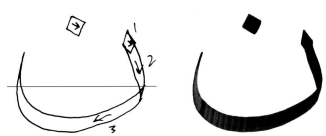

The tail of the *mim* is similar to that of the *ra*. Three strokes.

The *nun* is made like the tail of the *seen*. Although it is quite similar to the *ba*, note how the tail is more fully curved, with greater diagonal emphasis. It is also shorter than the corresponding part of the *ba*. The dot is integral to the letter. Three strokes and one dot.

Ha

Waw

Ya

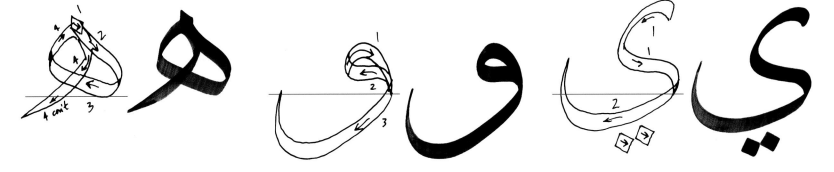

The fourth and final stroke of the *ha* overlaps the first and second strokes of the letter, and then flicks out to a twisted finish. Four strokes.

Waw has the same head as the *fa*. Note that the six-point tail is a pure diagonal stroke, and does not flick upwards at its end. The pen is twisted at the end. Three strokes.

Ya is a letter made entirely of subtle curves. The tail is the same proportion as the *qaf*. Two strokes and two dots.

Other Marks

In addition to the letters, there are a series of marks used for vowels and as diacritics. These are made with a smaller pen than the main text.

Joining the Letters

Once the student has mastered the independent forms of the letters, the hard work of putting letters into combinations follows. In this sheet of combinations, (opposite, below) a student works with the letter *ha*. Notice how the *ha* changes as it meets other letters in the alphabet; notice, too, that the letters that follow the *ha* differ from the independent forms that have been shown in the previous pages. The sequence is alphabetic, in the same order the letters were presented in the previous section. Compare the independent forms with the forms in combination shown here.

A student will go through the full sequence of connections for every letter of the alphabet. When he or she feels they are ready to show their work to the master, corrections will be marked in red, as they are here. The rapid, thin red underlines are the teacher's mark of approval: the student has received the go-ahead to move on to another set of combinations, all beginning with the next letter of the alphabet.

Tanween is used when vowels are doubled at the ends of words. This is a vowel and grammatical indicator. The double stroke version may appear above or below the letter.

Tirnak and *Tirfil* are purely ornamental spacers.

Hamza indicates a glottal stop. It is sometimes thought of as a letter.

Sukun indicates no vowel after the consonant; it appears above the letter.

Shadda doubles the consonant.

Damma represents the vowel **u**.

Kasra, which appears below the letter, indicates the vowel **i**. The same stroke, when it appears above the letter, is called *fatha* and represents the vowel **a**.

Left: A detailed study of the letter *ayn* as it relates to different following letters. Note the use of diamond-shaped strokes to check the proportions of the letters.

Below: An exercise sheet of letter combinations, beginning with the letter *ha*. The *ha* changes form as it meets other letters in the alphabet. Notice how the letters that follow the *ha* differ from the independent forms that have been shown in the previous pages.

Working with Text

Once the student has finished all the combinations, he or she returns to the writing of a full text. In this case, the *Bismillah* (top) and the *Rbbi* (below).

The Bismillah is a key text in Islam—"In the name of Allah, the gracious, the compassionate." It may be transliterated thus: *Bismillah al rahman al rahim*. Each *sura*, or chapter of the Qu'ran, begins with these words, except for the ninth sura. It is a standard text for calligraphers.

The student's work is shown here in black; the teacher has written the versions in red. Comparing the two, one sees the enormous subtlety required for mastery of Arabic. Notice the dashed lines that express the interrelationships between the different forms. Not only do the letters have to be made correctly, but also the composition has to hold together as a harmonic whole. Note also the way in which the letters relate to the horizon line, rising and falling like waves across the page.

Above: A student's worksheet with corrections by her teacher.

Other Styles

In these images, the calligrapher Wissam Shawkut writes out the *Bismillah* in eleven different styles, representing some of the diversity of Arabic scripts. The caption explanations are by Wissam Shawkat and Christopher Calderhead.

Early Kufic

Early Kufic reached perfection in the eighth century. It was widely used for writing the letters of the Prophet Mohammed letters and the Qu'rans. There is a clear contrast in this script between the verticals and the horizontals, as the verticals are very low and the horizontal lines are extended. It is a written script and not drawn by geometrical instruments. It has a distinguished roundness in some of the letters.

Eastern Kufic

A variant of the Kufic script with sharper stroke terminations and a decidedly diagonal bias to many strokes.

Maghribi

Maghribi is the characteristic script of North Africa. It was also used in Andalusia (Muslim Spain). It is written with a blunt, pointed reed that delivers a generous flow of ink to the page. The contrast of thick and thin is far less marked than it is in the other edged-pen Arabic scripts. With its strong vertical upright strokes, and emphasis on the horizontal continuity of the line of writing, it has clear links to the Kufic scripts.

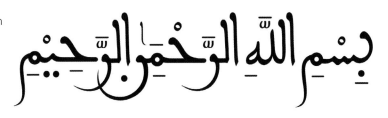

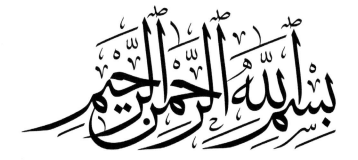

Fatimid Kufic

This variant of Kufic is drawn, rather than being written freely with a pen. Through history, it has often been used for carved inscriptions.

Square Kufic

Some researchers think that the Square Kufic is a result of using the Kufic script on the tiles found in buildings and mosques. It consists of straight horizontal and vertical lines and there are no curves. The thickness of the letter is equal to the space between the letters and the words in the composition. It is usually written in maze-like compositions and is well distributed.

Muhaqqaq

The word *Muhaqqaq* means that the writing has been produced and developed with details and reached the desired size and form. The style was developed by Ibn Muqla (d. 940) in the Abbasid dynasty and was perfected by Ibn Al Bawwab (d. 1022) and Yaqut Al Musta'simi (d. 1298). It was a popular script used for writing Qu'rans. The underline curves are shallow and wide and the midline curves are horizontally expanded; the word structure is compacted and has the upright strokes that tilt to the left. It has a similarity in some letters with Thuluth scripts.

Thuluth

This script was first formed in the seventh century. The word *Thuluth* means third, whether because of the proportion of the straight lines to curves or because it was a third of the size of another script called *Tumar*. It reached its final perfection and development in the hands of the Ottoman calligraphers in the nineteenth century. The Thuluth script is counted as the most important of all the scripts.

The overall look of this script is ornamental. The spaces above and bellow the letters are filled with vowel marks and decorative details. The vertical letters are long, usually distinguished by the triangular shape like that on top of the initial vertical letters. The initial, isolated, and medial letters have many versions and forms. Compare this composition to the Thuluth exemplar by Elinor Holland. The upright strokes in Thuluth lean to the left.

Ijaza

This style was invented in the ninth century, then developed and perfected by the Ottoman calligraphers in the nineteenth century. It also known as *Tawqeei*, meaning "signature," as it was used for writing the names and titles of the caliphs. Eventually it was adapted as a royal script. These days, it is used by calligraphers to write their signatures under their calligraphic work. It took the name *Ijaza*, meaning "certificate" as it was used to write the certificate text given by the calligraphy master to his student. It shares many characteristics of Thuluth and Naskh scripts as its origin comes between them chronologically. There is a cursive flow and roundness and the words are sometimes written linked together. This script is well spaced with a few vowel marks.

Naskh

Naskh is one of the earliest scripts that developed from Kufi. It was developed by Ibn Muqla (d. 940) in the tenth century, and was then further perfected by Ibn Al Bawwab (d. 1022) and Yaqut Al Musta'simi (d. 1298). It was fully developed during the Ottoman Empire and was widely used for writing the Qu'ran and prayers, as it was relatively easy to read and write.

Ta'liq

The Ta'liq script originated in Persia (modern Iran) in the tenth century. The name means "hanging" or "suspended."

Diwani

Diwani was developed from the Ta'liq in the late fifteenth century by the Ottoman Ibrahim Munif, and it was later fully developed by Mumtaz Bey in 1864. It was created primarily for chancelleries, and for official use was used for Imperial Fermans, the decrees issued by the Sultan.

Diwani is distinguished by its cursive flow and the roundness of its letters. The words are written at an oblique angle (from top to bottom and from right to left) to the baseline. The letters rest on a "point of balance." It has no vowel marks.

Above: A Persian manuscript from the seventeenth or eighteenth century. Ink, powdered gold, and watercolor on polished paper. 9 x 10 in. (23 x 25.5 cm) (open). The text recounts a story of the dream of Shah Mansoor. The script is Nastaliq, (a combination of Naskh and Ta'liq) the language, Persian.

The long tradition of book design in the Islamic world produced a unique aesthetic and novel layouts. The central text, boxed and bounded with gold and delicate blue watercolor, is surrounded by blocks of text written diagonally, creating a lush textural pattern. The small remaining triangles in the corners are filled with gold filigree.

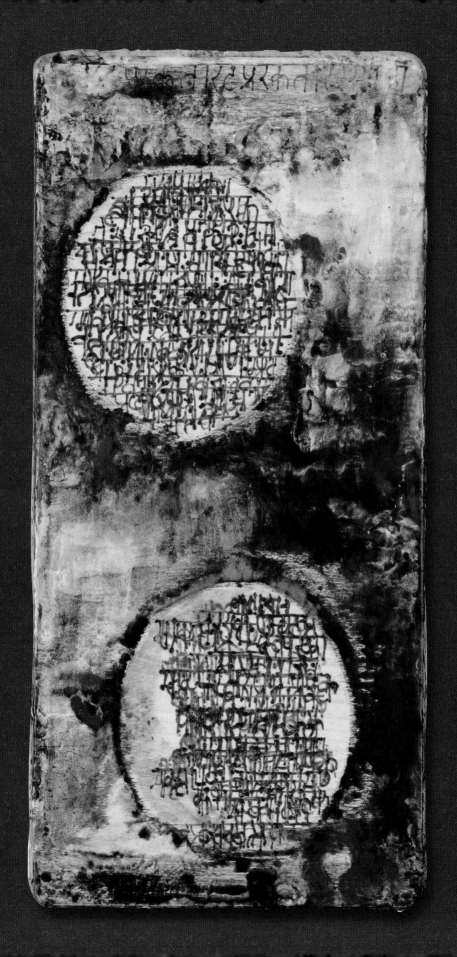

INDIC SCRIPTS
Scripts with Roots in Brahmi

By Holly Cohen

Syllabic Alphabets: *Each of the basic consonant characters is inherently followed by a short vowel sound, unless modified by diacritical marks to indicate other vowels. Vowel characters are used when vowels appear before, or separate from, a consonant character.*

Direction of writing: *left to right*

Majuscule/ minuscule distinction: *none*

All the scripts in this chapter share these basic characteristics. Tools and languages are included in small boxes that appear with the scripts in question.

Left: *Mantra (Directions)*, 2007. Calligraphy by Deborah Kapoor. Encaustic, burned text on wood veneer. 12 x 6 in. (30.5 x 15.2 cm). This mantra was written in Devanagari script.

The Indian subcontinent is the place of origin for a huge family of scripts that are used from the Tibetan Plateau in the north to Cambodia in Southeast Asia. Like the scripts of Europe—Greek, Roman, and Cyrillic— the Indic scripts share many basic forms, yet show a diversity of development. Because they are used to write languages of very different structures, from the Indo-European Hindi to the Dravidian Malayalam and the tonal Thai, they have been adapted to suit the needs of diverse cultures. All of these scripts are descendents of the ancient Brahmi script.

Within the modern nation of India, there are fifteen official languages, and eleven distinct scripts appear on the rupee note. The North Indian scripts can generally—but not always—be recognized by the flat "head" that caps most of the letters. The northern scripts include Gurmukhi, Devanagari, Gujarati, Bengali, and Oriya. The South Indian scripts generally lack this horizontal line, and are largely formed of circles and arcs. These scripts include Kannada, Telugu, and Malayalam.

The Indic scripts used outside the modern state of India include Tibetan, whose origins lie in the North Indian scripts, Sinhalese, used in Sri Lanka, and the scripts of Southeast Asia. The Southeast Asian scripts were received from South India, and were spread along with the teachings of Hinduism and Buddhism.

Origins

The Indic scripts are generally traced to the ancient Brahmi script, which was in use by the fifth century BCE. Classic examples of Brahmi are the rock-cut inscriptions made at the command of King Ashoka, the third ruler of the Mauryan dynasty, in the third century BCE.

Left: A study of Brahmi script. Sketch by Christopher Calderhead.
The Edicts of King Ashoka, dating from the third century BCE, were written in the ancient Brahmi script, which is the progenitor of the Indic family of scripts. This is a study after a plate from Alexander Cunningham's *Corpus Inscriptionum Indicarum,* originally printed in the Office of the Superintendent of Government Printing, Calcutta, 1879.

Ashoka ruled over a vast territory that included most of India and parts of modern-day Afghanistan and Iran. The first prominent Buddhist ruler of India, Ashoka encouraged the spread of Buddhism throughout India and Southeast Asia.

According to legend, Ashoka began his reign as a ruthless leader who murdered his brothers to assure his ascendancy to the throne. He was a merciless expansionist who converted to Buddhism after the Battle of Kalinga, one of the major battles in the history of India, which occurred around 265 BCE. Stories recount the emperor's horror, shame, and feeling of responsibility at the sight of hundreds of thousands of bodies that lay dead after the battle. From that time forward, he incorporated the pacifist teachings of Buddhism into his reign.

Ashoka's legacy was left for all to see and read upon the Pillars of Ashoka, a series of sandstone pillars, rocks, and cave walls located throughout Northern India and Pakistan. It was upon these rock surfaces that the Edicts of Ashoka were inscribed. Their profound significance is twofold. The pillars contain the first material evidence in history that refers to Buddhism, and the inscriptions embody the earliest datable examples of Indic script.

The Edicts of Ashoka were translated in the nineteenth century and while they mention Buddhism, they are not comprised of religious doctrine. Rather, they portray Ashoka's new edicts for his empire based on the concept of *Dharma,* the law that governs the universe according to Buddhist belief. It is interesting to note that the 13th Edict discusses the very Battle of Kalinga, the conclusion of which is cited as the turning

Below: Manuscript page, c. late nineteenth century. Black ink on polished paper. Special Collections Division, Newark Public Library. The Devnagari script is customarily used to write the Sanskrit language, as in this manuscript page. The text makes reference to religion and astrology.

Above: Manuscript page of tales from *The Bardic Chronicles of Rajputana,* 1839. Anonymous scribe. Black and red ink on polished paper. Special Collections Division, Newark Public Library. This piece of Western South Hindi language in Devanagari script is from the city of Jodhpur, India.

point in Ashoka's life. The inscriptions were carved in four languages: Brahmi, Kharoshthi, Greek, and Aramaic.

The carved forms of Brahmi inscriptional letters are purely geometric, composed of circles, arcs, and straight lines. Their strokes are rendered in monoline—lines of completely equal thickness. The Brahmi scripts diverged into their southern and northern branches sometime around the third century CE. New writing tools affected the shapes of the letters. Reed pens cut with a chisel edge were used to write on smooth, burnished paper, and pointed styli were used to scratch letters into palm leaves. Slowly, the forms of the many modern Indic scripts took shape. The strict geometries of Brahmi gave way to more fluid forms we know today.

Calligraphy in India, Sri Lanka, and Southeast Asia Today

Within India proper, the position of calligraphy is not unlike the position of calligraphy in the West. It does not enjoy the kind of central artistic position that calligraphy holds in the cultures of East Asia or in the Islamic world. It has not, on the whole, been used for purely artistic purposes. Instead, it is very much a craft tradition, and a subset of the graphic arts. There are certainly many calligraphers working today in India, but they occupy a very specialized niche. In this, they are much like the calligraphers who work with Western alphabets—maintaining and developing an ancient tradition, and working within graphic design practices.

Today's Indian calligraphers produce lettering for book jackets, posters, and logos. Many are experimenting with new forms of the traditional scripts. A few produce work for its own sake, incorporating painterly techniques and working at a large scale to produce calligraphic works of art.

There is also a lively sign-painting tradition that continues to thrive, and in

सतेज पोते

Because the subject of Indic scripts is so vast, we have selected a representative sample of scripts to explain the basic principles that underlie the whole family of writing systems. Each of these scripts is a syllabic alphabet like Brahmi, based on the *aksara* system where each consonant character is inherently followed by a specific vowel sound unless modified by diacritical marks; vowels appearing before or independent from a consonant character are represented by separate vowel characters, not diacritics.

We begin with Devanagari, which is perhaps the most important of scripts within India. Used to write both modern Hindi and the ancient sacred language of Sanskrit, it enjoys a privileged place within Indian culture. Gujarati, used in the Western part of India, is also a prominent script, so we also provide a full exemplar of this script. Bengali, used in the eastern part of the country, as well as in the nation of Bangladesh, is shown through an exemplar. The Gurmukhi script is used in the Punjab. As the script was created by a Sikh guru in the sixteenth century, Gurmukhi translates to "from the mouth of the guru." We illustrate this script with images from an old manuscript on the opposite page.

The other scripts have been shown through samples produced in study sessions with Western-trained scribes. We gathered together some of New York City's finest scribes for a challenging study day. Each scribe was assigned a script and presented with a packet that contained examples of calligraphy and/or typefaces in his or her assigned script. The scribes were tasked with analyzing their scripts. They had to figure out how the strokes of individual letters worked in tandem to create a unified script. They had to create a pen scale, ascertain the pen angle, and determine the most appropriate tool to use. Rather than show full exemplars, we present the basic organizing principles that guide the writing of these scripts.

Indian cities and in the countryside, one can often find inventive signs painted with brushes that evoke the calligraphic forms achieved with a pen.

Outside of India, the position of calligraphy is somewhat less prominent, probably due to the less-developed economies of the region. Thailand is an exception to this with its continued rich calligraphic

tradition. One need only walk through a market to come across handmade signs with calligraphic lettering. In Sri Lanka, a few monks are likely the only ones continuing the calligraphic tradition.

We have not included Tibet in this chapter. Although its calligraphic tradition is clearly part of the Indic family, we felt it best to treat the Tibetan scripts independently.

Opposite: Book cover design, 1998.
Calligraphy by Dattatraya Padekar. Thick felt
pen and brush. 8½ x 5½ in. (21.6 x 14 cm).

Top: Page from a manuscript book,
c. 1890. Ink and opaque watercolor on thin
polished paper.
This text comes from The *Mahabharata* and is
written in Gurmukhi script from the Punjab, India.

Right: Detail of above.
The scribe likely used a reed heavily loaded
with ink that takes great skill to control. Note
the thick monoline letterforms and their softly
curved stroke endings. These stroke endings are
quite different from the sharp stroke endings of
the Devanagari and Gujarati scripts that are also
illustrated in this chapter.

DEVANAGARI

This sample is written at a 45º pen angle.

North Indian Scripts

Similarities in the prominent Devanagari, Gujarati, and Bengali scripts can be seen in the exemplars below. Each exemplar was created with a broad-edged pen held at a 45° angle.

Devanagari

Principal tool: *broad-edged pen*

Languages: *Sanskrit, Hindi, Marathi, Nepali*

Devanagari (pronounced *dev-nagri*) script is a more contemporary name for the *Nagari* script, which means "city" or "urban" in Sanskrit. In Devanagari, one consonant beside another consonant will have a joined *matra* or headstroke, creating a new form that is called a compound consonant, i.e., a conjunct consonant. They can be combined both vertically and horizontally. In a compound consonant, the inherent vowel of the first consonant is automatically silenced by the conjunct. Characters are aligned by these headstrokes and are written beneath a top guideline.

The Devanagari characters can be written between one or two lines. Most important is the top guideline. The characters are aligned by the matra, and they begin just below the line, not directly on it. *Calligraphy by Dattatraya Padekar.*

अ आ इ ई उ ऊ
ए ऐ ओ औ अं अः
क ख ग घ ङ १
च छ ज झ ञ २
ट ठ ड ढ ण ३
त थ द ध न ४
प फ ब भ म ५
य र ल व श ६
ष स ह ळ क्ष ७
ज्ञ त्र श्र ८ ९ ०

Vowels

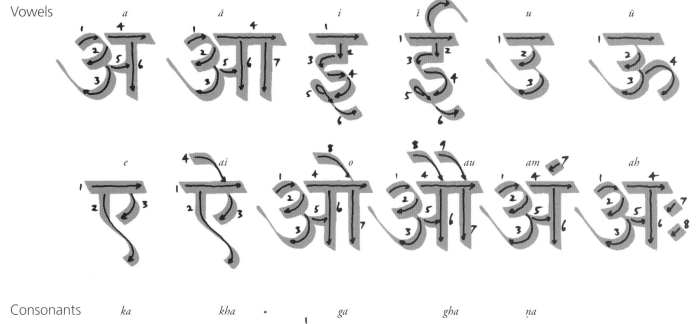

Consonants

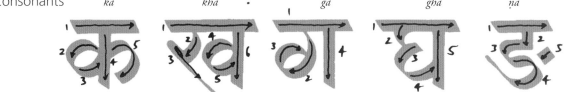

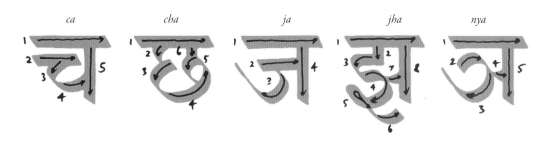

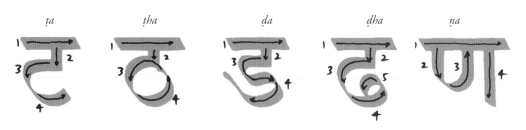

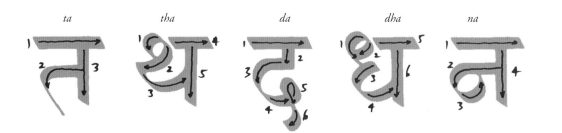

Consonants

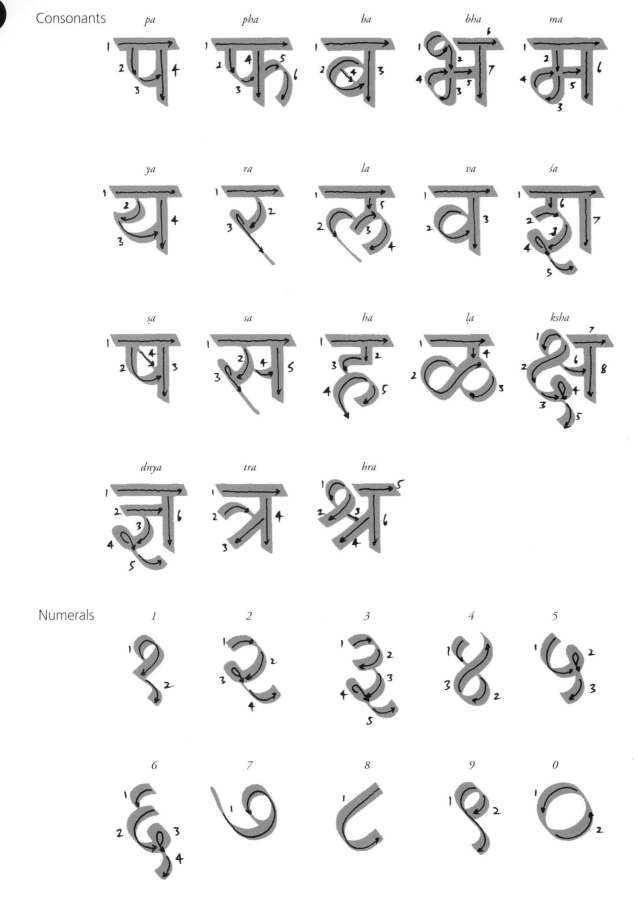

pa *pha* *ba* *bha* *ma*

ya *ra* *la* *va* *śa*

ṣa *sa* *ha* *ḷa* *ksha*

dnya *tra* *hra*

Numerals

1 *2* *3* *4* *5*

6 *7* *8* *9* *0*

Left: Passages from the Sanskrit epic, The *Mahabharata*. Black ink, colored inks, and gold on paper with painted ornament. Special Collections Division, Newark Public Library. This is written in Devanagari script.

विज्ञानाचे कार्य सदा मना भुलविते।
बटण दाबता सारे प्रकाशित करिते॥
आकाशमार्गे सारे जग फिरतसे।
दूरध्वनीवरी सारे बोलतसे॥
ग्रहावरी उपग्रह आणि यानांची भरारी।
हस्तयरोपणही सहज साध्य करी॥
संगणकावरी सर्व कामे होती।
विज्ञानाविण हे कोण देती॥
मना बुद्धी ही विज्ञानी असावी।
तरी का पावले ही मागे पडावी॥
ग्रहणकाळी घरे का बंद व्हावी।
मंदिरापुढे दर्शना का तिष्ठावी॥
स्वैरच का गणेश दुग्ध प्राशन करी।
हिता कारणे तूची शोधुली पाही॥

अंधश्रध्दा निर्मूलना।
साथ द्या सकळजना॥

Right: Devanagari script. Calligraphy by Dattatraya Padekar. Based on the text *Superstition Eradication*, written by the artist. The essence of the passage conveys the different superstitions that exist in society and the ways to eradicate them, as well as how to think in a scientific manner. Poetically written in the Marathi language.

The Contemporary Scribe

By Dattatrya Padekar

Today, a scribe versed in Indic scripts uses contemporary tools, along with the traditional reed pen *orboru*, including cut-nib pens, flat cut felt-tip pens, and brushes, both flat and round. Paper is ruled with a T-square and a set square, the same technique commonly used to rule up paper for Western scripts. The writing board or desk is slanted at a 45° angle, and the calligrapher often stands for larger work.

In the past, Indian calligraphy was used for inscribing sacred texts. Today it is only taught to art students for the purpose of incorporating it into advertising and print media for titles of books, articles, magazines, newspaper and magazine headings, etc. This is the most common use for Indian calligraphy today.

Left: Book cover design, 1998.
Calligraphy by Dattatraya Padekar.
8½ x 5½ in. (21.6 x 14 cm).
The calligraphy was created using a broad-edged pen.

Below: Book cover design in Devanagari, 1998.
Calligraphy by Dattatraya Padekar.
8⅞ x 5⅞ in. (22.4 x 14.7 cm).
This script was created using a broad-edged pen.

आदर वंदना,

आमचा पुत्र चि. मोहन व चि. रश्मी साळगी यांचे विवाहानिमित्त एक स्नेहसंमेलन रविवार दि. २८ मे १९७८ या दिवशी सायंकाळी ७.३० ते ८ या वेळात बालमोहन विद्या मंदिर (तळ मजला) शिवाजी पार्क दादर मुंबई २८ येथे आयोजित केले आहे. तरी आपण अवश्य उपस्थित रहावे ही आग्रहाची विनंती.

आपले स्नेहांकित, बळवंत वि. नाईक सौ. कमल ब. नाईक

कृपया अहेर आणू नये

Above: A concise description of Lord Ganesha, 1996. Calligraphy by Dattatraya Padekar. Handmade paper, pencil and watercolor. 12 x 12 in. (30.5 x 30.5 cm).

Right: Wedding invitation card in Devanagari Script, 1978. Calligraphy by Dattatraya Padekar. 10³⁄₈ x 4 in. (26.4 x 10.2 cm). This script was created using a Rotring pen.

Right: Wedding invitation card in Devanagari Script, 1980. Calligraphy by Dattatraya Padekar. 4½ x 10 in. (11.4 x 25.4 cm). This script was created using a broad-edged pen and brush.

GUJARATI

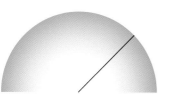

This sample is written at a 45° pen angle.

Gujarati

Principal tool: *broad-edged pen*

Languages: *Gujarati, Kachchi*

Gujarati is often described as a banker or merchant's script; until the middle of the nineteenth century it was used for business writing, as opposed to Devanagari, which was used for more scholarly text.

Derived from, and similar in nature to Devanagari, the characters of both scripts share similarities in shape and order sequence, however the matra is absent in Gujarati, making them easy to tell apart. Gujarati characters are also rounder in shape. *Calligraphy by Dattatraya Padekar.*

અ આ ઇ ઈ ઉ ઊ

એ ઐ ઓ ઔ અં અઃ

ક ખ ગ ઘ ઙ ૧

ચ છ જ ઝ ઞ ૨

ટ ઠ ડ ઢ ણ ૩

ત થ દ ધ ન ૪

પ ફ બ ભ મ ૫

ય ર લ વ શ ૬

ષ સ હ ળ ક્ષ ૭

જ્ઞ ત્ર શ્ર ૮ ૯ ૦

Vowels

a	ā	i	ī	u	ū

e ai o au am ah

Consonants

ka	kha	ga	gha	ṅa

ca	cha	ja	jha	nya

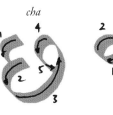

ṭa	ṭha	ḍa	ḍha	ṇa

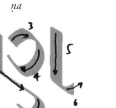

ta	tha	da	dha	na

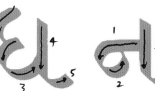

Consonants (continued)

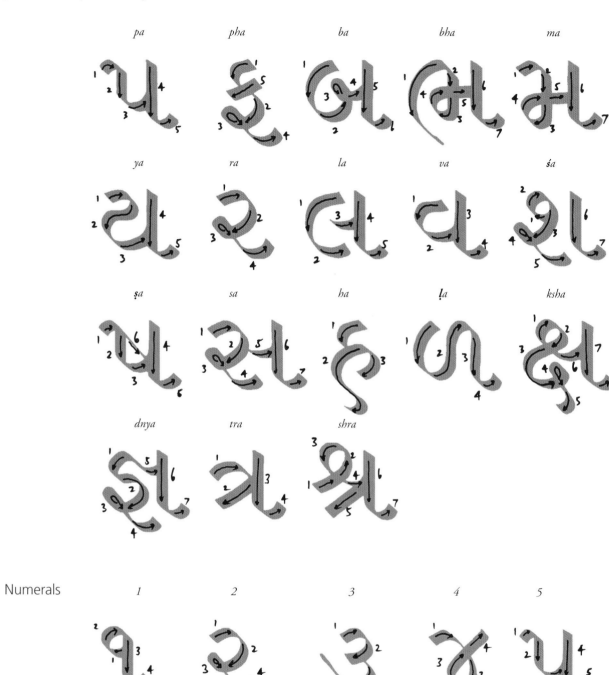

pa pha ba bha ma

ya ra la va śa

ṣa sa ha ḷa ksha

dnya tra shra

Numerals

1 2 3 4 5

6 7 8 9 0

કળા

કળા શબ્દનો અર્થજ આનંદ. કળામાં કોઈક એવું અદ્ભુત તત્ત્વ રહેલું છે જેથી માનવી તેમાં તદ્રુપ થઈને જીવનનો પરમાનંદ માણી શકે છે. કળાકાર પોતાની કલ્પના અને પોતાના અનુભવોને એની કળા વ્દારા વ્યક્ત કરે છે. ચિત્રકાર હોય તો રંગ-પીંછી વ્દારા એનાં હૃદયનાં સંવેદનો વિવિધ ભાવો એ ચિત્રમાં વ્યક્ત કરે છે.

Writing Bengali

Bengali

Principal tool: *broad-edged pen*
Language: *Bengali*

The basic ductus for writing the majority of characters in Bengali is the same as for Devanagari. Bengali is written left to right and typically the first stroke starts at the top left side of the character. Pen lifts should be kept to a minimum. As in Devanagari, characters are aligned by the matra, which is written just beneath the top guideline.

Christopher Calderhead created this Bengali exemplar. By studying the forms of Bengali letters both in the calligraphic work of Indian scribes and contemporary Bengali typefaces, he was able to ascertain the basic strokes that make up the alphabet. He comments, "It is always challenging—and a little dangerous—to attempt writing a script that is used for a language you yourself do not read. Nonetheless, by carefully examining a number of sources, a foreign scribe can often learn a great deal about the basic structure of the written form. Bengali has strong thick and thin strokes, clearly derived from the use of an edged pen."

This sample is written at a 45° pen angle.

Vowels

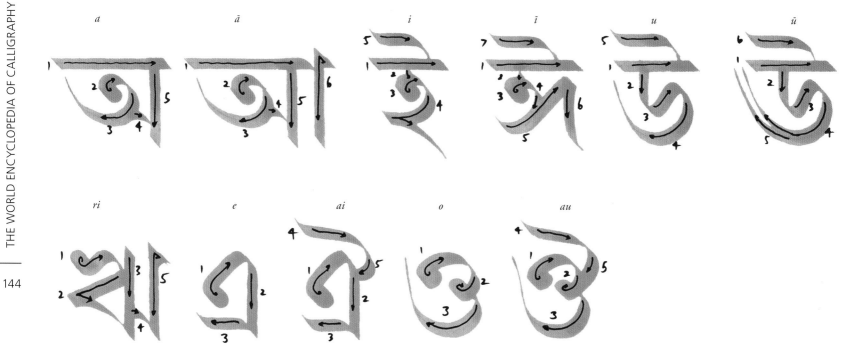

Consonants

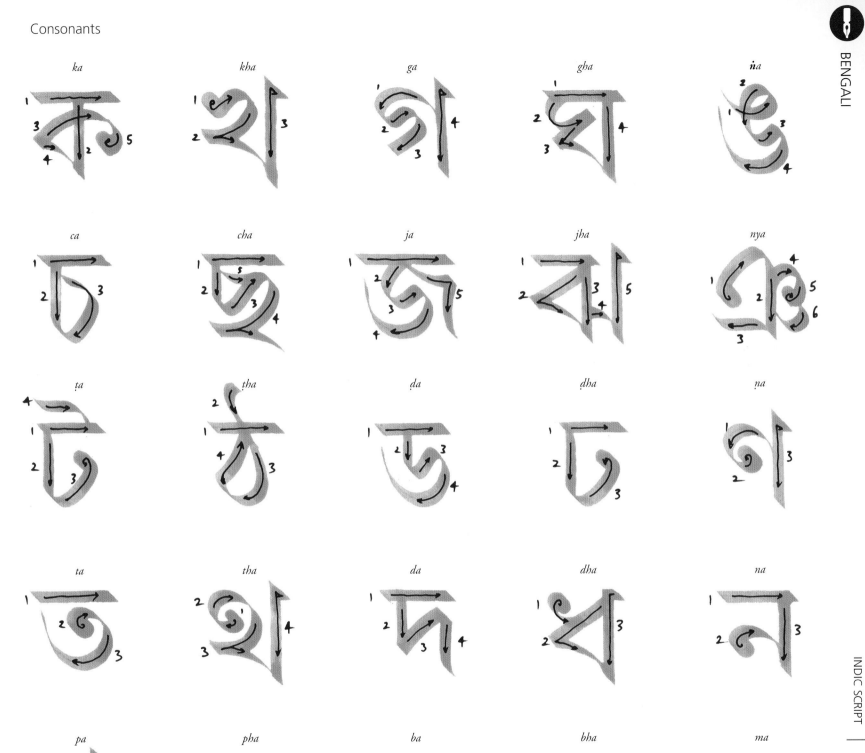

ka	kha	ga	gha	ṅa
ca	cha	ja	jha	nya
ṭa	ṭha	ḍa	ḍha	ṇa
ta	tha	da	dha	na
pa	pha	ba	bha	ma

Consonants (continued)

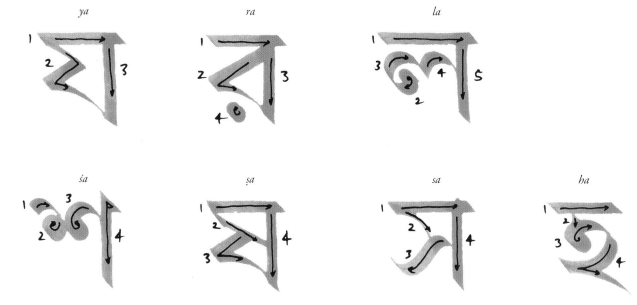

ya *ra* *la*

śa *ṣa* *sa* *ha*

South Indian Scripts

As Buddhism spread throughout East Asia in the third century CE, the Brahmi script evolved into several distinctive South Indic forms, quite different from their Northern ancestry. The four major Dravidian languages of South India—Telugu, Tamil, Malayalam, and Kannada—are all written with Brahmi-derived scripts, and are all syllabic alphabets, based on the aksara system. As such, each consonant character has an inherent vowel sound (the majority of the time it is the vowel /a/) which is pronounced after the consonant character just like in the North Indic scripts. When a vowel other than the one inherent to the consonant character appears, diacritical marks are used to represent them. When a vowel appears before a consonant, or separately from a consonant, vowel characters are used.

The characters of South Indic scripts are rounder in form than those of North India, in part due to the tendency for straight lines to tear the palm leaves upon which many texts were inscribed.

Below: Detail of a page from an Ola leaf manuscript, eighteenth century. Letters incised with stylus on palm leaf, pigment rubbed in. Special Collections Division, Newark Public Library. Buddhist texts are written in regional scripts; this leaf is written in the Tamil script and the Pali language. It was in the Pali language that the Theravada Buddhist scriptures were written during the first century BCE, in Sri Lanka.

Above: Kannada study day sheet.
Calligraphy by Elinor Holland.

We have illustrated the South Indian scripts of Kannada, Telugu, and Tamil with the aid of Western-trained scribes Elinor Holland and Chi Nguyen. Rather than show exemplars for these scripts, we asked our scribes to interpret these scripts and create study day sheets that can be seen on the next page.

By the eleventh century, a script called Old Kannada was used in the Deccan Plateau in India's southern peninsula. Some time near 1500, Old Kannada evolved into two distinct but similar scripts: Kannada and Telugu.

The Kannada script is similar to Telugu, with the distinguishing characteristic found in the shape of the headstroke. In Kannada, the matra is a parallel line with a slight upward slope on the right hand side. The script is typically written with a broad-edged pen and is used to write the Kannada (also called *Kanarese, Canarese*) language.

Elinor Holland created this study day sheet by examining calligraphy and typefaces of the Kannada script. She used a pen angle of 70°.

The Telugu script is similar in form and function to the Kannada script. The matra in Telugu, however, resembles a check mark, and the Telugu characters are not quite as wide as the Kannada characters. The Telugu script is typically written with a broad-edged pen and is used to write the Telugu language.

Western-trained scribe Chi Nguyen created the study day sheet on the top of the following page. She used a pen angle of 50°.

Above: Telugu study day sheet.
Calligraphy by Chi Nguyen.

Right: Tamil study day sheet.
Calligraphy by Chi Nguyen.

The Tamil scripts evolved from the Southern Grantha script and is used beneath the Deccan Plateau, farther south on the Indian Peninsula. Tamil, unlike most Indic scripts, does not use conjunct consonants. To silence an inherent vowel from a consonant, the *hasanta* stroke is used. In Tamil the hasanta is dot-shaped and is known as a *pulli*. It is written above the consonant character to negate the vowel.

Although Tamil does not use conjunct characters, the pulli mark can be used to silence a final vowel in a sentence similar to how a conjunct serves to silence the inherent vowel in the first consonant character.

The Tamil script is typically written with a broad-edged pen and is used to write the Tamil language.

Western trained scribe Chi Nguyen created the study day sheet below using a pen angle of 40°.

Sinhala and Palm Leaf Writing

By S. Leelaratne

A significant landmark in the development of Sinhala writing came with the discovery that Ola (palm) leaves could be used as a writing surface, and by the sixth century, the use of Ola leaves was commonplace. Because these leaves have a tendency to tear when horizontal lines are written upon them, the Sinhala script evolved using letters with a roundish shape to reduce the tearing of the writing surface. With this modification, so began the golden era of Sinhala writing.

A critical milestone arose in the first century BCE when the Sinhalese ruler Great Walagambahu sponsored the writing of Buddhist teachings. Hundreds of educated monks were tasked with inscribing the words of Buddha into 84,000 volumes of Ola leaf-manuscript books. This is the first formal codification of these teaching that had been formerly passed down in only the oral tradition, from elder monks to their pupils, who were required to memorize each word.

The alphabet evolved rapidly from the sixth through the eighth century CE. Frequent changes of script patterns and letter shapes indicate considerable foreign influence. It wasn't until the tenth century that the forms fully matured into the Sinhalese letters of today.

Palm Leaf Civilization

Before the introduction of paper, palm leaves were the chief raw material used for writing and painting. Manuscripts of religious text were treated as objects of worship and over the centuries the heritage and ancient wisdom of the Sinhalese have been preserved on hundreds of thousands of palm leaf documents.

In early writings, the snake-like sign "~" was mainly used to denote a period.

Above: Sinhalese study day sheet. Christopher Calderhead made a study of the Sinhala alphabet by looking at contemporary Sinhalese typefaces and details of old palm leaf manuscripts. He sat down with Sri Lankan native Leelaratne and reviewed the script letter by letter. Sinhala is a syllabic alphabet just like other scripts of the Indic family. Each of the basic consonant characters is inherently followed by a vowel sound that can be modified by diacritical marks to indicate other vowels. Vowel characters are used when vowels appear before or separate from a consonant character. These letters were written with a bamboo pen.

There were no other punctuation marks, nor were there spaces between words. Due to the insufficient supply of palm leaves, fewer characters were used in palm leaf writing.

Preparation of the Palm Leaf

Two fundamental properties of the palm leaf are its thick skin and soft interior. The skin, or epidermis is thick and smooth. The soft inner portion consists of mesophyll, which is traversed by a vascular system of thin, wire-like veins that almost intertwine with each other, providing strength for the palm leaf. The epidermis is firmly fixed to this inner part, but its structure is different and less absorbent.

There are many varieties of palm trees such as the palmyra palm, the talipot palm, and the fan palm. Those suitable for writing grow in the relatively dry climates of India, Myanmar, and Sri Lanka. Talipot palm leaves are soft and light in color and are used mainly when writing valuable books. While the length of palm leaves varies—some have been found to be one meter long—the width of every palm leaf is always between 8–10 centimeters.

Palm leaves have to be processed in a special manner. The Sinhalese use several processing methods, differing from area to area. One method is to cut the tender buds from the crown of the palm tree. Subsections are separated, and the middle rib is cut off. A hole is made in each leaf, making it easy to hang up later. The leaves are then wound in concentric circles to form rolls.

Next, a layer of these rolls is placed in a large clay vessel. On top of this, papaw nuts and pineapple leaves are placed. Consecutive layers are placed one on top of the other until the pot is almost full. The rest of the vessel is filled with water and then closed tightly with an earthen lid. A cloth is tied to seal it and the vessel is placed on three stacks of bricks and heated with firewood.

Once finished, a clothesline-like cord is hung out in the garden and the strips of palm leaves are placed over it to catch the dew in the early morning. Care is taken to avoid mildew. The leaves are exposed to mild sunlight for several hours a day and once dried, the leaves are again wound into rolls.

The next stage is the polishing of the palm leaf strip. A long trunk in the shape of a wooden pole is tied to two rods and placed six feet above the ground. A stone weighing approximately one pound is tied to one side of the palm leaf strip. The strip is immersed in water for several minutes before polishing. The leaf strip is then placed over the wooden pole with the stone end hanging down. The opposite end is grabbed and rubbed up and down against the pole until the wrinkles are smoothed and the leaf is flattened. Each palm leaf strip undergoes this treatment.

The forming of palm leaf strips into a bundle is another specialized process. Two holes are punched on either side of the leaf strip, enabling a cord to pass through. The leaves are placed one beneath the other and

Left: Talipot palm tree. Talipot palm leaves are used to write valuable books.

Top: A notch is visible at the edge of the thumbnail. The scribe will rest the stylus against this notch, and with his other hand, guide the stylus along the page, still resting against the thumbnail.

THE WORLD ENCYCLOPEDIA OF CALLIGRAPHY

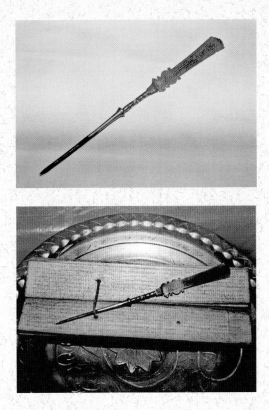

Top: A metal stylus.

Above: A metal stylus with a palm leaf manuscript.

Right and far right: These leaves from a Burmese palm leaf manuscript show the incised technique common across the region. Palm leaf manuscripts are known through South India, Sri Lanka, Burma, and Southeast Asia. A close look at the pages reveals an uneven text. The palm leaves had been written on prior to being assembled into this book. It appears that the leaves have been cut, reused, and rebound.

pressed tightly together, cut into the required size, and then put in a wooden mold. The four sides of the bundle are singed with a hot iron rod to ensure that the leaf folios are the same size as well as to prevent moths from eating the leaves. At the same time, the two punched holes are seared with the hot spike.

Writing on Palm Leaves

The scribe places the leaf strip on the palm of the hand, as it is easier to gauge the pressure needed for writing. Writing from left to right, the scribe uses the parallel lines of veins on the leaf to guide him to write straight. With the left thumb that he places on top of the leaf, he guides the stylus along the lines. Letters are uniform and evenly spaced. Two or more leaves can be stitched together with needle and thread to make a broader writing surface.

Inking the manuscript is another special art. The letters etched with the stylus are colorless and difficult to read, so they must be inked. For this, charcoal powder is used. It is mixed with *dummala* (resinous) oil and *kakuna* oil. The surface of the leaf is rubbed with a wad of soft cotton cloth that has been dipped in the prepared solution. These chemicals further help to deter

attacks by insects. The leaf is then left to dry; later the surface is cleaned with *kurakkan* powder. The powder absorbs the excess moisture and the excess black coloring. The letters on the palm leaf will then appear dark black and distinct.

Binding

Palm leaves cannot be bound like ordinary books. The folios are enclosed between two kolon wood panels slightly larger in size than the leaves. Sometimes the panels are studded with precious or semiprecious stones. A ribbon cut about one centimeter wide is attached to one of the corners of the square wooden panel. A palm leaf carrying the title of the work is placed over the cover of the manuscript and the book is wrapped in cloth to keep it free of dust. Finally, the ribbon is tightly bound all around the bundle to exert an even pressure on the manuscript. Precious manuscripts were sometimes kept in specially prepared wooden boxes. Because palm leaves are organic, they are extremely susceptible to deterioration. An application of *dummala* oil every two or three years helps to preserve them. Incredibly, this painstaking craft of palm leaf writing is still alive today, albeit essentially for ritualistic or artistic purposes.

Above: Detail from a Burmese manuscript page. Courtesy of Nirvana, Oriental Plaza Place, Bangkok, Thailand.

Southeast Asian Scripts

Looking at the scripts of Southeast Asia one can see the influence of South Indian scripts from which they derived. The South Indic writing system aided the spread of Buddhism and Hinduism. Scripts were adapted to accommodate the specific needs of individual languages.

Burmese is a syllabic alphabet like the North and South Indic scripts. The script is written with a broad-edged pen and is used to write the Burmese and Karen languages.

The Burmese script, or *ca-lonh* (round script), is a direct descendent of the Mon Script, which in turn was descended from a South Indic Brahmi-derived script from the eighth century. Similar in form to South Indic scripts, the Burmese script employs the use of conjunct consonants, but the writing system is even more intricate as the language is tonal, employing seven vowels. Like its Southern Indic ancestors, the characters evolved into rounded forms as the palm leaves upon which the text was written would tear when inscribed with straight lines.

Burmese Tamarind Seed Script

In Burma, a distinctive script evolved for the writing of religious manuscripts associated with Buddhist monasteries. It is named after the lustrous, dark brown seed of the Tamarind tree. The seed has a squared oval shape, giving its name to the squared-off letters of the script.

Manuscripts of the text known as the *Kammavaca* were—and still are—made in the Burmese monasteries to mark the ordination rites of new monks. Lay people consider the making of a Kammavaca an act of religious devotion, thereby earning them merit. Lavish manuscripts were produced at the behest of lay Buddhist devotees. The text of the Kammavaca is written in the Pali language with Burmese letters. The manuscript contains rules for the governance of Buddhist monks.

The leaves of the manuscripts are made from folded cotton cloth. It is considered especially auspicious if these are recycled from used monks' robes. The cloth is coated with multiple layers of lacquer, creating smooth, firm, but slightly flexible boards. Lines for writing are ruled out using orpiment, a yellow mineral pigment. The text is also similarly laid out using orpiment. The leaves are then gilded; the orpiment guidelines show lightly through the gold leaf. Each page is then ornamented with decorative red-ruled lines and delicate vine and leaf illustrations.

The medium for the writing is black lacquer, boiled down until it has become quite thick. The letters are then painted on. Tremendous control is required, as well as a quick touch; the heavily loaded brush drops a thick, gummy drop of the black lacquer onto the page, which settles onto

the gold surface. The letters remain slightly raised from the surface, catching the light. The edges of the lacquer letters are lighter, as the lacquer pools in the middle of each stroke. On the whole, the strokes are softly rounded. Occasional sharp terminations are made with a quick flick of the brush, pulling the thick lacquer to a fine point.

The form of these manuscripts mimic the long, thin shape of a traditional palm-leaf manuscript. The leaves, however, are decidedly larger and taller than is possible

Top: Cover of a Burmese manuscript.

Middle: Burmese manuscript page.

Bottom: Burmese manuscript page.

153

to achieve with a palm leaf. The completed pages are stacked and kept between bevel-edged boards. A single hole, or pair of holes, in each leaf allows the manuscript pages to be tied together with a bamboo pin and string. The manuscript is then wrapped in a cloth protective cover, and then tied with a distinctive ribbon known as a *sa-si-gyo*.

Thai Script

Thai script is Brahmi-derived and inspired by its South Indic derivations, and more specifically by the Old Khmer script. Ram Khamhaeng of Sukhothai is credited with fashioning the Old Khmer script into a form more appropriate for the Thai and Lao languages, and today the Thai script is used to write the Thai and Lao languages.

It is a syllabic alphabet but unlike the inherent /a/ vowel that follows each consonant letter in most Indic scripts, the inherent vowel in Thai is /o/. Diacritical marks indicate other vowels, but the actual letters in Thai are all consonants. A pointed pen is the primary tool used to write the script.

Below: Detail from the *Horse Bible Manuscript*, nineteenth century. Thai calligraphy written with a pointed pen. Courtesy of Nirvana, Oriental Plaza Place, Bangkok, Thailand.

Above: Detail from a Thai manuscript. Thai calligraphy written with a pointed pen. Courtesy of Nirvana, Oriental Plaza Place, Bangkok, Thailand.

Right top: Strokes made with a Speedball B nib. This example of Thai script by Rosemary Kracke, a Western scribe, was made using a special nib with a round termination. The Speedball B series is a good contemporary version of this kind of nib. The round, flat end of the nib is placed flat on the page. It makes even, unmodulated strokes with round ends.

Right bottom: Thai study day sheet. Rosemary Kracke was given a packet of information with typefaces of the Thai script. She studied the letterforms and determined that a Speedball B-1 nib would be the best nib to work with. She ruled guidelines at approximately 9 pen-widths high. Notice the word meanings of each consonant. In her packet was a child's word chart similar to an English, "A is for Apple," primer. She wrote out the words beneath each corresponding letter.

155

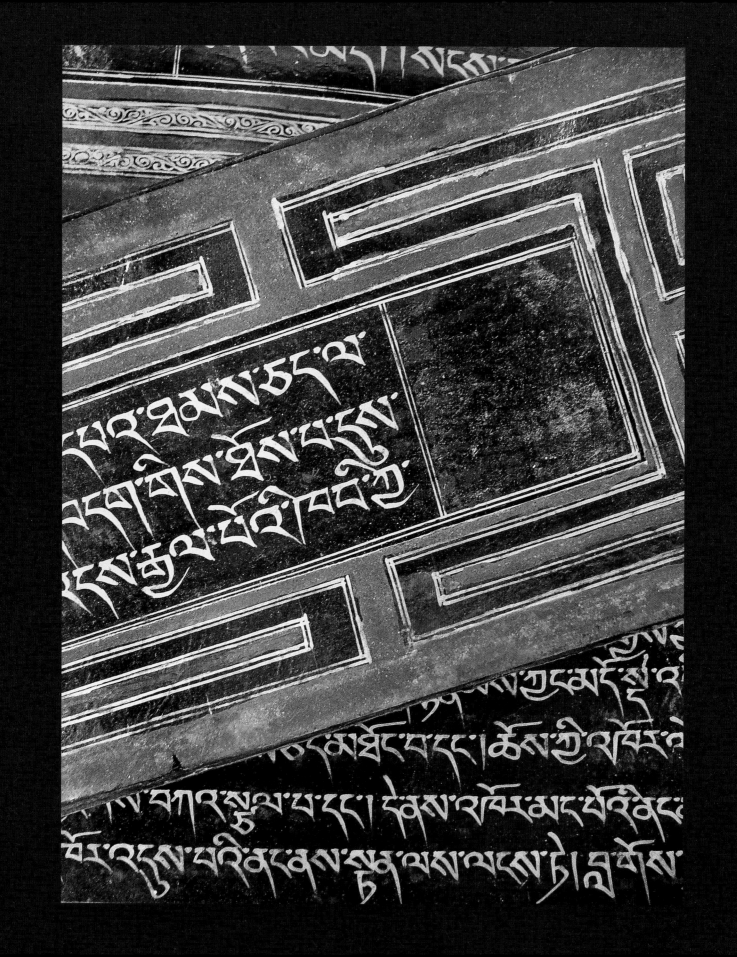

TIBETAN
Preserving a Culture
By Christopher Calderhead

Syllabic Alphabet: *Each of the 30 basic consonant characters is inherently followed by the same vowel sound unless modified by diacritical marks to indicate other vowels. Vowel characters are used when vowels appear before or separate from a consonant character.*

Direction of writing: *left to right*

Majuscule/minuscule distinction: *none*

Principal tool: *broad-edged pen*

Languages: *Tibetan and Dzongkha (Bhutanese)*

Opposite: The formal Tibetan Ü-chen script is used for this religious manuscript. This script is the noblest of the many Tibetan scripts and is traditionally used for texts of the highest importance.

Why devote a separate chapter to the calligraphy of Tibet? The Tibetan syllabary is, after all, an offshoot of the Indian scripts, with a clear visual relationship to scripts like Devanagari and Bengali. Tibet, however, has a unique place in the world of calligraphy. It had, until the middle of the last century, a strongly calligraphic culture. Due to a combination of lack of technological development, a commitment to the study of Buddhist texts, and a highly traditional form of society, calligraphy was treated as a significant art form in old Tibet. The making of manuscript books was a continuing practice and calligraphy was an important part of the education system. A large number of variant scripts were in regular use. As a result, calligraphy in Tibet enjoyed a status lost south of the Himalayas.

With the razing of so many ancient monasteries, the massive destruction of cultural artifacts, and the large exodus of refugees over the last fifty years, Tibetans have struggled to maintain their cultural heritage and importantly, they have learned to communicate it and share it with outsiders.

The Practice of Tibetan Calligraphy

Pema Bhum is the director of the Trace Foundation's Latse Library in New York. Born in Amdo province, he was trained in calligraphy from a young age. He agreed to be interviewed for this book, and is the source for much of the information shared in this chapter.

Types of Script

Pema Bhum explained that there are two main types of script. The most commonly seen today is *Ü-chen* (This is pronounced *oo-CHEN* and is often transliterated as *dbu-can*. The transliteration of Tibetan words is problematic. Various methods of rendering the sounds of Tibetan into English are in use. The standard transliterations contain many consonants that are functionally silent.). Ü-chen means writing "with a head." The other dominant script is *Ü-me* (pronounced *oo-MAY* and often transliterated as *dbu-med),* which means writing "without a head."

Ü-chen's "head" is the horizontal line that runs along the top of the letters. Vertical lines taper at the bottom. The body of each letter contains a square or round opening.

Ü-me is often referred to as a "cursive" script. It has no horizontal line along the top of the letters. Bhum told me, "There are many types of Ü-me scripts, but three are practiced most widely. The *Dru-tsa* (*drew-TSAH,* also transliterated *brug tsha*), has a rain-shaped body, elaborate sweeping lines to render the vowels, and dramatically long stems, used for ceremonies, invitation letters, contemporary cards, and so forth. *Chu-yig* (*chew-YIG,* also transliterated *Khyugs yig*) is a quickly written cursive script with linked letters. The *Dpe bri* script is also elegant but more compact than *Dru-tsa,* with a square body and much shorter legs that are not tapered. This last, which is most common in Eastern Tibet and is sometimes called Kham-writing, is frequently used for copying books. While the name literally translates as "text-writing" script, all scripts described here are used for writing texts.

Finally, one might consider the scripts found on woodblock prints to be also a sort of calligraphy. These scripts, too, vary in form—and depend on the training and talent of the calligrapher who originally penned the letters prior to their being carved.

Lantsa script.
v. geometrical.
(drawn?)

According to Tibetan tradition, it was a minister named Thonmi Sambhota who brought the Tibetan alphabet back from India in the seventh century. Adherents of this view claim that Tibetan Ü-chen script is based on the Lantsa Script. In the past century, this traditional view has been challenged by a number of scholars, who have used paleographic evidence to chart the evolution of the script. Many contemporary Tibetan scholars now believe that Tibetan writing was derived from the Gupta script. The full paleography of Tibetan scripts is still a matter of scholarly contention.

Hierarchies of Scripts

Traditionally, Ü-chen was reserved for sacred texts. Ü-me was used for secular purposes, for government writings, economic matters, legal briefs, and personal letters. This division has not lasted to the present. Typographic fonts in

Above: This page shows the strong geometric forms of the Lantsa script.

Opposite: Traditional Tibetan pens are cut from lengths of bamboo, and are made by the scribes themselves.

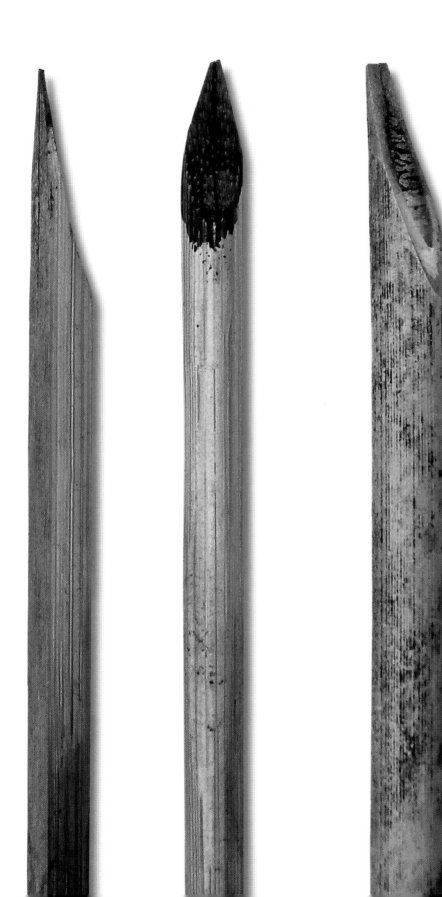

Tibetan are commonly Ü-chen, and contemporary printed documents are invariably set in a typographic version of this script. Under the pressure of Chinese and Romanization, Ü-me is slowly being eclipsed.

Tools and Techniques

There used to be many tools used in Tibetan calligraphy, including a string used to line writing boards and other surfaces. The introduction of paper, however, has made the use of string unnecessary.

During Bhum's generation, the necessary tools were paper, bamboo, and ink, as well as glue and sugar used as additives for the ink. A knife and whetstone for sharpening the knife were also basic elements of the calligrapher's tool kit. When Chinese ink was purchased, sugar was added to resist water and glue was added to make the ink shiny.

Pens were fashioned from bamboo, using both rounded and flat bamboo sticks, both of which were shaped into pens.

Prior to the implementation of writing on paper, wooden boards were employed. One of these is shown in the introductory chapter.

Pens

Although it is possible to purchase calligraphic pens, many calligraphers still prefer to make their own. Knives are used to fashion pens out of lengths of bamboo. When fashioning a pen, it should be no longer than the span from the thumb to the middle finger; nor should it be shorter than the length of the index finger.

When carving a pen, a slight hollow is carved about ½ inch from the tip of the pen; alternately one can carve out a slight hollow or make the surface concave on the softer side of the bamboo until it reaches the tip. The harder, outer surface is retained. This is called shaping the *smyug rdzing* (the "pond" for the ink). The tip is about ⅛ or ¼ inches (0.32 cm or 0.64 cm) wide, depending on the size of the letter desired.

So that the ink can run fluidly, a crack is made in the center of the tip. For a slow controlled flow, this slit should be thin. Otherwise, if more ink flow is desired, a wider cut can be made. Once the pond has been formed and the slit cut, the nib is cut with one swift motion.

In Amdo province, it is considered important that the joint of the bamboo rests about two-thirds of the way back on the bamboo. Sometimes the back end is carved until it is flat and sharpened.

The nib of the pen may be cut at different angles, depending on the script being written. For Ü-chen, the tip is slanted upwards. For writing the cursive Ü-me script, it is better to use a pen with a downward slant.

The choice of ink used for Tibetan calligraphy is very important. A rather shiny ink is preferred. The ink used for fountain pens does not work for this type of calligraphy, as it is too blue. Chinese ink is too thick, so it is necessary to add some water—but then it bleeds. Pema Bhum explains that to prevent the ink from spreading, sugar is added. To make the ink shiny, glue is added.

In Western countries, the need to fashion pens from scratch is rare as manufactured calligraphy pens are available. Tibetan calligraphers are not traditionally accustomed to a nib that has a straight cut, but they can adjust the position of the pen in their hand when using a square-cut nib.

Paper

Pema Bhum writes on paper only, rather than on wooden boards or other surfaces. The type of paper depends on the ink. If the ink is thin or watery, he prefers to use a well-sized paper with a hard, smooth surface. Some Tibetan papers, made from plant fibers, are rather absorbent, and require a thicker consistency of ink. Among western papers, he prefers watercolor paper or calligraphy papers from art stores.

Posture

Posture is a major consideration for all calligraphy. When we asked Pema Bhum his recommended posture, he told us that when he was younger, he used to sit cross-legged on the floor at a low table. Nowadays, he sits at a chair at a table or a desk. Another

Opposite: This pencil drawing shows how folded paper was traditionally used to provide guidelines for writing. The drawing is after a sample of writing by Tashi Dundrop that was created for a workshop and displayed at the Latse Library in New York.

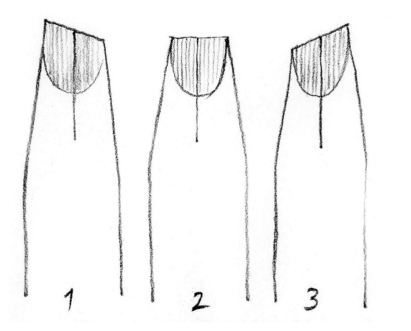

Left: Hand-cut pens for writing the Tibetan scripts are cut at different angles, depending on the script. These sketches show three pens, seen from the top. The semicircular shape at the top is the flat surface created by slicing a segment from the top of a round reed or bamboo. From left to right: a pen for writing Ü-me, a pen for writing Dru-tsa, and a pen for writing Ü-chen.

Tashi Tsundrup folds paper to make lines for u-c...

u-chen

calligraphy training was in fact the backbone of the educational system. At a conference held in 2005 at Columbia University, calligrapher Rigzin Samdup described this classic form of education. He later published an extended version of his experience in the *Latse Library Newsletter*. The training he received was rigorous and took place within a very hierarchical system. Teachers and their assistants had clear ranks, and students would advance in stages. Even the color of inks defined one's place in the pecking order: The teacher wrote in red; the class head wrote in blue; and the class monitor wrote in black.

As a young child, a beginning student would be assigned to a *Kashib Shibko* (*Khai'i zhib go*), or Alphabet Monitor, who was an advanced student functioning as a teaching assistant. The student sat cross-legged on the floor, and used a wooden writing board. Standing behind the student, the monitor would take hold of his or her hand, demonstrating the movements of writing an alphabet on the board. Once the movements had been mastered, the monitor would write a few model letters on the board that the student would then trace in ink. Students progressed from writing on their wooden board to writing paper. The paper would be folded accordion-style, as described previously.

Moving through the course of study, the student would progress up the hierarchy, being placed in turn under the *Tsuk-ring Shibko* (*Tshugs ring zhib go*), or Elongated Form Monitor, then the *Tshukshib* (*Tshugs zhib*), or Form Monitor, and finally under the *Chidrel Shibko* (*spyi gral zhib go*) or "General Corrector." Under each of these successive tutors, the student would study a set sequence of scripts, beginning each one on the board and moving on to paper when the forms had been mastered. The scripts progressed from the Elongated Form of Ü-me—*Tsuk-ring*—to smaller and more

traditional posture was to sit on the floor cross-legged with a hard tablet held in one's lap. If no tablet was available, the writer could again sit on the floor, and, folding the paper accordion style, use the palm of the nondominant hand as a supporting surface. As each line of writing was completed, the paper would be refolded, revealing the next blank panel.

Guidelines

Tibetan is generally written on a three-line system, although the guidelines actually drawn will vary, depending on the skill of the writer. When ruling up for Tibetan scripts, the top horizontal line is the most important. All the letters hang from this line. The next line below marks how far the main body of each letter hangs down. The third, bottom line marks the depth of the longest descending strokes.

Bhum generally does not rule his own lines. If the paper is rather thin and the letters relatively small, he sometimes uses a ruled paper with dark lines underneath his writing sheet, or places graph paper underneath.

Sheets of paper can also be folded accordion-style and then unfolded, creating a pattern of parallel lines that may be used as guidelines. This is a good method for students, and is only appropriate for rather large writing.

Uses for Tibetan Calligraphy

Calligraphy is still frequently used for book titles, though the book itself might be in print. Tibetan calligraphy books are still produced and used as models and one can find Tibetan calligraphy on exhibit. A few Tibetans have started to develop calligraphy into an art form using it for cards for Tibetan New Year and other occasions. Finally, one often finds congratulatory remarks written in calligraphy by certain scholars or leading figures for the launching of a book, anniversary issue, commemorative issue, or other special edition.

A Traditional Calligraphic Education in Lhasa

Before 1959, a comprehensive training in calligraphy was given to aristocratic children at private schools in the Tibetan capital, Lhasa. Although other subjects, such as arithmetic, were covered at the schools,

delicate scripts, ending with a cursive form. Mastery of calligraphy was an essential step in moving into the higher echelons of society in the civil service or business.

How Do Students Learn?

Pema Bhum: "I have experience with Alak Tseten Zhabdrung, a very learned teacher in Lanzhou. I studied how to write in Lantsa script that is used for writing Sanskrit in Tibetan. My teacher also taught me Tibetan cursive script. We used a writing board, which we smeared with butter and sprinkled powder. Then my teacher would use a pen made of soft wood and scratch the letters into the powder. I would copy his writing and then he would correct my writing. Once we accomplished this, then we could graduate to using paper. My training was not as formal as the teaching methods in Lhasa."

The Tibetan Book

The traditional shape of the Tibetan book is derived from the palm-leaf format common in the region. Long, thin pages are stacked together and held between boards. There is no binding structure: the pages are loose. The book shown here is a scripture from the Buddhist canon, and is written on stout laminated pages. The outer boards are extra thick, bound together with little leather ties and is a study in chastity: plain yellow writing on a somber, black background. Inside, however, the book reveals a series of sumptuous opening pages. These become progressively simpler as one turns the pages; the interior pages of the book are solid black, its text is written with a reed in Ü-chen. The pages have been prepared with layers of pigment, burnished to a high sheen in the central area where the text is written. When not in use, the book is carefully wrapped in cloth.

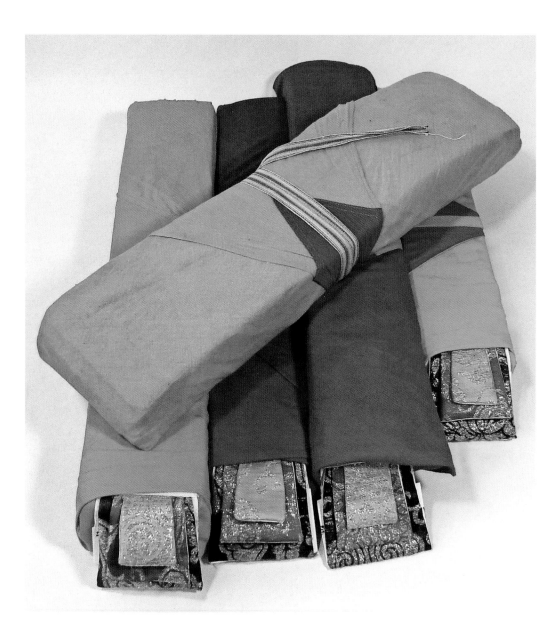

Opposite, top: Tibetan books present a bright spectacle in their saffron wrappings. The small brocade flaps hide labels identifying the contents.

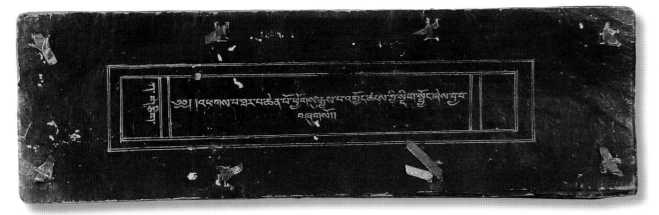

Left: The cover of the book is extremely simple, giving no hint of the rich page treatments inside.

Right: A scripture from the Buddhist canon shows the elegant structure and page layout of the traditional Tibetan book. The long, unbound pages are kept in a neat stack between heavy covers, and the book is stored in a cloth wrapper. The opening pages of the manuscript are the most elaborate, with blue and gold borders.

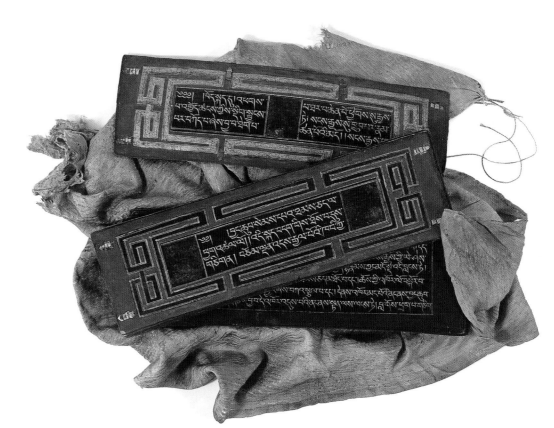

Left: Most of the internal pages of the manuscript are simple black pages. The unadorned lines of text are surrounded by a chaste ruled border.

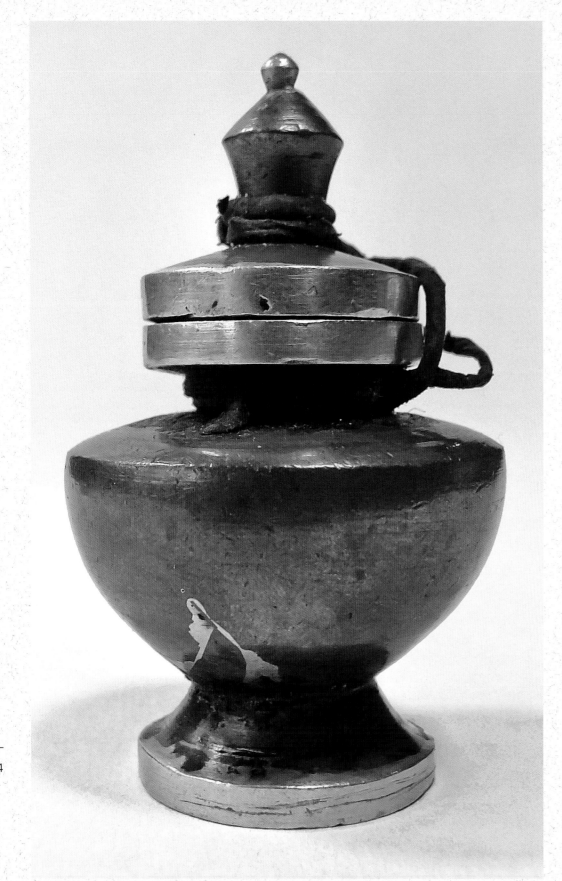

Inkwells

In traditional Tibet, an inkwell was an item of prestige. Some important officials even wore them attached to their robes to advertise their erudition and authority. The shapes of these handmade inkwells are inventive; they take the form of urns, stupas, and other fanciful forms. To prevent the ink from spilling, these inkwells have a deep well and large stoppers; leather thongs keep lids from being lost. Before writing, the scribe swirls the ink in the pot to mix it. After dipping, he raps his reed pen against the side to knock off excess ink.

Left: Closed bronze inkwell with thong attaching stopper to neck.

Below: Inkwell with stopper removed.

Above: Brass inkwells ranging in size from 2 to 6 inches (5.1 to 15.2 cm).

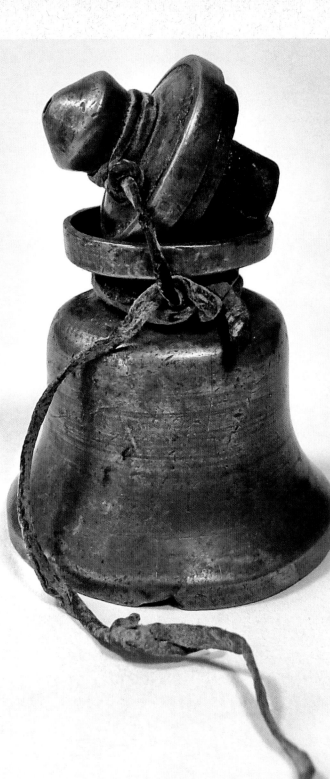

Above: The stopper has been opened and is leaning on the top of the inkwell. A thong keeps the stopper from being lost. The inkwell is in the shape of a stupa.

Writing Ü-me: Tsuk-ring or Elongated Form

The exemplar on the following pages is a "progressive" alphabet: each letter is shown as a sequence of strokes building up (from left to right) to the finished letter. Note that the last stroke of every letter is an upright straight line—this is a marker used between certain syllables in Tibetan texts. It is not integral to the letterform, but rather is a convention used after a letter of the alphabet when it is written outside the context of words.

The pen angle is variable; it slides between 10° and 30°. At the bottom of many strokes, the pen is turned onto its left corner. The stroke can be a sudden movement or a more gradual shift. For example, in the first letter, *Ka*, seen at the top of the opposite page, the two diagonal strokes have a gradual pen lift onto the corner, while on the long stroke, the pen is turned at the very last minute, producing the small protrusion at the base. Thin lines are always made with the left corner of the pen. *Calligraphy by Rigzin Samdup Langthong.*

The dominant pen angle varies between 10° and 30°.

Manipulated strokes

The Ü-me script contains many manipulated strokes. As the scribe executes the stroke, the pen is turned onto its left edge, so that the whole surface of the edged pen is not longer in contact with the page. A sample of such strokes is shown below.

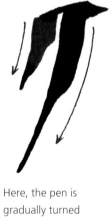

Here, the pen is gradually turned onto its left corner, beginning at the middle of each downstroke. The manipulation begins at the point where the stroke becomes narrower.

At the very end of this stroke, the pen is suddenly turned on its left corner and is pulled off to the right.

Here, the pen is turned on its left corner at the end of the stroke.

This stroke is made with a gradually steepening pen angle. The stroke begins at about 15°. As the pen is moved along the curve, its angle steepens to almost 90°. At the point where the stroke becomes narrower, the pen has been turned onto its left corner and the right corner of the nib has lost contact with the page.

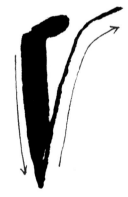

The fat part of this stroke is made at the standard 10° pen angle. At the bottom of the stroke, the pen is suddenly shifted to its left corner. The thin, unmodulated line that brings the stroke back up to the top is made with only the corner of the pen.

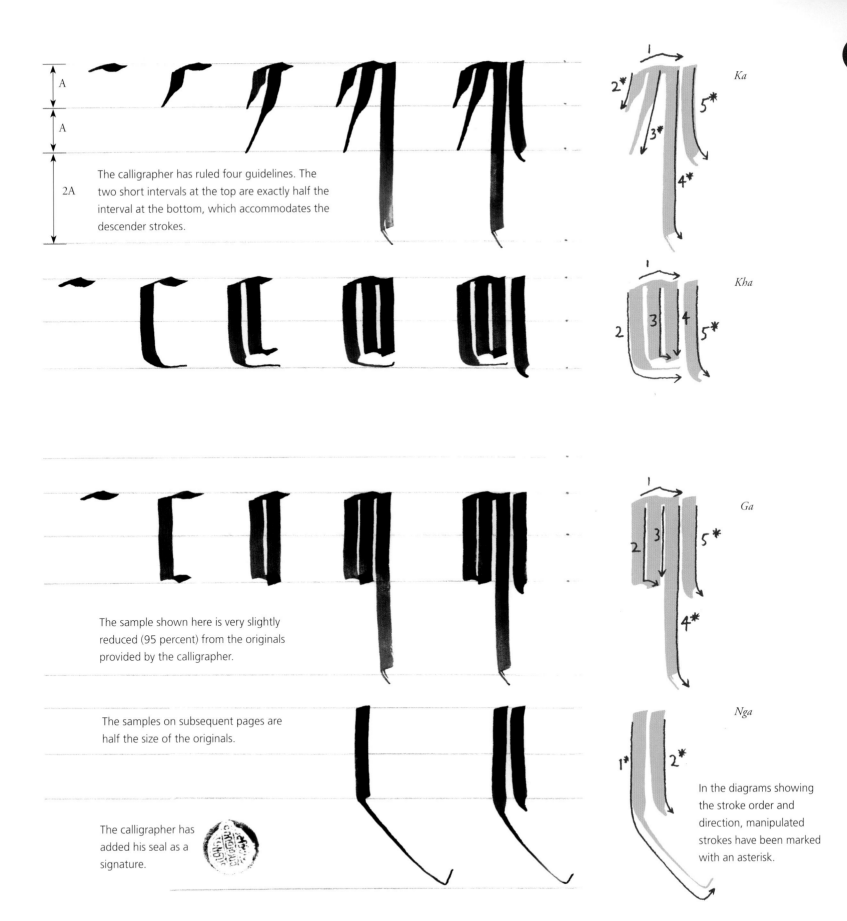

Ka

The calligrapher has ruled four guidelines. The two short intervals at the top are exactly half the interval at the bottom, which accommodates the descender strokes.

Kha

Ga

The sample shown here is very slightly reduced (95 percent) from the originals provided by the calligrapher.

The samples on subsequent pages are half the size of the originals.

Nga

The calligrapher has added his seal as a signature.

In the diagrams showing the stroke order and direction, manipulated strokes have been marked with an asterisk.

Ü-me Letter Progressions

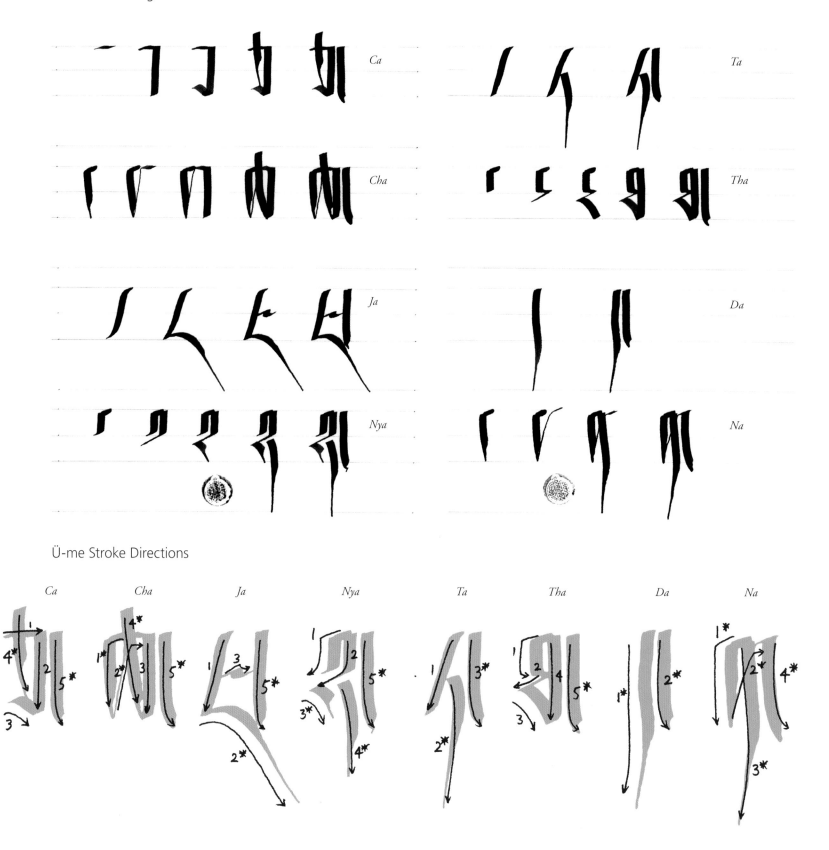

Ca

Cha

Ja

Nya

Ta

Tha

Da

Na

Ü-me Stroke Directions

Ca	Cha	Ja	Nya	Ta	Tha	Da	Na

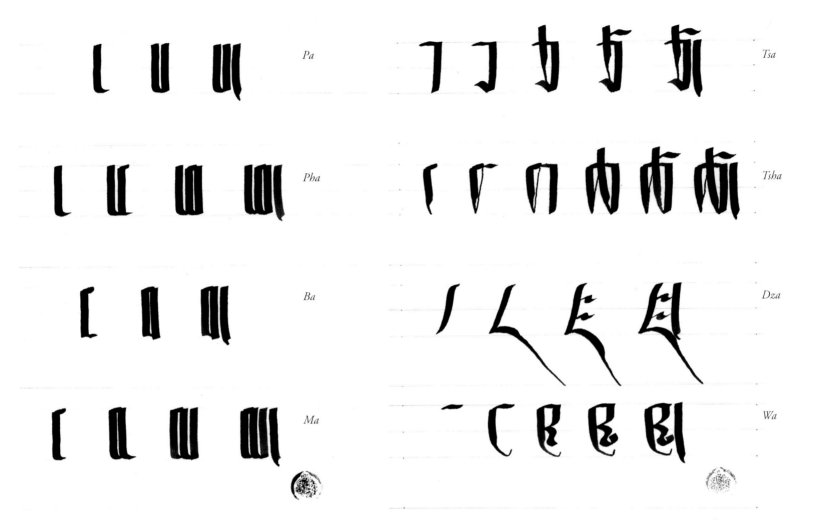

Ü-me Letter Progressions

Pa

Pha

Ba

Ma

Tsa

Tsha

Dza

Wa

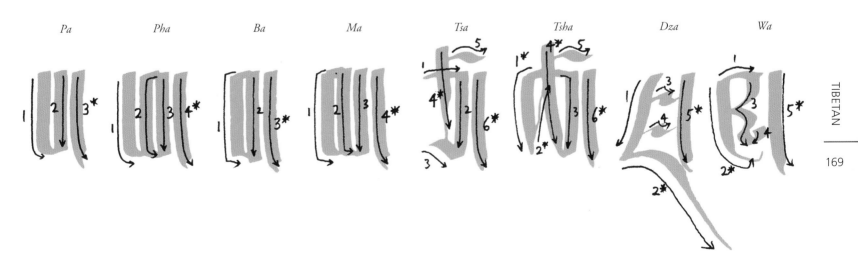

Ü-me Stroke Directions

Pa	Pha	Ba	Ma	Tsa	Tsha	Dza	Wa

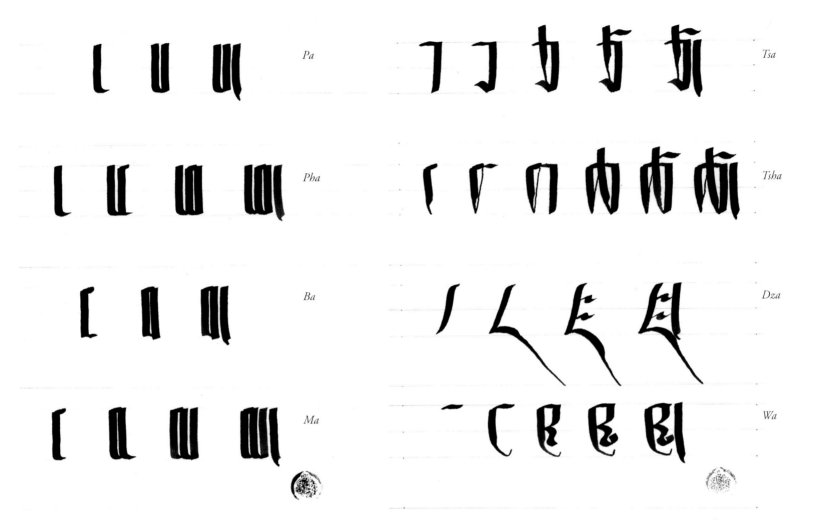

Ü-me Letter Progressions

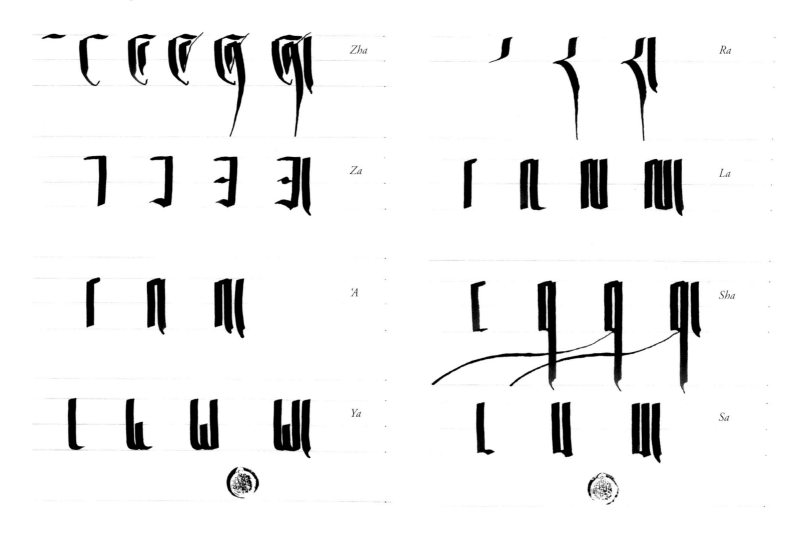

Zha

Ra

Za

La

'A

Sha

Ya

Sa

Ü-me Stroke Directions

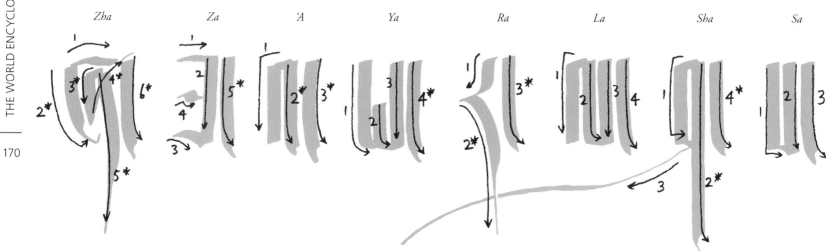

Zha Za 'A Ya Ra La Sha Sa

Ü-me Letter Progressions

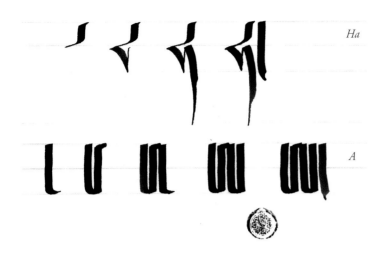

Ha

A

Ü-me Stroke Directions

Ha *A*

Details

Above: Two lines of text demonstrate the placement of words in relation to each other and line spacing.

Right: Letters are sometimes stacked to place two consonants together without an intervening vowel sound.

Right: Each of the characters represents a full syllable, ending with an ah sound. To indicate the other vowel sounds, a diacritical mark is added, which changes the standard ah value of the syllable to a different vowel. The diacritics in this script are written in the white space above and below the letters. The are as follows:

1. Re, made of the letter *Ra* with the diacritical for an e sound.

2. *Chu*, made of the letter *Cha* with the diacritical for a u sound.

3. *Mi*, made of the letter *Ma* with the diacritical for an i sound.

4. *Zho*, made of the letter *Zha* with the diacritical for an o sound.

1 2

3 4

Writing Ü-chen

Ü-chen is written at a fairly consistent 70° pen angle. As in the Ü-me script, some strokes are manipulated. *Calligraphy by Pema Bhum.*

The dominant pen angle in this script is 70°.

Ü-chen Letters

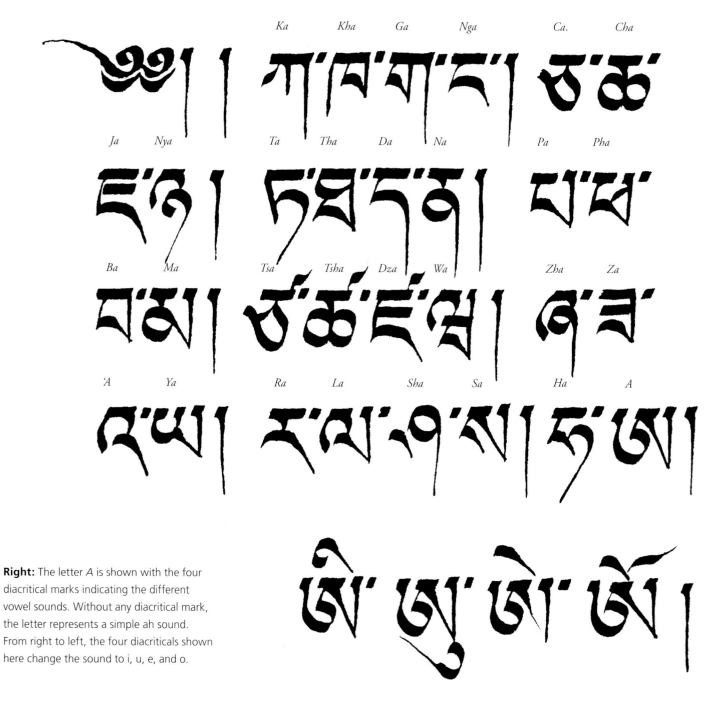

Right: The letter *A* is shown with the four diacritical marks indicating the different vowel sounds. Without any diacritical mark, the letter represents a simple ah sound. From right to left, the four diacriticals shown here change the sound to i, u, e, and o.

Ü-chen Stroke Directions

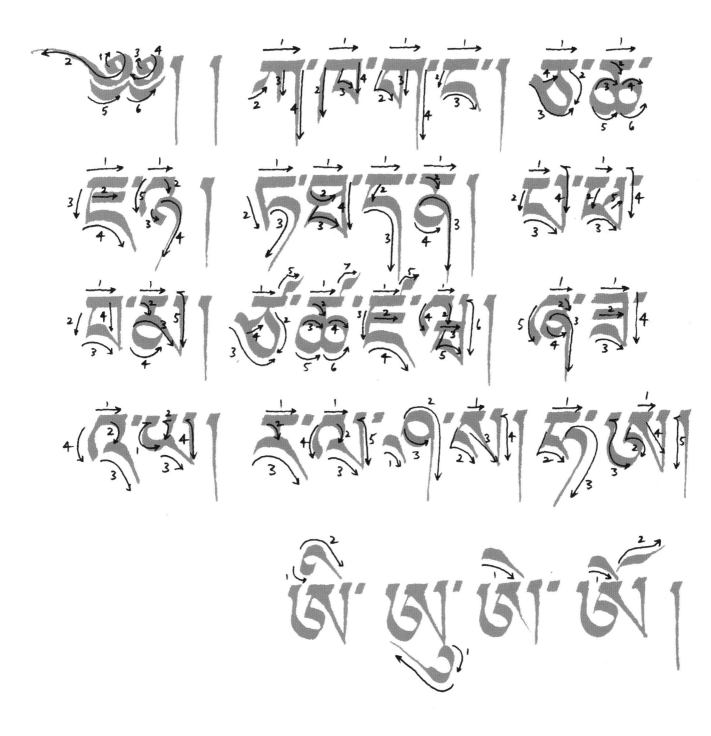

ཀ ཁ ག ང ཅ ཆ ཇ ཉ ད

ཕ ༄༅། །ཀཁགང་། ཅཆཇཉ། ཏཐ ད

ན བམ། །ཙཚཛྫ། །ཞཟའཡ། རལཤས། ཧཨ། ཕ

ཉ ༀ །ཡིག་གི་བསྐྱེད་བཅོས་ལས། ཤུཞིམི་ཆེཆུམི

པ ཡོགས། །ཀློཾ ༀ། །ཿ བམིཆེམུ་ནེ བ

མ མེད། །ཀ་ཁྭི་གི གུ གེ གོ མི་རིང་ཆུ་མི ཚ

ཚ འཕོག །ཉིཾ ༡༢༣༤༥༦༧༨༩༠ ཉིམ་ཉུས་མེན ཇ

མ་ཚར། །ཡིག་ཀློ་ཚོ་ནས་བ་དཾཿ འམ་དགོས། །

པ ཉིམ་མཚེས་དག་ལ་གཏོད་མ་ཉེད། །ཿ ཞ

བྱ ཌ ཡ ར ལ ཨ ས ཧ ཨ

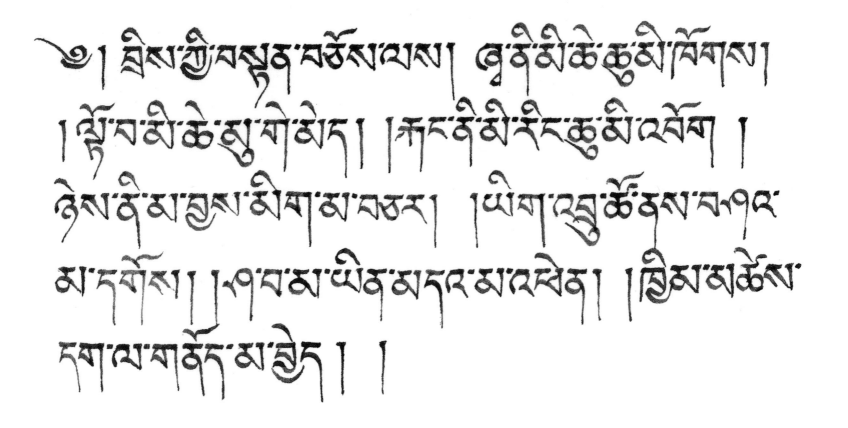

Opposite: A Ü-chen alphabetical panel by Pema Bhum. The small row of monoline figures near the center are Tibetan numerals.

Above: A passage of text written in Ü-chen, giving advice to calligraphers in the form of pithy aphorisms, states: "The hat doesn't need to be too big: it won't block rain" (Don't make the top bars too long). "Don't make the eyes blind: the letter is not a criminal" (Don't let your white spaces disappear by making the circular shapes of the letters too small). "The alphabet shouldn't be fat: we don't need to kill it for meat" (Don't make the letters too wide).

The little curled mark at the upper left, called a *yin-go*, functions like a paragraph marker, showing where the text begins. The long strokes, called *sheys*, are roughly equivalent to a period. Calligraphy by Pema Bhum.

Other Varieties of Script

Dru-tsa

Dru-tsa is used mostly for decorative purposes, like titles, although it may be used, as it is here, for text. Its tear-shape bowls makes dru-tsa easily recognized. *Calligraphy by Rigzin Samdup Langthong.*

THE WORLD ENCYCLOPEDIA OF CALLIGRAPHY

Tsuk-kyuk

These free cursive letters were made with a Tibetan bamboo pen. *Calligraphy by Rigzin Samdup Langthong.*

Tsuk-chung

A short-legged variety of Ü-me. *Calligraphy by Rigzin Samdup Langthong.*

Kham script

The distinctive Kham script seen here has been used to transcribe a passage from the Buddhist scripture, the *Arya Astasahasrika Prajnaparamita.* Square and extremely regular, this script is associated with the Eastern regions of Tibet. It is especially valued as a book hand for writing extended passages of text. *Calligraphy by Pema Bhum.*

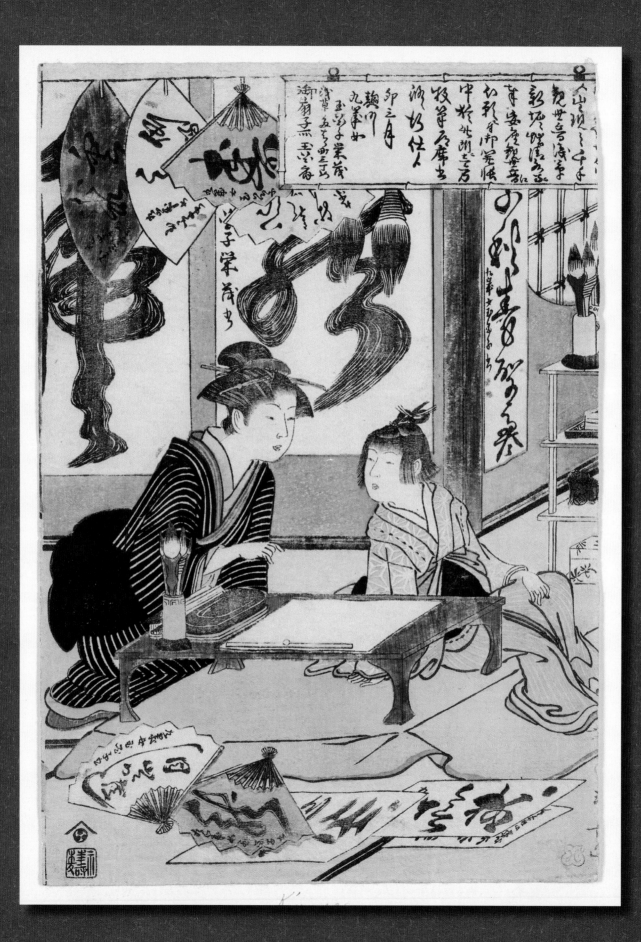

THE EAST ASIAN BRUSH
The Four Treasures of the Scholar

By Christopher Calderhead with comments by Yoo Sung Lee

Left: *The Young Girl Gyokkashi Eimo,* c. 1781. Torii, Kiyonaga (1752–1815). Woodblock print in color. 8¾ x 6 in. (22.1 x 15.5 cm).

This print, from a series depicting young calligraphic prodigies, depicts Gyokkashi Eimo with her calligraphy instructor. They sit, Japanese fashion, on the floor facing a low writing table. Under the table, a cloth has been placed to protect the tatami mats. Arrayed around them are fans, scrolls, and unmounted sheets, all showing examples of calligraphy. The table is prepared for writing and a clean sheet of new paper lies in front of the girl. It is held down by a long, thin paperweight. A pot of brushes and an inkstone lie ready at the side.

The brush, ink stick, inkstone, and paper are known as the "Four Treasures of the Scholar" in East Asian cultures. More than just basic tools and materials, these four objects are traditionally honored elements revered by the calligrapher as integral to the calligraphic arts. In this section, we look at the use of the brush.

Brushes are made from a wide variety of animal hairs, including squirrel, wild rabbit, badger, goat, ox ear, horse, weasel, deer, or even wolf. Many brushes will be made of a combination of hairs, with the stronger, stiffer hairs creating a firm core, while an outer layer of hairs provides a tip that is more supple. Some contemporary brushes are made of synthetic fibers such as nylon.

Good brushes are an investment. To prolong their use, it's a good idea to give them the simple care they require. A newly purchased brush will usually come with a plastic tube protecting its bristles. This is only used when packing new brushes; it should be discarded.

The bristles are usually dipped in starch to bind them firmly together during shipping and storage. The new brush should therefore be soaked in water for a short time (less than an hour) to dissolve this binder, leaving the bristles soft and flexible.

Brushes will usually have a small loop opposite the writing end to allow them to be suspended from a rack when not in use. After writing, once the ink has been rinsed from the tip, it is good to let the brush dry suspended from the loop in order for it to retain its shape. Once the brushes have dried, they can be stored in a pot, bristles facing up. For travel, brushes may be rolled in a small bamboo mat, which protects the delicate bristles and prevents them from being squashed or bent.

When writing with the East Asian brush, it is held point down, and generally in an upright (as opposed to an angled) position (see the section on Kanteiryu in the Japanese chapter for an exception to this rule). It is an

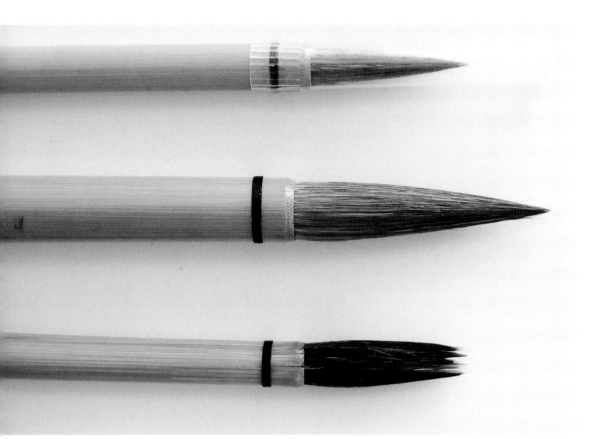

Left: A new brush (top) will often be sold with a plastic tube protecting the bristles. This should be discarded. The middle brush, also brand new, has bristles that have been treated with starch; this holds the bristles together and protects them during shipping and storage. The bottom brush has been left to soak in a pot of water, bristles down; this dissolves the starch, and frees the bristles. The brush is now ready to be used.

Below: A brush lying in the grooves of a brush-holder.

incredibly subtle, responsive tool. That the same tool is used for painting and writing in East Asian cultures is no accident; the variety of strokes that the brush can make is far more than the strokes made with an edged or pointed pen.

Posture

The body postures used in writing with a brush vary from culture to culture and country to country. The Chinese, for instance, have always worked sitting in a chair at a table similar in proportion to a Western desk. By contrast, the Japanese have traditionally sat on the floor and have used a low table, or they have laid their paper directly on the floor. In modern times, with the increased use of Western-style furnishings in Japan, people do sometimes work at tables as we do in the West. No matter what posture is adopted, the writing surface is always flat, not tilted.

Right: Tools for calligraphy belonging to the Korean calligrapher Yoo Sung Lee are laid out on a piece of orange cloth. The cloth will be used as a pad underneath the sheet on which he will write, providing a pliant surface and protecting the table-top from ink that may soak through the thin paper. The tools are as follows:

1. Brushes of various sizes.

2. A large brush, used for painting large ink washes (this brush is not used for calligraphy).

3. Ceramic pots to hold water. These characteristic pots each have two small holes and are filled by being immersed in a larger container of water. The small holes allow the calligrapher to drip very small, precise amounts of water into his inkstone.

4. Small ceramic brush-holders. These allow the calligrapher to put down a brush still wet with ink; the brush will not spill ink onto the table, or roll away when a brush-holder is used.

5. Two porcelain paperweights and one long metal paperweight. Because East Asian papers are so thin, it is important that they be held in place with weights before the writing is executed.

6. At the very top, a partial view of an inkstone with a carved cover.

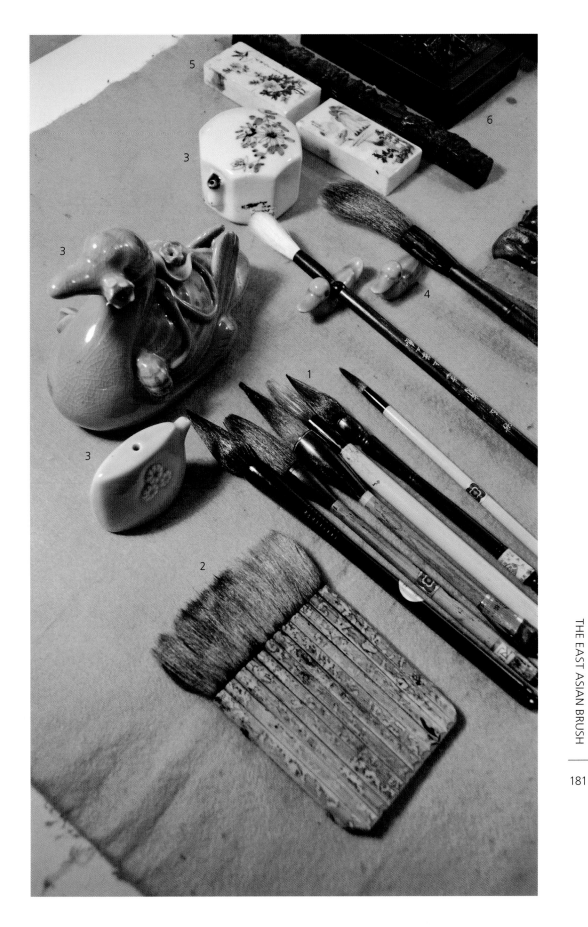

The Korean calligrapher Yoo Sung Lee gives this advice: "Your posture while you write depends on the size of the characters you intend to write and your physical condition. Proper posture will affect the speed of your progress and also your health."

It is important that the body be at ease. He continues, "When sitting in a chair, the body should be erect, the shoulders balanced and the back straight. The legs should be apart, the feet placed evenly and firmly on the ground. The paper is held down gently by the left hand. The right hand holds the brush. The head is slightly forward, but be careful not to bow too low. Fix your eyes on the spot where you intend to write. Your eyes and the tip of your writing brush should be about 30 centimeters apart. Your whole body should feel natural; do not pay undue attention to posture, or your body will become stiff or rigid. Correct posture simply prevents deformity of your body and enables you to write well. If you write characters larger than 10 centimeters, you will have to stand up and write."

How to Hold the Brush

Mastering the brush hold is essential to the practice of all the East Asian scripts. The action of writing is more like Western painting than like Western writing. Pen-writing involves a relatively fixed position of the hand, which grips the tool firmly near its writing tip, and rests comfortably on the table. By contrast, the writer using a brush holds the tool suspended in the air above the paper. The hand grasps the shaft of the brush rather high up, halfway or even two-thirds of the way up the length of the tool. To those unfamiliar with the brush, this can be unnerving; the tool may seem hard to control at first. But the free movement that this brush-hold allows is crucial to the subtle movements that are required for the East Asian scripts.

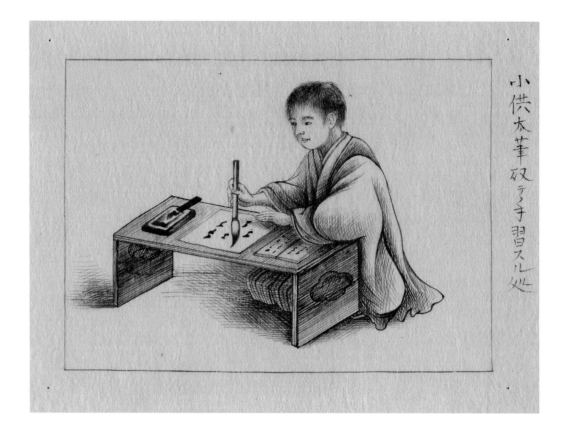

Above: *Learning to write*, 1878.
Ink drawing. 2½ x 3½ in. (6.5 x 9.2 cm).
A Japanese boy kneels at a writing table, preparing to write. Note how he holds the brush, upright, with the bristles pointed down—a classic hold for the East Asian brush.

There are many variations of brush holds. In general, the thumb, index, and middle finger wrap around the shaft of the brush, with the pinky and ring finger tucked under. The palm of the hand does not touch the brush; it remains relaxed and open.

The position of the hand on the shaft of the brush may vary depending on the size of the writing and the size of the brush being used. In general, smaller writing requires the hand to grasp the shaft closer to the bristles, while larger writing is made with the shaft held farther from the bristles.

Opposite, bottom: Yoo Sung Lee demonstrates and explains the technique for making ink: "*Meok,* the ink stick, is rubbed with water on the *byeoroo.* Place a little water in the well of the inkstone. Keep the *meok* upright; hold it with the thumb on the one side and the index and middle fingers on the other side. Press the *meok* on the *byeoroo* very lightly and start describing circular movements with the stick until the right consistency of ink is achieved. You may add more water during the grinding if necessary. Your ink should be rich and black, not thin and watery. If a large amount of ink is desired, several small batches should be prepared in the inkstone and transferred to a larger inkpot. One should not keep leftover ink or store ink in liquid form; new ink should be made for each writing session. Learning to rub the *meok* is an essential part of calligraphy study."

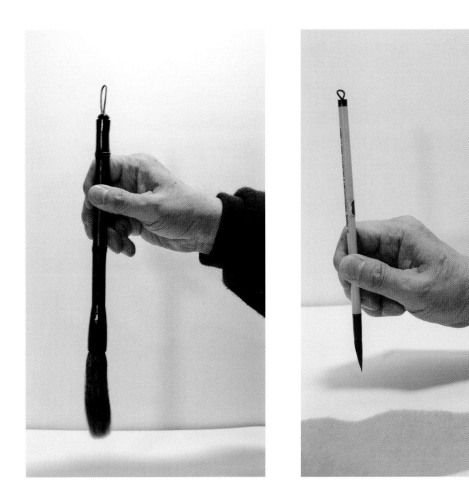

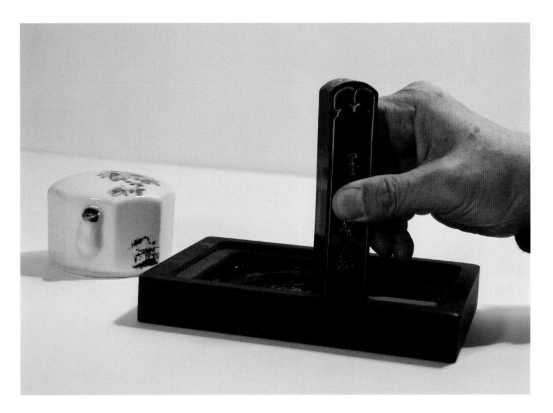

Top left and top right: There are four standard ways to hold the brush. They are: (i) rest, (ii) cushion, (iii) lift, and (iv) suspend. Two of them are illustrated here. To the left, the brush is held in position (iv); the position for holding a brush to write large characters. To the right is position (ii); the position for holding a brush to write small characters. A full description of the brush-holds by Yoo Sung Lee appears below:

"To practice calligraphy, you should learn the proper way to hold the brush. This has much to do with the body's posture. You should also learn how to use your wrist and elbow while writing.

"The brush should be held midway between the two ends. If you write characters larger than 10 centimeters, you are recommended to hold the upper two-thirds of the brush. Basically, use three fingers—your thumb, index, and middle fingers—to hold it, resting your ring finger for support and allowing your pinkie to lie naturally. The brush is always held upright, with the hand not touching the paper.

"Besides the fingers, one should use the wrist and elbow to write well. The wrist is crucial and must be used with agility. You use the wrist to manipulate the tip of the brush. The four positions of the wrist are: (i) rest, (ii) cushion, (iii) lift, and (iv) suspend.

(i) Rest the wrist of your right hand on the table. This will enable you to use your fingers well. Employ this method when you are writing very small characters; (ii) Cushion the wrist of your right hand. Usually you cushion it with your left thumb or your left wrist. This lifts your right wrist. This method is very often used for writing ordinary small characters.

(iii) Lift your right wrist from the table. Some people also call it suspending the wrist. It is used to write medium-sized characters.

(iv) The last position is to suspend both the wrist and the elbow. Neither touches the table. This method is used to write big characters.

"These four wrist positions are only relative. If you intend to raise your calligraphy to the level of art, you should practice the suspended-wrist position from the very beginning. Would-be calligraphers should not be afraid of difficulty. They should acquire this basic skill."

The Four Treasures of the Scholar

These descriptions, written by Yoo Sung Lee, describe the Four Treasures from a specifically Korean perspective and use specifically Korean terminology. They are, however, equally applicable to writing from China and Japan.

Necessary Tools

Necessary tools in *Seoye* (calligraphy in Korean) include (1) *Boot* (brush), (2) *Moek* (ink stick), (3) *Byeoroo* (inkstone), and (4) paper. These "Four Treasures" are also referred to as the "Four Friends of Study."

Boot (Brush)

Unlike Western calligraphy, which is written with a hard pen, the traditional writing implement in East Asian calligraphy is the brush pen (*boot* in Korean). The body of the brush pen is usually made from bamboo, and its head is made from the hairs or feathers of a wide variety of animals. Different kinds of hair are mixed together to make an appropriate quality for any particular purpose such as texture (soft, stiff, or combination of the two) or size (small, medium, or large).

Meok (Ink Stick)

The preferred ink for calligraphy is an ink stick. Today, much cheaper, pre-mixed bottles of ink are available, but these are used primarily for practice. Stick inks are considered higher quality, and are the only inks suitable for use in hanging scrolls. Ink is obtained from the refined soot derived from burned wood or oil. It is bonded with a fragrant adhesive and molded into a solid stick. To create liquid ink, the stick must be rubbed with water on the *byeoroo*.

Byeoroo (Inkstone)

Water droplets are poured onto the inkstone, and the solid ink stick will be rubbed into this water on the stone creating liquid ink. The inkstone will contain the ink once it is liquid. A good *byeoroo* retains liquid ink for a long while, and is rubbed producing very fine particles of *meok*. A cheaper *byeoroo* can be made of plastic. *Byeoroos* are often carved, so they are collectible works of art on their own. As for Korean products, *Haeju-yeon* (*yeon* is another terms for *byeoroo*) are made of stone from the sea off Haeju, Hwanghae-do Province. *Jongseong-yeon* are made from the stone of the rugged mountain of Jongseong-gun, Hamgyeongbuk-do Province. These two kinds of inkstone are said to be the best. *Nampo-yeon* from Chungcheongnam-do Province is also famous.

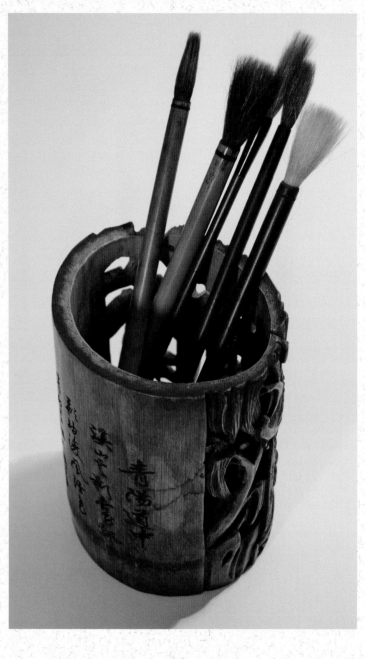

Right: Brushes in a decorative Chinese bamboo pot. Brushes may be stored bristles up in a pot, or be hung on a rack from the loop at the far end of the shaft.

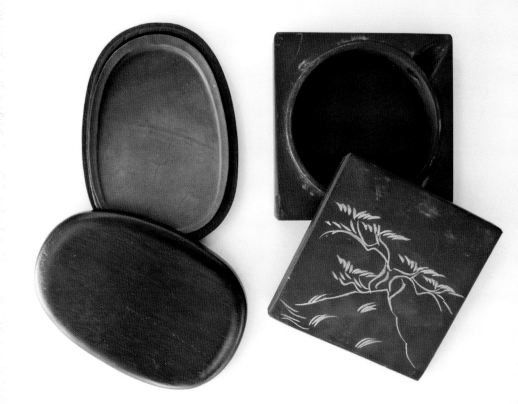

Additional Tools

A paperweight (a piece of heavy metal or stone bar prevents the paper from moving), water container, small dish, rolling brush mat, desk pad (*Hwaseonji* paper is placed on top of a pad that's usually made of soft cloth), and a seal (for the writer's signature) might also be needed. Contemporary calligraphy might require more tools and materials, such as different colors, different media (coarser-fibered paper or pre-decorated paper), and tools other than the brush.

Left: Inkstones come in many shapes and sizes. Some have lids to prevent evaporation in case the writer has to step away from the desk for a moment. All inkstones have a flat well on which the ink stick is ground using a small amount of water. Some, as in the example shown on the left, have a well that is deeper at one end; when a large amount of ink is needed, the ink is ground on the flat portion of the stone, and the excess pools in this deeper part of the inkstone.

Below: Ink sticks sitting with their protective wooden boxes. Ink sticks are always wiped off after ink has been made, and are often stored wrapped in paper. They should always be replaced in their boxes, so as not to be jostled and broken.

Paper

"Rice paper" is not made from rice. Westerners have tended to call East Asian papers "rice paper" because rice has been a symbol for the East (Asia), contrasting wheat for the West. Special types of paper are used in East Asian calligraphy. In Korea, *Hanji* paper, traditionally hand-molded in Jangseong-gun villages, Jeolanam-do Province, is the preferred type of paper. It is made from the mulberry plant (*Broussonetia kazinoki*). Some other materials like bamboo, hemp, rice plant, and wheat plant are also sometimes used for paper manufacture. Among different kinds of *Hanji*, the *Hwaseonji* paper is suitable for calligraphy due to its silky texture and good absorption. The quality of paper for calligraphy depends on material fibers, roughness, thickness, absorption, and color.

The Brush In Motion

Before making a stroke, the brush is dipped into the ink that has been prepared. Although the bristles are fully loaded with ink, only some of them will come into direct contact with the page. The ends of the bristles nearest

Above: The Chinese and Japanese character for the numeral one.

Below: An example of Japanese hiragana. The horizontal stroke is made first. The long stroke from the top moves downward, turns a corner, and then is lifted from the page. As the brush is lifted, the stroke narrows, and the tip makes a fine pointed shape at the end of the stroke. The bottom stroke, made last, is a continuation of the same motion; the tip touches down again, and then the brush is pushed down and to the right. In the East Asian scripts, these fine pointed shapes made with the tip of the brush offer important clues to the movement of the brush.

the shaft of the tool lend support and deliver a steady flow of ink to the tip, but they never touch the paper directly.

When making a stroke, the brush is never rammed straight down onto the page, despite the upright position of the tool. Instead, the writer places the tip of the brush gently onto the page, and as he moves the brush, uses its side and its tip.

Strokes vary in thickness depending on the amount of pressure used. Pushing the brush down creates a thick stroke, while lifting it slightly achieves a more attenuated stroke. In practice, this variation of pressure is continuous—all the strokes are carefully modulated.

Even the simplest stroke, a pure horizontal line, like the Chinese and Japanese character for the number one (一), for instance, begins by placing the brush down onto the paper at a slight angle, using some pressure. The beginning of the stroke thus has a bit of weight. Drawing the brush to the right, the writer eases the pressure on the brush, lifting it slightly as he writes. Coming to the end of the stroke, the writer begins to press down again, thickening the stroke as it comes to its end. The stroke ends with a finishing gesture: the brush pauses for a moment, pressed into the paper, and then is lifted off *to the left*, rather than trailing off indecisively to the right.

The resulting stroke therefore has strongly made ends and a slightly narrower waist. The motions of the brush are three dimensional: the brush is not only gliding along the flat surface of the paper, but the writer is moving it up and down, pressing it into the paper, casing it off, pushing one side of the brush or the other into the paper to create a corner or a strong ending stroke. Additionally, pulling the brush off the page delicately allows the fine pointed hairs to describe a tiny trace of the action of the brush leaving the paper. At the same time, the writer is aware of the position of the bristles, not letting them twist or tangle, but keeping them in alignment. The writer

needs to pay heed to the part of the brush that is most fully engaged with the paper. In the character *one*, for instance, the balance of weight is on the bristles that are directly in the middle of the stroke. In other characters, one side or the other of the brush may produce the leading edge: one side of the stroke may be more firmly made than the other, producing a stroke with one smooth side and one slightly rougher side, where the bristles are more loosely engaged with the paper.

In most East Asian scripts, strokes are very subtly curved. In Chinese Standard script, for instance, there are no perfectly straight lines. The character for *one* is an organic form, not a rigid straight line. Like many horizontals, it also inclines gently upwards.

The movements of the brush in the air are as important as the movements when the brush is in contact with the paper. Very often the "leave," the point at which the brush breaks contact with the paper, points to the next stroke that will be made. According to calligrapher Jim Zhang, who made the examples of Chinese characters in the Chinese chapter, calligraphy is a "dance movement executed on paper." Others have compared East Asian writing to a swallow flying across a lake: as the swallow flies, the tip of her wing graze the still surface of the water, leaving a fine trace. The bird's movement is continuous, but we only see the moment of contact with the water as a mark on the glassy-still lake. Thus, the black marks on the page are expressions of a larger movement of the body of the writer, and the dynamic quality of the writing arises precisely because we can sense the movement of the writer when we look at the marks that have been left on the paper.

Given the importance of the brush in the history of East Asian culture, the tool was traditionally treated with great respect. In traditional China before the Revolution, some great masters would not discard worn brushes as trash. Instead, they would bury their old brushes in the *bi jung*—the tomb of the brush.

A Brush Demonstration

Yoo Sung Lee demonstrates the use of the brush by writing two Korean characters.

Below and following pages: In this sequence of photographs, Korean calligrapher Yoo Sung Lee writes a straight upright stroke. His paper lies atop a piece of orange felt cloth. It is held in place at the top by a small porcelain paperweight. To the left of the paper you can see a portion of his inkstone, with a small puddle of ink. To the right of the inkstone is long paperweight made of metal.

Note: The enlarged photographs at the bottom of the pictured sequence show the position of the brush at various stages in the writing sequence. Note that these enlarged photos have been taken from the side, to show the position of the brush's bristles; the top of the stroke is at the left.

Straight Upright Stroke Sequence

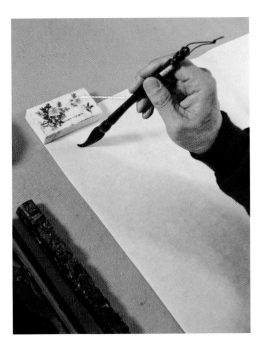

1

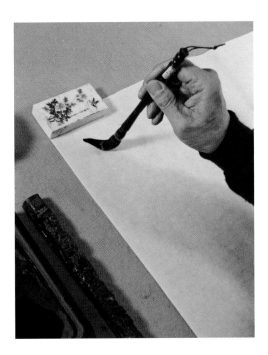

2

1. The tip of the brush makes contact with the page.

2. The brush is pressed down at to make a stroke at a 45° angle to the upright.

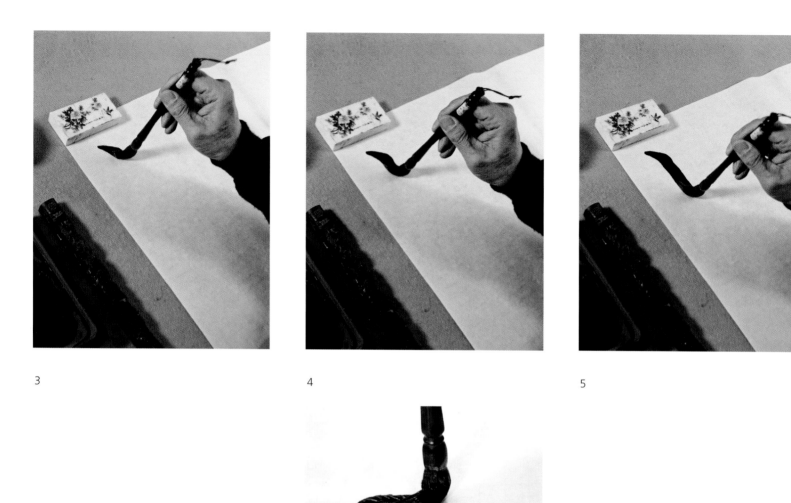

3

4

5

3. After the brush has been pressed down to make the head of the stroke, it is lifted slightly as it begins its path straight downward. Note that the brush has been rotated very slightly clockwise, to keep the bristles from twisting as the stroke changes direction.

4. The brush moves downward with a confident motion, maintaining an even thickness.

5. About two-thirds of the way down, the brush is lifted slightly, making the stroke taper evenly on both sides.

Straight Upright Stroke Sequence (continued)

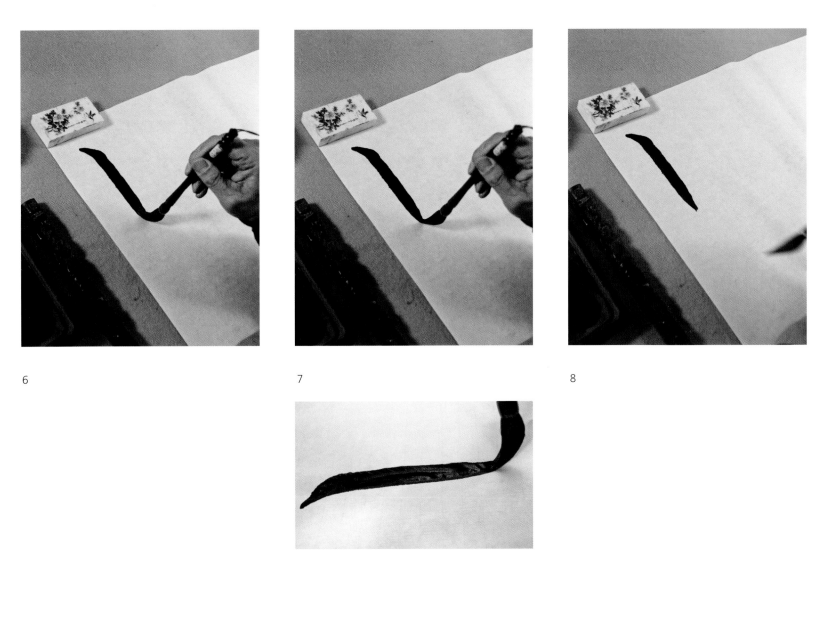

6

7

8

6. As the stroke comes to its end, the brush continues to be lifted, making an ever narrower stroke.

7. At the end, only the tip of the brush is in contact with the paper.

8. The brush is lifted cleanly off, leaving a crisp, pointed end to the stroke.

Round Character Stroke Sequence

Right and opposite: In this sequence of photographs, Yoo Sung Lee writes a round character. He uses two strokes to make this character.

Note: These photos have been taken from the side; the top of the stroke is at the left.

1. The brush is placed firmly on the page, beginning one half of the circle.

2. As the stroke curves, the brush is turned. The bristles must not become twisted.

3. Here, as the brush moves around the curve, the beginning of the stroke can be seen. Notice that the tip was not used in this stroke to make a sharp point; the blunt end will be covered by the second stroke.

4. The brush continues to turn as it moves along the curve.

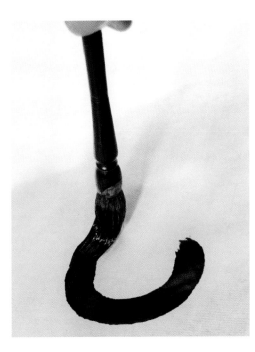

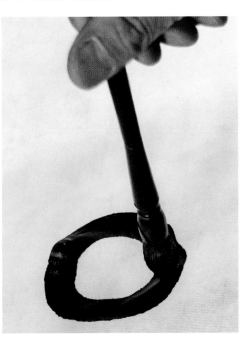

5. The brush is lifted at the bottom of the half-circle.

6. Now the brush is placed in the same position at which it began, in order to make the second half of the circular character.

7. As before, the brush turns as it describes the circular shape.

8. At the bottom, the two strokes meet, creating a perfect circle.

CHINESE
The Fount of East Asian Scripts

By Christopher Calderhead

Semanto-phonetic Writing System: *Where individual characters can convey either semantic meaning or phonetic meaning. Sophisticated readers will have mastered more than 6,000 characters, and comprehensive dictionaries may have as many as 56,000 separate characters.*

Direction of writing: *top to bottom and right to left*

Majuscule and minuscule distinction: *none*

Principal tool: *pointed brush*

Language: *Chinese; has also been historically used in many neighboring cultures of China proper.*

Left: This large single character, meaning "to fly" or "to soar," was written by Jim Zhang. The height of the character is just over 15 inches. Zhang wrote the character many times at the same size. He selected the best one; the red seals he has added indicate that this has been chosen for display.

Calligraphy holds a central role in the development of Chinese art and culture. The tools of the Chinese painter and calligrapher are one and the same, and there is no clean line of demarcation between the two arts as exists in the West. Historically, Chinese calligraphy in its highest form was largely the province of scholar calligraphers, gentlemen of substance connected to the highest echelons of society. Emperors, members of the Imperial Household, governors of provinces, and wealthy literati created a body of work that remains the touchstone for contemporary practitioners. The old system of civil service exams that existed in Imperial China put a major emphasis on acquiring a fine hand.

The roots of Chinese written language lie in the middle of the second millennium BCE. Simple pictograms were engraved on bones and tortoise shells. In the first millennium BCE, these early systems developed more fully and were engraved on bronze vessels; early scripts were based on monoline forms. The adoption of the brush as the primary writing tool transformed Chinese characters; the tool began to reshape the script. Writing became squared off and more abstract, and a set of standard strokes began to emerge. Most importantly, the brush produced a fluid, modulated line that quickly developed into a written artform.

One of the most striking things about Chinese calligraphy is its longevity and continuity. Beautifully painted handscrolls were passed down from collector to collector over the years. Each new owner would add his seal to the work, until a painting or text was covered with small red seals. No Westerner would think of adding a stamp to

a Michelangelo painting. But in China, the practice of documenting the chain of provenance to cherished works enhanced their value. Furthermore, scholars would add their own calligraphy to existing scrolls, composing texts in praise of, or commenting on, the piece in question. Thus, a Chinese handscroll might bear calligraphy from collectors spanning hundreds of years. Only a culture with real continuity is able to create an artifact like this, where the additions of later calligraphers sit in harmony with the works of their forebears.

In our own day, calligraphy continues to be an integral part of Chinese culture. No longer solely the realm of the upper classes, it is honored and practiced by people at many levels of society and still provides one of the essential artforms in Chinese society.

Opposite, left: A religious text from the Buddhist Canon, written in Japan in 1395 CE. Chinese writing is not restricted to one country; the Japanese adopted Chinese writing in the sixth century. Over time, they would adapt it and alter it for writing their native language, as we see in the chapter on Japanese calligraphy. This manuscript, however, is written in pure Chinese characters, in a clean, scholarly hand.

Opposite, right: The poem "Magpie Bridge." Calligraphy by Jim Zhang.

Top: It is a long tradition in China to carve calligraphy in wood or stone, retaining all the nuances of the brush-made characters. This sign hangs on a street in New York's Chinatown.

Right: Calligraphy is deeply imbedded in Chinese culture. This notice on a restaurant door in New York's Chinatown advertises meal specials. The calligraphy, carefully executed in brush and ink, is exuberant if not entirely expert. Despite this, who could imagine a similarly competent work of Western calligraphy in a comparable non-Chinese restaurant?

A Place to Write

China is a table-and-chair culture, like that of Europe. The historic Chinese scholar's study was a retreat, an inner sanctum, like the *studiolo* of the Renaissance Humanists. Its furnishings were elegant and carefully chosen to reflect the refinement and taste of their owner. Today, of course, practicing calligraphers do not always have the luxury of retiring to a country villa to cultivate their art.

Writing Surfaces and Posture

A wide rectangular table made of polished hardwood provides a surface on which to write. According to the scholar Chiang Yee's 1974 book *Chinese Calligraphy*, this desk should be a little higher than a standard desk or dining table, allowing the writer to stand when making large characters. When a chair is used, this should be high enough so the top of the table reaches the lower abdomen. Chinese calligraphy is not made on tilt-top desks. It is always executed on a flat table.

The table is furnished with an inkstone, a small water vessel with a small opening, a brush stand, and brush container. The paper is laid out flat on the surface of the table. Traditionally, a second sheet underneath the writing sheet protects the table from ink when it penetrates the absorbent surface of the paper.

Most contemporary calligraphers place a sheet of felt on their table as an under-layer for their writing. This provides both protection for the table and a pliant surface against which to write. This may be a plain length of black felt—the black hides the stains of ink. For students, it may be gridded with squares that show through the thin paper and are useful as guidelines. This would be less useful for the more advanced calligraphers, as it delimits the writing to a single size; an experienced calligrapher would be expected to write without any guidelines at all.

Paperweights are also essential tools. These come in many sizes, some of them quite large. They are often made in decorative shapes. Before writing, weights are placed at the top and bottom of the paper. This holds the paper in place, preventing it from moving or being caught by a breeze.

Learning

Students learn by carefully copying models, either from copy-books or collections of the work of great historical masters, or by copying the work of their teacher. The basic techniques of brush handling are taught in school, so serious students of calligraphy have already had an introduction to the use of the tool. But to become truly adept one must spend years mastering the forms of one's models.

A copy-book provides examples of calligraphic characters printed in red ink. The student takes a brush dipped in black ink and carefully writes over the model character. If the student's work is good, no red ink will show; the newly written character will match the example precisely. One may also copy a model freehand, which is the way the more advanced students work.

Above left: As students learn calligraphy, they often use gridded guidelines to help them write characters that are balanced in shape and properly proportioned. The most basic grids are simple squares—one character is written in each square. The square is sometimes subdivided with additional lines. The top square has been divided into a "Nine-Palace Grid" and the bottom square into a "Rice-Character Grid."

Above: Chinese calligraphers traditionally write on a stout table. A piece of cloth or paper may be placed on the table, underneath the sheet of paper that will receive the writing. This protects the table from the ink that sometimes bleeds through the thin paper.

Opposite, top: One way of producing guidelines for writing is to fold the paper. The exemplars by Jim Zhang in this chapter were prepared in this way. The photo shows what the raw originals look like. Not only can you see how the paper has wrinkled as a result of its contact with the wet ink, but you can also see how Zhang has folded the paper before writing to make neat squares as guidelines for the placement of each character. In East Asian calligraphy, the thin paper can be folded and is allowed to wrinkle, because a finished piece will be mounted in a scroll format; once paste is applied to the back of the sheet, it will relax, and, once mounted, dry completely flat.

Students are sometimes given characters written in a square on a grid of lines, which give the student a frame of reference to judge the proportions of their writing. These grids come in two forms: Nine-Palace Grids (九宮格) and Rice-Character Grids (米字格) (see opposite page, top left). The first is a square divided into nine smaller squares; the second takes its name from the character for rice (米), and is divided into eight sections, just as its eponymous character suggests.

Many of the current generation of calligraphers, raised during the disruptions of the 1960s and '70s, are self-taught. With little access to books or teachers, they sought out what sources they could, and persevered on their own. An enormous value is placed on direct copying; personal expression or experiment must wait until the lessons of the past masters have been learned.

Dynamic Balance and Structure

The Chinese characters are so numerous that students must spend years simply memorizing them. More important, each character is made up of multiple strokes that exist in a carefully balanced composition. Asymmetrical by nature, each character has its own unique balance. Students need to look for the center of gravity of each character in order to write it properly. Tiny errors in the length, direction, and shape of strokes can throw a character out of harmony. In addition, many characters are composites of other characters; the student needs to learn how to adjust the shape of each component to keep the new composite character in balance.

The Chinese speak of writing as having bone and flesh. An early source of this idea is the treatise "Battle Formation of the Brush," attributed to Lady Wei (衛夫人) (272–349), a famous calligrapher of the fourth-century Eastern Jin dynasty.

The treatise describes the act of writing in martial terms. It goes on to describe fine writing ("real calligraphy") as having bone—good structure— and flesh, which should be lean and sinewy, like a man wise and ready for battle. Fleshy and corpulent characters are derided.

Other early treatises describe the principles of calligraphy through an examination of the character *Yong*, meaning *eternity*. This character is said to contain all the necessary components for mastering the art of writing well. It contains eight basic strokes, each of which must be mastered in turn, and then combined into the complete character. Interestingly, the eight "strokes" do not correspond exactly to the character as it is written as a whole—the character is written in five strokes. The eight components are: 1. the dot, 2. the horizontal, 3. the erect stroke, 4. the hook, 5. the raised stroke, 6. the curve, 7. the short slant, and 8. the *na*, or pressing forcefully. Compare these strokes to the master strokes later in this chapter.

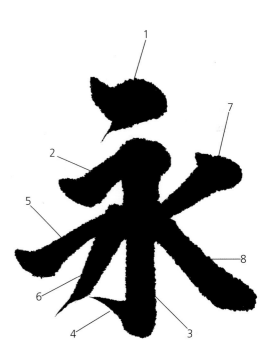

Above: The character *Yong*, meaning *eternity*, with its eight component parts.
1. the dot, 2. the horizontal, 3. the erect stroke, 4. the hook, 5. the raised stroke, 6. the curve, 7. the short slant, and 8. the *na*, or pressing forcefully.

Wang Xizhi and Stone Rubbings

Wang Xizhi (王羲之), who lived from 303 to 361 CE, is one of the most famous Chinese calligraphers. A disciple of Lady Wei, his calligraphy has been held in the highest esteem. One of his most famous works is his *Preface to the Poems Composed at the Orchid Pavilion* (蘭亭集序), written in the year 353. The *Preface* describes a poetry gathering:

> *In the ninth year of the Emperor Mu's reign, which was the year of the Ox, early in March, we all gathered at the Orchid Pavilion in the county of Shanyin, in the Prefecture of Guiji to attend the Spring Purification Festival. . . . Young and old, the prominent people were there. . . . The pavilion sat between two rushing streams. . . . There were no musicians, but the wine flowed freely and the guests recited poetry. . . . One could observe the abundance of things. . . . What joy.*

Wang Xizhi continues, reflecting on the human condition. He writes that all people, diligent or lazy, stern or self-indulgent, are happy when things go well, but happiness is transitory. The literary works of the past sadden him, because he is aware that the people who wrote them are now gone—and this is humanity's lot. And so, he appeals to his reader to think of him. As he writes, he surely imagines us reading his words, and having the same reaction as he does when reading works of the past.

The *Preface* was not only a famous work of literature, but it was a famous work of calligraphy. Later on in the Tang dynasty, the original writing came into the collection of the Emperor Taizong (599–649). The Emperor, who had long coveted the scroll, tricked the monk who had inherited it into revealing its whereabouts to one of his agents. The precious scroll was duly seized, and brought to the Emperor. Delighted with his new treasure, Taizong had copies traced from Wang's original, and had facsimiles carved in stone. While the original is now lost, the work lives on through copies.

One might ask how much we can know about Wang's *Preface* without having direct access to it. But that would be to miss the point: within the Chinese tradition, faithful copies are an integral part of the transmission of works down through the ages. Stone carvings, in particular, preserve the works of the great masters of the past. Ink rubbings taken from these stone inscriptions disseminate the work to a wider audience.

Below: (right to left) This accordian-fold book is a carefully made woodcut from a calligraphic original. The binding is made of simple wooden boards. The title page is a later addition. On the opposite page, we see an enlargement of two panels from the book (bottom left).

Opposite: This religious work was written in the Ming Dynasty during the period 1573–1619. During that time there was a revival of the style of Wang Xizhi, and this book is in that style. The signature on the rubbing is Huang Qi Long 黃起龍 and is a worthy piece of calligraphy, but probably not as historically important. People would have used the rubbing for calligraphic study.

振鷲於四天葉樹還止
迦葉闡揚於九部裹以
清淨為本之以目果曰神
於是馬鞦荊澄鑒之藏
獅座盛梁朝之講慧
恭揚唄天衣奏於屬霄

Writing Standard Script

For detailed instruction in writing Chinese characters, we use the Standard Script. *Calligraphy by Jim Zhang.*

Basic Strokes

Over the centuries, many writers have tried to establish a fixed number of basic strokes for Chinese characters. The simplest formulation is based on eight strokes of the character *Yong*, eternity, as mentioned. But this is too small a number to really capture the basic movements of the Chinese brush. Other systems have been unwieldy, comprising up to eighty or more strokes. Any selection is by nature artificial; in practice, any stroke will take various forms when it is combined with others to make a fully realized character.

The strokes we show here are good starting points, but as they are used in the following set of characters, they are only a beginning.

Standard Script with Stroke Direction

Dot

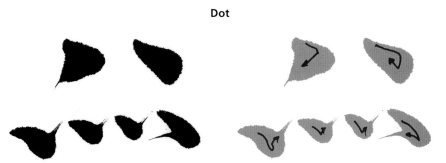

A dot is never a formless mass; it always has direction. Whenever a dot is made, the direction of the initial approach, the movement of the brush within the shape, and the direction of the brush parting from the page are all crucial. The brush approaches on its tip, and the side of the brush is then gently laid on the paper. When the brush is pulled off, the fine tip often trails slightly, indicating the direction with which the brush is removed. Note that the top dot on the right doubles back on itself; its leave-taking is less obvious than that of the other dots.

Diagonal strokes

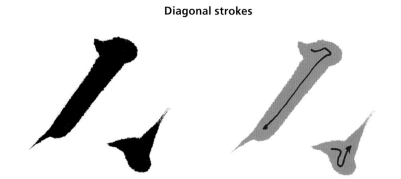

The stroke on the left begins with a firm placement of the brush on the page. Steady pressure creates a firm stroke, which then tapers to the left until it is pulled off on its point. The second stroke has a downward motion, which rebounds to the right.

Right diagonal strokes

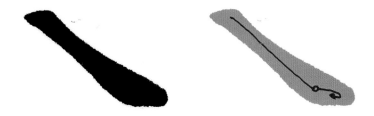

This stroke is made with a firm motion to the right. About two-thirds of the way down, the brush is pressed firmly into the paper, widening the stroke as the motion also moves slightly to the right. Tapering off at the end, the brush is then lifted out in the direction from which it came.

Horizontal strokes

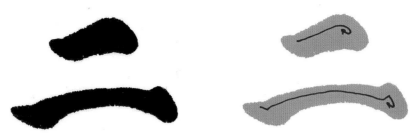

The bottom stroke begins with pressure, eases in the middle, and ends again with a definitive pressure. Note the curvature and direction of the stroke. In the top, short stroke, pressure is increased as the brush moves to the right, creating a gradually widening stroke.

Vertical strokes

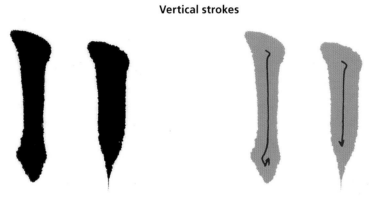

Note the different terminations of the two strokes. The bottom of the left-hand stroke should swell equally on both sides.

Sharp corners

At the turning point of both these strokes, the brush is pressed down to make a strong junction between the two components of the stroke. The motion of the bottom stroke, the Flat Hook, involves a strong press-and-release movement; the brush leaves the page sharply, pulling to a neat point.

Standard Script with Stroke Direction (continued)

Hooked strokes

Note the curvature along the upright parts of these two strokes. At the end of each stroke, the brush is pulled to the left as pressure is released, creating a fine line. The left stroke is known as the Bow-shaped Hook.

Horizontal hooked strokes

In the top stroke, known as a Dragon Tail Hook, the tail ends with a significant pressure, which is then released as the brush is pulled off straight upward. Note the different direction of the pull-off in the bottom stroke.

Diagonal hooked strokes

The basic principles of these strokes should be apparent from the strokes already discussed; the direction only is different.

Complex strokes

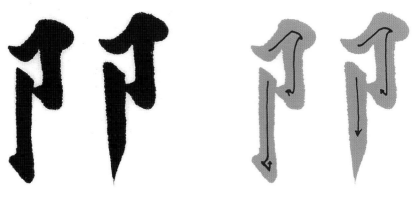

These two strokes are combinations of those that have come before. Note that the stroke on the left does not end with a thin, fine line; the brush is gently pressed to the left to create a slightly bulging base before doubling back and pulling away in the direction from which it came.

A common complex stroke

This stroke, which is considered as a unit, forms the base for many characters..

Vertical hooked strokes

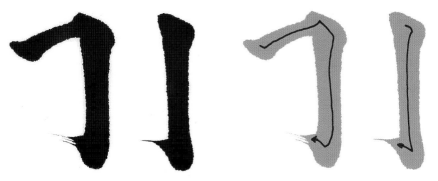

Both of these strokes terminate with a gradual release of pressure as they are pulled off to the left.

Standard Script

Twenty-four characters are shown here and on the following page in bold black. They begin with simple strokes, and gradually grow more complicated. They are composed of the basic strokes we have just seen. This is a collection of individual characters; it is not a complete text in Chinese.

The characters should be copied precisely, following the stroke orders provided. Note how each character is centered in a square. The white spaces between the strokes are as important as the strokes themselves. Pay close attention to the proportions of each element as well as to the white space in between—and note that these characters are written in the Chinese order—from top to bottom, with the lines running from right to left.

The strokes on these and the following pages are numbered to indicate the sequence in which they are written. For stroke directions, consult the master strokes shown.

Each number is placed near where the stroke begins and where the brush first touches the paper. These numbers indicate the sequence in which the strokes are made.

Note that some of the strokes move in one direction, pause, and then change direction without the brush being lifted from the page.

Special attention should be paid to the very fine, thin, pointed endings to many of the strokes. These indicate the point at which the brush leaves the paper.

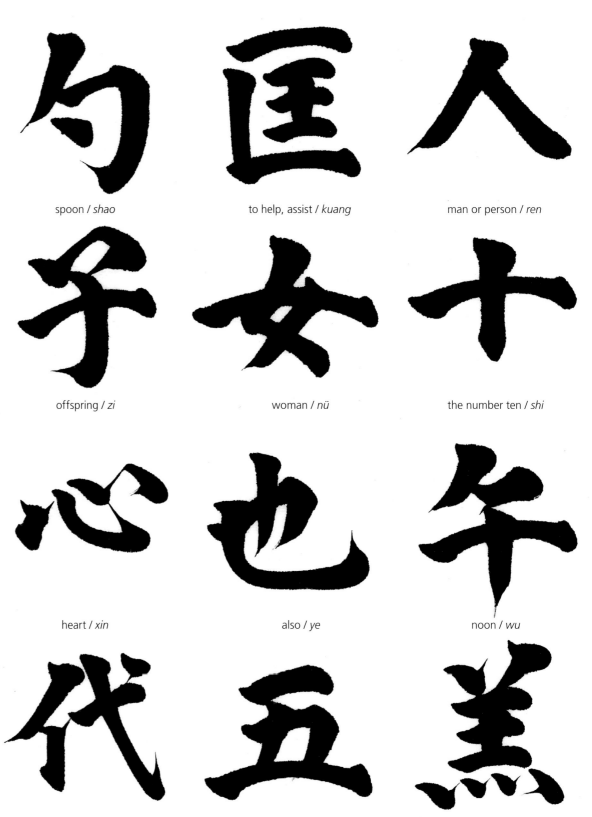

spoon / *shao*

to help, assist / *kuang*

man or person / *ren*

offspring / *zi*

woman / *nü*

the number ten / *shi*

heart / *xin*

also / *ye*

noon / *wu*

generation or dynasty / *dai*

the number five / *wu*

baby sheep or goat / *gao*

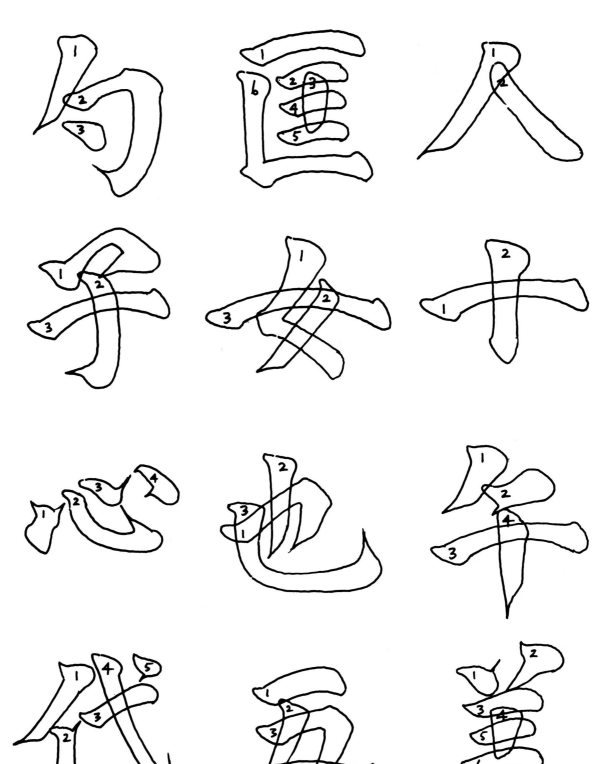

country / *guo*

the color red / *hong*

submerge / *mo*

how / *nai*

that / *na*

ancient / *gu*

roundabout / *yu*

limit / *xian*

home or family / *jia*

village / *cun*

spring / *chun*

wind / *feng*

Five Scripts

Although the variety of Chinese scripts is dazzling in its complexity, the basic styles can be defined into five categories. We show here a selection of ten characters to illustrate these five classic styles. The characters appear in the same order on each page for easy comparison. The names of the styles are given in both Chinese and Japanese, as both traditions make reference to the Chinese categorization.

Ten characters on these and the following pages are shown in five different scripts and are placed as they are written and read in Chinese.

6. the color red / *hong*

7. home or family / *jia*

8. wind / *feng*

9. limit / *xian*

10. country / *guo*

1. noon / *wu*

2. woman / *nü*

3. baby sheep or goat / *gao*

4. generation or dynasty / *dai*

5. to help, assist / *kuang*

6　紅　　1　午
7　家　　2　女
8　鳳　　3　羔
9　阻　　4　代
10　國　　5　匡

Seal Script

(Opposite)

篆書 *Zhuànshū*

Japanese: *Tensho*

Seal Script is based on the most ancient forms of Chinese writing. It is not generally legible, even to a fluent reader of Chinese. The strokes are of a uniform weight with round terminations. A special brush can be used to make these characters with longer bristles and a somewhat blunt end. The Seal Script evokes the foundations of Chinese culture; just as Westerners would use Roman Capitals for their sense of *gravitas*, the Chinese use the Seal Script to lend weight to the written word. It has been used in carved inscriptions, as a titling script, and, most importantly, for the carving of seals with which to mark one's work. Seal Script bears the cultural memory of the earliest inscriptions on bronze vessels. The characters of the Seal Script are often recognizably based on the simplified drawings of physical things that formed the basis of the Chinese writing system.

Clerical Script

隸書 *Lìshū*

Japanese: *Reisho*

Clerical Script was the first fully formed brush script. Its forms approach those of the Standard Script, but it carries with it some of the qualities of the earlier, pre-brush scripts. Horizontal in emphasis and strongly squared off compared to its forebears, it clearly shows the way the brush influenced the forms of the Chinese characters. It was popularized by government scribes, hence the name.

Standard Script
(right)
楷書 *Kǎishū*
Japanese: *Kaisho*

Regular, legible, with forms that have evolved in harmony with the brush, the Standard Script is definitive of written Chinese. It forms the basis for the typographic treatment of Chinese writing.

Running or Semi-cursive Script
(Opposite, left)
行書 *Xíngshū*
Japanese: *Gyōsho*

Running Script is a more fluid rendition of the Chinese characters. Here, the strokes become somewhat simplified. As the brush is lifted less often, some of the strokes elide into one another. Others lose their corners and become rounded off. This is where a careful attention to the standard stroke-order becomes crucial; the logic of the well-understood sequence of motions defines how the brush travels across the page. The script, despite these differences from the Standard form, is still legible.

Grass or Cursive Script
(Opposite, right)
草書 *Cǎoshū*
Japanese: *Sōsho*

Pushing the edge of legibility to its limits, the Cursive Script cannot be read by many native speakers. A highly artistic and expressive form of writing, it begins to break down the rules of proportion and arrangement. Characters may become larger or smaller, the brush may not be lifted between characters, and lines of text may begin to deviate from the purely upright, ordered rows of other scripts. (Note that the single characters shown here are minding their manners and staying within their bounding boxes.) Cursive Script becomes an exercise in abstraction.

6 紅

7 家

8 風

9 限

10 國

1 午

2 女

3 羔

4 代

5 匡

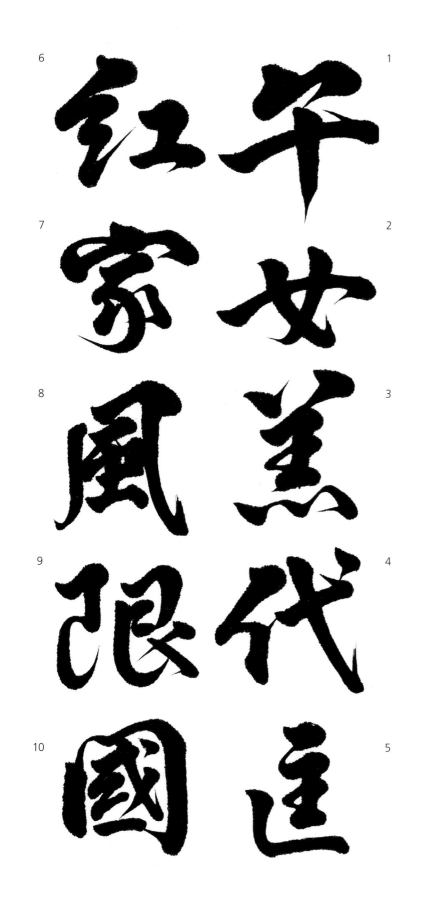

字たつもらふまてをらうつらめあまうま
小くひまつうつもく小人ゑれをまうまてく
うにてうまもへまハ影てにまてをまうまて
う
うにてうやもれあうつのへの字や
㊞惟
むうつて女てとよ捩まへゑ碼れとう
つらとつてへてを
㊞旨
一妻れわらたる男のうへまたをうもゑと
くく
㊞男
うつまれを今へ行てうまれくわれゆきまわ
㊞恩
をと東れをてのへ人一てのうやうる

JAPANESE
Indigenous Traditions

Syllabary: A writing system where symbols phonetically represent syllables. The two syllabaries referred to as Kana are never used alone but always in conjunction with the Chinese-derived Kanji. There are more than 2,000 basic Kanji. Each syllabary consists of 46 characters.

Direction of writing: *top to bottom and right to left*

Majuscule minuscule distinction: *none*

Principal tool: *pointed brush*

Language: *Japanese*

Opposite: A seventeenth-century manuscript copy of the *Ise Monogatari*, a classic collection of narrative romantic poetry. It is written in the Oiye or Court script. The markings in red denote proper names, quotations, and other notations.

JAPANESE KANA CALLIGRAPHY

by Tsutsumi Kawabe with Christine Flint Sato

The modern Japanese writing system consists of a combination of three scripts: Chinese characters, or *Kanji* in Japanese; and two indigenous phonetic syllabaries, called *Hiragana* and *Katakana*. In modern Japan, Roman letters are also used. These are referred to as *Romaji*. The scripts are used in combination, and may be seen in any Japanese text. For example, the Basho poem we will discuss later in this chapter reads: 古池やかはつとびこむ水のおと. The Kanji are marked here in red, while the hiragana are in black. Although the phonetic syllabaries can in theory replace the Kanji, the latter are retained for ease of understanding, as there are many homophones in Japanese. Still, the proportion of Kanji in texts is lower than in the past.

There are about 2,000 commonly used Kanji, and fourty-six each of Hiragana and Katakana. Kanji are used to write the meanings or the root of the words, and Hiragana for the inflexions and grammatical particles. Katakana is mainly used for words of foreign origin, for slang, and onomatopoeia. Romaji is used primarily for typing Japanese on the computer (software converts it to the Japanese script forms).

Apart from this linguistic differentiation, the choice of script also indicates a difference in style or tone. Kanji was traditionally the script of learning and bureaucracy and it still retains those connotations. Choosing to write a Kanji in its Hiragana or Katakana equivalent offers alternative associations. Hiragana is often felt to be more emotional, and can represent the Japanese spirit. Katakana tends to represent the Western world and is felt to be more logical or rational. Calligraphers and graphic designers sometimes exploit these differences.

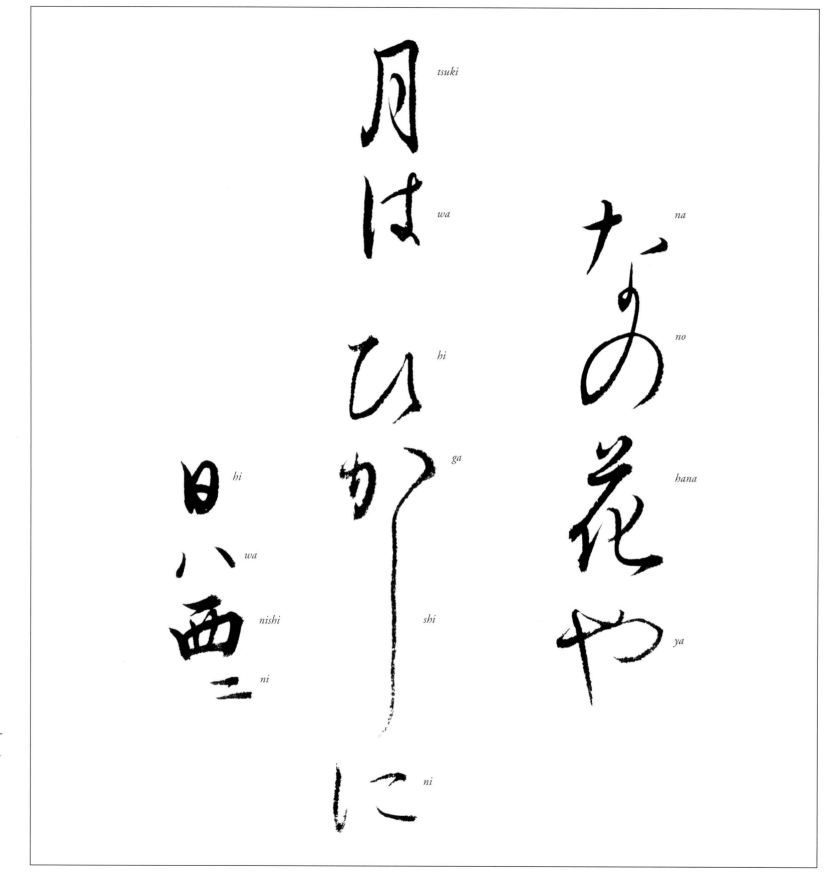

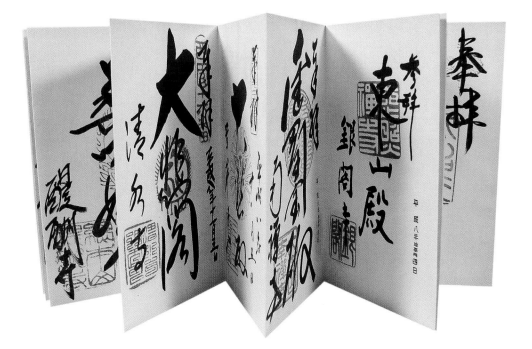

Above: A small souvenir book records visits to important shrines and temples. It is a tradition in Japan to bring a little accordion book when visiting a temple; a monk will inscribe the book and stamp it with seals.

Opposite: Buson's poem reads:
なの花や月はひがしに日は西に、
translating to "A field of rape blossom, the moon in the east, the sun in the west."
This poem and the poem by Basho (page 205) are models for beginners of kana calligraphy. Once a student has mastered the basic forms of kana shown in this chapter, they should copy these two poems.

The origin of this complex system dates back to the sixth century when Kanji entered Japan. Previously developed calligraphically in China, the various script forms (standard, clerical, seal, cursive, and semi-cursive) were imported to Japan. With no written system of their own, the Japanese adopted the Chinese characters, along with the cultural and religious ideas they expressed. By the ninth century Kanji had also begun being used phonetically to represent the syllables of the Japanese language. These are known as *Man' yougana,* named after the eighth-century poetry anthology, *The Man' youshuu.* Kanji and syllable did not correspond one to one, however, and a variety of Kanji could be used for the same Japanese sound. The system of using Kanji to represent Japanese syllables, over time, proved to be unwieldy.

The ninth century saw the development of both the Hiragana and Katakana phonetic syllabaries. The cursive form of the Man'yougana was the precursor of Hiragana. The forms were much more simplified; *hira* means "easy" or "rounded." In contrast, the Katakana syllabary developed from component parts of the standard form of Man'yougana, where *kata* means "partial" and the letters are rather block-like. They were initially used as mnemonic devices for priests when reading Buddhist texts. The origins of the syllabaries are reflected in the scripts—Hiragana is supple and flowing; Katakana is more angular.

Kana calligraphy was further developed from Hiragana. It was originally used in personal correspondence and diaries and became known as *onnade,* or "women's writing" (it was commonly used by women who did not read or write Chinese). During the later part of the Heian Period (794–1185), Kana calligraphy reached a high level of artistry, both calligraphically and decoratively, using sumptuous papers, known as *ryoushi.* These calligraphic works are seen by many as the apogee of Kana calligraphy and are still used as models for calligraphers.

As Chinese writing continued to be used for learning and government, two systems of writing were used in Japan. The origins of the present-day writing system date back to the twelfth century when Kanji and Kana began to be combined. Nowadays, Japanese calligraphy reflects the early divide and is either based on Kanji and its Chinese texts, or on Kana. This calligraphy based on Chinese texts became, in Japanese hands, a softer, more rounded expression, with the preference of semi-cursive and cursive scripts. With further influxes of early Chinese texts from the late nineteenth century, twentieth-century calligraphers developed more robust styles, and with the influence of abstract art from the West, abstract calligraphy.

In contrast, Kana calligraphy is felt to be an indigenous art form, expressive of the Japanese spirit. Kana calligraphers today tend to fall into two camps: more traditional or modern. The latter, as with other experimental calligraphic developments in the twentieth century, prioritizes personal expression, often using contemporary poetry or writings, and making use of all script forms.

Left: *The Courtesan Chōzan of Chōji-ya.* Santō Kyōden (1761–1816). Published in 1784. Woodblock print 13⅛ x 24¼ in. (34 x 24.5 cm).

This eighteenth-century woodblock print shows the courtesan Chōzan sitting at her writing table while her attendant prepares incense in a small brazier. She sits on the floor near her low, Chinese-style inlaid table, surrounded by books and tools for writing. A box in the alcove behind her is full of books. On her table, a small vessel holds her brushes, small water-pots, and seals. To the left, under a pile of books, is a lacquer box, its brocade rope unfastened— perhaps her writing box, where she would store her calligraphy tools. The long slips of paper directly in front of her are ready to write her New Year's greeting verses.

The print comes from an album entitled *Yoshiwara keisei shin bijin-awase jihitsu kagami* (*A Contest of New Yoshiwara Courtesans with Examples of their Calligraphy*). The writing in the space above her to the right shows a *waka* poem, reproducing Chōzan's own calligraphy.

Much larger work is also produced for display in exhibition halls.

More traditional Kana calligraphy, which is inspired primarily by that of the Heian Period, is introduced in this chapter. It is essentially a small-scale, intimate art form often used for Japanese *haiku* and *waka* poetry, for which it is eminently suitable.

Kana was not fully standardized until the twentieth century. Before the standardization, each Hiragana character existed in a variety of forms. These are now often used by calligraphers for artistic effect. Nowadays, Kanji, in their cursive or semi-cursive form, are also used in Kana calligraphy. For example, in the Buson poem illustrated, the final characters are 日ハ西ニ. 日 and 西 are Kanji, meaning "sun" and "west" respectively; ハ and ニ are a kind of Man'yougana, from Kanji for the numbers 8 and 2 are used as the grammar particles *ha* and *ni*. These would more commonly be written in Hiragana as は and に. The symbols ハ and ニ are also Katakana for *ha* and *ni*. The Japanese enjoy this kind of lexical layering, and reference to calligraphic precedent and literary association is part of the appreciation of Kana calligraphy.

Characteristics of Kana Calligraphy

The overall impression of Kana calligraphy must be unhurried, leisurely, and composed. The Kana line is called a "willow leaf" line, meaning that each stroke begins thin, widens, and then closes to a thin point again at the end. Kana is often linked, and form natural groupings or phrases to create rhythms throughout the work. This is based on the visual composition of Kana symbols and their relation to the rest of the piece, rather than their meaning. For example, in the Basho poem illustrated on page 219, the Hiragana symbols for the last word, *oto* おと, meaning "sound," have been split and are written in different columns. Placing the final と to the left by itself completes the composition of the whole piece. Although some Kana artwork may be seen to illustrate the meaning of the poem, the basic calligraphic approach is formal, not interpretive.

In Kana calligraphy, spacing is vital. The columns of script meander over the paper, the heights and lengths vary, sometimes they are reduced to a solitary word. The space between the columns is not uniform and sometimes Kana overlap. The impression is free and natural as if the Kana had been scattered over the page. In Japanese, this form of composition is called *chirashi gaki*. Controlling the amount of sumi ink used can further enliven the space. When the brush is fully loaded with sumi, it is wetter and heavier, allowing a stronger contrast with the space; as the calligrapher writes, the line becomes thinner and drier. The result is that the white, or color of the paper, emerges and a subtle play of black line and space develops.

When Kanji is used in Kana calligraphy, the calligrapher does not differentiate between the Kanji and Kana, but writes them as "in one breath." To help the two scripts blend compositionally, calligraphers choose cursive styles of the Kanji, which have fewer strokes, and Kana alternatives, which have more strokes, in order to avoid elongating the Kana too much.

Further thoughts on Kana
by Souteki Kawabe

Brushes and Ink

For Kana, the calligrapher usually chooses a small, weasel-hair brush with a pointed end. Special Kana brushes have a few extra-long hairs protruding from the tip in order to create very fine lines. The ink used for Kana calligraphy comes in the form of Japanese stick sumi. It is usually prepared with only a tiny amount of water so it is strong and black, not washy and thin. The tint of the sumi (brownish black or bluish black), which is important for other forms of calligraphy, is not so important in Kana, since when the sumi is not watered down, it is usually not noticeable. Bottled sumi is never used for Kana artwork, as it is too sticky.

Paper

For Kana calligraphy, the paper has been sized with animal glue and mixed with a small amount of alum. For exhibition work, *washi* or Japanese handmade paper is used. There is a large variety of decorated paper available. There are no absolute rules governing their choice. The sumptuous paper used for famous Heian Period Kana calligraphy has been replicated for calligraphers. Copying and reproducing old masters is an accepted calligraphic practice. The calligraphy is so prized that exhibitions of these works are held.

For practice, cheaper machine-made paper is used. It is thin and light, and the surface is smooth. Calligraphers usually practice on *hanshi* paper 9½ x 14¼ in. (24 x 36 cm). Finished work can also be done on this size paper. Other common sizes are *tanzaku*, 2⅗ x 14½ in. (6 x 36 cm), on which two columns of kana are written, or *shikishi*, paper boards measuring 9½ x 14¼ in. (28 x 24 cm).

Guidelines

Guidelines are not used for Kana calligraphy. On the other hand, calligraphers have to practice the piece of calligraphy over and over. The final piece is written many times and the best example out of these is chosen as the finished piece.

In the case of Kana calligraphy, the composition is freer, and there are various ways to arrange the columns of Kana. The most important point, however, is to avoid left/right symmetry in the layout.

Posture

For Kana calligraphy, calligraphers sit or kneel at a desk and rest the wrist (but not the little finger) on the desk to write. The

brush is held lightly about two inches from the tip and is kept vertical. The calligrapher uses the entire brush head when writing; the tip is used for fine lines, but the brush is opened up to create thicker parts of the line. It is important to keep a straight, but relaxed, back while writing. It is easier to sit for longer if the back is comfortable; it also ensures that the calligrapher views the calligraphy from the same angle throughout.

Calligraphy Styles and Scripts

Standard, clerical (scribe's), seal, cursive, and semi-cursive Kanji script forms are basically the same as those used in China. Additionally, there are Hiragana and Katakana syllabaries. Convention governs the use of script form and calligraphic style. Standard script is used officially and for public communication. Clerical (scribe's) script may be used for signs or newspaper names, and seal script for seals. Cursive and semi-cursive scripts are rarely used in the public arena as they are more difficult to read. Occasionally, advertisers will make use of clerical script for Chinese products, as well as cursive or semi-cursive scripts for product labels on more traditional Japanese goods.

Hiragana and Katakana can be used instead of Kanji for ease of communication. For example, some location names are now being written in Hiragana since the Kanji have local pronunciations. Advertisers may use these instead of Kanji to attract attention and also to evoke the associations mentioned in the introduction.

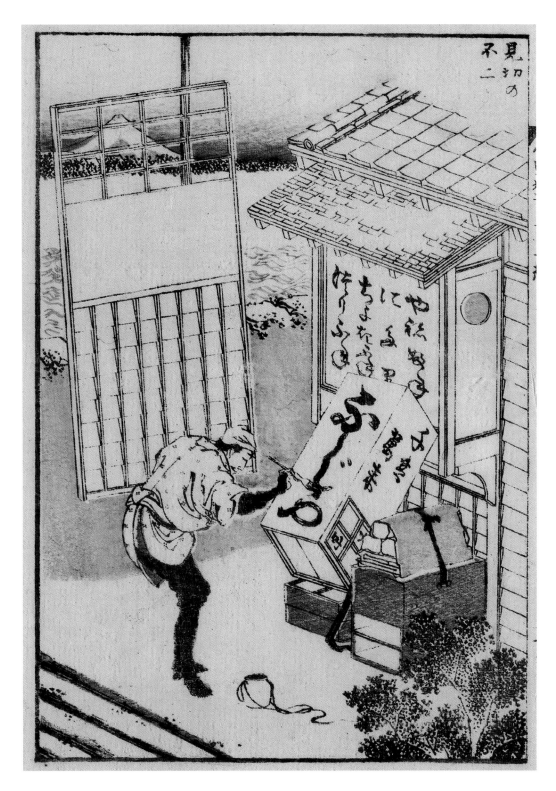

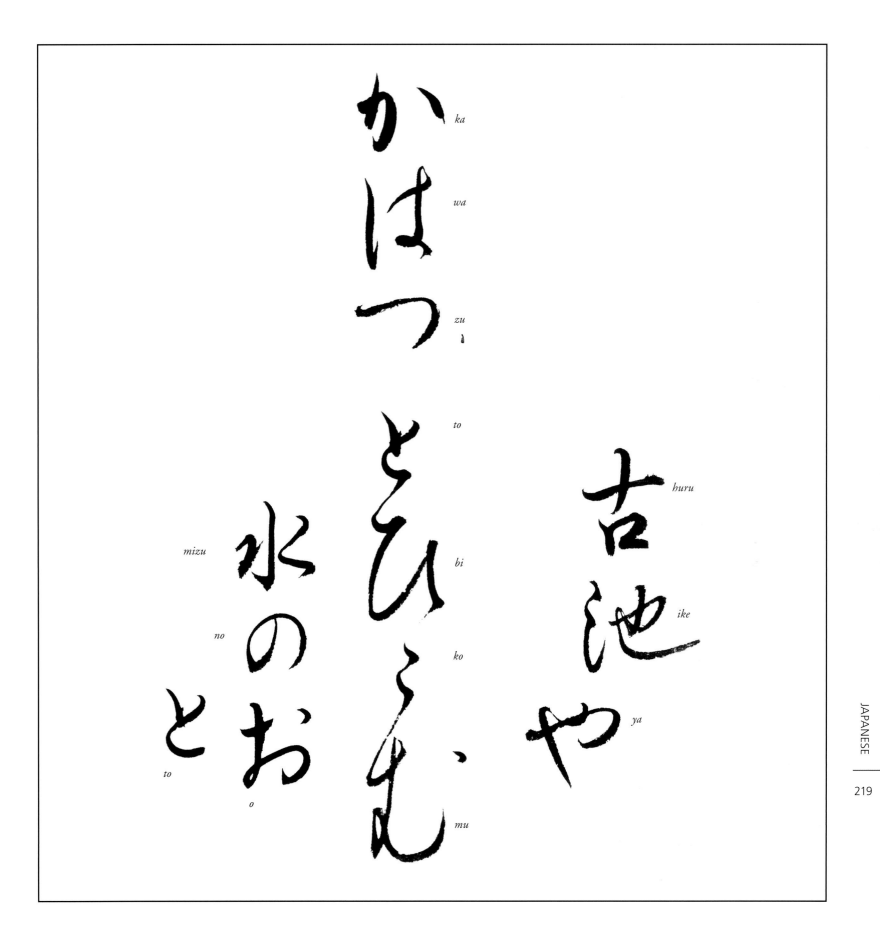

古池や
huru
ike
ya

かはづとびこむ
ka
wa
zu
to
bi
ko
mu

水のおと
mizu
no
o
to

Writing Kana Hiragana

せ *se*

さ *sa*

け *ke*

そ *so*

し *shi*

こ *ko*

す *su*

The example of Hiragana and Katakana scripts shown here are written as they are taught in elementary schools. Use a medium-sized, slightly hard brush. The main characteristic of Hiragana is its curvilinear nature, while Katakana is a more angular script form. These aspects of the scripts should be emphasized.

The strokes have been numbered to show the sequence of strokes. The numbers appear at the place each stroke begins.

Note: In the middle of the second stroke, there is a full loop; the stroke then continues downwards.

Hiragana
Note that the red lines drawn next to the characters indicate alignment; a circle indicates that a space should be left. *Calligraphy by Tsutsumi Kawabe.*

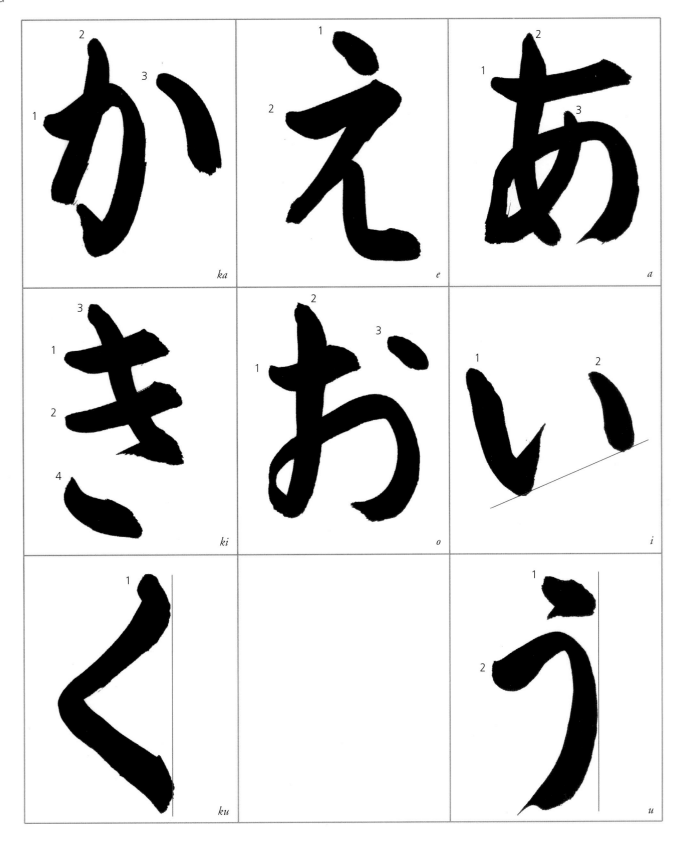

へ

he

は

ha

ね

ne

ほ

ho

ひ

hi

の

no

ふ

fu (or hu)

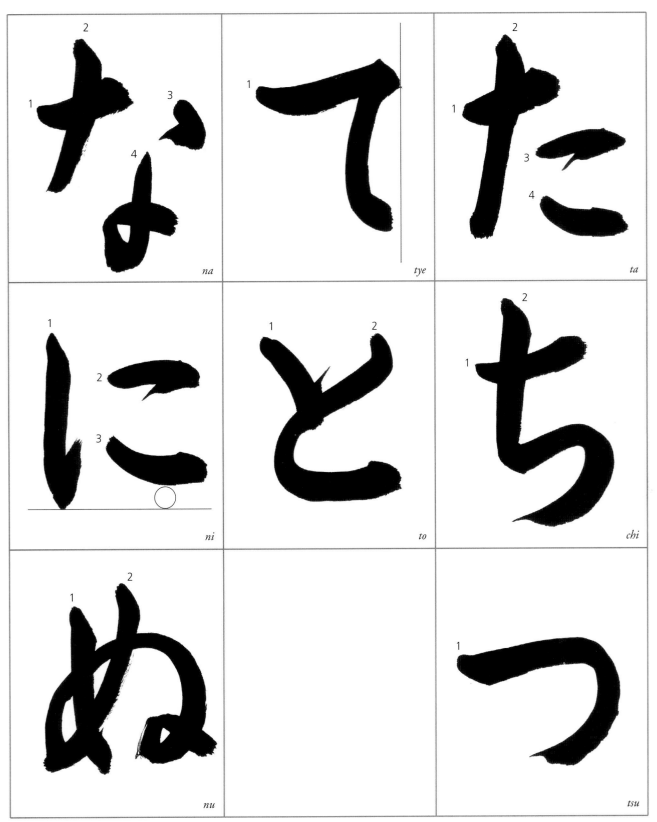

わ

wa

れ

re

ら

ra

を

wo (or o)

ろ

ro

り

ri

ん

n

る

ru

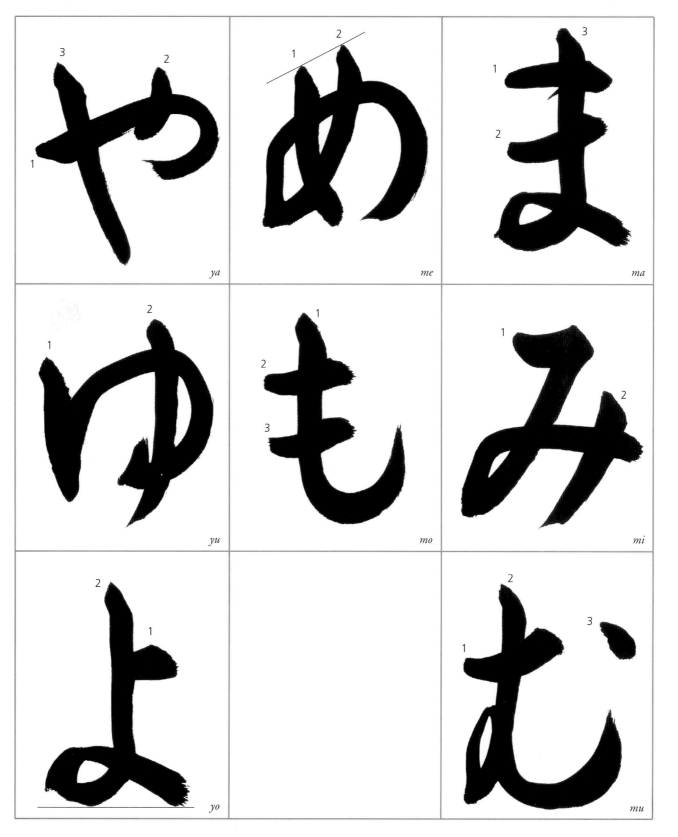

ya

me

ma

yu

mo

mi

yo

mu

セ *
1
2
se

サ
2 3
1
sa

ケ
1
2
3
ke

ツ
1 2
so

シ
1
2
3
shi

コ *
1
2
ko

ス *
1
2
su

Katakana

Note that some strokes begin in one direction, pause at a corner, and finish in another direction. These have been marked with red asterisks. *Calligraphy by Tsutsumi Kawabe.*

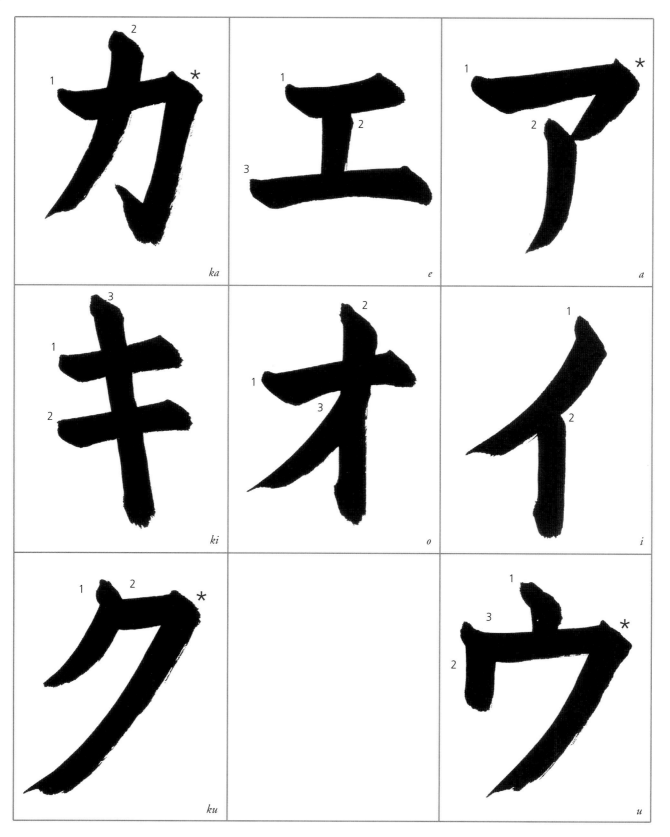

ヘ
1

he

ハ
1 2

ha

ネ
1
2 *
4
3

ne

ホ
2
1
3 4

ho

ヒ
2 1
*

hi

ノ
1

no

ラ
1 *

fu (or hu)

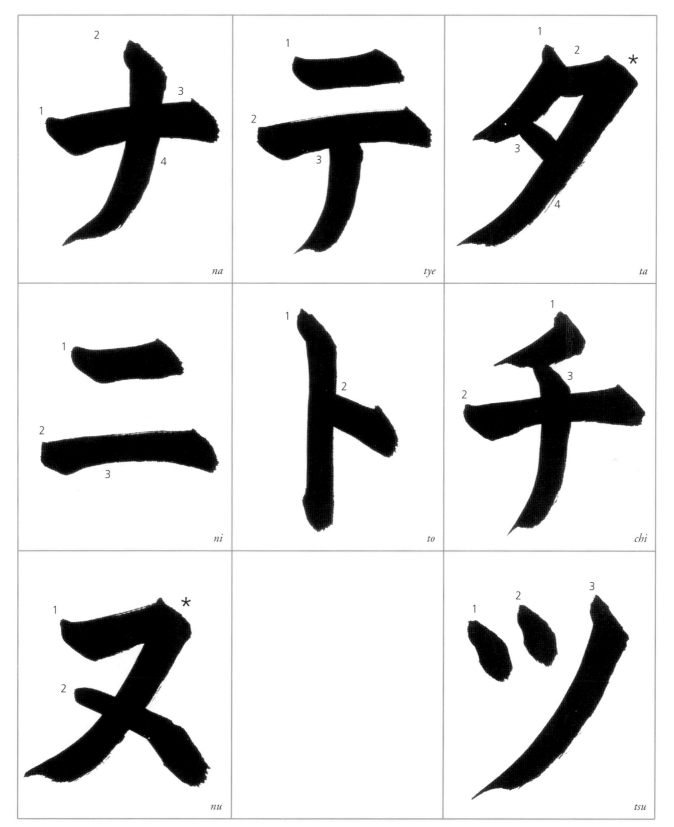

na

tye

ta

ni

to

chi

nu

tsu

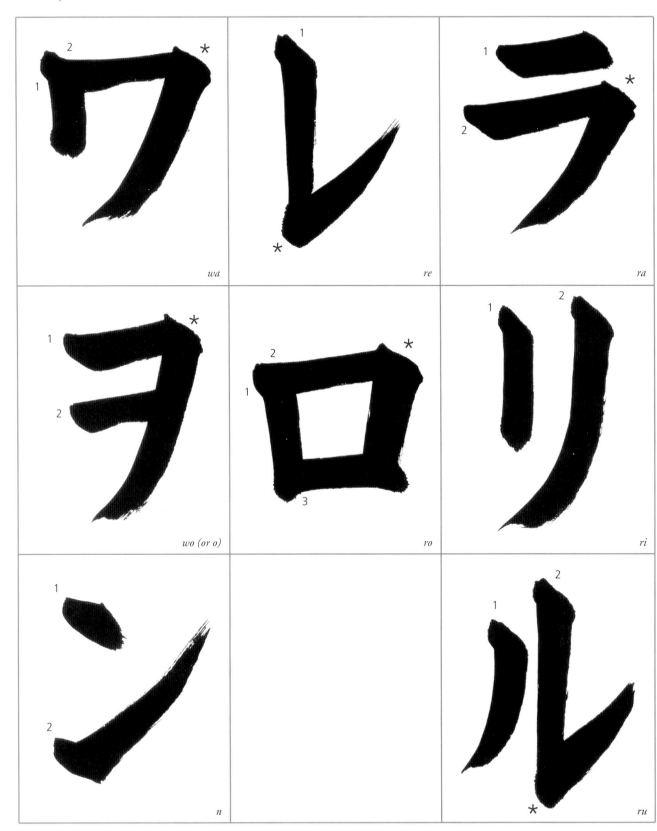

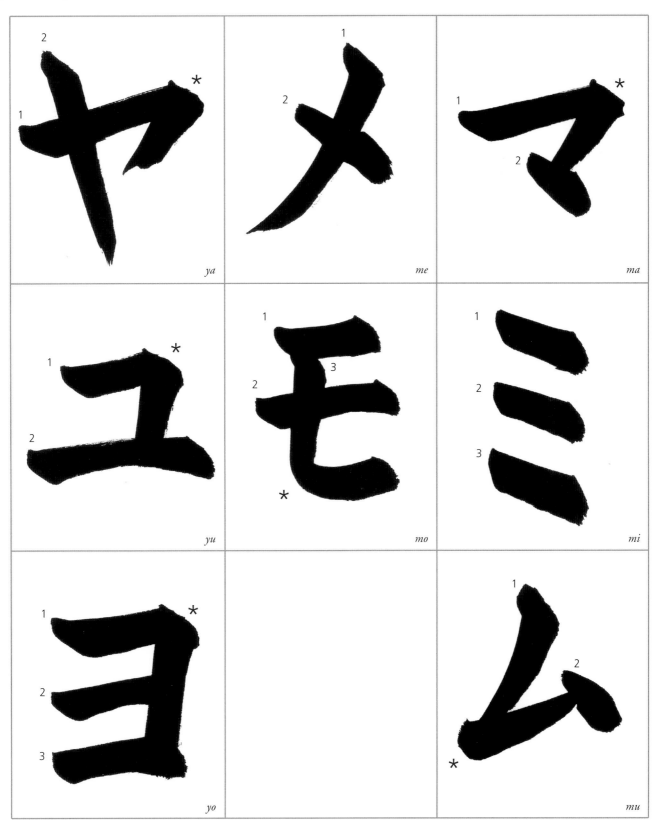

ya	*me*	*ma*
yu	*mo*	*mi*
yo		*mu*

Above: The pink, white, and green panel was created for the Setsubun Festival, celebrated at the beginning of February when beans are customarily thrown around the house to drive out the devils in order to welcome in good fortune. The main calligraphy reads: *Mami Maki*, meaning "bean throwing." The smaller kanji on the left reads: *Fuku ha uchi, Oni ha soto,* meaning "Good luck in, Devils out!" The pastel coloring echoes the traditional Kabuki red and green. Calligraphy by Tsutsumi Kawabe.

KANTEIRYU
by Christine Flint Sato

Kanteiryu is a specialized script form used for notice boards and programs advertising the Kabuki theater. In the early twentieth century, this script became popular among businesses when creating their signs, since it was visually associated with Kabuki and, by extension, good fortune. Nowadays, it has gained popularity due to its use as a font on the computer.

Kanteiryu was originally invented by calligrapher Okazakiya Kanroku (1746–1805), who was asked by Nakamura Saburo, proprietor of the Nakamura Kabuki Company in Edo (Tokyo), to create a new script for the New Year's production in 1779. The script he wrote in was based on the standard script, and is essentially the same now as it was then. It incorporates three stylistic innovations inspired by the art of Kabuki:

1. The strokes of the characters must be fat, with no spaces in between, giving the impression of a full house.

2. The strokes should all be rounded, heralding a mellow performance, with no sharp lines, which would indicate displeasure.

3. All the strokes should turn in at the tips, beckoning the audience into the theater.

A calligrapher writes Kanteiryu as if dancing Kabuki, and tries to express the flexible poses and rhythm of the art form. In contrast to other Japanese calligraphy, the priority is the form of the character rather than the vigor of the stroke. Some strokes are therefore brushed two or three times in order to thicken them and to produce an undulating line.

A regular, short-haired brush is used with either stick or bottled sumi. The ink should be very thick and black, giving the

impression of abundance.

Photocopy paper is usually used for both practice and finished work as it has a smooth surface and does not absorb the sumi. This is important, as the paper should not allow any bleeding. Washi (handmade Japanese paper) is rarely used.

Pencil guidelines are used for the columns of script so that the calligrapher can relax while writing. They are rubbed out afterward.

Calligraphers usually sit at a table to write, and if the work is large they may stand at a table; they rarely work on the floor.

When writing with a small brush, it is held the same way one holds a pencil or ballpoint pen, and at a 45° angle to the paper. The little finger of the writing hand rests on the other hand, which is laid on the desk and acts as a support. When using a larger brush, no supporting hand is employed.

As Kanteiryu was originally written by a handful of professionals for the Kabuki theater, there were no classes to teach it to the general public until 1975. Today, Jutei Fushiki, the principal teacher of Kanteiryu, teaches about five or six different classes regularly. He also teaches by correspondence with students from all over the country. As of yet, there is no system for promoting calligraphers to teachers, but there are plans to start a teaching qualification examination in 2008.

Right: The yellow panel is a New Year's greeting. The calligraphy is known as *Fukujusou,* the name of a bright yellow flower. The story is told that a samurai on the run hid his gold in a mountain. Later in the year, Fukujusou flowers bloomed all over the mountain-side. The flower is therefore associated with hidden treasures. Calligraphy by Tsutsumi Kawabe.

Writing Kanteiryu
by Jutei Fushiki

Here we present a sample of characters and short phrases written in the Kanteiryu script. The characters are Kanji, Hiragana, and Katakana. The sequence of strokes is noted in the small diagrams that appear next to each character.

With its strikingly dense, compressed forms, Kanteiryu is very different from the classic style of the Kana shown at the beginning of this chapter. In some cases, Kanteiryu also departs from the stroke order and direction of standard scripts. *Calligraphy by Jutei Fushiki.*

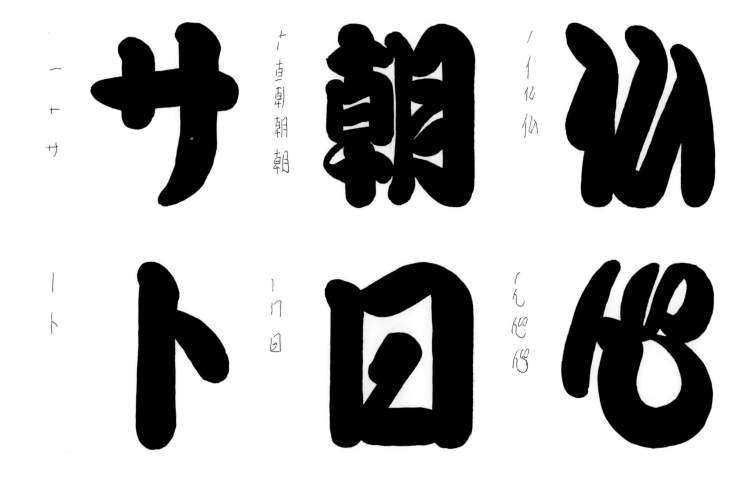

サトsato in Katakana meaning village　　　朝日 morning sun　　　仏心 Buddha mind

土 earth

口 mouth

上 up

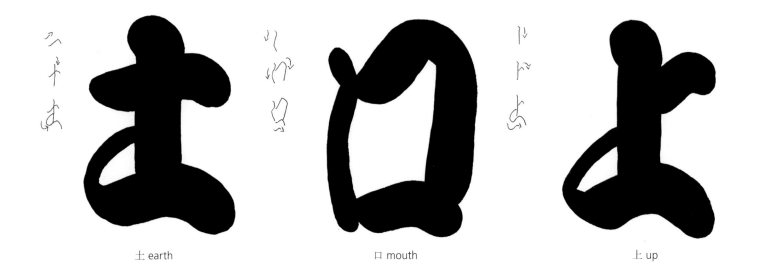

下 down

大 big

中 middle

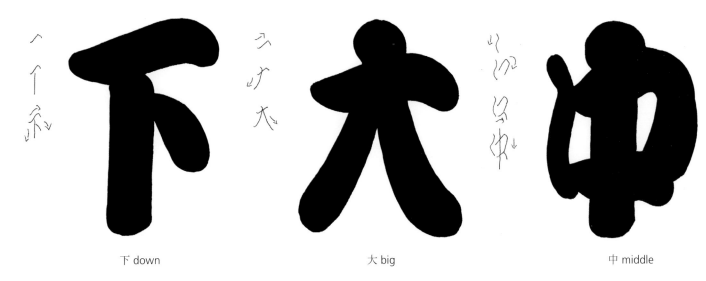

小 small

山 mountain

川 river

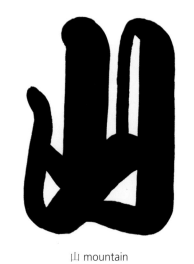

THE WORLD ENCYCLOPEDIA OF CALLIGRAPHY

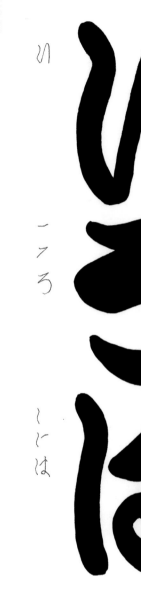

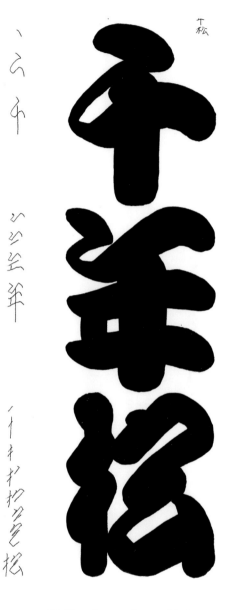

いろは *i ro ha* in Hiragana, the beginning of a Japanese alphabet poem

一 二 三 one two three

千年松 a thousand-year-old pine

236

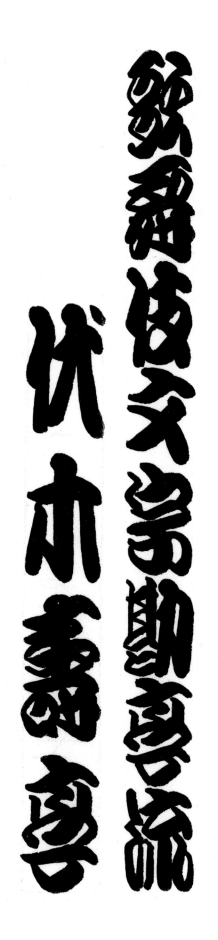

Right: These two lines of writing say:
歌舞伎文字勘亭流 (Kabuki calligraphy kanteiryu)
伏木寿亭 (Fushiki Jutei)

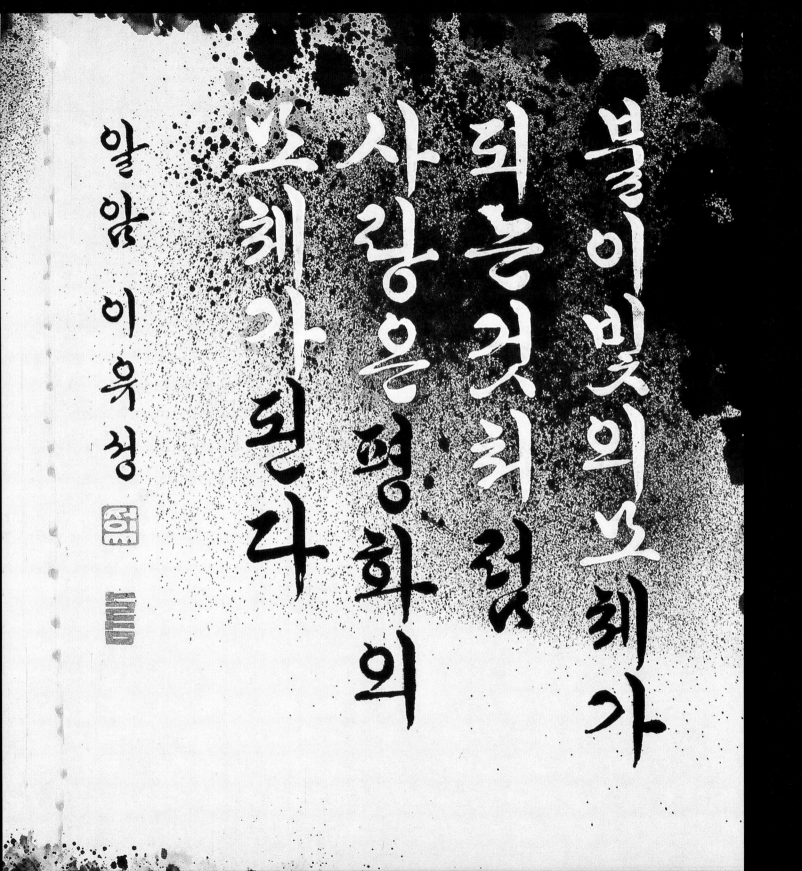

불이 빛의 모체가 되는 것처럼 사랑은 평화의 은혜가 된다

알암 이우성

KOREAN
The Hangeul Syllabary

by Yoo Sung Lee

Syllabary: 24 symbols phonetically represent syllables; individual phonetic symbols are combined to form square units.

Direction of writing: *top to bottom and right to left*

Majuscule and minuscule distinction: *none*

Principal tool: *pointed brush*

Language: *Korean*

Left: *Fire and Love.* Calligraphy by Yoo Sung Lee, 1999. Ink on paper (scroll). 23½ x 35¼ in. (58.42 x 88.9 cm). Contemporary style.

*H*angeul is the script used to write Korean, a language of seventy-six million speakers. It is an alphabet of twenty-four letters; fourteen consonants and ten vowels. Unlike the Roman alphabet, in which independent letters are arranged in horizontal lines, for the Hangeul script, consonant and vowel letters are combined to create syllabic blocks.

Whereas the origins of most writing systems are unknown, Hangeul, originally called *Hun-min-jeong-eum* (meaning "the correct sounds for the instruction of the people"), was created in 1443 by King Sejong (1397–1450), of the Joseon dynasty (1392–1910) with his royal scholars.

Hangeul was unique at the time when all of Asia still was using Chinese characters. Though the Korean syllabary was much simpler than Chinese, it was not widely used for many centuries after it was created, partly because the scholar-bureaucrats of the Joseon dynasty felt that it threatened their elite status if the script was too easy to learn. It was not until 1894 that the Hangeul script was used in official government documents. The first all-Korean script newspaper, *Tongnip Sinmun* (*Independent News*), was published in 1896 by Seo Jaepil (1863–1951). The name *Hangeul* ("Korean script") was given by Ju Sigyeong (1876–1914), one of the earliest modern Korean grammarians.

The design of the Hangeul letters is the result of a deep understanding of phonetic principles and East Asian cosmological philosophy on the part of the king and his royal scholars. Originally, twenty-eight basic letters (seventeen consonants and eleven vowels) were introduced, but three consonants and one vowel are no longer used in the current writing system.

The consonant letters *k* (or *g*), *n*, *s* (or *sh*), *m*, and *ng* are designed after the shape made by a person's mouth, tongue, and larynx while

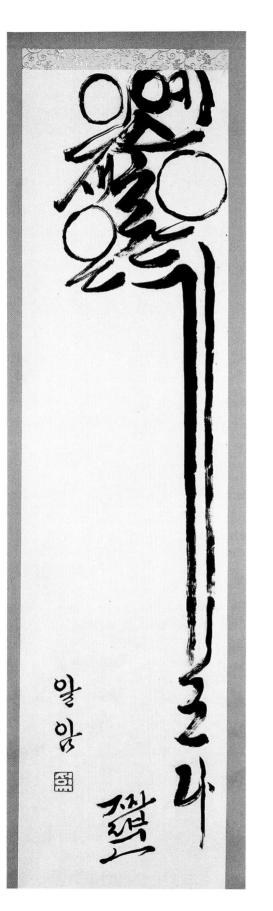

pronouncing these letters. The other consonant letters are made either by adding a stroke or two to these, or by extending the initial forms. An extra stroke indicates a different feature of articulation, such as aspiration when an extra puff of air produces a sound. In this respect, the Hangeul script is unique and more refined in representing sounds than any other script.

Vowel letter designs are based on the *eum-yang* (*yin-yang* or male-female) philosophy of universal complementary forces and the East Asian cosmological belief that heaven, earth, and human(ity) are the three most fundamental features in the universe. The three initial vowel letters are designed after the round shape of heaven (a circle or dot), the flat shape of earth (a horizontal line), and the upright shape of a human standing (a vertical line). The other letters are made by combining the three initial letters. These combinations are guided by the principles of the Eum-yang theory as to how heaven interacts either with the human being or with the earth.

Because of its systematic and scientific organization as well as its sophisticated phonetic representation, the Hangeul script is regarded as one of Korea's cultural treasures. It is recognized by scholars outside of Korea for its linguistic and cultural value. October 9 is celebrated each year as Hangeul Day, a national holiday in Korea, and is associated with the estimated date of the first promulgation of Hangeul. The original record of Hun-min-jeong-eum was registered as a World Record Heritage by UNESCO in 1997.

Far left: *Art and life.* Calligraphy by Yoo Sung Lee, 2010. Ink on paper (scroll). 27 x 36¼ in. (69 x 92 cm). Contemporary style.

Near left: *January.* Calligraphy by Yoo Sung Lee, 2000. Ink on paper (scroll). 12 x 49 in. (30.48 x 124.46 cm). Contemporary style.

Hangeul *Jamo*

Jamo literally means the mother(s) of a script. There are twenty-four basic letters: fourteen consonants and ten vowels. These can also be combined to make an additional twenty-seven complex clusters. Altogether, there are fifty-one Jamo, which form the basic units of Korean writing. The twenty-four basic letters are shown in the table below.

The Jamo letters are arranged in syllabic blocks as mentioned above. Each word is made up of more than one syllable, and in modern typeset text there is a space between words in a sentence. The sentence is in a linear arrangement. In typeset texts, the direction of writing can be either horizontal or vertical. Korean calligraphy favors the vertical line arrangement to the horizontal one, because the structural characteristic of the vertical down-stroke in each syllable creates a backbone for the vertical linear arrangement of a sentence. Normally, the space between words is omitted in Korean calligraphy.

The Basic Letters
Consonants
Each consonant is shown with its name and Roman alphabet equivalent.

ㄱ	ㄴ	ㄷ	ㄹ	ㅁ	ㅂ	ㅅ
giyeok	nieun	digeut	rieul	mieum	bieup	siot
g k	*n*	*d t*	*r l*	*m*	*b p*	*s*

ㅇ	ㅈ	ㅊ	ㅋ	ㅌ	ㅍ	ㅎ
ieung	jieut	chieut	kieuk	tieut	pieup	hieut
ng	*j*	*ch*	*k*	*t*	*p*	*h*

Vowels
Each vowel is shown with its Roman alphabet equivalent and pronunciation indicated with bold letters in an English word.

ㅏ	ㅑ	ㅓ	ㅕ	ㅗ
f**a**ther	**ya**cht	l**aw**n	l**aw**n	g**o**
a	*ya*	*eo*	*yeo*	*o*

ㅛ	ㅜ	ㅠ	ㅡ	ㅣ
yoyo	s**ue**	**you**	p**u**t	m**ee**t
yo	*u*	*yu*	*eu*	*i*

Left: The Hangeul letters are stacked to form blocks representing syllables. The blocks are divided into sections indicating the order in which the characters are read to make up a syllable; the six configurations (left) show the positions of the initial (I), medial (M), and final (F) letters in each block. The order in which the letters are stacked depends on the shape of the medial character.

Below: The words "azalea" (*jindalae*) and "flower" (*ggot*). The initial, medial, and final positions of the letters within each syllable block have been labeled.

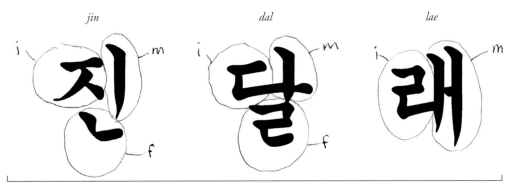

jin *dal* *lae* *ggot*

azalea flower

Right: *Love and Faith.* Calligraphy by Yoo Sung Lee, 1999. Ink on paper (scroll). 24¼ x 26 in. (60.96 x 66.04 cm). Contemporary style.

Above: *The Lord's Prayer.* Calligraphy by Yoo Sung Lee, 1999. Ink on paper (scroll). 21¾ x 47¼ in. (53.34 x 119.38). Panbonche and Gungche Heulimche style.

Above: The distinctive square forms of the historic Panbonche style. Calligraphy by Yoo Sung Lee

Panbonche Script

At the time of the promulgation of Hangeul, the alphabet was printed in sans-serif angular lines of even thickness. This style can be found in books printed before 1900, and on stone carvings. This original diagrammatic box style was not conducive to continuous, smooth calligraphy. It was modified and developed over time, as can be seen in contemporary Panbonche styles.

The former might be called *Panbonche goche* ("goche" means older style) and the latter might be called *Panbonche pilsache* ("pilsache" means ink-brush writing style). Originally, the beginning of line and dot strokes were somewhat rounded, but they became more angular with the later brush-style. Characteristic of the Panbonche style are an even thickness of lines, rectangular-shaped syllabic blocks, and the symmetrical geometric-looking shapes that make up the syllabic blocks.

Gungche Script

Gungche means "Palace Style." It can be considered the standard script for Korean calligraphy, and is the style used in the exemplar in this chapter. It was originally used to produce royal literature for and intra-palace communication by women (including queens and maidservants), as well as palace officials of the Joseon dynasty court. For more than 350 years, this *seoye* (calligraphy) style has been continuously used and developed since the days of King Sukjong as the representative Korean calligraphy style. This style comprises simple elegance and grace in composition. However, because it is much simpler than Chinese characters, it requires well-balanced beauty in terms of the hidden beauty in the line and of organized line and space. It is said that writing too strictly in this style might tend

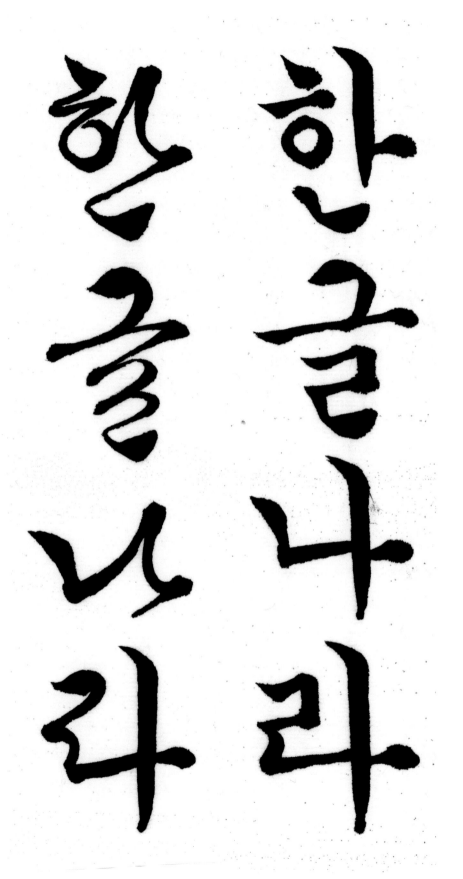

to diminish its artistic value. This style is more fitting for the vertical arrangement of scrolls. Gungche can be written in the formal standard style, as well as in a range of cursive and semicursive styles.

Contemporary Calligraphy in Hangeul

One of the modern movements in calligraphy is to foster a livelier vehicle for personal expression, with feeling being conveyed far more directly than ever before. In this trend, calligraphers try to rid themselves of all kinds of traditions, in an attempt to demolish and reconstruct characters in the pursuit of artistic beauty and unlimited creativity. Regardless of earlier styles, modern calligraphers are attempting to harmonize this art with the life and philosophy of our time. This is not an art form to be read, but to be appreciated in purely visual terms. In other words, the art is to be contemplated for its values as abstract forms.

Left: An example of a contemporary style, showing a free interpretation of the historical forms, and an expressive use of the brush. Calligraphy by Yoo Sung Lee.

Right: *Enjoying the fragrant black ink*. Calligraphy by Yoo Sung Lee, 1999. Ink on paper (scroll). 19½ x 47¼ in. (48.26 x 627.38 cm). Extremely cursive Gungche style.

Opposite, far left: The same text written in two variations of the Gungche style. On the right, the text is written in *Jeongja*, or regular, script. On the left, in *Heulim*, or cursive, script. Calligraphy by Yoo Sung Lee.

Opposite, left: *Love is the mother of Peace*. Calligraphy by Yoo Sung Lee, 1999. Ink on paper (scroll). 19½ x 26¼ in. (48.26 x 66.04 cm). Gungche Heulimche style.

Writing Korean

When writing Korean, bear in mind certain principles: every Hangeul syllabic block is built up in its own square with a variety of structure and composition. For each syllabic block there is a definite number of strokes and appointed positions in relation to the whole. No stroke may be added or deleted for decorative effect. Strict regularity is not required. The pattern should have a lively movement and be well balanced. *Calligraphy by Yoo Sung Lee.*

Six Basic Brush-strokes in Hangeul

To learn calligraphy, it is vital that you learn to write the six basic strokes before you learn to write Korean Jamo. Stroke order can refer to the order in which strokes are written, or to the direction in which the writing tools (i.e., brush pen) should move in a particular stroke (see following pages). In writing any Jamo, the order of the strokes is fixed and should be learned by heart. Horizontal lines are written from left to right, and vertical lines from top to bottom. The enclosing bottom stroke is always written last.

Making these strokes is the basic skill in writing. These six basic strokes will be illustrated using the model of Gungche, the most popular style of Korean calligraphy.

This model of the Gungche style shows all vowels and consonants. Please note that the letters are ordered by ease of stroke so that the student will gainfully master the forms.

Vertical down-stroke
This stroke is used for:
ㅏㅑㅓㅕㅣㅂ

Horizontal dash-stroke
This stroke is used for:
ㅗㅛㅜㅠㅡㅍ

Bending stroke
This stroke is used for:
ㅋㄹㅁㄷㄹㅌ

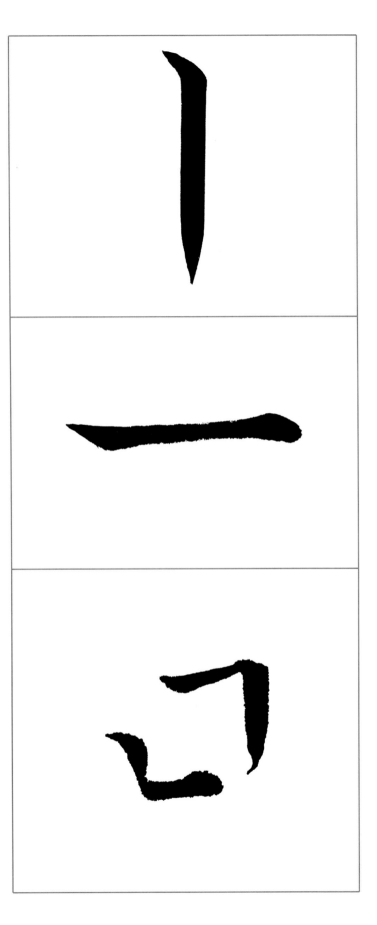

Left falling stroke

This stroke is used for:

ㅠ ㅅ ㅈ ㅊ

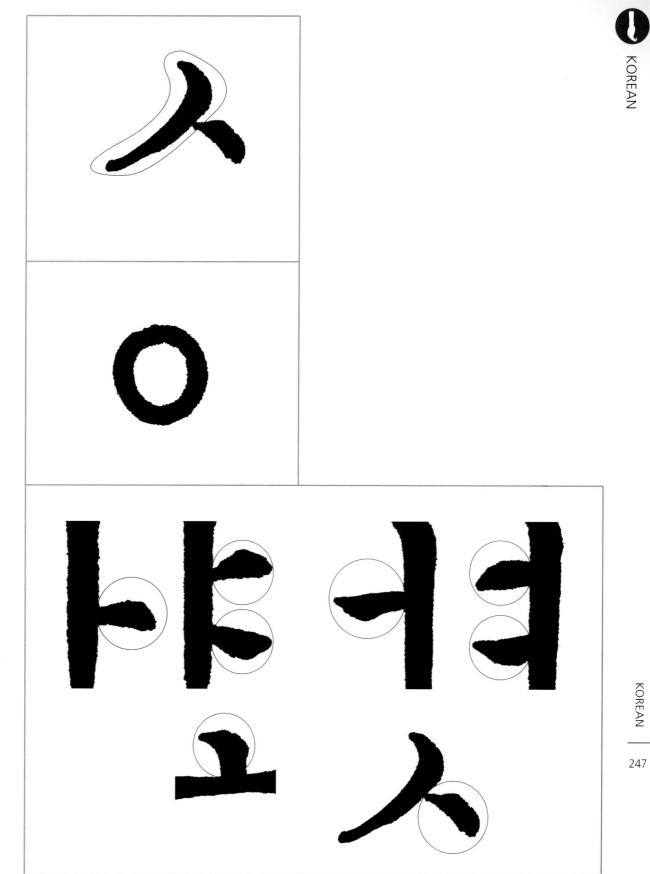

Circle stroke

This stroke is used for:

ㅇ ㅎ

Dot or Very Short Line Stroke

The student must be careful when comparing the different forms and try to grasp their characteristics, mastering the way to write the dot with a brush. There are several ways to make the dot stroke, which are discussed in the detailed exemplar that follows.

This stroke is used for:

ㅏ ㅑ ㅓ ㅕ ㅗ ㅛ ㅂ ㅍ ㅅ ㅈ ㅊ ㅎ

Practicing Two Basic Strokes

Let us practice two basic strokes first: the vertical down-stroke and the horizontal dash-stroke. Practicing these two strokes will prepare you for exercises in writing entire vowels and most of the consonants that appear in the composition of all syllabic blocks. *Calligraphy by Yoo Sung Lee.*

eu

i

Writing the horizontal-dash stroke

1. Starting (*gi-pil*): Touch the brush on the paper at an angle of 45°. Rebounding off to the right, decide the thickness of the line, and then take a pause briefly.

2. Processing (*song-pil*): Continue until the brush reaches the end of the stroke, keeping your brush point on the center of the stroke the entire time. Take a pause briefly. There is a slight upward tilt in the entire stroke. Usually the horizontal stroke is thinner than the vertical one.

3. Ending (*su-pil*): Make the end-mark by pressing the tip down with the same angle of 45° degrees that you started with. Move the tip back slightly to retrace its path. Lift the brush smoothly away from the paper, somewhat to the left of the end of the line, which will give a smooth appearance to the conclusion of the stroke. The right and left ends of the stroke should be well balanced.

Writing the vertical down-stroke (i)

1. Starting (*gi-pil*): When the brush makes contact with the paper at an angle of approximately 45°, it moves from the upper left to the right. By turning the brush downward, decide the thickness of the line, and then take a pause briefly.

2. Processing (*song-pil*): Continue straight down up to two-thirds of entire length. Keep your brush point on the center of the stroke. Take a pause briefly. Usually the vertical stroke is thicker than the horizontal one.

3. Ending (*su-pil*): Lift the brush gradually at the bottom third of the stroke ending. When the brush point reaches the end, allow only the very tip of the bristles to bend slightly to the left.

Step-by-step through the Hangeul Alphabet

ㅏ: After making the vertical down-stroke, lightly touch the brush point about two-third of the way down from the top of the stroke. Press down and turn slightly clockwise to make a horizontal elongated dot. Lift the brush smoothly away from the paper.

ㅑ: The vertical down-stroke will be divided into three parts by two dots. The dots will be written just as in "ㅏ." The two dots may run parallel to each other or the top dot can angle upward while the lower dot angles slightly downward.

The red circles indicate that the spaces created by the dots should be about equal.

a *ya*

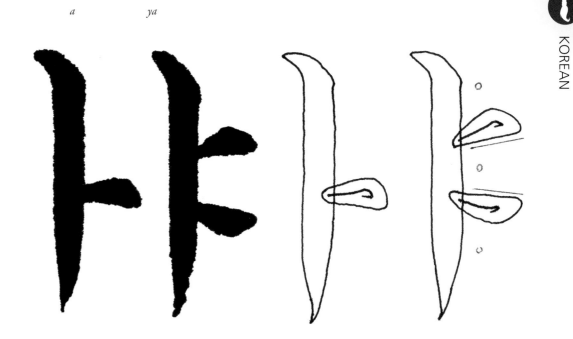

ㅓ: After making the vertical down-stroke, touch the brush point lightly on the vertical down-stroke and move it slightly upward. The weight should be thinner than the vertical stroke.

ㅕ: To create the upper dot, lightly touch the vertical down-stroke "ㅣ." With gradual pressure, turn the brush slightly clockwise. This should result in a rounded shape on the upper portion of the dot and a flat line on the bottom of the dot. To make the lower dot, lightly touch the vertical down- stroke "ㅣ" and move the brush with gradual pressure by turning slightly counterclockwise. This should result in the opposite shape of the upper dot. Here, the upper portion of the dot should be flat and the lower portion should be rounded. The lower-flat shape of the upper dot and the upper-flat shape of the lower dot should run almost parallel to one another.

eo *yeo*

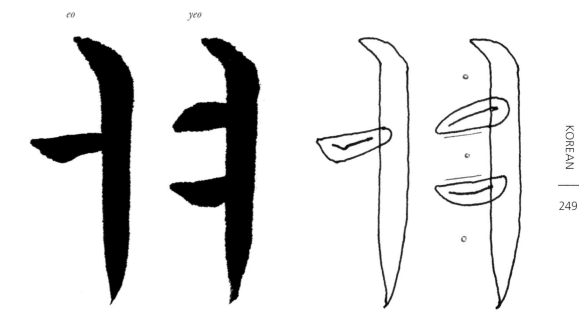

Step-by-step through the Hangeul Alphabet (continued)

ㅗ: Begin as if you are making the upper portion of the vertical down-stroke and let the stroke begin to run straight down. Lift the brush point at once so that you make a short dot instead of a long vertical down-stroke. The dot should be located a bit right from the middle of the horizontal dash-stroke, which is made second. These two strokes may overlap so that you cannot see where the dot stroke ends.

ㅛ: The horizontal dash-stroke will be divided into three parts by two dots. The dots will be written just as in "ㅗ." Both dots can be the same height, or the second dot may be slightly higher than the first.

o *yo*

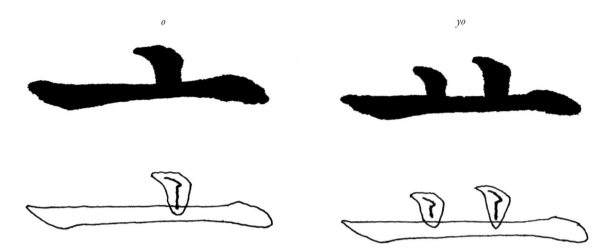

ㅜ: Make the horizontal dash-stroke and lightly touch the brush point about two-thirds the way from the starting point. Make an elongated dot by pressing down. The dot is basically a shortened version of the vertical down-stroke. By overlapping strokes, the starting point is hidden.

ㅠ: The horizontal dash-stroke will be divided into three parts by two elongated dots. These elongated dots are written the same way as in the stroke "ㅜ." The first dot is normally shorter in length than the second one. These two dots may run parallel, or the first dot may fall slightly to the left.

u *yu*

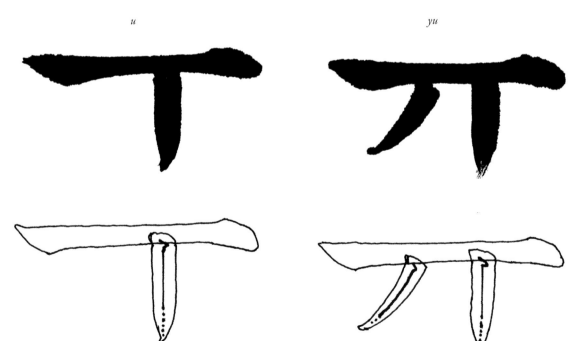

g/k

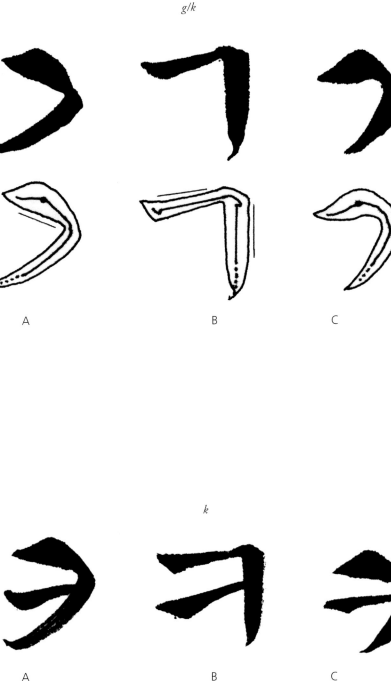

A B C

k

A B C

ㄱ: Three forms of this letter are shown, because the shape changes depending on the letter that follows.

A: Touch the brush point to the paper as if you were making an elongated horizontal dot. Press down and turn the brush to the right, complete the top part of the stroke by lifting slightly as you move diagonally to the right. Next, the brush turns the corner and executes a left falling stroke. The stroke terminates suddenly without a sharp edge and the brush points upward slightly. This is used for writing the combinations 가, 갸, 거, and 겨.

B: Begin as though you were writing the horizontal dash-stroke, turn right and pull down into the vertical down-stroke. This is used for writing the combinations 고, 교, and *batchim* (special consonants added at the bottom of a syllable block).

C: Begin as though you were writing the horizontal elongated dot. Press by turning right and downward, as you lift the brush, turn downward briefly, and then turn sharply, creating a left-falling stroke that is rounder and shorter. This is used for writing the combinations 구, 규, and 그.

ㅋ: The only difference between "ㅋ" and "ㄱ" is the placement of an additional horizontal dash-stroke inside the letter, which is actually a shortened, horizontal dash-stroke. The various basic forms of "ㅋ" are the same as "ㄱ."

Step-by-step through the Hangeul Alphabet (continued)

ㄴ: Four forms of this letter are shown, because the shape changes depending on the letter that follows.

A: Begin by making the upper portion of the vertical-down stroke. Lift the brush at once to make a short narrow ending and pause briefly. Turn the corner and continue with a horizontal movement, narrowing gradually to the end of the line. The end will normally be hidden in the vowel. Note that after turning from vertical to horizontal, there will be a slight upward tilt in the horizontal stroke. Usually the horizontal stroke is thinner than the vertical. This is used for writing 나, 냐, and 니.

B: Begin the stroke the same as (A), above. After turning the corner, press down harder and then lift the brush quickly. This will result in a short stroke meeting the vowel. The upper line should be straight and tilt upward, and the lower line should be rather round and tilt sharply upward. This is used for writing 너 and 녀.

C: Begin the stroke the same as (A), above, but make the stroke shorter. After turning from the vertical stroke into the horizontal, note that there should be a slight upward tilt in the horizontal stroke. This lower horizontal line should be tilted and with straight sides, not round. This line should be parallel to the next vowel. The end of the stroke is the same as the end of the horizontal dash-stroke. This is used for writing for ㅗ, ㅛ, 누, 뉴, and 느.

D: Begin the stroke the same as (A), above, but make the stroke shorter. Turning from the vertical to the horizontal, press heavily so that lower line is more round, and then lift pressure gradually to the end. The upper line will stay horizontal and it may have a slight upward tilt. This is used for writing *batchim*.

n

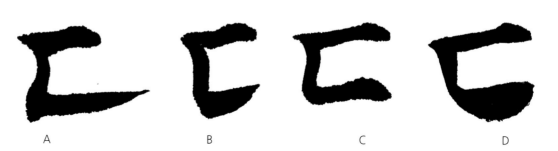

A　　　　　　B　　　　　　C　　　　　　D

d/t

ㄷ: The difference in "ㄷ" from "ㄴ" is an additional short horizontal dash-stroke above. When these two strokes are combined to make this letter, the beginning of the "ㄴ" is made a little smaller than it is when the "ㄴ" stands alone. The various basic forms of "ㄷ" are the same as "ㄴ."

A　　　　　　B　　　　　　C　　　　　　D

t

A B C D

ㅌ: The various basic forms of
"ㅌ" are the same as "ㄷ."

r/l

A B C D

ㄹ: The various basic forms of
"ㄹ" are the same as "ㄷ."

Step-by-step through the Hangeul Alphabet (continued)

ㅅ: Three forms of this letter are shown, because the shape changes depending on the letter that follows.

The red lines in the diagram for this letter and in the diagrams for the two letters that follow indicate the alignments of the various components of the letterforms. The red circles indicate spaces between the strokes that should be of roughly similar size.

A: Touch the brush point down at a 45° angle, making a large elongated dot. Lift the brush point slightly, turn and continue to make a left-falling stroke, narrowing the thickness while keeping the brush point on the center of the stroke all the way through. The stroke may bend slightly upward at the end. The next dot stroke should not be smaller than the first dot stroke. These two strokes should be symmetrical to each other in terms of the angle between them. This is used for writing for 사, 샤, and 시.

B: Touch the brush point down at a 45° angle to make a large elongated dot. Lift the brush point slightly, turn and make a left-falling stroke. Narrow quickly by releasing pressure and make a shorter stroke than that shown in (A). The next stroke for the dot should be more elongated and perpendicular (drooping) to allow more space for the vowel. This is used for writing 서 and 셔.

C: Touch the brush point down at a 45° angle to make a large elongated dot. Lift the brush point slightly, turn and make a left-falling stroke. Narrow quickly by releasing pressure and make a shorter stroke. The next stroke for the dot should be as short as the previous stroke, leaving a wide angle between them to make enough space for the vowel. These two strokes should be symmetrical to each other in terms of the angle between them. This is used for writing 소, 쇼, 수, 슈, and 스.

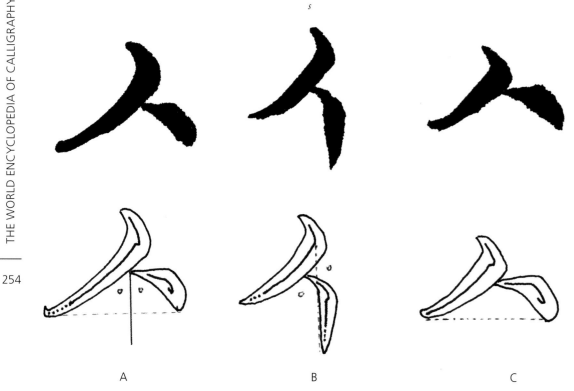

s

A　　　　　　　　B　　　　　　　　C

j

ch

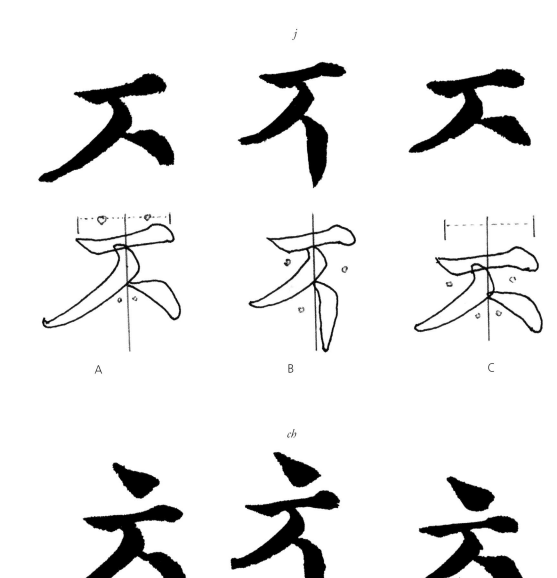

A B C

ス: The difference between "ス" and "人" is an additional horizontal dash-stroke on top, which is a shortened horizontal stroke. In the stroke "ス," the lower joining point of the two strokes of "人" should be located under the middle of the top horizontal stroke. The other important characteristics of "人" mentioned above can also be applied to "ス." The various basic forms of "ス" are the same as "人."

え: The difference between "え" and "ス" is an additional dot above. To make the dot, touch the brush point down at a 45° angle, turn toward the horizon line and stop quickly. In the stroke "え," the dot should be located above the middle of the horizontal stroke. The important characteristics of "ス" mentioned above can also be applied to "え." The various basic forms of "え" are the same as "ス."

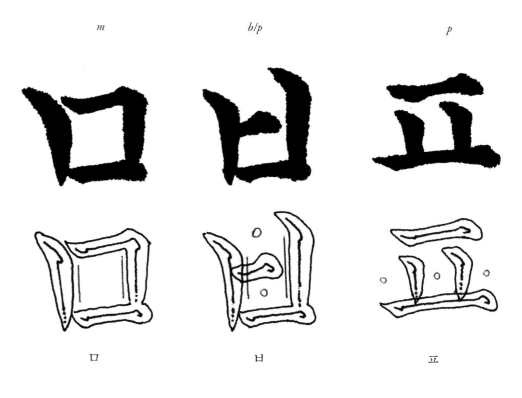

m *b/p* *p*

ㅁ ㅂ ㅍ

These three letters are shown together, as they have very similar construction and proportions.

ㅁ: To make the first vertical stroke, touch the brush point down at an angle of 45°. The line slants downward while maintaining its vertical position. The second stroke is a bending stroke of "ㄱ." The two vertical strokes should be parallel. The third stroke is a short horizontal stroke. Both vertical strokes are thicker than the horizontal strokes.

ㅂ: To make the first vertical stroke, touch the brush point down at an angle of 45°. This is the same as the first stroke in "ㅁ." The second stroke is the shortened form of the vertical stroke and should be parallel to the right line (vertical) of the previous stroke. The third and fourth strokes are both horizontal: an elongated dot and the shortened form of the horizontal stroke.

ㅍ: The top stroke is made first. It is a shortened horizontal stroke. The second and third strokes are the same as the first and second strokes in "ㅂ" and should be parallel to one another. The fourth stroke is a horizontal stroke. It should be wide enough to support the second and third strokes.

The form of the following vowel determines what form the last stroke will take. When combined with "ㅏ, ㅑ, ㅣ," the last stroke is extended to the vowel. When combined with "ㅓ, ㅕ," the last stroke is shortened to meet the vowel. When combined with "ㅗ, ㅛ, ㅜ, ㅠ, ㅡ," there should be a wider space between the second and third strokes, and the last stroke should be shortened to meet the vowel.

ng *h*

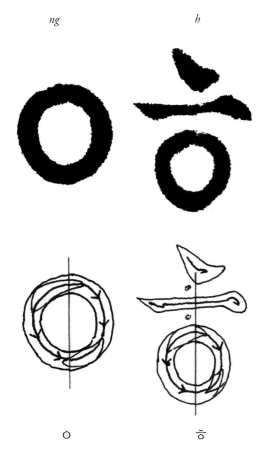

ㅇ ㅎ

These two letters are shown together, as they have very similar construction and proportions.

ㅇ: The circle may be written either with a single stroke or with two combined strokes. The latter technique is shown here. When written with two combined strokes, the point where the strokes join should be hidden, not visible. Keep the brush in a vertical position and maintain even thickness all the way through.

ㅎ: To make the dot, touch the brush point down at an angle of 45°, and turn to the horizon line and stop quickly. This is the same dot stroke as the dot stroke in "ㅊ." The second stroke, the shortened form of the horizontal stroke, is also the same in "ㅊ." The third stroke is a circle slightly smaller than an "ㅇ." Each stroke should be arranged on an imaginary vertical line, and each space in between should be even.

Below: The Jamo letters have here been placed in syllable blocks. By comparing the letters here to those given in the exemplar, you can see how many of them are modified in shape to relate visually to one another. Note that in Korean calligraphy, spaces are not left between words. Calligraphy by Yoo Sung Lee.

기 리 궁
분 슬 체
이 씨 는
다 의 우

257

A Comparison of Styles

As was mentioned earlier, there are many different styles of Korean Hangeul script. Following are the same words written in five distinct ways, so that the styles may be easily compared. The words are the same as those used earlier to demonstrate how syllable blocks are constructed: "azalea" (*jindalae*) and "flower" (*ggot*).

Two versions of the Panbonche style are shown. One has quite rigid lines of equal thickness and squared endings, while the other is more fluid and shows more movement of the brush. Two versions of Gungche are shown, regular and cursive. And the final, most fluid, writing of the series is in the Minche or Commoner style.

Right: The words *azalea* and *flower*, written in five standard styles.

Panbonche (Goche)

Panbonche (Pilsache)

Gungche (Jeongjache)

Woodblock printing style (old style)

Woodblock printing style (transcript style)

Palace style (regular)

Gungche
(Heulimche)

Minche

Palace style (cursive)

Commoner style

청산은 나를 보고 말 없이 살라 하고 창공은 나를
보고 티 없이 살라 하네 사랑도 벗어 놓고 미움도
벗어 놓고 물 같이 바람 같이 살다가 가라 하네
월인은 나를 보고 덕 없이 하지 않고 옥즉는 나를 보
고곳 없다 않네 편뇌 도벗어 고욕심도벗어 두
고강 같이 구름 같이 말 없이 가라 하네

나옹선사 시를쓰다 일암 이우성

Above: Poem by Korean monk Naong Seonsa
(1320–1376). Calligraphy by Yoo Sung Lee, 2002.
Ink on paper (scroll). 21½ x 48¾ in.
(54.61 x 121.92 cm). Gungche Heulimche style.

ARMENIAN AND OTHER TRADITIONS

Calligraphy and Identity

I n this chapter we have included a selection of scripts that, with the exception of Syriac, have survived and ensured the cultural continuity of smaller, insulated nations living in the shadow of powerful empires. Here we explore the scripts of Armenia, Georgia, Ethiopia, and Mongolia. Though Syriac is a script used by Christians not just in one nation but in an entire region, it has been maintained by a relatively small group of people living in countries where it is by no means the predominant script. For this reason, we feel it belongs here.

Syriac

By George Kiraz

Abjad: *Consonant alphabet where 22 letters represent consonants and perhaps some, but not all, of the vowels. Vowels not represented by letters may be indicated with diacritics, but the diacritics are often not used.*

Direction of writing: *right to left*

Majuscule/minuscule distinction: *none*

Principal tool: *broad-edged pen*

Languages: *Syriac, Aramaic, Assyrian Neo-Aramaic*

Origins

The Syriac script derives from Aramaic, the lingua franca of the Near East for centuries before the rise of Islam. Syriac became an important literary language around the second and third centuries CE. The earliest dated Syriac inscription is from the sixth century CE, and the earliest parchment, a deed of sale from 243, is the earliest example of informal writing. Perhaps the earliest dated manuscript in any language, as well as the earliest dated example of formal calligraphy, is a manuscript from CE 411.

Syriac has three distinct scripts that are still used in the present day. The oldest, known as *Estrangelo,* after the Greek for "rounded," was fully developed by the fifth century. Later, two geographic scripts would derive from it: West Syriac, whose proper

name is *Serto*, and East Syriac. At the time of Genghis Khan (twelfth century), the Mongolian script was derived from Syriac.

Materials and Tools

Traditionally, calligraphers used both the quill and the reed pen. At present, scribes use pens with either metal nibs or marker pens. In the case of the former, one may use special nibs designed for left-handed calligraphers, since Syriac is written from right to left.

Historically, calligraphers used both papyrus and vellum. Today, calligraphers use heavy paper or special art paper.

An ancient tool for ruling guidelines is still in use, beginning with a plank of wood whose size is the trim size of the paper. For each horizontal line, one creates a little notch on both ends of the wood, then strings and fastens a thin thread representing the line. One can also string vertical threads for the left and right margins. When ready, one places the paper on top of the wood, and presses with the thumb on each line. This makes line markings on the paper. In time, the thread marks on the paper will fade. This is similar to the mastara board used by Arabic and Hebrew calligraphers (see the Arabic and Hebrew chapters).

Most calligraphers write on their lap. The paper is turned almost 90° counterclockwise. Hence, essentially one is writing from top to bottom. The page is then turned back where the text is read from right to left.

There are no schools for formal training, and almost all calligraphers today are either monks or married priests. The tradition is simply handed from teacher to student without following any particular curriculum. The teacher begins writing letters and the student imitates him (alas, no female calligraphers are known). After that, the teacher moves to simple words, then to full-fledged texts.

The Scripts

The Estrangela script is the most ancient, with the first dated codex written entirely with this hand dating from 411 CE. The script was restored by the end of the tenth century in Tur Abdin, in southeast Turkey. Today, Estrangela is simply used for headings.

The Serto (or West Syriac) script goes back to the sixth century, although it seems to have a relation to the cursive script of the aforementioned parchment of 243. The first dated codex is from 732. Today, communities using the West Syriac dialect (namely, the Syriac Orthodox, Syriac Catholics, and Maronites) still use this script.

Above: Page from a Mongolian manuscript, late seventeenth or early eighteenth century. Special Collection Division, Newark Public Library. 5779-81.

The text is of Buddhist (or Lamaist) scripture. Before the Chinese invasion of Mongolia, Tibetan lamas had educated the Mongolians in their Buddhist religion and culture. It wasn't until 1200 CE that the Mongolians had a writing system of their own. When Genghis Khan seized power over vast territories, writing became a necessity. Prior to that time, the nomadic clannish people were able to get by with only their spoken tongue. *Uigur*, the Mongolian alphabet, was derived from the Syriac. Uigar is written in vertical columns that read from left to right.

Writing Eastern Syriac
By Eleanor Winters and Maureen Squires

The East Syriac script derives directly from Estrangela and was similar to it until the thirteenth century, when it became more cursive. The script is used by those speaking in the East Syriac dialect (namely, Assyrians and Chaldeans). Both communities have their counterpart churches in India that use the respective scripts.

Syriac calligraphers have always produced manuscripts, and the tradition continues until the present day. Most contemporary calligraphers produce liturgical manuscripts, although a few artist-calligraphers have appeared recently. In fact, the Syriac Orthodox *Pahnqitho* (yearly liturgical cycle) is used in all churches in the manuscript form.

At one time, Syriac was a prominent language in Persia. Today, Arabic has all but taken its place. We asked Eleanor and Maureen, two Western scribes, if they would create a Syriac exemplar. We sent them a packet of information about the script along with samples of the alphabet, both calligraphic and typeset. By studying the strokes of each character and determining the general pen angle used in the script, they were able to create this exemplar.

Below: Eastern Syriac exemplar by Maureen Squires and Eleanor Winters.

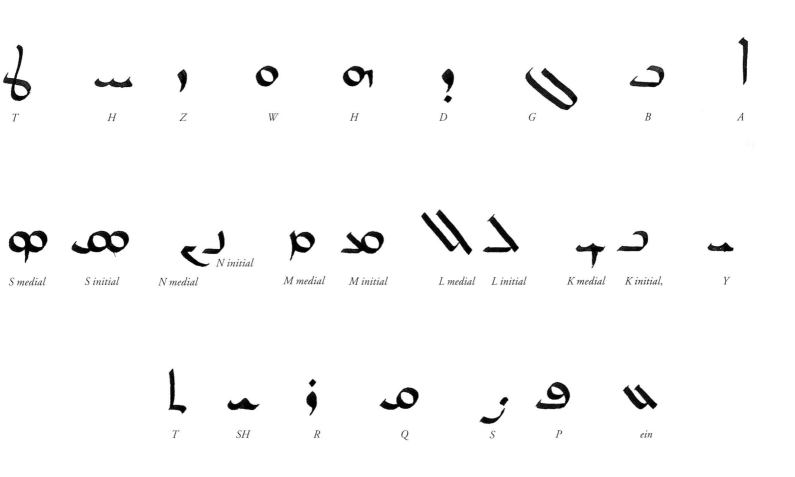

| T | H | Z | W | H | D | G | B | A |

| S medial | S initial | N medial | N initial | M medial | M initial | L medial | L initial | K medial | K initial, | Y |

| T | SH | R | Q | S | P | ein |

Georgian
By Eka Maraneli

Alphabet: *33 ordered letters of consonants and vowels represent the corresponding sounds of speech.*

Direction of writing: *left to right*
Majuscule/minuscule distinction: *none*
Principal tool: *broad-edged pen*
Languages: *Georgian, Mingrelian*

Origins

The earliest evidence of Georgian script is found inside a church in ancient Israel in an inscription from 430 CE. The origins of the script are unclear. Some scholars believe that it was created by the same Mesrop Mashtots (c. 361–440) who is credited with creating the Armenian alphabet, while others argue that it was the creation of Georgian King Farnavaz (born c. 317 BCE).

Modern-day Georgian script *Mkhedruli* is called the "warrior" script, evolving from two earlier Georgian scripts: *Asomtavruli* or the "capital letter" script, which had round letter forms, and the later, more angular *Nusxa-xucuri* script.

While Mkhedruli emerged in the tenth century, the other two scripts were still in use at that time and primarily used for religious texts. Occasionally letters from the two scripts were mixed together. Today, Asomtavruli can be seen in titles and as the first letter in a sentence.

an a ban b gan g don d en e vin v zen z tan t' in i kan k las l man m nar n

Use corner
of pen.

on o par p zan z rae r sans tar t un u p'ar p' k'an k' gan g qar q

Note the steeper
pen angle.

Use corner
of pen.

sin s c'in c' c'an c' zil z cil c car c xan x jan j hae h

Use corner
of pen.

Note the steeper
pen angle.

Left: Mkhedruli broad-edge letters. Calligraphy by Christopher Calderhead.

Writing Mkhedruli Monoline
By Eka Maraneli

The letters of *Mkhedruli* are written within four ruled guidelines leaving equidistant space for the x-height, ascenders, and descenders. Although the script does not contain capital majuscule forms, letters can be written at the same size within the grid, lending the appearance of all capitals when needed.

Right: Calligraphy by Eka Maraneli. This exemplar is arranged by ease of stroke for the student. For Mkhedruli letters in alphabetical order, see Christopher Calderhead's study of Mkhedruli broad-edge letters on opposite page.

თბილისი
Tbilisi

დილა
morning

ჰაერი
air

გიორგი
Giorgi

თინათინი
Tinatini

თამარი
Tamari

ნანა
Nana

საქართველო
Sakartvelo

მზე
sun

დედამიწა
earth

დღესასწაული
holiday

ია
violet

Mkhedruli Letters (continued)

The above letters rise above the upper
baseline.

The above letters descend below the
lower baseline.

The above letters both rise above and
descend below the baselines.

At school, children learn to write using a
four-lined grid.

In print, these four letters are written
without the baseline.

ARMENIAN

By Ruben Malayan

Alphabet: *39 ordered letters of consonants and vowels represent the corresponding sounds of speech.*

Direction of writing: *left to right*

Majuscule/minuscule distinction

Principal tool: *broad-edged pen*

Language: *Armenian*

The most stunning examples of Armenian calligraphy lie in the tens of thousands of manuscripts that have been preserved to this day. As works of art, these manuscripts have inspired a period of scientific and philosophical learning for a number of academic (philological and linguistic) communities, and are themselves living cultural remnants of exceptional aesthetic value.

More than 30,000 manuscripts survived the devastation wrought upon the Armenian nation by continuous invasions of Arabs, Mongols, and Ottoman Turks (e.g., more than 10,000 manuscripts were burned by Seljuk Turks in 1070 after a forty-year siege of Kapan, the capital of the Suinik province of the Armenian Bagratuni Kingdom). Today, parts of collections are housed at libraries and museums in Vienna, Jerusalem, Venice (San Lazzaro Island), New Julfa, Paris, London, and Los Angeles. The largest collection by far is that housed at the Matenadaran in Yerevan, Armenia, with more than 17,000 manuscripts in total. The oldest surviving complete Armenian manuscript is the Mlk'é Gospel of 862 at San Lazzaro.

Origins

Archaeological digs of the last decades on the territory of the Armenian Plateau show signs of a developed culture capable of building temples and using agriculture around the twelfth to seventh millennium BCE, making it one of the oldest inhabited parts of the world. Armenians pride themselves on being the first nation formally to adopt Christianity as their state religion (301 CE.), the consequences of which

Left: A catechism and book of prayers. Armenian manuscript page dated 1741. Inscribed by "Paul," a monk from Asia Minor.

played a decisive role in the formation of an Armenian spiritual culture and the birth of the national alphabet and literacy.

The creation of the Armenian alphabet was a pivotal moment in the history of the Armenian nation. The alphabet was invented in the year 405 CE by St. Mesrop Mashtots and designed with the help of the scribe Rophanos. Fifth-century Armenia became the location of ceaseless confrontations between Byzantium and Persia, and the invention of the new alphabet prevented assimilation into the linguistic dominance of one of the neighboring empires, establishing a true national identity based on an innate substance.

The alphabet of Mashtots was so lucid and easily learned as to become current, widely and instantaneously, across the social and economic boundaries of Armenian society in the fifth century: soldiers scribbled it on papyri, pilgrims scratched it on rocks. It immediately evolved cursive forms and became permanently inseparable from the essential components of Armenian identity; Armenian was never again to be written otherwise, and even Armenians who spoke alien tongues used their own script to write in them.

Prior to this, documents were written in Greek, Syriac, and Aramaic—scripts that Mashtots studied extensively as possible source models for the Armenian writing system during his travels across Asia Minor, Egypt, and Sinai. One-to-one correspondence between sounds, letters, and order constitutes a similarity with the Greek alphabet and displays an apparent intention of orienting Armenians westward. Interestingly, according to the biography of Mashtots, Koriun, a pupil of Mashtots, carefully avoided giving total credit to Mashtots for creating the script. In fact, Koriun avoids using the word "creation" or "invention" anywhere in his account, referring to Mashtots as a "translator" who

was "looking for a thing" that was "found" in Edessa where Mashtots received his "divine" vision inspiring the new alphabet.

Despite the controversy surrounding its origins, the Armenian alphabet is a remarkable achievement; its adoption began a period of illumination and intellectual expression unparalleled in Armenian history. It allowed Armenians to translate into their own language the works of Christian theology and of Greek, Latin, Persian, and Arabic classical literature. In fact, a number of these works have been preserved only through their Armenian translations. The new alphabet created conditions for the

Above: Erkata'gir alphabet. Calligraphy by Ruben Malayan.

development of scholarly institutions and a distinct body of literature, profoundly transforming the cultural image and the spiritual atmosphere of the country.

The Alphabet

Paleographers have proposed different views on the roots of the Armenian alphabet, some citing Phoenician, Assyro-Babylonian, Hittite, and Greek origins. It is the latter theory that is universally accepted—the base script for twenty four letters that Mashtots completed and adopted is Greek. They are identical to Greek in their phonetic value and their almost entirely preserved order, but the Armenian language is more complex and required an additional fourteen letters for correct phonetic representation. With these additional fourteen letters, the number of Armenian letters reached thirty-six, representing six vowels and thirty consonants. In the following centuries, three more characters were added, bringing the total number of letters to thirty-nine.

In his book *Mashtots the Magician*, J. R. Russell explains how the Armenian alphabet reveals a complex system of thought interlinked with mathematics, metaphysics, and philosophy. The Armenian word for alphabet is *ayb-u-ben*, named after the first two letters of the Armenian alphabet. It is composed as a prayer, beginning with Ա – Astvats (=God) and ending with Ք – K'ristos (=Christ). Numbers are represented by letters and since Mashtots had to determine for himself the order of the letters in his alphabet after the first, classical twenty-two, those ordinal numbers and their corresponding letters, in particular, reflect their inventor's knowledge of esoterica and his intentions.

Among the first words and sentences written in the Armenian alphabet by Mesrop Mashtots were, "To know wisdom and gain instruction; to discern the words of understanding."

The Calligraphic Tools

Until the introduction of paper in the tenth century, the common writing material was parchment. For some of the better-preserved manuscripts, the parchment was of an exceptional quality, allowing the ink to retain most of its density until the present day; it was thin and soft as paper, bright, sometimes simply white. There was naturally a variety of parchment in common use at this time, ranging from thick pieces of varying quality in the early years, to these aforementioned higher quality specimens; much of this was, of course, a function of the wealth of the supporting patron or monastery for which a piece of work was commissioned. The quality of parchment was affected by whether it was well treated on both sides or not. It was made from the skin of domestic animals, with the most appreciated pieces taken from the skin of a lamb or a stillborn animal. Especially refined parchments (vellums) were used

Top: Bolor'gir alphabet. Calligraphy by Ruben Malayan.

Left: The letter *Ayb* stylized Bolor'gir. Calligraphy by Ruben Malayan.

Left: *Matean* in Bolor'gir.
Matean is the Armenian word for codex.
Calligraphy by Ruben Malayan.

in Cilician Armenia and were most likely imported from Western Europe and the Crusader's Kingdoms. The earliest dated Armenian handwritten manuscript on paper (Matenadaran No 2679) was created in 981 by the priest Davit and his son, calligrapher Gukas.

Calligraphy was a well-established practice in medieval Armenia, with a calligrapher typically in possession of a wide assembly of tools. Early writing tools were made of metal, which were later replaced by reed pens known as "kalam." Quill pens were used as well. The perfected tool became the pen-and-ink bottle, which made the action of dipping the pen in ink obsolete.

Many early Armenian manuscripts employed brown ink containing an iron oxide rather than the dark black of an Indian or Chinese ink. The inks were tested on marble plates and were prepared in containers made from clams. There were virtually hundreds of recipes for ink, prepared chemically or from natural pigments and minerals. Apart from basic components such as clay and metal, egg yolk and honey, other natural elements were used. Water was used to mix the ink and by the end of the process, gold, silver, or wax polish was often applied to the surface. Black and red colors were most frequently in use, along with some usage of brown, green, and blue, which were famous for their quality across Europe and the East. Arab writers and calligraphers often used and praised Armenian colors, especially *vordan karmir*, known in Europe as *Porphyrophora hamelii*, or "Armenian red," and in the Arab world as *kirmiz*, a deep crimson dye (RGB 220, 20, 60), extracted from an the insect known as *Pseudococcus*, common to the Ararat Valley.

The Script

For the descriptions that follow, I am indebted to D. Kouymijian's essay from *The Album of Armenian Paleography*. The distinction between the different script styles are neither neat nor clean cut. The use of one type with another is common.

Erkata'gir script is monumental in terms of style. When using majuscule, the letters are large, very erect, with gracefully rounded lines connecting the vertical elements of the letters or springing from them. All the letters of the Erkata'gir script are written on the baseline between two imaginary parallel lines, with ascending and descending elements being only slightly extended with the exception of two letters whose elements extend more drastically. Across the range of manuscripts, up to ten varieties of this script are observable.

Round Erkata'gir is characterized by a contrast between thick vertical forms and razor-thin connecting curved strokes. The columns are well defined and characters are clearly separated, which gives the script a more geometrical essence and feeling.

Above: Sła'gir alphabet.
Calligraphy by Ruben Malayan.

Below: Sła'gir, 1880.
Calligraphy by Ruben Malayan.

Straight Erkata'gir differs by slanting to the right at varying angles. Connecting strokes have more variety and characters are placed more closely than in Round Erkata'gir. The height of letters comprises half of the space between lines. These factors give this particular script a certain dynamism.

The *Bolor'gir* script developed more elegant and graphic forms and although by its definition a round script, the characters are slanted and letters appear to have sharp corners. The contrast between the base shape and the connecting strokes is not as extreme as in Erkata'gir, and it is a more cursive type of script (characters are placed closer to one another), with smaller sizes and altered shapes. It is a four-line script with the body of the letters positioned between the baseline and capline with extensions placed between ascending and descending lines that terminate the movement of the hand. Some characters are composed of two elements, therefore doubling their size in width, with the height of the letters including the extension of doubles or triples. There are two varieties of Bolor'gir: the Cilician and the Eastern (Armenia proper), with the former being more articulate and precise, while the latter retains some of the cornerstone elements of Erkata'gir.

Sła'gir cursive script is rarely seen in manuscripts and was used mainly for notes. Executed with reed pens, its main characteristic was that it possessed an equal width of all elements. In general, the shape of the letters recalls that of an irregular

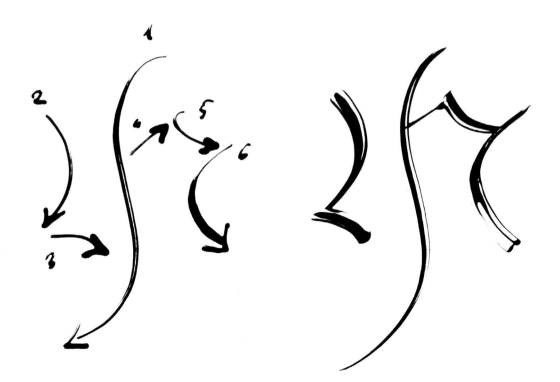

Above: Letter evolution *Ben-Da-Tje-Qe*.
The varieties of all four major Armenian scripts
and their development over time.
Calligraphy by Ruben Malayan.

Below: Notr'gir alphabet. Calligraphy
by Ruben Malayan.

Bolor'gir, although some elements of Straight
Erkata'gir are in evidence as well. This
became the basis for contemporary hand-
written scripts in Armenia.

Notr'gir notary script is a blend of
Bolor'gir and Sła'gir with predominant small
and cursive forms. It was used in the seven-
teenth and eighteenth centuries. The secre-
tary working as a scribe (in Latin *notarius*,
in Armenian *dpir*) at the royal court or the
Catholicosate, employed, by necessity, time-
saving cursive versions of Bolor'gir and even
smaller Notr'gir letters. The term could have
entered Armenian from either late Byzantine
Greek or Latin.

Grigor Tatevatzi, a philosopher and
painter of the fourteenth century, gave a
symbolic and aesthetic interpretation for the
relationship between black (dark) text and
the white space of the paper. According to
his vision, apart from the evident purpose of
good visibility and easy comprehension of
words, the black color symbolized the pain
of original sin, while the white color was a
symbol of innocence at birth. The white
margins surrounding the text represent the
four sides of the cross.

Writing Erkata'gir
By Cherrell Avery

Erkata'gir Alphabet with Stroke Order

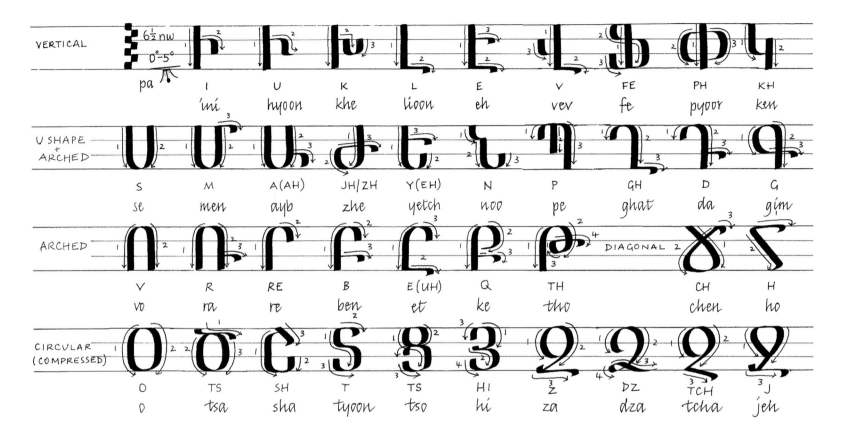

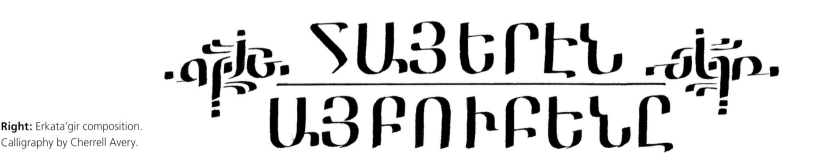

Right: Erkata'gir composition.
Calligraphy by Cherrell Avery.

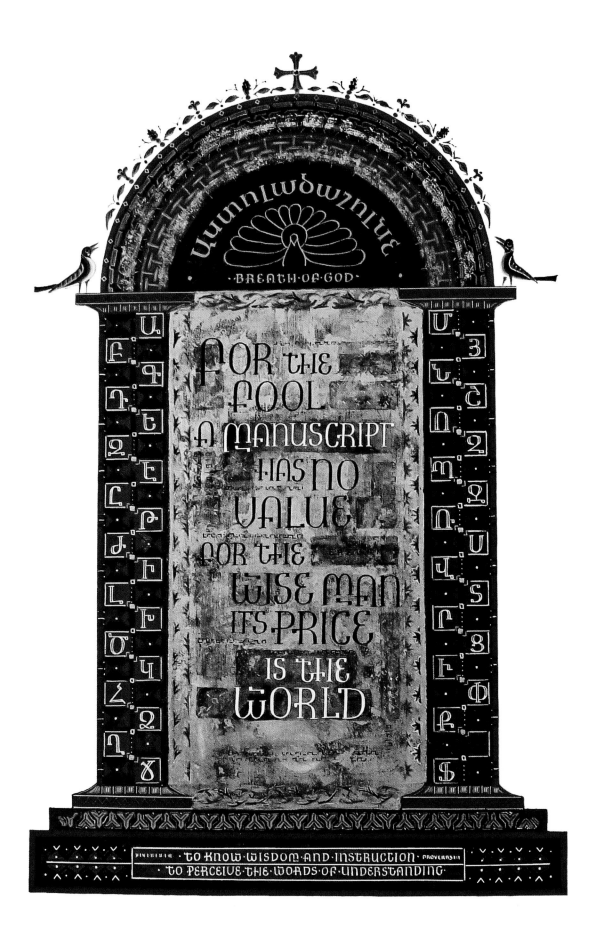

For the fool a manuscript has no value for the wise man its price is the world

BREATH OF GOD

To know wisdom and instruction · To perceive the words of understanding

Left *"Armenia."*
Calligraphy by Cherrell Avery.
Erkata'gir script. Gold leaf and shell gold with acrylic inks on stretched vellum panel.
A response to research commissioned by the British Library to facilitate an educational program to accompany the Armenian exhibition "Treasures of the Arc."

Ethiopic

By Christopher Calderhead

The rich ecclesiastical history of Ethiopia has produced a lavish manuscript tradition. Up to the modern era, scribes have continued to make fine books by hand in the traditional manner, writing on vellum and binding their manuscripts between wooden boards.

The Ethiopic script is based on a simple logic that has produced a complex result. A relatively small set of consonants is in use, but each of these has multiple forms, depending on how the diacritic is added to the base form. As a result, there are functionally just over 200 distinct letter forms.

The script is written on a two-line system. The letters have an almost playful, dancing quality to them, as they tilt freely back and forth, arrayed against the straight baseline.

The seventeenth-century book of Psalms (see below) shows a classic version of the

Ethiopic script. During a study day, Anna Pinto, an American scribe, worked with the book to learn how the script worked.

The pen angle is very shallow: it varies from perfectly flat to about 10°. The strokes are made from left to right, top to bottom. The projecting parts at the bottom of the script do not project below the baseline, which explains some of the dancing quality

of the script. The spacing is quite open, as is often true of Ethiopian writing.

Anna's study is presented in two parts (opposite): at the top, she has made a facsimile of a portion of the manuscript text, at the bottom, she has produced a series of typical letters, showing in one column the base consonant form, and in the second column, one of the possible variants with a diacritic mark.

Syllabic Alphabet: Each of the 26 basic consonant characters is inherently followed by the same vowel sound. Each basic consonant is modified by the addition of one or more additional strokes to represent syllables with differing vowel sounds. This results in between 7 to 9 variants for each consonant letter. In addition, there are 25 letter variants representing labiovelars.

Direction of writing: *left to right*

Majuscule/minuscule distinction: *none*

Principal tool: *broad-edged pen*

Languages: *Ge'ez, Amharic, and several smaller language groups*

Right: Psalter, Seventeenth century. Ethiopia. 5¾ x 7 in. (14.5 x 18 cm). Manuscript on vellum with leather-covered wooden covers. Psalter, Franklin H. Williams Ms. 1, HMML Rare Book Collection, Hill Museum & Manuscript Library, Saint John's University, Collegeville, Minnesota.

Right: Study of Ethiopian letters from a manuscript page. Calligraphy by Anna Pinto.
Western scribe Anna Pinto reviewed samples of Ethiopic calligraphy and typefaces to help her create a study of Ethiopian letters.

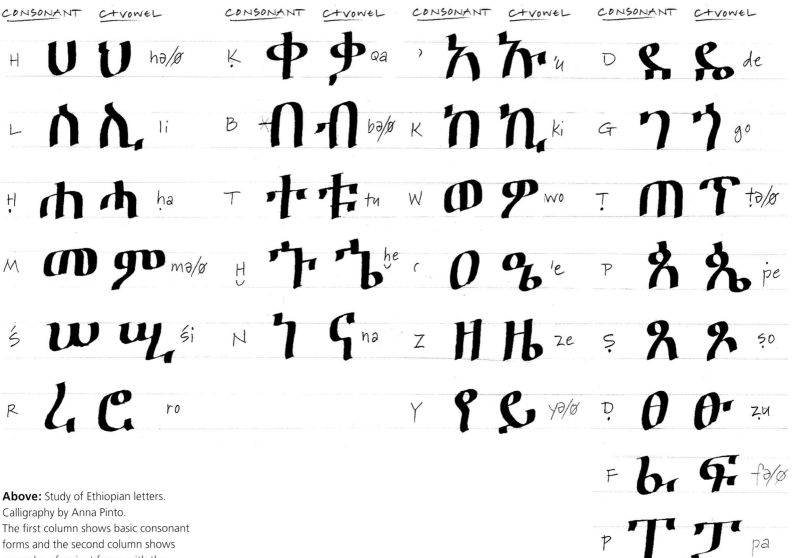

Above: Study of Ethiopian letters. Calligraphy by Anna Pinto.
The first column shows basic consonant forms and the second column shows examples of variant forms with the addition of diacritic marks.

AFTERWORD

by Christopher Calderhead and Holly Cohen

This book has been five years in the making. It has involved the generous contributions of calligraphers and scholars from all over the world. The project could have continued for another five years; we have learned a tremendous amount and still see room for improvement. But here it is. A project must come to completion. If we have achieved anything, this book will be a valuable resource for beginning the study of the calligraphy of different cultures. It is no more than a beginning. It is our hope that others will pick up where we have left off.

Toward a World Calligraphy

Because this book is intended as a resource to study the many traditions of world calligraphy, it has been focused on the history and major scripts from each. We have organized each chapter around classic scripts. Calligraphy everywhere is deeply grounded in the history and practices of specific cultures. If you want to understand the tradition, you have to begin with its classic styles and techniques.

You could be forgiven if you have come away from reading this book with the impression that calligraphy is an art solely rooted in ancient history. The truth is far more complicated. Very few calligraphers in any country are interested in their art as a purely antiquarian exercise. Many scribes concentrate on historical styles in order to perpetuate the classic forms, yet even these traditionalists feel they are doing something for today, for a contemporary audience.

Other calligraphers have adapted traditional forms to new contexts, or played with them to make new variations. It's a fact that even traditional calligraphy today looks different from work done fifty years ago. Small changes show continuing development in what are living, vital traditions.

But most striking has been the way calligraphy today is becoming a global enterprise. With better, faster communication in the interconnected world, the traditions don't carry on in isolation. Just ten years into the Internet revolution, we now can share graphic images and written ideas faster and more effectively than any generation before us. In this technological world, we hope our book will not only be a visual resource, but will encourage the direct work of writing by hand, with ink on paper or stylus on palm leaf.

Calligraphers are not separate from the cultures in which they live, and many are adept at typography, graphic design, or contemporary art. In the introductory sections of each chapter, we have tried to show some of the experimental work that today's calligraphers have been making, in addition to their work in a more traditional vein. There's nothing fusty, musty, or sepia-toned about contemporary calligraphy. It often has strong color, a keen sense of layout, and delights in experimentation.

This book is organized into discrete chapters, clearly defining the limits and borders of each tradition. Today these borders are more porous than they have ever been. Calligraphy is cross-fertilizing across cultures.

Calligraphers the world over are increasingly drawing from traditions other than their own, and this is perhaps a process that this book will make easier. By looking at other world traditions, calligraphers are inspired to try new layouts, adopt new tools, and experiment with new purposes for calligraphy.

Opening Boundaries

The study of world calligraphy inevitably brings us into contact with other cultures and histories. Writing is one of the arts that preserves and celebrates the history of a people. On recent trip to China, Holly wrote in her diary:

> September 2010: I went to see *The Scorching Sun of Tibet* exhibition at the Songzhuang Art Center on the outskirts of Beijing, China. An installation by Tibetan artist Nortse, titled *Thirty Letters* (2010), carpeted a huge expanse of floor with a literal graveyard of the Tibetan alphabet. Cut from metal with a rusted patina of decay, each letter of roughly three feet in length rested on its own plot of soil. Partitioned and cordoned off by wire, a butter lamp of remembrance sat at the head of each figure. I kneel as if in prayer. My hope: our book will help perpetuate the life of these letters.

279

Opposite: *Wet Ink*. Calligraphy by Christopher Calderhead, 2010.
The letters were written with an Automatic Pen, then flooded with ink to evoke the wet, rich quality of calligraphic writing.

Glossary

A

Abecedarian sentence: A sentence containing all letters of the alphabet.

Abu Ali Muhammed Ibn Muqla (866–940): Credited with giving Arabic cursive a system of proportion that remains in use to this day, the system of "proportioned script" known in Arabic as *al-Khatt al-Masub*.

Afatsa: In Hebrew, "gallnut."

***al-Khatt al-Masub*:** Arabic system of "proportioned script" created by Abu Ali Muhammed Ibn Muqla (866–940) in which shapes of letters are organized according to a system of rhombic dots and related circles.

Almemar: The raised platform in Jewish synagogues where the Torah is read.

***Aleph*:** The first letter of the Hebrew aleph-bet.

Aleph-bet: The Hebrew alphabet, named after the first two letters, *aleph* and *bet*.

***Alif*:** The first letter of the Arabic alphabet.

Aniconic: Forbidding the use of artistic representations of humans and animals lest one fall into idolatry.

Aramaic: The lingua franca of the Near East for centuries before the rise of Islam.

Aramaic alphabet: Derived from the Phoenician alphabet, progenitor of modern Middle Eastern scripts.

Armenian red: A deep crimson dye extracted from the insect known as *pseudococcus*, common to the Ararat Valley.

Aron ha-Kodesh: The holy ark where the scrolls of Torah are stored in a synagogue.

Ascenders: In Roman scripts, the upper portion of a minuscule letter that extends above the waistline.

Ashkenazi: Jewish people of German or Eastern European descent.

Ashkenazi script: A Hebrew script influenced by the European use of quills.

Ashoka, King: The third ruler of the Mauryan Dynasty and first prominent Buddhist ruler of India. Ashoka ruled over most of India and parts of modern-day Afghanistan and Iran. See also **Pillars of Ashoka.**

Askara System: A system used in Indic scripts in which each consonant character is inherently followed by a specific vowel sound unless modified by diacritical marks.

Asomtavruli: Georgian "capital letter" script, characterized by round letterforms.

Ayb-u-ben: The Armenian alphabet, named after its first two letters.

Azbuka: The Cyrillic alphabet.

B

Bamboo mat: Asian brushes are customarily rolled and stored in bamboo mats when traveling, to prevent the bristles from bending or being squashed.

Bar mitzvah: Jewish religious ceremony performed when a boy reaches the age of thirteen.

Bat mitzvah: Jewish religious ceremony performed when a girl reaches the age of twelve or thirteen.

Baseline: A horizontal line on which the letters sit.

Batarde: A late-Gothic cursive script.

Batchim: Special consonants added at the bottom of a Korean syllabic block.

Ben Asher Codex of the Prophets: Hebrew manuscript of 896 which contains the earliest dated Hebrew micrography.

Bengali: North Indian script used in the eastern part of India as well as in the nation of Bangladesh.

Beyt Ari: A style of K'tav Ashurit (Hebrew Scribal script) used by those of Chasidic descent or influence.

Beyt Yosef: A style of K'tav Ashurit (Hebrew Scribal script) used by Ashkenazi Jews.

Bickham, George: Published treatise on handwriting, *The Universal Penman*, in the mid-eighteenth century.

***Bi jung*:** Chinese for "Tomb of the Brush," a place where old brushes were buried instead of discarded in traditional China before the revolution.

Bimah: A raised platform in Ashkenazi synagogues where the Torah is brought to be read. See also **Almemar.**

Binder: An additive to paint or ink that binds pigment to the page.

Bismallah: Phrase repeated in the Qu'ran at the beginning of almost every sura, or chapter, "In the name of Allah, the gracious, the compassionate."

Bolor'gir: An Armenian cursive-style script.

Book of Hours: A book containing a set of prayers for different hours of the day in medieval Christendom.

Bookhand: Scripts that were commonly used for writing manuscripts.

Boot: Korean for "brush."

Boustrophedon: Alternating lines that reverse direction, as found in early Greek inscriptions.

Bow-shaped hook: A Chinese stroke where the brush is pulled to the left as pressure is released, which creates a fine line.

Bowl: The circular-shaped part of certain letters, such as can be found in the Roman minuscules *b, d, g, p,* and *q.*

Brahmi script: Progenitor of the Indic family of scripts, in use by the fifth century BCE.

Brush lettering: Writing created with a brush. In the twentieth-century Western

calligraphic tradition, brush lettering was largely connected with advertising signs or showcards.

Brush stand: An East Asian stand on which brushes are hung to dry.

Burmese: A tonal language and an Indic script; a syllabic alphabet written with a broad-edged pen.

Burnish: To rub with a stone or other smooth object to create a polish or smooth texture such as on paper.

Byeoroo: Korean for "inkstone."

C

Ca-lonh: Burmese round script.

Callos: Textured African paper named after the callosities on the southern right whale.

Carolingian: The first Western script to introduce the use of mixed majuscule and minuscule forms, formalized in the ninth century.

Carpenter's pencil: A graphite tool that can be shaped with a knife into a straight edge.

Catich, Edward: Twentieth-century American scholar and calligrapher who discovered that the classic forms of Inscriptional Roman Capitals match perfectly with the use of an edged brush.

Chai: In Hebrew, "life." Spelled with the Hebrew letters *het* and *yod* which, when added together, have a numerical value

of eighteen; all multiples of eighteen are considered good luck.

Chidrel Shibko: A title for a Tibetan schoolmaster.

Chirashi gaki: A Japanese form of composition that gives a free and natural impression as if *kana* had been scattered over the page.

Chu-yig: A Tibetan cursive script quickly written with linked letters.

Cicilian Bolor'gir: An Armenian script.

Clerical script: The earliest form of Chinese script, also used in Japan.

Codex: Manuscript book.

Codices novelli: Greek minuscules of the Middle Ages dating later than the mid-fifteenth century.

Codices recentiores: Greek minuscules of the Middle Ages dating from the mid-thirteenth to the mid-fifteenth centuries.

Codices vetusti: Greek minuscules of the Middle Ages dating from the mid-tenth to the mid-thirteenth centuries.

Codices vetustissimi: Greek minuscules of the Middle Ages dating from the ninth to the mid-tenth centuries.

Cola-pen: A contemporary tool made of a chopstick to which a folded flange of metal cut from the side of a soda can is attached with tape.

Compound consonant: Indian conjunct consonant.

Copperplate: A pointed-pen script.

Copybooks: For use in practicing Chinese calligraphy, copybooks provide examples of calligraphic characters painted in red ink. Students use brushes dipped in black ink to carefully write over the model characters.

Counter: The negative shape of a letter.

Crossbar: A horizontal stroke that runs across the vertical stroke of a letter.

Crow-quill: A very fine metal mapping pen.

Curing the quill: A process for preparing a quill for cutting, involving the application of heat.

Cyrillic alphabet: Derived directly from the Greek Uncial hand and adapted to accommodate sounds specific to Slavic languages; invented to write Old Church Slavonic.

Cyrillic Uncial: A script based closely on Byzantine-era Greek Uncials.

Czar Peter the Great (1672–1725): Czar of Russia, credited with the modernization of the Cyrillic alphabet.

D

Damma: An Arbic mark that represents the vowel *u*.

Darkening the page: In Arabic calligraphy, this refers to a practice where a novice calligrapher covers every bit of a page with text.

Dead Sea Scrolls: Some of the earliest surviving Hebrew documents discovered in a cave in Qumran in 1947.

Dead Sea Scroll script: A Hebrew script based on the script of the Dead Sea Scrolls. Also called Yerushalmi script.

Demotic scripts: The Greek word *demotic* means "of the people." Demotic scripts are less formal, rapidly written scripts.

Descender: In Roman scripts, the lower portion of a letter that falls below the baseline.

Devanagari: A North Indian script used to write modern Hindi and the ancient sacred language of Sanskrit.

Dharma: Laws that govern the universe according to Buddhist belief.

Diacritic: A mark near a letter that indicates a change in pronunciation.

Dipthong: A complex vowel composed of two vowel sounds put together.

Dividers: A metal tool used for ruling up a page.

Diwani script: An Arabic script that was created primarily for chancelleries and for Imperial Fermans, decrees issued by the Sultan. It is distinguished by its cursive flow and the roundness of its letters.

Double pencils: Two sharp pencils tied together with tape to function like an edged pen.

Dpe bri: An elegant Tibetan script with a square body and short legs that are not tapered.

Dpir: Armenian for "scribe."

Dragon tail hook: A Chinese stroke where the tail ends with a significant pressure that is then released as the brush is pulled off straight upward.

Dru-tsa: A Tibetan script that has a rain-shaped body, elaborate sweeping lines to render the vowels, and dramatically long stems.

Ductus: The number of strokes that make up a written letter, as well as the direction and order in which they are written.

Dummala oil: A resinous oil that may be applied to palm leaf manuscripts every two to three years to help preserve them.

D'yo: Hebrew for "ink."

E

Early Kufic script: An Arabic script that reached perfection in the eighth century in which there is a clear contrast between the verticals and the horizontals, as the verticals are very low and the horizontals are extended.

East Syriac: A script derived from the Estrangela script.

Eastern Bolor'gir: An Armenian script.

Eastern Hebrew script: The Ashkenazi and Sephardi bookhands grew out of this script that flourished between the ninth and eleventh centuries.

Eastern Kufic script: A variant of the Kufic script with sharper stroke terminations and a decidedly diagonal bias to many strokes.

Edged pen: Cut reed, quill, or metal nib; its square-cut tip creates thin or thick marks depending on the direction of the stroke.

Englishman's Greek: A form of Greek letters used within educated English society in the Renaissance and later periods.

Eraser knife: Used to scratch away mistakes after ink has dried thoroughly.

Erkata'gir: An Armenian script with angular shapes.

Estrangelo: The oldest Syriac script, fully developed by the fifth century.

Ethiopic script: A script with a small set of consonants in which each one has multiple forms depending on how a diacritic is added to the base form; functionally there are more than 200 distinct letterforms.

Eum-yang: Korean for "ying-yang," or male-female.

Ex-libris: A bookplate.

Exemplar: A carefully made sample of letters or characters accompanied with detailed directions for how writing is made.

F

Fatha: An Arabic mark that appears above a letter and represents the vowel *a*. The same stroke, when it appears below a letter, is called kasra and indicates the vowel *i*.

Fatimid Kufic script: A variant of Kufic that is drawn rather than freely written with a pen. Throughout history, it has often been used for carved inscriptions.

Feng: Chinese for "wind."

Flange: The metal part of a pen where the nib is inserted.

Flat hook: A Chinese stroke involving a strong press and release movement, where the brush leaves the page sharply, pulling to a neat point.

Flat pen angle: When the edge of pen is held flat to the baseline at zero degrees.

Flourish: Also referred to as a swash; a decorative stroke added to a letter.

Folio: In bookbinding, a single sheet of paper folded to make a quire, or section. Can also be used to describe the size of a large book similar in size to a coffee table book.

Foundational Hand: An upright Roman hand that Edward Johnston created, based on the script in the Ramsey Psalter.

G

Gematria: The calculation and comparison of numerical values in Hebrew letters, words, and phrases.

Gi-pil: Korean for "starting."

Giddin: The Hebrew name for the animal sinew used to bind religious books.

Gild: To apply gold leaf to a surface.

Gold leaf: Thin gold used to illuminate manuscripts.

Gouache: An opaque watercolor medium commonly used to write in color.

Gothic scripts: Densely packed, upright verticals popular from the late thirteenth century to the sixteenth century.

Gothicized Italic: A twentieth-century script, based on two historical scripts, the late Gothic cursive known as Batarde, and on a classic Italic.

Ggot: Korean for "flower."

Grass script: A highly artistic and expressive form of writing used in China and Japan.

Greek script: One of the oldest scripts in continuous use in the world, which for a time was the lingua franca of the educated elite across the eastern Mediterranean world; the root script of a number of important writing systems.

Gridded guidelines: Squares sometimes divided with additional lines; used in Chinese calligraphy to help students write characters balanced in shape and properly proportioned.

Guard sheet: A piece of paper kept between the hand of the writer and the surface being written on to protect the writing surface from dirt and the natural oils that accumulate on the hand.

Guidelines: Lines made on a page to define the proportions of a script. Guidelines may be ruled in pencil or made by folding the page.

Gujarati: A prominent script used in the western part of India.

Gumy-rabik: Hebrew for "gum arabic."

Gum arabic: A binding agent made from the sap of acacia trees.

Gum sandarac: A substance that repels water and helps ensure that ink will not bleed into paper; can be lightly dusted on a writing surface and rubbed in gently.

Gungche: Palace-Style Korean script. Considered the standard script for Korean calligraphy; includes a formal standard style as well as a range of cursive and semi-cursive styles.

Gungche Heulimche: Korean Palace Style cursive script.

Gungche Jeongiache: Korean Palace Style regular script.

Guo: Chinese for "country."

Gupta script: Script believed by many contemporary Tibetan scholars to be the basis for Tibetan writing.

Gurmukhi: North Indian script used in the Punjab; created in the sixteenth century by a Sikh Guru.

G'vil: Hebrew for the flesh side of the inner layer of an animal hide.

H

Haiku: A form of Japanese poetry.

Hairline: A very fine line.

Halacha: Jewish religious law.

Hamza: An Arabic mark that indicates a glottal stop; sometimes thought of as a letter.

Handscroll: As opposed to a hanging scroll, a handscroll is relatively small, usually under twelve inches in width and designed to be held in the hand.

Hangeul: Korean script.

Hangeul Day: A Korean national holiday observed on October 9 that celebrates the promulgation of Hanguel.

Hanji paper: Korean paper used for calligraphy.

Hanshi: Japanese paper measuring 9½ x 10¼ in. (24 x 26 cm).

Hasanta: Indian stroke used to silence an inherent vowel from a consonant.

Haskalah: The Hebrew Enlightenment.

Heian Period: The period of Japanese history from 794 to 1185.

Het*:** Hebrew letter with numerical value of eight. See also ***Chai.

Hieroglyphics: The most ancient form of Egyptian writing involving pictograms and other symbols.

Hiragana*:** One of Japan's indigenous phonetic syllabaries. Used for inflections and grammatical particles. See also ***Katakana.

Holy Ark: In Hebrew, "Aron ha-Kodesh." Where the scrolls of Torah are stored in a synagogue.

Homophone: A word that shares the identical sound as another, for example, *wear* and *where*.

***Hong*:** Chinese for the color red.

Hot-pressed watercolor paper: Smooth-textured watercolor paper.

***Hun-min-jeong-eum*:** In Korean, the original name of Hangeul; "The correct sounds for the instruction of the people."

I

Ijaza: An Arabic script meaning "certificate." It is also known as Tawqeei, which means "signature," as it was used for writing the names and titles of the caliphs.

Indian ink: A standard grade of rich black ink.

Indic scripts: A huge family of scripts originating on the Indian subcontinent, used from the Tibetan Plateau in the north to Cambodia in Southeast Asia. All are descendants of the ancient Brahmi script.

Ingres paper: Artist paper that comes in a wide variety of colors and has fine laid lines.

Ink rubbings: Copies of carved lettering, made by placing paper over a stone inscription and rubbing ink over it.

Inkhorn: An animal horn filled with ink, used by scribes in the Middle Ages.

Ink stick: East Asian ink obtained from refined soot derived from burned wood or oil that is bonded with a fragrant adhesive and molded into a solid stick.

Inkstone: Carved stone upon which water droplets are poured and a solid ink stick is rubbed to create liquid ink.

The Inkwell of the Scribe: *Keset Hasofer*, in Hebrew; reference manual for a sofer.

Inscriptional Roman Capitals: The earliest form of the Roman alphabet that still remains in use. Written in ancient times with an edged brush, known to us principally through carved examples that were brush-written and then carved in stone.

Italic: A script that emerged in Italy during the Renaissance. It was used both as a formal bookhand and as the basis for daily handwriting.

J

Jamo: The mother(s) of a script in Korean. The twenty-four basic letters can be combined to make an additional twenty-seven complex clusters. The fifty-one jamo form basic units of Korean writing.

Jia: Chinese for "home" or "family."

Jindalae: Korean for "azalea."

Johng shing: Tibetan student's writing board.

Johnston, Edward: Founder of the modern English calligraphy revival of the early twentieth century.

K

Kabbalah: The study of Jewish mysticism. In Hebrew, *kabbalah* means "receiving."

Kabuki: A Japanese theater tradition that became popular during the Edo Period. With its elaborate sets, costumes, and music, it is akin to Western opera.

Kakuna oil: Mixed with dummala (resinous) oil to help deter attacks by insects on palm leaf manuscripts.

Kammavaca: Text used to mark ordination rights of new monks.

Kanji: Chinese characters in Japanese; there are about 2,000 commonly used *kanji.*

Kankantum: Hebrew for "vitriol"; i.e., iron or copper sulfate.

Kannada: South Indian script in which the matra is a parallel line with a slight upward stroke on the right-hand side.

Kanroku, Okazakiya (1746–1805): Japanese calligrapher who originally invented *kanteiryu* when asked by Nakamura Saburo, proprietor of the Nakamura kabuki Company in Edo (Tokyo), to create a new script for the New Year's production in 1779.

Kanteiryu: A specialized Japanese script form used for notice forms and programs advertising the Kabuki theater. Visually associated with Kabuki and by extension, good fortune.

Kasher: Hebrew for "kosher."

Katakana: One of Japan's indigenous phonetic syllabaries. Mainly used for words of foreign origin, slang, and onomatopoeia.

Kashib shibko: Tibetan for "alphabet monitor," an advanced student functioning as a teaching assistant.

Kasra: See **Fatha.**

Keset Hasofer: Hebrew for "The Inkwell of the Scribe," reference manual for a sofer.

Kettubot: Hebrew marriage contracts.

Kham script: Square and extremely regular Tibetan script associated with the Eastern regions of Tibet. It is especially

valued as a bookhand for writing extended passages of text.

Kirmiz: Arabic name for Armenian red, a deep crimson dye extracted from the insect known as *pseudococcus*, common to the Ararat Valley.

K'laf: Hebrew for "parchment"; the hairy side of the outer layer of animal hide.

Kneaded rubber eraser: A soft putty-like eraser.

Kosher: Hebrew word meaning "valid."

K'tav Ashurit: Hebrew script used by religious scribes for writing religious texts; the three styles are: Beyt Yoseph, Beyt Ari, and Sefardi (Veilish).

Kufa: Town on the Euphrates in what is now Central Iraq; Arabic Kufic script was named for this town.

Kufica: The first formalized Arabic script; features include rather rigid forms and letters with flat tails.

Kulmus: The name of the quill used in Hebrew calligraphy.

Kurakkan powder: Used to absorb the excess black charcoal powder that has been left on a palm leaf after it has been inscribed and inked.

L

Ladino: A Sephardic language based on medieval Castilian Spanish with some influence from Hebrew and other languages; also known as Judeo-Spanish.

Lady Wei (272–349): A famous calligrapher of the fourth-century Eastern

Jin dynasty, attributed to writing the treatise *The Battle Formation of the Brush*, which speaks of writing as having bone and flesh.

Laid lines: A pattern of lines made in a sheet of paper by a metal screen during the papermaking process.

Lamed: The only Hebrew letter that has an ascender.

Lantsa script: Used for writing Sanskrit in Tibetan; some believe the Tibetan Ü-chen script is based on this script.

Latin Vulgate: Translation of the Old and New Testaments, the official bible of Western Christianity, into Latin through the Middle Ages.

Layout: The arrangement of graphic elements on a page.

L'chaim: in Hebrew, "To life!" See also *Chai.*

Left oblique nib: A nib that is cut at an angle rather than straight across. Left-handed calligraphers typically find it easier to use.

Lhasa: Capital of Tibet.

Ligatures: Joins between strokes.

Lightbox: A box with a translucent top that is lit from behind by a powerful lamp.

Lombardic Capitals: Form of capital letters often used in conjunction with Gothic minuscules.

M
Mahabharata, The: A Sanskrit epic.

Maimonides: A Jewish sage of the twelfth century, also known as Rambam; scholar of the Talmud, physician, and philosopher who authored, among other titles, *The Guide for the Perplexed*.

Maghribi: Arabic script characteristic of North Africa in which the contrast of thick and thin is far less marked than in other edged-pen Arabic scripts.

Majuscule: Capital letters; uppercase.

Makta: Arabic cutting surface that supports the tip of the pen when the final cut is made; can be made of any hard material: hardwood, bone, and, historically, ivory.

Malayalam: A South Indian script.

Mame-loshn: Yiddish for "mother-tongue."

Manipulated stroke: The pen turns on its edge, so the whole surface of the edged pen is not on the page.

Man'yougana: By the ninth century, *kanji* had also begun being used phonetically to represent syllables of the Japanese language. Named after the eighth-century poetry anthology *The Man'youshuu*.

Masorah: In Hebrew, the word has roots in the word *tradition* and means " to pass on." It is a compilation of notes written in the Torah to ensure that the tradition of Torah study is passed on accurately.

Masoretic scribes: Initiated micrography as a Jewish art form. They created elaborate carpet pages with patterns similar to those in Oriental rugs, all illustrated with micrography and heavily influenced by Muslim art from the communities in which they lived.

Mastar: Arabic cardboard ruling guide. See also **Mastara.**

Mastara: Jewish cardboard ruling guides. See also **Mastar.**

Matean: Armenian for "codex."

Matra: Indian headstroke.

Megillat Esther: *The Book of Esther*, written as a scroll, read on the Jewish feast of Purim.

Meok: In Korean, "ink stick."

Mesrop Mashtots (c. 361–440): Credited with creating the Armenian alphabet; some scholars also credit him with creating the Georgian alphabet.

Metal nibs: Commercially manufactured metal pen tips that are made in a wide variety of shapes and sizes, and do not require the skill of cutting a reed or quill.

Mezuzah: Small scroll containing a religious text enclosed in a case, which is hung on the doorpost of observant Jews.

Micrography: A Hebrew art form where decorative pictures and patterns are made up entirely of tiny letters.

Midrash: Hebrew interpretations of the Torah.

Minche: Korean Commoner Style script.

Minuscule: Lowercase letters; small letters.

Mizrachim signs: Hung on eastern walls of Jewish homes to direct prayers toward Jerusalem; in Hebrew, the word *mizrach* means "east."

Mkhedruli: Georgian warrior script that emerged in the tenth century; evolved from two earlier Georgian scripts: Asomtavruli and Nusxa-xucuri.

Moek: In Korean, "inkstone."

Monoline: Thin fine line of equal thickness.

Muhaqqaq script: An Arabic script where the underline curves are shallow and wide and the middle curves are horizontally expanded; the word structure is compacted and the upright strokes tilt to the left. "Muhaqqaq" means that the writing has been produced and developed with details and reached the desired size and form.

Muller: Glass object used for grinding powdered pigments on a ceramic dish.

N

Na: In Chinese, "pressing forcefully."

Naskh: An Arabic script, one of the earliest to develop from Kufi.

Nastaliq script: An Arabic script derived from the Naskh and Ta'liq scripts.

Negative space: The space between and around strokes made on the page.

Nib: The writing end of a pen.

Nibbing; The last cut that is made when cutting a quill, giving a clean sharp edge to the tip of the pen.

Nib cornering: See **Pen-cornering.**

Nib-width: A system of measurement based on the width of a particular edged pen. The ratio of nib-widths to letter height defines the weight of the written character.

Nikudot: In Hebrew, "vowel marks."

Nine-palace grids: Chinese grid for students made up of squares divided into nine smaller squares.

Notarius: "Scribe" in Latin.

Notr'gir: Armenian notary script. A blend of Bolor'gir and Slag'ir.

Nusxa-xucuri: A Syriac script with angular letters.

O

Oak gall ink: A dark brown ink that can be purchased in powdered or liquid form. It tends to have a variable tone when used for writing, as the ink pools at the end of a stroke.

Oblique holder: A pen holder to be used with a pointed pen nib, which it holds at the proper angle.

Ola leaf: A palm leaf. In the fifth century it was discovered that palm leaves could be used as a writing surface.

Old church Slavonic: The liturgical language of the Orthodox churches in the Slavic lands.

Old Kannada: A script used in the Deccan Plateau in India's southern peninsula some time near 1500.

Old Kannada evolved into two distinct but similar scripts: Kannada and Telugu.

Old Khmer script: Ram Khamhaeng Sukhothai is credited with fashioning the Old Khmer script into a form more appropriate for the Thai and Lao languages.

Onnade: Japanese "women's script"; *Kana* calligraphy, commonly used in personal correspondence and diaries by women who did not read or write Chinese.

Orboru: Indian reed pen.

Oriya: A North Indian script.

Ornamental drawings: Ornate drawings made with a pointed pen.

Orpiment: A yellow mineral pigment used to rule out lines for writing the Kammavaca.

P

Pahnqitho: The yearly liturgical cycle in Armenian.

Paillasson, Charles: A French writing master who died in 1789.

Paleographer: One who studies ancient scripts.

Pali: An ancient language in which the first Buddhist canon was written.

Panbonche script: An older Korean script more conducive to type than calligraphy; characteristics include an even thickness of line, rectangular-shaped syllabic blocks, and symmetrical geometric-looking shapes that make up the syllabic blocks.

Panbonche goche: Korean woodblock printing-style script.

Panbonche pilsache: Korean ink brush writing style, woodblock-printing style, and transcript-style script.

Paperweight: In East Asian calligraphy, paperweights are often in decorative shapes. Before writing, weights are placed at the top and bottom of a page to hold the paper in place.

Papyrus: A paper-like sheet made in ancient Egypt by pounding thin strips of the papyrus reed together. The word *paper* derives from the word *papyrus*.

Pasul: In Hebrew, "invalid according to law"; not kosher.

Pen angle: The angle of the writing edge of the nib relative to the baseline.

Pen-cornering: Refers to the use of the corner of the pen to draw in small details or fill in small gaps between pen-made strokes.

Pen holder: An instrument with a hollow middle, lined with a metal sleeve and "teeth" inside, which are designed to hold the pen against the metal sleeve.

Pen manipulation: A change in pen angle while making a stroke; twisting of the pen.

Phantom liner: Projects guidelines onto a page without leaving marks; ideal for use with dark or opaque papers that do not work well on a lightbox.

Phoenician alphabet: The earliest known form of alphabetic writing named after the Phoenicians, who lived on the east coast of the Mediterranean.

Pictogram: A writing symbol that is a picture of an object.

Pigment: Colored substance that is used to make ink or paint. Pigments include soot, ground minerals, liquids derived from plants, animals, and synthetic materials.

Pillars of Ashoka: A series of pillars, rocks, and cave walls located throughout Northern India and Pakistan upon which are inscribed the Edicts of Ashoka. They contain the earliest datable examples of Indic script.

Pointed pen: An instrument that naturally produces a monoline.

Polished paper: Smooth paper that has been burnished.

Pressure-release stroke: A technique where adding pressure to the nib widens the stroke and releasing pressure thins it.

Proportioned script: *al-Khatt-al-Masub* in Arabic. A system created by Abu Ali Muhammed Ibn Muqla (866–940) in which shapes of letters are organized according to a system of rhombic dots and related circles.

Pulli: A dot-shaped stroke in the Tamil script that is written above a consonant character to negate the vowel.

Q

Qalam: Arabic reed pen.

Qumran: Sight of the first discovery of the Dead Sea Scrolls.

Qu'ran: Holy book, sacred text of Islam.

Quill: Classic tool of Western calligraphy; the principal tool in use until metal nibs became popular in the nineteenth century. Feathers from turkey, geese, and swans are commonly used feathers.

Quill knife: A distinctively shaped knife ideal for cutting quills.

R

Rambam: See **Maimonides.**

Ramsey Psalter: Tenth-century manuscript written in Carolingian minuscule; basis for Edward Johnston's Foundational Hand. Shelf number in the British Library: Harley 2904.

Rbbi: Arabic prayer that asks that the task of writing will be made easy, often copied out by beginning students as an exercise.

Reed: The oldest form of edged pen that continues to be the dominant tool in the Arabic tradition and others; a pen cut from a reed that can be found in a variety of sizes from thin reed to large bamboo.

Reservoir: Sometimes detachable, a small piece of metal that slides either over or under a nib to hold a puddle of ink near the pen tip.

Rice character grids: Chinese grid for students comprised of eight smaller triangles within each larger square.

Romaji: In Japanese, "Roman characters," used primarily for typing Japanese on the computer, where Japanese script forms can be converted by software.

Rophanos: The scribe who helped Mesrop Mashtots design the Armenian alphabet.

Round Erkata'gir: Armenian script characterized by a contrast between thick vertical forms and thin connecting curved strokes.

Rubrications: Typically, red marks used in medieval manuscripts to denote the start and finish of specific text blocks.

Ruling up: To draw guidelines.

Running or Semi-cursive script: A more fluid rendition of Chinese characters.

Ryoushi: Sumptuous Japanese papers used calligraphically and decoratively; Ryoushi was used for *kana* calligraphy when it reached a high level of artistry during the later part of the Heian Period (794–1185).

S

Sa-si-gyo: A distinctive Burmese ribbon used to tie the cloth of the protective cover of a Kammavaca manuscript.

Saint Cyril: An Evangelist to the Slavs; credited with the creation of the Cyrillic alphabet.

Sanskrit: An ancient Indian language in which the Vedas are written.

Sargel: A Hebrew scribal ruling implement.

Scriptorium: In medieval Europe, a workshop for calligraphers.

Seal: A stamp to mark one's work in East Asian calligraphy.

Seal script: A Chinese script based on the most ancient form of Chinese writing. Strokes are of uniform weight with round terminations, used for the carving of seals.

Sefardi (Veilish): A style of the K'tav Ashurit Hebrew Scribal script generally used by Sephardic Jews.

Semi-cursive script: See **Running script.**

Seoye: In Korean, "calligraphy."

Sephardi: The Jewish community and their descendents that were forced to leave Spain during the Expulsion of 1492.

Sephardic script: Hebrew script influenced by the reed; it has less of a weight distinction when compared to the Hebrew Ashkenazi script.

Serif: A small projection that marks the termination of a stroke.

Serto: West Syriac script derived from the Estrangela script.

Set square: (British English) A triangle; a tool used with a T-square to rule pages.

Setsubun Festival: A Japanese festival celebrated in the beginning of February when beans are customarily thrown around the house to drive out the devils in order to welcome in good fortune.

Shadda: An Arabic mark that doubles a consonant.

Shades: The "swell" shape seen in thicker strokes of Copperplate.

Shell gold: Pure gold ground and suspended in a watercolor medium that may be used as a paint.

Sheys: Long Tibetan strokes that are roughly equivalent to periods.

Shikishi: Japanese paper boards measuring 11 x 10¼ in. (28 x 24 cm).

Showcard: Ephemeral signs promoting goods and services in brush lettering; handmade signs common in mid-twentieth-century America that advertised all manner of products and services in local stores.

Showcard writers: Skilled brush sign painters.

Shtetl: Yiddish for "town." Shtetls were small Jewish towns in Eastern Europe before the Holocaust.

Sinhala: Also called Sinhalese; an Indic script used in the country Sri Lanka. Refers to both the language and the script used by the majority community in Sri Lanka.

Sikkin: Arabic pen knife.

Size: Any chemical additive to paper that has the property of resisting water. Size may be added either in the papermaking process or it can be applied to an existing sheet of paper. The water-resistant qualities of a well-sized paper allow a hard pen to be used on the page without the danger that the ink will bleed.

Slagir: A cursive Armenian script that became the basis for contemporary handwritten scripts in Armenia.

Smyug rdzing: In Tibetan, the "pond for the ink." When carving a pen from

bamboo, a slight concave hollow should be made on the softer side of the bamboo.

Sofer: Jewish religious scribe who adheres to stringent laws in order to ensure the Torah is valid.

Sofer STaM: A Hebrew religious scribe. STaM stands for: sefer Torah, Tefillin, Mezuzah; the scribe's three main activities of religious text.

Sofit: Hebrew final letterforms used for the letters *khaf*, *mem*, *nun*, *peh*, and *tzadi* when they appear at the end of a word.

Sofrut: Hebrew scribal arts.

Song-pil: Korean for "processing."

Speedball B nib: This series of metal nibs by the Speedball company ends with a round termination. The round flat end of the nib is placed flat on the page to produce even, undulated strokes with round ends.

Square Kufic script: An Arabic script that consists of straight horizontal and vertical lines without curves.

Stroke order: Refers to directions that tell the writer in what sequence to make each mark in order to write a letter or character.

Sukun: An Arabic mark that indicates there is no vowel after the consonant; it appears above the letter.

Sura: Chapter of the Qu'ran.

Standard script: The definitive script of written Chinese; the basis of Chinese typography.

Stonyhurst Gospel: A manuscript of the Gospel according to John, which belonged to Saint Cuthbert, the bishop of Lindisfarne. It was buried with him, and is currently on display at the British Library; it contains a classic version of Uncial letters.

Straight Erkata'gir: An Armenian script that slants to the right at varying angles. The characters are placed more closely together than in the Round Erkata'gir script.

Studiolo: Renaissance Humanist study or retreat.

Stylus: A pointed metal tool.

Sumi: The Japanese word for "ink." Sumi usually comes in solid stick form. Bottled liquid sumi is also available.

Su-pil: In Korean, "ending."

Syriac: A script derived from Aramaic.

T

T-square: A T-shaped tool used for ruling up.

Taggin: Small ornate crownlets that grace the top of Hebrew letters in the K'tav Ashurit script.

Ta'liq script: An Arabic script that originated in Persia in the tenth century. The name means "hanging," or "suspended."

Talipot leaves: Palm leaves that are soft and light in color, used mainly for writing valuable books.

Tamarind Seed script: In Burma, a distinctive script evolved for the writing of religious manuscripts associated with Buddhist monasteries; named after the seed of the Tamarind tree. The seed has a squared oval shape, like the squared-off letters of the script.

Tamil script: Used beneath the Deccan Plateau in India, this script does not use conjunct consonants.

Tanween: An Arabic vowel and grammatical indicator, used when vowels are doubled at the ends of words.

Tanzaku: Japanese paper measuring 3⅜ x 14¼ in. (6 x 36 cm).

Tatami mats: Traditional flooring of a Japanese home.

Tawqeei: See **Ijaza.**

Tefillin: Strips of leather with small boxes containing ritual texts that observant Jews tie on their arm and forehead in preparation for prayer; also called phylacteries.

Telugu: A South Indian script with a matra resembling a check mark.

Temunah: Hebrew for "symbol."

Thai script: An Indic script derived more specifically by the Old Khmer script.

Thuluth script: A standard Arabic script often practiced by beginning students, it was first formed in the seventh century and is counted as the most important of all the Arabic scripts. *Thuluth* means "third," perhaps because of the proportions

of straight lines to curves, or because it was one-third the size of another script called Tumar.

Tibetan script: An Indic script whose origins lie in the North Indian scripts.

Timak: An Arabic ornamental spacer.

Tirfil: An Arabic ornamental spacer.

Tonguip Sinirsun: "Independent News," the first all Korean-script newspaper published in 1896 by Seo Jaepil (1863–1951).

Tooth: In calligraphy, this refers to texture on paper.

Torah: Scrolls of the Jewish Bible; The five books of Moses.

Trajan Column: Famous inscriptional Roman capitals can be found on the base of this column in Rome in Trajan's Forum; dates to the second decade of the second century.

Tsuk-chung: a short-legged variety of the Tibetan Ü-meh script.

Tsuk-kyuk: a Tibetan script.

Tsuk-ring: in Tibetan, "Elongated Form."

U

Ü-chen: A Tibetan script characterized by a horizontal line along the top of letterforms.

Ü-me: A Tibetan script characterized by the lack of a horizontal along the top of letterforms.

Uigar: The Mongolian alphabet.

Ummah: The community of Islam.

Uncial: Early medieval majuscule script popular from the fourth to the eighth centuries, characterized by its rounded appearance.

Ustav: Cyrillic Uncial script.

V

Vellum: The skin of an animal prepared for writing.

W

Waistline: See **x-height.**

Waka: A form of Japanese poetry.

Great Walagambahu: During the first century BCE, he sponsored the writing of all Buddhist teachings in 84,000 volumes of Ola leaf manuscript books, the first formal codification of these teachings.

Washi: Japanese handmade paper.

West Syriac: Also called Serto, a script derived from the Estrangela script.

Whetstone: Knives used to fashion pens out of lengths of bamboo in Tibet.

X

X-height: The height of the minuscule letter *x*; the term is used for Roman scripts and may usefully be applied to Greek and Cyrillic.

Xian: Chinese for "limit."

Xizhi, Wang (303–361): One of the most famous Chinese calligraphers and a disciple of Lady Wei. Author of the preface to the *Poems Composed in the Orchard Garden,* dated 353.

Y

Yad: Hebrew for "hand"; a hand pointer used to keep one's place when reading a Torah scroll, often in the shape of a hand with a pointed finger.

Yeon: Another Korean term for *byeoroo*; inkstone.

Yerushalmi script: Also called Dead Sea Scroll script. A Hebrew script designed in the twentieth century after the discovery of the Dead Sea Scrolls. A triangular shape is often evident at the beginning of each letter.

Yiddishkeit: Jewish way of life.

Yin-go: A little curled mark in Tibetan that functions like a paragraph marker, showing where the text begins.

Yod: Hebrew letter with a numerical value of ten. See **Chai.**

Yong: Chinese character for "eternity."

Y'riot: Hebrew for "sheets of parchment."

Selected Bibliography

Almost all of the information and images in this book have been gathered from working calligraphers who have generously contributed text and samples of their calligraphy created from their own knowledge, skill, and experience. Their contributions are acknowledged in the text. In addition, the editors and authors have given credit in the text to written sources used in preparing each chapter.

Over the course of writing this book, we have consulted many manuals, books, and articles. If we were to list all the sources that we consulted, the list would be unwieldy. We do wish, however, to list here the books, periodicals, and websites that have been of direct help in compiling this work.

BOOKS:

Abrahamyan, A. *History of Armenian Letters and Writing*. Yerevan Aremenia: Yerevan State University Press, 1959.

Akshara Ankan Compilation of Indian Calligraphy (catalog). Bombay: Design Centre, Sophia J. K. Somani College of Art & Design, 1989.

Aryan, K. C. *A Book on the Anatomy of Deva-nagri Calligraphy and Symbols*. Delhi: Rekha Prakashan, 1966.

Boudonnat, Louise, and Harumi Kushizaki. *Traces of the Brush: The Art of Japanese Calligraphy*. Seuil Chronicle, 2003.

The British Cyclopedia of the Arts, Sciences, and History. Wm. S. Orr and Company, 1838.

Brown, G. M. L. *Specimens of Oriental MSS and Printing*. New York: Foliophiles, 1928.

Christin, Anne-Marie, ed. *A History of Writing: From Hieroglyph to Multimedia*. Paris: Flammarion, 2002.

Daniels, Peter T., and William Bright, eds. *The World's Writing Systems*. New York: Oxford University Press, 1996.

De Silva, W. A. *Catalogue of Palm Leaf Manuscripts in the Library of the Colombo Museum*. Vol. I (Memoirs of the Colombo Museum Series A. No. 4). Colombo, Sri Lanka: Ceylon Government Press, 1938.

Earnshaw, Christopher J. *Sho: Japanese Calligraphy*. Boston: Tuttle, 1988.

Efendi, Mehmed Sevki. *The Thuluth & Naskh Mashqs*. Istanbul: International Commission for the Preservation of Islamic Cultural Heritage, 1999.

Enokura, Kouson. *Kana. Shodo jotatsu no subete*. Part I. Tokyo: Nihon Hoso Shuppan Kyoukai, 1994.

Fazzioli, Edoardo. *Chinese Calligraphy: From Pictograph to Ideogram*. New York: Abbeville, 1987.

Fushiki, Jutei. *Kabuki Moji Kanteiryu Tokuhon*. Tokyo: Kanrin Shobo, 1996.

Ghafur, M. A. *The Calligraphers of Thatta*. MA (Dacca), PhD (Hamburg). Karachi: Pakistan-Iran Cultural Association, 1978.

Greenspan, Jay Seth. *Hebrew Calligraphy*. New York: Schocken Books, 1981.

Gunawardana, Sirancee. *Palm Leaf Manuscripts of Sri Lanka*. Colombo, Sri Lanka: Viator Publications, 1997.

Ismar, David. *The Hebrew Letter*. Northvale, New Jersey: Jason Aronson Inc., 1990.

Jonas, Gina. *Hebrew Calligraphy Styles*. Self-published, 2nd ed. 1996.

Khan, Gabriel Mandel. *Arabic Script*. Translated by Rosanna M. Giammanco Frongia. New York: Abbeville, 2001.

Kodansha Encyclopedia of Japan. New York: Kondasha America, 1983.

Knight, Stan. *Historical Scripts*. 2nd ed. New Castle, Delaware, 1998.

Kushner, Lawrence. *The Book of Letters: A Mystical Aleph-bait*. New York: Harper & Row, 1975.

Nakanishi, Akira. *Writing Systems of the World: Alphabets, Syllabaries, Pictograms*. Boston: Charles E. Tuttle Co., Inc., 1980.

Phachalean, Simeon, Varjapet. *Haykakan Geghagrutiun (Armenian Calligraphy) (Study Schoolbook)* Nor Nachijevan: 1870.

Podwal, Mark. *A Book of Hebrew Letters*. Philadelphia: The Jewish Publication Society of America, 1978.

Polastron, Lucien X., and Abdallah Akar. *Découverte des calligraphies de l'arabe*. Paris: Dessain et Tolra, 2003.

Quigly, E. P. *Some Observations on Libraries, Manuscripts, and Books of Burma from the 3rd Century A.D. to 1886 (with special reference to the Royal Library of the last Kings of Burma)*. London: Arthur Probsthain, 1956.

Reed, William. *Shodo: The Art of Coordinating Mind, Body, and Brush*. Tokyo: Japan Publications, 1989.

Russell, J. R. *Mashtots' the Magician*. Boston: Harvard University, 2005.

Russell, J. R. *On the Origins and Invention of the Armenian Script*. Le Museon: 1994.

Safadi, Yasin Hamid. *Islamic Calligraphy*. London: Thames and Hudson, 1978.

Sampson, Geoffrey. *Writing Systems*. Stanford, CA: Stanford University Press, 1985.

Sohn, Ho-Min. *The Korean Language*. Cambridge, MA: Cambridge University Press, 1999.

Stone, M., D. Kouymjian, and H. Lehmann. *Album of Armenian Paleography*. Aarhus, Denmark: Aarhus University Press, 2002.

Suzuki, Yuuko. *An Introduction to Japanese Calligraphy*. Tunbridge Wells, UK: Search Press, 2005.

Toby, L. F. *The Art of Hebrew Lettering*. Tel-Aviv, Israel: Cosmopolite, 1973.

Yardeni, Ada. *The Book of Hebrew Script: History, Paleography, Script Styles, Calligraphy & Design*. London and New Castle, DE: The British Library and Oak Knoll Press, 2002.

Yee, Chiang. *Chinese Calligraphy: An Introduction to Its Aesthetic and Technique*. 3rd ed. Cambridge, MA: Harvard University Press, 1973.

CITATIONS:

Kouymijian, Dikran. "Armeno-Greek Papyrus." In *Album of Armenian Paleography*. Edited by M. Stone, D. Kouymjian, and H. Lehmann. Aarhus, Denmark: Aarhus University Press, 2002.

Kouymjian, Dikran. "Script Classification." In *Album of Armenian Paleography*, Edited by M. Stone, D. Kouymjian, and H. Lehmann. Aarhus, Denmark: Aarhus University Press, 2002: 63–75.

Ramsey, S. Robert. "The Korean Alphabet." In *King Sejong the Great*. Edited by Young-Key Kim Renaud. Washington, D.C.: International Circle of Korean Linguistics, George Washington University, 1992: 43–50.

PERIODICALS:

Arkinian, Nerses. "The discovery of the Armenian Alphabet." *Handes Amsorya*. Vol. 52. 1938.

Latse Library Newsletter. Vol. 4. 2006. Tasean, Yakovbos (P. Jacobus Dashian). "Overview of Armenian Paleography." 1989. Vienna. *Handes Amsorya*. Vol. 11 (1897), nos. 2–12; Vol. 12 (1898), nos. 1–6.

WEBSITES:

Ager, Simon. *Omniglot: Writing Systems & Languages of the World*. Available at http://www.omniglot.com.

Hangeul Museum, The National Institute of the Korean Language. www.hangeulmuseum.org/new/art/shape/panChar02.isp. Naver, South Korean search portal. www.100.naver.com/100 nhn?docid=759100.

"Three Burmese Buddhist Kammawasa Manuscripts." Ancient East: Fine Art and Antiques of Asia. Available at http://www.ancienteastantiques.com. (accessed: December 15, 2008).

Xizhi, Wang. "Postscript of Battle Formation of the Brushstroke." http://www.rice-paper.com. n.d. Webolt Co. (accessed: December 30, 2008).

Contributor Biographies

Georgia Angelopoulos was introduced to calligraphy in high school. Her art teacher taught the Edward Johnston tradition. Strongly rooted in the arts, her family in Greece encouraged her to study Classical and Byzantine models for inspiration. She studied art history in Greece and at the University of Victoria, in British Columbia, and retains a strong interest in the calligraphic tradition. Although much of her work is in English, she is keen to connect to her Greek heritage and create work that explores and bridges the richness of cultural identity. She is an active member of the Fairbank Calligraphy Society in Victoria, BC, Canada.

Cherrell Avery is a professional calligrapher and lettering artist from London. She holds a degree in calligraphy and is an elected Fellow of The Society of Scribes and Illuminators and the Calligraphy and Lettering Arts Society. An accredited calligraphy tutor, Cherrell runs workshops around the UK and has taught at the Royal Academy of Art, MODA, and the British Library. Her work is regularly exhibited and is in private collections in the UK and abroad.

Pema Bhum is director of the Latse Contemporary Tibetan Cultural Library in New York City, a project of the Trace Foundation, where he has worked since 1997. He holds an MA in Tibetan Studies from the Northwest Nationalities Institute in Lanzhou, Gansu Province (PRC), where he also taught Tibetan language and literature. After his arrival in India in 1988, he founded the first independent Tibetan language newspaper in exile, *Dmangs-gtso*, and the Tibetan literary magazine *Ljang-gzhon*. From 1992 to 1996, he served as

founding director of the Amnye Machen Institute in Dharamsala, India, and for two years taught Tibetan language and literature at Indiana University. He is the author of two memoirs of the Cultural Revolution—*Six Stars with a Crooked Neck* (2001), and *Dran tho rdo ring ma* (2006)—as well as *Heartbeat of a New Generation*, now translated into three languages. He has also authored several articles, the most recent of which are published in issues of the Latse Library Newsletter.

Karen Charatan has created pen, brush, and drawn lettering as well as calligraphic paintings during her thirty years as a lettering artist. Her work ranges from advertising lettering, graphic design, and greeting cards to point-of-purchase displays, murals, and sign design. Karen is the designer/author of the how-to marker book *ABC ZIG Calligraphy*. Karen has taught brush lettering, business card design, and sign writing for the annual international lettering arts conferences and for calligraphy guilds in the United States, Canada, Europe, and Japan. Her association with Asian calligraphers has also focused her attention on exhibitions of abstract calligraphy with the East/West group the Art of Ink in America. A few of her abstract calligraphic works are in the collection of the Mobile Museum of Art in Mobile, AL. Some of Karen's abstract works can be seen in *Letter Arts Review,* Vol. 17, No. 2, and more traditional work can be seen in the book *Artist & Alphabet* by the New York Society of Scribes.

Nan DeLuca has been a professional calligrapher since 1994, living in New York City, and specializing in pointed-pen

scripts such as Copperplate and Spencerian. Her work has been published in leading wedding magazines such as *Brides*, *InStyle Weddings*, and *Martha Stewart Weddings* as well as providing props for photo shoots and TV (*Law and Order: Criminal Intent*). A former Society of Scribes board member, she is currently on the board of IAMPETH (International Association of Master Penmen, Engrossers, and Teachers of Handwriting).

Melissa Dinwiddie is an accomplished calligrapher. Her works are in private collections around the world and published in a number of books and respected journals. An inspiring and engaging teacher, she's presented workshops on a variety of topics on calligraphy for guilds around the United States. She publishes a free email newsletter of her inspirational calligraphic artworks, which you can find at her blog, Living A Creative Life (http://melissadinwiddie.com) When not making art, writing, or coaching, Melissa can be found entertaining audiences with her voice and ukulele as a jazz singer/songwriter and "Uke *Diva*."

Jacob El Hanani was born in Casablanca, Morocco, and was raised in Israel. He attended the Avni School of Fine Arts, Tel Aviv, Israel, and the Ecole des Beaux-Arts, Paris, France. Drawing upon the tradition of micrography in Judaism, a technique utilized in decoration and transcribing holy texts, El Hanani creates highly intricate works through the repetition of minuscule marks using ink on paper or canvas. Solo exhibitions include Steven Zevitas Gallery, Boston, MA; Mills College, Oakland, CA; Nicole Klagsbrun Gallery, New York, NY; Galerie Renée Ziegler, Zurich, Switzerland;

and Galerie Denise René, Paris, France and New York, NY. Major group exhibitions include the DeCordova Museum and Sculpture Park, Lincoln, MA; the Corcoran Art Gallery, Washington, DC; The British Museum, London, UK; The Whitney Museum of American Art, New York, NY; and the Tel Aviv Museum, Israel. El Hanani's work is included in many important public and private collections including the Solomon R. Guggenheim Museum, the Museum of Modern Art, the Jewish Museum, the Fogg Art Museum, and the Metropolitan Museum of Art. He lives and works in New York City.

Jutei Fushiki first began learning Kanteiryu in 1976 with Kotei Hosaka. In 1993 Hosaka granted him principal teacher status. Currently, Fushiki is the only Kanteiryu calligrapher of this rank in Japan. He does all the Kanteiryu calligraphy for the Kabuki theaters in Tokyo, Nagoya, and Hakata (Kyushu). In 2006, he held a solo exhibition of his work in the foyer of the Shochikuza Kabuki Theater in Tokyo. Throughout 2008 he contributed calligraphy for the 120th commemorative issues of the Shochikuza magazine.

Elinor Aishah Holland is a lettering enthusiast. Her passion for calligraphy began during a visit to Istanbul as a teenager and has not ceased. As a freelance lettering artist in Roman and Arabic scripts, her work includes all aspects of involvement with the art, including exhibiting, teaching, and doing commercial and commission work. She has been a student of master calligrapher Mohamed Zakariya for many years and has studied with top teachers in the Western tradition as well. She continues to further her craft and knowledge of calligraphy and related book arts and illumination. She teaches, presents, and exhibits throughout the United States and Canada.

Ted Kadin resides in Brooklyn, NY. He has a BFA from Brooklyn College and has studied at the Institute of Fine Arts, NYU Masters Program, and for a decade in a Rabbinical seminary. He was a faculty member at the New School for Social Research/Parsons Calligraphy Workshop for nine years. He taught at the 92nd Street Y in New York City. He currently works as a professional calligrapher/lettering artist, and graphic designer specializing in Hebrew, Copperplate, Italic. His signature funky-but-chic calligraphy, illuminated kettubot, and most recently the design of several typefaces. Mr. Kadin's work is in private and corporate collections worldwide and can be seen in some major motion pictures. Mr. Kadin's Judaica work is included in the permanent collection of the Jewish Museum, New York. His client list includes the Ford Foundation, the Whitney Museum, the Newark Museum, Miramax Films (Vatel), the BBC, the New York Knicks/Madison Square Garden, Vera Wang, Carolina Herrera, the Jewish National Fund, Itzhak Perlman, JP Morgan, Gucci, AXA/Equitable Life, Hallmark, the New York Public Library, Cravath, Swaine & Moore, *Martha Stewart Weddings*, and Harper's *Bazaar*. He created major installations for the Brotherhood Synagogue and the American Jewish Committee, both in New York City.

Deborah Kapoor works in two- and three-dimensional formats, combining encaustic with non-traditional grounds such as veneer, lace, and paper. The result is a heightened visceral effect, blurring the line between painting and sculpture. Travel to India informs the work, where vivid imprints of palms are made beside doorways to ward off evil; *pooja* (prayer) ceremonies happen daily in the street; mounds of food and flower offerings are left for the gods. Seeing these examples of casual prayer and blessings inspired her study of *Samskara*. She utilizes text within her work as a visual form of chanting and exploring the cultural markers of being human. Deborah is represented by ArtXchange Gallery in Seattle, WA, whose focus is to promote cultural exchange through art. You can find more of her work at deborahkapoor. com and www.artxchange.org. She lives and works in Seattle.

Souteki Kawabe and Tsutumi Kawabe are the son and daughter of master calligrapher Seika Kawabe. Souteki (born in 1957) now heads the calligraphy school, which is part of the Mainichi Calligraphy Association. He has regularly won prizes for his calligraphy and is now one of the representative calligraphers of the annual West Japan Mainichi Calligraphy Exhibition. He is a member of the avant-garde Keisei Kai calligraphy group. Tsutumi (born in 1955) teaches at the family calligraphy school. While also taking part in the Mainichi Calligraphy Exhibitions, she often exhibits solo in West Japan and France.

George A. Kiraz is a computational linguist and a specialist on the Syriac language. He is the founder of Beth Mardutho (the Syriac Institute) and Gorgias Press. He has written extensively on the Syriac language and its heritage.

Alice Koeth, a native of New York City, began learning the art and craft of calligraphy and lettering while attending evening classes at the Brooklyn Museum Art School. A freelance designer since 1953, she designed the calligraphic exhibition signs and display lettering for the prestigious Pierpont Morgan Library for twenty-nine years, and inscriptional lettering for bowls, vases, and plaques for Steuben glass. Alice has taught calligraphy study programs at the School of Library Services at Columbia University and has been on the faculty of eleven international conferences. She is a founding member of the New York City Society of Scribes and was a co-curator of its extensive twenty-fifth anniversary exhibition, *Artist & Alphabet.*

Rosemary Kracke is an art director in the book publishing and direct mail industry in New York City. She is a freelance lettering artist, whose calligraphy work appears in *Real Simple Weddings* magazine. An active member of the Society of Scribes, she holds BFA in Graphic Design from Long Island University, C.W. Post.

Rigzin Samdup Langthong was born in Tibet and studied Tibetan calligraphy at the private school Nyarong Shar for ten years before 1959. In 1958, he trained as a Tibetan government lay official (*Tsëkhang lekhung*). Rigzin Samdup passed his exams and became a lay official after only six months, at the same time the Dalai Lama was taking his *geshe* degree. He worked in the Tibetan government for about one year. In March 1959, he was arrested and was imprisoned because of his government status for twenty-one years. While he was incarcerated, he continued learning calligraphy from the many other government officials there, and was able to maintain his writing skills. Since his

release in 1980 he has worked at various jobs, and in 1992, his family opened two restaurants in Lhasa, Tashi 1 and Tashi 2, very popular gathering places for foreign visitors to Lhasa. He has also been tutoring children and Tibetan language teachers in calligraphy in Lhasa: for these last few decades. In October 2005, he was invited by the Latse Contemporary Tibetan Cultural Library in New York to attend a Tibetan Calligraphy workshop. His calligraphy work was published in children's books, such as *Little Shepherd, Little Shepherd. What Are You Doing?* and the *Concise Tibet-English Visual Dictionary.*

Yoo Sung Lee (pen name, **Aram**) is a Hangeul calligrapher who has been practicing for over fifty years. At age seventeen, he became one of three male disciples of Lee Chul-Kyung, a master calligrapher who, together with Kim Chung-Hyun, standardized the Hangeul script (in *Gungche*). He remains one of two of those original disciples who joined to found her society, now in its fifty-first year and considered essential for the debut of every aspiring calligrapher. While Hangeul calligraphy enjoyed a major revival with the *Hallyu* (Korean wave) movement since the late 1990s, Yoo Sung Lee remains one of a handful of individuals who has continued the practice from prior to that time. He has also contributed to the shaping of Hangeul calligraphy's unique *ki*, or "dynamic energy," in contemporary practice. He has taught, lectured, and demonstrated Hangeul calligraphy widely. He has exhibited in numerous galleries and museums in the United States, France, China, and Korea. He is a member of the Korean American Calligraphy Association, Art of Ink in America Society, and Aram Hangeul Calligraphy Group.

S. Leelaratne, or Leela, as affectionately called by his American friends, started serving his land of birth, Sri Lanka, as a teacher. His caring nature for the suffering of people drew him to health sciences and before long he was involved in helping people to overcome faulty vision. A member of the Sri Lanka Optometric Association, he published two books, *Cataract of the Eye* and *A Handbook for Opticians,* most of which were distributed free. Leela has served as the General Secretary of SLTA, the highly respected temperance movement of Sri Lanka, and he has written poetry and articles for the enjoyment of the Sinhala diaspora in America, especially those closely associated with the New York Buddhist Vihara, of which he is a devout supporter. He has written several books including *Father of the Nation; Ye Monks Preach for the Betterment of Mankind; History of Buddhism in North America;* and *The Immortal Man.*

Yves Leterme of Saint-Kruis, Belgium, spends half of his time teaching Latin in a Brugean secondary school and the other half as a freelance calligrapher, continuously shifting from various commissions (lettering and artistic works) to more personal pieces for exhibitions. He has taught his approach to the lettering arts in workshops all around the world. For more information, visit his website www.yleterme.be.

Ruben Malayan is a graphic designer, photographer, and art director born in Yerevan, Armenia, and currently resides in Tel Aviv, Israel. Famous for portraiture, photography, and graphic design, Ruben Malayan is a distinguished art director with a rich history of graphic design and television production. His career spans over twelve years and includes extensive experience in virtually all types of media production including broadcast animation

and camera work. He has a degree in Fine Arts and since 1990 has participated in annual exhibitions at the Union of Armenian Artists and the Institute of Fine Arts in Yerevan, Armenia. Ruben Malayan is a founder of the "Armenian Genocide in Contemporary Graphic and Art Posters" project, which has received wide coverage in the international press, with posters published in a number of books and magazines worldwide. For the past several years, he has been working on research about the art of specialized scripts, and has developed a portfolio of unique stylized Armenian calligraphy. Ruben is fluent in Armenian, English, and Hebrew. Contact Ruben at 15levels@gmail.com

Eka Maraneli was born in the Republic of Georgia and earned graduate and postgraduate degrees from the Tbilisi State Academy of Fine Art. In 1993 Eka, her husband, and their three-year-old son left Georgia for the United States. Since then, Eka has continued her career as an artist and educator. She has taught painting, drawing, and illustration in several American universities. Over the last decade, Eka has exhibited in the U.S., Spain, Great Britain, Austria, the Netherlands, Russia, and Georgia. Her works are held in museums and private collections in the United States, Great Britain, the Netherlands, Turkey, and Georgia. Eka lives with her husband and two children in Brookline, MA. She is an adjunct Professor of Painting and Drawing, Boston University.

Hassan Massoudy was born in Najef, South of Iraq. In 1961 he left for Baghdad and started working as an apprentice for various calligraphers. He visited exhibitions of modern art, which fascinated him and from then on, he dreamed of studying art.

The unfolding political events and ensuing dictatorship prevented him from doing so. He eventually left Iraq for France in 1969, freed from the oppressing regime but heartbroken. He arrived at the Ecole des Beaux-Arts in Paris, where he first worked on figurative painting. But he did not stop calligraphy altogether; he practiced it to pay for his studies. Over the years, calligraphy progressively entered into his figurative painting and eventually took its place. In 1972, he created the show *Arabesque* with an actor and a musician. *Arabesque* was a public performance combining music and poetry together, with calligraphies being performed and projected on a large screen. Traditionally, Arabic calligraphy is done with black ink. To better express himself, Hassan broke from the tradition and introduced other colors, particularly on his work on large-size paper. Creations from Hassan Massoudy are a subtle mix of present and past, oriental and occidental art, tradition and modernity. He perpetuates tradition while breaking from it. Over the years he has purified and simplified the lines of his drawing. Contact Hassan at www.massoudy.net.

Marc Michaels (Mordechai Pinchas) was born in Greenwich, London. Marc gained a Diploma in Graphic Design and Communication from Goldsmiths College and worked initially as a designer and illustrator for the Central Office of Information before moving to marketing for the government. He holds an MA in Jewish Studies from the Leo Baeck College, London and studied *Sofrut* under Vivian Solomon. He is a Sofer STaM and freelance designer, author of the *Tikkun for Megillat Hashoah* and the designer of the Movement for Reform Judaism *siddur, Forms of Prayer*. He has written many books including *Thoroughly Modern Moses*; *The East London*

Synagogue: Outpost of Another World; *Care of Your Torah: A Guide* and *Give!*. His scribal website is at www.sofer.co.uk.

Barry Morentz was motivated by his love for language and handwriting to study calligraphy. After thirty-four years he remains fascinated and challenged by the power and beauty of letterforms to dramatically convey the emotional power of a text. Shakespeare, Dante, and the music of Elgar, Verdi, and Wagner continually inspire his calligraphic interpretations. He owns and operates his Madison Avenue studio, where he creates calligraphic works and handmade books, boxes, and portfolios. He began his formal calligraphic studies, primarily with Sheila Waters, in 1977, and eventually with Gottfried Pott, Hermann Zapf, and numerous other calligraphic luminaries. A highlight of his education was paleographic studies in Rome and the Vatican Library. He has taught at five international conferences and has led workshops in Tokyo, Hong Kong, Singapore, and throughout the United States and Canada.

Chi Nguyen is a calligrapher/designer who also teaches calligraphy and papercrafts in New York City. She remembers fondly and gratefully her first pointed-pen class with Caroline Paget Leake, and her first broad-edge nib class with Alice Koeth. She has since enjoyed many, many workshops and classes as a longtime member of the Society of Scribes. Contact Chi at www.chidesign.com.

Jeanette Kuvin Oren is known internationally for Judaic art and graphic design. Jeanette grew up in Palm Beach, Florida, and earned degrees from Princeton and Yale Universities. She nearly completed her Ph.D. in epidemiology when she

decided to commit herself full-time to a career in Judaic art. Jeanette began making kettubot (Jewish marriage contracts) in 1984, teaching herself Hebrew and English calligraphy, paper cutting, gouache illumination, and silk painting. Since then, she has made kettubot for more than 300 marrying and anniversary couples. Jeanette also creates Torah covers, *Huppot* (marriage canopies), Ark curtains, donor recognition walls, murals, mosaics paper cutting, family trees, limited-edition prints, and wall hangings. More than 350 houses of worship, organizations, community centers, and schools have commissioned her work. In recent years, Jeanette has added graphic art, logo, and marketing design to her repertoire. You can find Jeanette's Judaic art at www.KuvinOren.com, and her graphic design at www.JeanetteKuvinOren.com.

Dattatraya Padekar holds a diploma in both Applied Art and Fine Art. His professional career in visual art spans thirty-seven years with nine solo shows in India and abroad. He has won a total of seventy awards at the national and state level in the fields of drawing, portrait, landscape, painting, poster design, calendar design, calligraphy, illustration, press campaign, sculpture, and graphic prints. He has won National Awards as a calligrapher and designer in 1983, 1984, and 1985. He was selected among 100 artists worldwide for a book published internationally, titled, *How Did You Paint That? 100 Ways to Paint People. (Volume 2)*. He was commissioned to create two paintings for the *Queen Mary II* Cruiser, was on the teaching faculty of Sir J.J. Institute of Applied Art, Mumbai, from 1972 to 1977, worked as an illustrator for the *Times of India* from 1977 to 1985, and worked as a visualizer-cum-calligrapher in *Loksatta* (daily newspaper), Mumbai, from 1992 to 1997.

Anna Pinto divides her time between freelance work and teaching in the art department of Long Island University's Brooklyn Campus and for various calligraphy guilds. Her work can be seen in publications ranging from *Lady Cottington's Pressed Fairy Calendar 2006* and *Artist and Alphabet: Lettering Art in the 20th Century* to *The Perfect Wedding Reception,* by Maria McBride, and *Drawing Dimensions,* by Cynthia Maris Dantzic, as well as in the collections of the San Francisco Public Library, the Dana Library at Rutgers University, Newark, and the Beinecke Library at Yale.

Izzy Pludwinski is a freelance calligrapher and calligraphy teacher. He studied as a Sofer STaM in Jerusalem and took his formal calligraphy training at London's Roehampton Institute. His varied commissions have included calligraphy for two special-edition Haggadot, work for the President's Office of Israel, lettering for the Yakar Synagogue in Jerusalem, and the design and publishing of a fine-art edition of the Song of Songs. In 2004, Izzy had the honor of being invited by Donald Jackson to Wales to work on the Hebrew for the St. John's Bible. Izzy is currently writing a comprehensive book on Hebrew calligraphy as well as working on a large project writing the entire Pentateuch. Though firmly entrenched in the world of traditional Judaica, Izzy's calligraphic passion lies in finding ever-new expressive forms for the Hebrew aleph-bet—a path that has led him from font development to Zen-influenced abstract Hebrew calligraphy. He lives in Jerusalem with his wife and two beautiful daughters. His work can be seen at: www.Impwriter.com.

Marcy Robinson is a freelance lettering artist residing in New Jersey. She has

studied with Julian and Sheila Waters and has taken workshops with many other calligraphic artists. Her work may be seen in *Brides* magazine, the Calligraphy Engagement Calendars, *Letter Arts Review,* and other calligraphic publications. In addition, two pieces of her calligraphic work were purchased for inclusion in the San Francisco Library/Richard Harrison Collection. Marcy was also on the faculty of several calligraphy conferences.

Christine Flint Sato is British and studied calligraphy under Seika Kawabe for ten years, from 1982 to 1992. She is now a practicing sumi ink painter and writes about the sumi arts. Contact Christine at www.sumiwork.com.

Wissam Shawkat is originally from Basra, Iraq, and now lives in Dubai, UAE. Passionate about calligraphy from an early age, his degree in Civil Engineering, received from Basra University in 1996, complemented his artistic pursuits and offered him the skills necessary to excel at draftsmanship and design. His unique style borrows from the exquisite craftsmanship of traditional practitioners and the vibrancy of contemporary culture. A calligrapher and designer of logotypes with more than twenty years experience, he has worked for well-known clients in branding design, advertising agencies, and big corporations. In addition to the graphic applications of his calligraphic works, he has practiced calligraphy as an art form, producing fine art calligraphy pieces that are included in private and public collections throughout the world. He has participated in local and international competitions and exhibitions and has won many awards locally and internationally. He has been a judge and consultant for local and international calligraphy functions and exhibitions and

is a founding member of the Dubai Arabic Calligraphy Center. Wissam's work has appeared in many books and publications featuring the art of calligraphy and logos. Selected pieces are part of important private collections around the world. Showcased internationally, Wissam's work resonates with a wide range of audiences and testifies to the fact that calligraphy knows no boundaries.

Maureen Squires is on the faculty and is a former board member of the Guilford Art Center. She was an artist in residence at the Josef and Annie Albers Foundation winter of 2001. Maureen has directed three international calligraphy conferences in Philadelphia, New York, and Guilford, CT. Teaching experience has included several conference workshops and college level through adult education. She holds a BA in art from Seton Hill University. Further study included two years of advanced calligraphy at Carnegie Mellon University with Arnold Bank along with many years of study with other fine calligraphers. She approaches her lettering from a painter's perspective and exhibits her work widely.

John Stevens is a calligrapher, designer of logotypes, and illustrator of expressive letterforms with thirty years experience. He has worked for well-known clients in book and magazine publishing, packaging, type design, graphic design, television, and film. In addition to the graphics application of his work, John has practiced calligraphy as an art form, producing one-of-a-kind commissioned pieces that are included in many private and public collections throughout the world. He has had several solo exhibitions, and has participated in many group exhibitions throughout the world (most recently, Japan). Invitations to teach his craft at international calligraphy

conferences have brought John to many cities throughout the United States and several excursions to Europe and Japan. Originally from New York, he now lives in Winston-Salem, NC, where he teaches at Cheerio Calligraphy Retreats.

Rabbi Yonah Weinrib specializes in elaborate manuscript illumination, combining a wide array of art techniques and media to enhance his exacting calligraphy. An accomplished author as well as artist, he has published volumes on *Bar Mitzvah*, *Bat Mitzvah*, the Jewish wedding, Grace after Meals, *Megillat Esther*, an internationally acclaimed edition of *Ethics of the Fathers*, and his magnum opus, *The Illuminated Torah*. Rabbi Weinrib's illuminations, designs, and writings contain a fascinating interplay of artistic imagery and profound research based on traditional texts and sources. Rabbi Weinrib has exhibited and lectured internationally, and has been commissioned to design presentation awards for a number of organizations, as well as for heads of state. His work is found in prestigious museums, galleries, and private collections around the world.

Eleanor Winters has been working as a calligrapher and calligraphy teacher since the mid-1970s. Author of *Mastering Copperplate Calligraphy* (Dover); *Calligraphy in Ten Easy Lessons* (Dover); *Calligraphy For Kids (*Sterling); and *1-2-3 Calligraphy* (Sterling), she was the editor of *The Calligraphers Engagement Calendar* for twenty-five years. She is an adjunct professor of art at Long Island University and a member of the Society of Scribes calligraphy faculty. Eleanor was the director of the Calligraphy Workshop at the New School University from 1985 to 1998, and has taught at numerous international

calligraphy conferences. She teaches workshops in the United States, Europe, and Asia and exhibits her work in the United States and Europe. She has an MA from New York University.

Lili Cassel Wronker was born in Berlin, Germany, and has lived in New York for sixty-five years. She was taught calligraphy by the sculptor Robert Russin at Washington Irving High School, studied lettering with William Metzig, and assisted Arnold Bank at *Time Magazine*. In 1950, Jerusalem's Bezalel Art School held an exhibition of her book illustrations. She designed book jackets for World Publishing Company for one-and-a-half years and was a member of George Salter's Book Jacket Designers Guild. In 1974, she was a co-founder of the Society of Scribes after a course with Donald Jackson. She taught calligraphy for thirty-three years at various schools and workshops. Her collections are at the Rare Book Room of the San Francisco Public Library.

Jim Zhang was born in Bejing and started practicing calligraphy when he was eight or nine years old. Before coming to the United States in 1981, he was a graduate student of English and American literature at Nankai University, Tianjin, China. After 1985, he graduated from the department of Cinema Studies at New York University and became a freelance film critic and a photographer. For the past twenty-five years, he's been teaching courses on Chinese cinema, and Chinese history, as well as Chinese language at a number of universities in New York. In addition, he has been teaching calligraphy at the China Institute for over twenty years. His calligraphy has been published in various books and magazines.

Index